PAUL STRAND

PAUL STRAND

EDITED BY MAREN STANGE

ESSAYS ON

ROBERT ADAMS, WILLIAM ALEXANDER, RUSSELL BANKS
RICHARD BENSON, MILTON W. BROWN, BASIL DAVIDSON
EDMUNDO DESNOES, CATHERINE DUNCAN, CAROLYN FORCHÉ
BREWSTER GHISELIN, JIM HARRISON, JAN-CHRISTOPHER HORAK
ESTELLE JUSSIM, JEROME LIEBLING, GLORIA NAYLOR

HIS LIFE

REYNOLDS PRICE, BELINDA RATHBONE, JOHN ROHRBACH
NAOMI ROSENBLUM, WALTER ROSENBLUM, CHARLES SIMIC
ALAN TRACHTENBERG, ANNE TUCKER, KATHERINE C. WARE
MIKE WEAVER, STEVE YATES

AND WORK

APERTURE

Contents

vii Illustrations

 xi Preface

 1 Introduction, ALAN TRACHTENBERG

 18 The Three Roads, MILTON W. BROWN

 31 The Early Years, NAOMI ROSENBLUM

 53 *Women of Santa Anna*, Mexico, 1933, GLORIA NAYLOR

 55 Modernist Perspectives and Romantic Impulses: *Manhatta*, JAN-CHRISTOPHER HORAK

 72 Portrait of a Marriage: Paul Strand's Photographs of Rebecca, BELINDA RATHBONE

 87 The Transition Years: New Mexico, STEVE YATES

101 *Mr. Bennett*, Vermont, 1944, RUSSELL BANKS

103 Print Making, RICHARD BENSON

109 Photographs of Mexico, 1940, KATHERINE C. WARE

122 Strand as Mentor, ANNE TUCKER

137 *Susan Thompson*, Cape Split, Maine, 1945, JIM HARRISON

138 A Personal Memoir, WALTER ROSENBLUM

148 Paul Strand as Filmmaker, 1933–1942, WILLIAM ALEXANDER

161 *Time in New England*: Creating a Usable Past, JOHN ROHRBACH

179 *Bombed Church*, Host en Moselle, France, 1950, CAROLYN FORCHÉ

181 Praising Humanity: Strand's Aesthetic Ideal, ESTELLE JUSSIM

192 The *TAC* Cover, NAOMI ROSENBLUM

197 Dynamic Realist, MIKE WEAVER

209 *Arbres et Maison*, Botmeur, Finistère, 1950, JEROME LIEBLING

211 Working with Strand, BASIL DAVIDSON

225 *Hilltown*, BREWSTER GHISELIN

229 *Shop, Le Bacarès*, Pyrénées-Orientales, France, 1950, CHARLES SIMIC

231 The Years in Orgeval, CATHERINE DUNCAN

239 Strand's Love of Country: A Personal Interpretation, ROBERT ADAMS

249 Paul Strand, Dead or Alive, EDMUNDO DESNOES

257 *The Family*, Luzzara, Italy, 1953, REYNOLDS PRICE

259 A Narrative Chronology

268 Notes

293 Selected Bibliography

305 Contributors

311 Index

Illustrations

1. *Blind Woman*, New York, 1916
2. *Abstraction*, Bowls, Twin Lakes, Connecticut, 1916
3. *The White Fence*, Port Kent, New York, 1916
4. *Wall Street*, New York, 1915
5. *Wire Wheel*, New York, 1918
6. *Lathe*, Akeley Shop, New York, 1923
7. *Garden of Dreams/ Temple of Love/ Versailles, 1911*
8. *Abstraction, Porch Shadows*, Twin Lakes, Connecticut, 1916
9. *Man in a Derby*, New York, 1916
10. *Akeley Motion Picture Camera*, New York, 1922
11. *Lathe*, Akeley Shop, New York, 1923
12. *Ghost Town*, Red River, New Mexico, 1930
13. *Women of Santa Anna, Mexico, 1933*
14. *Manhatta*, shot #2, film still, 1921
15. *Manhatta*, shot #13, film still, 1921
16. *Manhatta*, shot #4, film still, 1921
17. *Manhatta*, shot #20, film still, 1921
18. *Manhatta*, shot #38, film still, 1921
19. *Manhatta*, shot #63, film still, 1921
20. *Manhatta*, shot #64, film still, 1921
21. *Rebecca at Dr. Stieglitz's*, Mamaroneck, New York, October, 1920
22. *Rebecca Salsbury*, New York, 1921
23. *Rebecca*, New York, 1922 or 1923
24. *Rebecca Strand*, New York, 1922
25. *Rebecca*, Taos, New Mexico, 1932
26. *Mesa Verde*, Colorado, 1926

27. *Store Window (Mehle)*, Ghost Town, Colorado, 1932
28. *New Mexico*, circa 1931–1933
29. *Badlands*, near Santa Fe, New Mexico, 1930
30. *Dark Mountain*, New Mexico, 1931
31. *Black Mountain*, Cerro, New Mexico, 1932
32. *Mr. Bennett*, Vermont, 1944
33. *Landscape*, Near Saltillo, Mexico, 1932
34. *Cristo with Thorns*, Huexotla, Mexico, 1933
35. *Man*, Tenancingo de Degollado, Mexico, 1933
36. *Church Gateway*, Hildago, Mexico, 1933
37. *Paul Strand* (by George Gilbert)
38. *Paul Strand* (by George Gilbert)
39. *Susan Thompson*, Cape Split, Maine, 1945
40. *Dunes near Abiqui*, New Mexico, 1931
41. *Driftwood*, Dark Roots, Maine, 1928
42. *White Shed*, Gaspé, 1929
43. *Cobweb in Rain*, Georgetown, Maine, 1927
44. *The Wave*, film still by Ned Scott
45. *The Plow That Broke the Plains*, film still
46. *Native Land*, film still
47. *Church on a Hill*, Northern Vermont, 1945
48. *Splitting Granite*, New England, 1945
49. *Figurehead, Samuel Piper*, New England, 1945
50. *Tombstone and Sky*, New England, 1946
51. *Church*, Vermont, 1944
52. *Bombed Church*, Host en Moselle, France, 1950
53. *Men of Santa Ana*, Lake Patzcuaro, Michoacán, Mexico, 1933
54. *Flowers in the Sand*, South Uist, Hebrides, 1954
55. *Mrs. John McMillan*, Benbecula, Hebrides, 1954
56. *Loch Bee*, South Uist, Hebrides, 1954
57. *Skeleton/Swastika*, Connecticut, ca. 1936
58. *Bell Rope*, Massachusetts, 1945
59. *Haying*, Haut Rhin, France, 1950
60. *Near Dompierre*, Charente, France, 1950
61. *Arbres et Maison*, Botmeur, Finistère, 1950, from *La France de Profil*
62. *Sea Rocks and Sea*, The Atlantic, South Uist, Hebrides, 1954
63. *Ewan McLeod*, South Uist, Hebrides, 1954
64. *Window*, Daliburgh, South Uist, Hebrides, 1954

65. *Cattle Sale*, Loch Ollay, South Uist, Hebrides, 1954

66. *Kitchen*, Loch Eynort, South Uist, Hebrides, 1954

67. *Hilltown*, Sicily, Italy, 1952

68. *Shop, Le Bacarès*, Pyrénées-Orientales, France, 1950

69. *Roots, Gondeville*, Charente, France, 1951

70. *Pathway to the Gate*, Orgeval, 1957

71. *Great Vine in Death*, Orgeval, 1973

72. *Bird on the Edge of Space*, New York garden, 55th Street, 1975

73. *Eagle*, Massachusetts, 1946

74. *Toward the Sugarhouse*, Vermont, 1944

75. *Parlor*, Prospect Harbor, Maine, 1946

76. *Young Boy, Gondeville*, Charente, France, 1951

77. *Ekuwah Mansah*, Larteh, Ghana, 1963

78. *Oko Yentumi*, Omankrado of Tutu, and Family, Ghana, 1963

79. *The Family*, Luzzara, Italy, 1953

Editor's Preface

The occasion for this volume is the centennial in 1990 of Paul Strand's birth, certainly a fitting time to gather together the considerable body of scholarly research, critical analysis, and general appreciation that surrounds this seminal figure in modern American art and photography.

The essays published here have been commissioned in their present form exclusively for this book. The objective has been, with the aid of the advisory committee, not only to offer writing on well-known aspects of Strand's work and life, but also to shed new light on less studied periods and photographs. The resulting texts include a variety of points of view that not only confirm but also contend with each other, providing a usefully provocative perspective. Combining personal recollection, creative response, and new scholarship, the collection offers an appreciation of unparalleled scope and thoroughness, and it complements the centennial exhibition mounted by the National Gallery and the accompanying publication, *Paul Strand*.

Particular credit must go to Steve Dietz, who was involved in conceptualizing the project and in its initial stages, and to the advisory committee, Carole Kismaric, John Rohrbach, and Naomi Rosenblum, for their invaluable and unstinting contributions to this book.

ALAN TRACHTENBERG

Introduction

The fame Paul Strand enjoys as an original artist in photography hardly needs reaffirmation. He is universally acclaimed as a master, and his pictures rank high among the most often reproduced masterworks of photography. And not only of photography: his pictures have an honored place within the canon of modern art as such. We think at once of *Blind Woman*, *Wall Street*, and *White Fence* and the New England portraits of Mr. Bennett and Susan Thompson, views of vernacular American churches and meetinghouses and graveyards, close-up views of rocks and mushrooms and flowing iris leaves of the New England terrain, distant, encompassing landscapes of Gaspé and New Mexico, the Mexican portraits and minutely seen views of religious carvings or *bultos*, the French and Italian and Hebridean portraits of village life. People viewing his work for the first or the hundredth time find themselves captivated within a visual domain of extraordinary immediacy and freshness, not just in textures, shapes, and forms but in subtleties which make for resonating coherences within and among images. We might almost believe that Strand leaves his mark on the world itself, as if a Prospero had willed matter to look just this way for the camera. But we know better, that the external world only shares credit for how it looks in Strand's pictures, shares it with his camera, with the photographer's eye and body, which alters their place, angle, and degree of closeness in order to produce *the* image that seems at once true to the world and to the artist.

"It is through the actual factual world that we express life," Strand told a Chicago audience in 1946.[1] For many lovers and artists of photography this proposition states a cardinal truth, the very essence of photography and the key to its aesthetic potentiality. The camera gives us access to things as they are, according to this apparent law, and things as they are, rendered by an artist with complete trust in the medium and respect for its intrinsic properties, express more than themselves; they express the artist's sense of life. For almost three generations Paul Strand's pictures

have struck wonder and pleasure in the eyes of viewers as majestic examples of that proposition. Strand's pictures often make us believe that they are not just true to life but *truer* than life, more real than factual reality itself. There is a sleight of hand, or of eye, involved in this, a magician's craft of making illusions that disguise themselves as reality. The magic works, to be sure, so far as we believe in it, and Strand's role in fostering conviction in a certain kind of photographic truth has been as monumental as his oeuvre itself.

The notion of photography as a potentially higher truth, not something supernatural but transcendent, lies close to the heart of the modernist movement centered around Alfred Stieglitz and his gallery 291 in the years just before World War I.[2] The idea also draws on and expresses a native romantic ideal, as close to the writings of Emerson, Thoreau, and Whitman as to the formal doctrines of early modernism as formulated by Kandinsky and others. Strand adopted an American romantic version of the aesthetic ideology of modernism at the outset of his career in 1915 as Stieglitz's brilliant young acolyte, and he held to it in most essentials until his death in 1976 at age eighty-five. A notoriously commodious and ill-defined term, modernism embraces many practices in photography that Strand did not follow; experiments in oblique angles and pure light and lensless images pursued by Russian constructivists like Rodchenko, Bauhaus artists like Moholy-Nagy, and dadaists like Man Ray did not appeal to Strand. After a few notable experiments in near-abstraction in 1916, he applied his modernist aspirations within the mode of realism; his images are always recognizable traces of a familiar world, even if seen often in unfamiliar and defamiliarizing ways. The traditional illusion of reality remained his goal: the construction of two-dimensional imitations of three-dimensional space just as the main tradition of Western art defined that practice. In Strand's modernism the perceptual world may appear in a new light but it remains intact. If modernism taught him certain principles of abstract form, his romantic sensibility kept him well within the boundaries of the recognizable. Modernism may have taught him to see the world with rigorous attention to the abstract form underlying every perception; romanticism, his more powerful angel, taught him loyalty to the fullness of the world as it is. For Strand photography updates the ancient arts of illusion; "only a new road from a different direction," he wrote in 1917, "but moving toward the common goal, which is life."[3]

If this cleaving to an old idea of the real may seem a limit to Strand's modernism, it also provides a deep clue to what photography meant to him. As an aesthetic outlook modernism shows more readily in his attention to technique and in his formal experiments than in his choice of subjects, which tend, after his early city street portraits and views, toward the more romantic genres of landscape and portraiture and toward pastoral iconography. The proposition that photography has a "pure" nature, one

which allows the factual world to show or utter itself directly to the viewer of a photograph, has a modernist ring to it, one which makes a special virtue of technique. The more true to its nature, the more "straight" the photograph (unmanipulated, faithfully continuous in its tones), the more modern it seemed to be in its forthright acceptance of the scientific and mechanical basis of the medium. Modernist signifies, in this regard, what is up-to-date, undisguised, accepting of speed, accuracy, and the liberty of unrestricted perspectives. Objectivity is another term often employed by Strand, Stieglitz, Weston, and other self-conscious modernists of the camera. Yet, if Strand's adventuresome use of close-up registers a modernist impulse toward experimental objectivity, the subjects of his close-ups, such as rocks, plants, faces, tools, look true to their names, just as our normal perceptions tell us they should. Strand's modernism does not alter normal perception but heightens it, wrenches the normal, we might say, into new visual significance.

Looking at Paul Strand's pictures today puts us in touch with an idea of photography and of photography's relation to the wider world that helped establish the legitimacy and integrity of the medium as a modern art. Strand's generation believed in that idea, believed they had discovered and enunciated a hard truth about the medium. In Strand we meet on its own ground one of the founding ideas of modern American photography. How better to understand what Strand meant by photography than to experience his pictures, to undergo their magic, and then to reflect upon the experience as a means of understanding it. Knowledge of the photographer begins here, in what we undergo as experience when we take in his pictures. Through our experience of his art we come in touch with the underlying ideas which inform it.

In knowing Strand we have ideas to contend with as much as images, and here begin complications. His words and his pictures are not always in harmony; when we try to match the boundaries of his verbal concepts with the borders of his pictures, we sometimes encounter discordances. Hardly unusual, and D. H. Lawrence's dictum "trust the tale, not the teller," provides a trustworthy formula for such moments. Strand the incomparable artist of illusion was also a man of ideas, an intellectual. He was a figure, not merely a photographer. And as a historical figure, a whole person, he presents difficulties and contradictions. They are part of the Paul Strand we want to know.

This collection of new essays opens the book on the historical Strand, describes the major phases of his sixty years in photography and film, and poses some key questions, particularly about his relation to modernism. On the evidence of most of the essays, especially those by Milton Brown, Jan-Christopher Horak, Estelle Jussim, and Mike Weaver, modernism represents the central problematic issue in Strand's career, for it determined his most fundamental idea of himself as an artist in photography. His early

aesthetic commitments implicate, moreover, his later political stands and the allegiance he apparently adopted sometime in the 1930s to Marxism of a Stalinist brand. To be sure, as far as the record shows, Strand never mentioned those once-hushed words, Marx, Marxism, Stalin, in public. Was he or wasn't he ... what? Actual facts regarding allegiances, commitments, activities, or memberships are quite rare and the picture unclear, more a matter of gossip, rumor, and fragments culled from the scandalous FBI files. In any case, Strand's "politics," in the sense of public statements, positions taken, or policies endorsed, are his own business as a citizen. He is hardly alone among what we might call cold war modernists in art, Marxists in politics. Picasso comes at once to mind, as well as Diego Rivera, Pablo Neruda, Ben Shahn, and more writers and artists in America than one can count easily. The company is not bad, even if the self-deception may be painful to admit and to detail.[4]

In the narrow sense of affiliation and allegiance, Strand's politics bear an uncertain relation to his art, and seeking out connection between them is probably fruitless. But there is a more interesting and quite relevant sense of the political in his work, one which does affect our experience and understanding of his pictures. These essays help us identify it by showing how his earliest commitments to his formative idea of photography already included a political component. One of the distinctive notes we catch in Paul Strand's voice from the beginning of his career is a seriousness about photography as a cultural principle, something more than a technique of picture-making. We hear the same note in other voices in Strand's generation, a conviction that the world is undergoing profound moral and philosophical change and that photography has a central role to play in the unfolding cultural revolution. What we want most to understand about Strand's work and career is the politics of his aesthetics, for in that conjunction of art and politics we are most likely to find the historical figure.[5]

For today's audience Paul Strand looks enigmatic, difficult to place exactly. Like all classics, the historical Strand has been distilled into a forbiddingly translucent image inspiring homage more than critical thinking and careful evaluation. The essays assembled here go far toward restoring the figure to his cultural time and space. To begin, we get a better sense of the person, a man who inspired admiration and respect if not always untroubled or unmixed affection. A person of high principle, he often took too high a perch for easy rapport with others. He believed in his own rectitude. Edmundo Desnoes speaks of the messianic tone of his prose. Perhaps more of an "intellectual" than Alfred Stieglitz and Edward Weston, whom Calvin Tomkins named along with Strand as the "only three photographic artists in America" of the caliber of a Matisse or a de Kooning,[6] Strand lacked the flair and charisma of Stieglitz and the spellbinding intensity of Weston.

He shared their romantic egotism, however, even if he rarely indulged in their self-dramatizations. Strand seemed to suppress the ego deliberately, yet in a manner which seemed egotistical in its own right. The rarity of his intimate revelations in print or recorded conversation makes all the more revealing Belinda Rathbone's account of Strand's hitherto unexamined series of portraits of his first wife, Rebecca, which he made, we learn, in rivalry with Stieglitz's famous O'Keeffe portraits.

Strand's photographs seem self-effacing; Tomkins remarks that he virtually disappears into his art.[7] And in his writings he celebrates objectivity above all. So do Stieglitz and Weston, but Stieglitz also said, "When I photograph I make love," and Weston's confessions in his *Day-Books* reveal a powerful erotic current. For the austere and more consistently doctrinal Strand, "objectivity" represented the impersonal imperatives of subject matter, the priority of the world over the self. "I don't have aesthetic objectives," he explained to a visitor in his French home at Orgeval shortly before his death.

> I have aesthetic means at my disposal, which are necessary for me to be able to say what I want to say about the things I see. And the thing [sic] I see is outside myself—always. I'm not trying to describe an inner state of being.[8]

The diction may seem impossibly pedantic, the tone presumptuous, but that was one of Strand's styles, as if he were speaking directly into the ear of History.

In her essay, Estelle Jussim refers politely to this denial of "aesthetic objectives" as a "dubious proposition." Strand the theorist would deny exactly what Stieglitz and Weston insist upon: the passionately autobiographical sources of their art. When Strand does admit the subjective into the formula of art he makes it seem more a rule or principle than something ineffably inward. His famous formulation in 1917 of photography's "absolute unqualified objectivity" puts it this way:

> It is in the organization of this objectivity that the photographer's point of view toward Life enters in, and where a formal conception born of the emotions, the intellect, or of both, is as inevitably necessary for him, before an exposure is made, as for the painter, before he puts brush to canvas.[9]

The tone itself of Strand's language, its solemnity and self-importance, dates such a passage from the early modernist moment of manifestos and proclamations.

The very earnestness about "Art" that Strand shared with his generation might well disadvantage him in the eyes of many among today's audience. The core vocabulary of the early American modernists has become widely suspect recently; in the atmosphere of post-modernist skepticism words like

"spirit," "genius," "universality," "Life," or "Truth" have come to seem a protective facade of rationalization for the elitist privileges of predominantly white male artists. In a sense the founding generation of (mostly white male) modernists has been on trial, and one can imagine the charges against Paul Strand. How does he reconcile his attachment to socialism with his aesthetic commitment to purity of means and ends, to producing fine prints? (Richard Benson's essay here should put to rest the legend of Strand's craftsmanship, clarifying as it does the difference between a fine print and an exactly realized vision.) And conversely, in Strand's studies of peasant and Third World culture, beginning with his Mexican pictures of the 1930s and continuing in the postwar books he produced on village and agrarian life in France, Italy, the Hebrides, Egypt, and Ghana, doesn't he more regularly project an ideal image of pastoral heroism than a realistic picture of struggle and conflict, poverty, despair, and anger? We can imagine the accusations flying from both sides: his radical politics are factitious; they are the wrong radical politics.

However much he insists that "I've always wanted to use photography as an instrument of research into and reporting on the life of my own time," doesn't Strand in his pictures strive more for an effect of the timeless and the universal than of the immediate, the contingent, the unsettled moment?[10] What do his pictures or his books have in common with the work of Mathew Brady and his colleagues during the Civil War, or of Lewis Hine, who first initiated Strand into the secrets of photography at the Ethical Culture School in 1907 and introduced him to Stieglitz and 291, or of Dorothea Lange, Ben Shahn, Walker Evans, and other Farm Security Administration photographers? Do we go to Strand for pictures of "what's going on in the world"?

In a climate of suspicion, questions of evaluation often appear as indictment, as charges leveled and evidence arrayed. The essays collected here also raise difficult issues about art and politics, but they do so in a spirit of revision rather than accusation. Strand invites comprehensive understanding and criticism, for his career dramatizes some of the most fraught issues in twentieth-century art and politics, such as the relation between the aesthetic revolution implied by World War I-era avant-garde art and the opposing political revolutions of socialism and fascism which defined the decades between the great world wars. Strand's work enacts a pervasive dilemma which springs from modernism's equivocal historical situation in an age of contrary revolutions: can art be true to itself, to its aesthetic character, and at the same time serve social justice?

Whatever his genuine intellectual attachment to Marxism, American romantic modernism had more to do with shaping his thought and informing his artistic habits and practices. He began his career of conscious photography in the "experimental laboratory," as Stieglitz called it, of 291. The route from 291 (and Stieglitz's later galleries in the 1920s) to depres-

sion-era and cold war Marxism was more continuous than many may think, as the careers of a number of his friends, including the writer Waldo Frank and the theater director and critic Harold Clurman, reveal. One lesson of the essays here is that in his beginnings lay the germ of his unfolding—including his becoming what he called "a politically conscious person."[11]

What does Strand mean in the 1990s? Do his works speak to us as contemporaries? What might we learn about ourselves, about the sources of our own time, from a critical reappraisal of his work and career? The essays gathered here offer beginnings rather than final answers; they provide grounds for the kind of reevaluation of the past that Strand's generation took as a high priority of their cultural agenda. We learn here that Strand lived his life and undertook his work with determined self-awareness. By touching on the many phases of Strand's career, the essays collectively portray a figure in motion through specific cultural fields, including his early tutelage under Stieglitz (each tutored the other in different ways), his ventures into the New England and Gaspé countrysides, and the critical New Mexico period upon which Steve Yates casts new light. His gravitation toward Harold Clurman and to the "Group Idea" in the early 1930s proved significant, a logical outgrowth of his career to that point.[12]

Many today think of Stieglitz and 291 as preciously aesthetic, apolitical, and scandalously elitist. Yet Harold Clurman wrote in *America and Alfred Stieglitz* in 1934 that Stieglitz's 291 "reveals that classic conception of art that today we call *collective*," at least in potential. The gallery failed to realize its own ideals, according to Clurman; it served more as a "protective association" than a genuine "group." Clurman wanted to distill the political essence of Stieglitz's incipient group idea, to extract the implicit radicalism of 291:

> Our arts cannot live separate from the world, and if we feel that art such as Stiegliltz's and those he sponsored has a right to be, we must have some conception of the kind of world that would give it nurture. We cannot do this without considering the whole structure of society. We must finally find a political equivalent for the ideal we discover in our artists. And to the political group whose aims are consonant with our own we must give our support and lend our talents. An art that cannot be integrated with every human activity is a sick art.[13]

It is significant that Strand came closest to fulfilling the overtly political collectivist ideal Clurman articulates in this important essay as a filmmaker rather than a still photographer. In Mexico and in his work with Frontier Films, from the middle 1930s and to the early 1940s, he found both a visual content, especially the assault on trade unions and on civil rights in the film *Native Land*, and a form of production congenial both to the political urgencies of the time and to his need for a controlling role as director

and auteur. The politics of his film work is well covered in the essay by William Alexander. Less important as a constructive force in his own photography but valuable for what it reveals about his influence and his teaching was Strand's role in the Photo League, recalled in the memoir by Walter Rosenblum. Anne Tucker offers new information and insight into Strand's relations with this ambitious New York group of photographers devoted to collective documentary projects during the depression and war years. Though he supported them, Strand did not participate in their collective projects. One wonders whether his romantic individualism and his ideal of the artist as an avant-garde prophet prevented the surrender of autonomy required by group enterprises that he did not control. Essays like Catherine Duncan's shed new light, biographical and analytical, on the rich last phase of Strand's career, during which he focused chiefly on making books in which the combined images and text represent another mode of collaboration, if not exactly a view of art as a fully collective enterprise.

From his initial efforts as an avant-garde artist during the early years of the First World War, which Naomi Rosenblum explores, to his final phase as a maker of books on pastoral societies in modern conditions, Strand felt himself part of a larger history. If in his leftist phase it was a history represented by social and political movements, in his earliest phase as a modernist art-photographer it was a cultural movement of change in the arts, a movement in which he saw photography as a potential vanguard medium. In the 1970s he would recall in conversation with the art historian William Innes Homer his years with 291: "You felt that you were a part of something happening in the world that was going to be very important to many people."[14] As noteworthy as his turn toward "popular front" politics in the 1930s, and his continuing allegiance to Soviet-style socialism during the cold war, is the continuity of his bent toward politics and the essentially political and cultural basis of his art of photography from the beginning of his career.

Strand's roots lay in the American variant of international modernism, a peculiar synthesis which adopted the tenets of formal modernism tactically, as it were, on behalf of a larger goal: the transformation of American life, its society, culture, and politics, by means of a transformed *art*. Strand grew up as a young photographer in the atmosphere of what historians call the "Lyrical Left," an openly romantic movement which declared Whitman to be its precursor and prophet. About 1912 signs of change appeared among young artists, writers, critics, and intellectuals who began to speak of liberation from the hold of a "genteel" past; they hoped to free themselves and, in the process, America as a whole from conventional, official, bourgeois "Americanism," an amalgam of sentimental, puritanical, and aggressively imperial values. For Stieglitz, who defined photography as "an entire philosophy and way of life—a religion," 291 signified a "revolt against all authority in art, in fact all authority in everything."[15]

Strand partook of the cultural ferment and intellectual excitement in New York just before and during the First World War. New York provided the stage for the drama of cultural change.[16] As America's only metropolis it was port of entry for new European art and ideas and seemed more like a European than an American place in its mixing of diverse cultures.[17] It was among New York intellectuals and artists in the World War I era that the ideal of a heterogeneous American culture appeared, what Randolph Bourne called a "trans-national America."[18] New York metropolitanism and cultural nationalism were cut of the same urban cloth; both derived in large part from the active participation in the city's cultural life of many assimilated immigrants. The influence of metropolitanism on Strand's early development invites closer scrutiny. His education at the Ethical Culture School would have introduced him to cultural pluralism and to a secular humanist version of Jewishness tailored to fit that ideal. While there is no evidence that Strand, a child of the Upper West Side Jewish middle class without traces of the Lower East Side immigrant experience, ever identified himself as Jewish, he quickly gravitated toward other assimilated Jewish intellectuals such as Stieglitz, Waldo Frank, Paul Rosenfeld, and Harold Clurman. It was perhaps their typically displaced Jewishness that made many New York Jewish intellectuals into ardent *Americans* in search of a culture to which they might belong. Their particular contribution lay in a fusion of urbanity, a prophetic conception of art, and most important, a complex ideal which Bourne called "dual allegiance," allegiance at once to a particular national-ethnic culture and to a multinational, pluralistic American state.[19] Although allegiance to Jewish culture or even Jewish identity seemed of small or no importance to Strand and his group, their allegiance to an ideal American community based on a common "usable past" which they would invent and on a secular-aesthetic religiosity which they would propagate shares the *form* of the "cooperative Americanism" Bourne finds in the Jewish immigrant experience and even in the ideal of Zionism. The invisible Jewishness of Strand's modernism casts, in short, additional light on the politics of his aesthetic modernism.

Strand's publication of his early essays in avant-garde journals including *Seven Arts* and *Broom* is a telling sign of his participation in cultural metropolitanism in this early period and throughout the 1920s and 1930s. His friendships included writers and critics like Bourne, Frank, Rosenfeld, and Clurman, as well as artists. Strand's important personal links were less with photographers (Stieglitz was the major exception) than with intellectuals and artists like John Marin, Marsden Hartley, Georgia O'Keeffe, and the sculptor Gaston Lachaise. Much of his writing in the 1920s, which appeared in *Broom, The Freeman, Creative Art,* and *The New Republic,* concerned painting and other arts, as well as photography.

Strand's immersion in modernism appears in his early concern with experimentation. In later interviews he stressed his obsession with formal

problems such as, Milton Brown explains, learning how to construct a picture by experimenting in abstraction; how to capture city people in motion; and how to make candid portraits on the street without the subject's awareness of the camera. But the aesthetic ferment he absorbed in these years was not exclusively formalist. His essays from these years presents photography primarily as a medium of cultural change, a force with religious overtones for changing the world. Not in the pragmatic way of "progressive" reform that Lewis Hine practiced, but by changing aesthetic perception, teaching the world a new way of seeing. The influence of Stieglitz in these early writings cannot be mistaken.

Strand's 1917 essay in *Seven Arts* offers *Camera Work* as proof that in photography "America has really been expressed in terms of America without the outside influence of Paris art schools or their dilute offspring here."[20] "It was born of actual living," he writes, rather than of historical example or academic models — in short, a native art which brings American life to a higher realization of itself. Strand compares the new photography to architecture:

> In the same way the creators of our skyscrapers had to face the similar circumstance of no precedent, and it was through that very necessity of evolving a new form, both in architecture and photography that the resulting expression was vitalized.[21]

More ambitious and subtle, his essay in *Broom* in 1922 identifies the social forces against which serious photography must contend: the unholy trinity of the "Machine," "Materialistic Empiricism," and "Science." Together with the "religious concept of possessiveness" (the Protestant ethic underlying capitalism) these mechanical-scientific-industrial forces have forced the experimental artist to become a heretic.

The artist's heresy lies in his or her rejection of the prevailing ideology of rationalist empiricism on behalf of what Strand calls, perhaps echoing Waldo Frank's essays in *Our America* (1919), "the synthesis of intuitive spiritual activity." Evoking Jack London's sinister image of the Iron Heel, Strand (like Frank) blames the scientist for "the present critical condition of Western Civilization, faced as it is with the alternatives of being quickly ground to pieces under the heel of the new God [the Machine] or with the tremendous task of controlling the heel."[22]

The image of the heel conveys the sense of menace Strand and others felt in postwar America. The Red Scare, the Palmer Raids which rounded up radical "aliens" for deportation, the vast consolidation of business corporations under way during and just after the war, the defeat of labor in major strikes: a sense of historical urgency generated by these events lies within Strand's often strained diction. His essay evokes a prewar avant-garde belief in revolution-by-art and proposes that photography provides just the model for overcoming the threat of a rationalized bureaucratic and

technological society. Photography demonstrates the 'immense possibilities in the creative control of one form of the machine, the camera."[23] Strand makes the work of the modernist photographer, Stieglitz in particular, into a parable of revolutionary change:

> A few photographers are demonstrating in their work that the camera is a machine and a very wonderful one. They are proving that in its pure and intelligent use it may become an instrument of a new kind of vision, of untouched possibilities.[24]

Just as the threat of the iron heel appears greatest in America, "the supreme altar of the New God," so the responsibility of the American photographer is all the more pressing.

> And so it is again the vision of the artist, of the intuitive seeker after knowledge, which, in this modern world, has seized upon the mechanism and materials of a machine, and is pointing the way. . . .
> He has evolved through the conscious creative control of this particular phase of the machine a new method of perceiving the life of objectivity and recording it. . . . In thus disinterestedly experimenting, the photographer has joined the ranks of all true seekers after knowledge, be it intuitive and aesthetic or conceptual and scientific.[25]

The stakes for which the photographic artist plays are nothing less than the integration of opposites, science and art, concept and spirit, reason and intuition, into a "new religious impulse."[26]

Some may grind their teeth at such prose, but a whole generation of cultural critics and incipient theorists wrote just like this; Strand speaks in the enlightened jargon of the times. What matters is that he embraced and retained a conception of photographic art as a potential cultural and political force. Nothing less than a spiritual conversion lay at the base of the cultural revolution Strand imagined would flow from photography. As Jan-Christopher Horak argues in his essay, Strand pulled back from the utmost implications of his sweeping theories of the machine and retreated, as the pastoralism in *Manhatta* reveals, to a romantic opposition to the machine. He pulled back from the strictly logical modernism which culminated in futuristic celebrations of sheer mechanical force and energy and power. Against the rhetoric of his prose we have the evidence in Strand's pictures (including *Manhatta*) of his testing the limits of doctrine, of his rubbing philosophical ideas against the hard forms of the world he was drawn to photograph: less and less after 1922 the world of cities and social conflict, and more the pastoral realm of seemingly organic, symbiotic relations between human communities and natural conditions.[27]

The political issue remains vexing and needs to be faced openly. It comes down to this. Strand believed his pictures contributed to social justice and

human progress. Yet they do not seem to do so in any recognizably politi-
cal way. They seem too absorbed in their own form, simply too beautiful
to matter as political statements. Is there something amiss in the politics of
the pictures or in the response which expects more overt signs of political
analysis and commitment in photographs? These questions are not easily
answered, but the questions themselves help situate our responses to
Strand within issues under contention today. Can Strand shed light on
the future of a political art of photography?

Strand evolved a view of art in service to a larger vision of the world:
how it is, how it might be. Though in his single images he is often in-
tensely lyrical, revelatory, and orphic, his *conception* of photography seems
more appropriate to the mode or genre of epic. He has a large story to
tell, *tout ensemble*, larger than the aestheticism which often threatens to sub-
sume our response to his pictures when we see them as isolated images,
outside the contexts he provides either in the tangible form of the book or
the less tangible and more problematic context of his general ideas. Mike
Weaver argues provocatively that the key to the meaning of that larger
story lies in Strand's "dynamic realism," a socialist theory of art related to
if not actually derived from dialectical materialism. Whether or not this is
the case, the broad outlines of a consistent philosophy of art does make
itself felt in his work as a whole. Wholeness is clearly an ideal Strand held
dear, another generational sign which marks him off from today's post-
modernist skepticism. Like other American romantic modernists Strand
believed in totality, in a dynamic relation among parts to form a whole,
whether the parts of a composed landscape (the artist's composition repre-
senting his or her *idea* of wholeness) or separate images combined into a
portfolio or book, images of rocks and living plants set in an informing
rapport with other images of faces and human dwellings.

Critical study of any photographer's ideas, of the intellectual content
and implications of his or her forms, has been a rare phenomenon among
writers on photography, who prefer to talk about styles or techniques or to
parade global theories about the medium as such. Strand poses a special
challenge. His very solemnity and austerity represent a demand that view-
ers be *serious* about his work, that he be taken not as a photographer alone
but an artist of substance, one who has something big, important, and
carefully considered to say through his pictures. Strand's ambitions for his
art may seem dated, excessively romantic or modernist or programmatic,
but they saved his work from aesthetic preciosity; they elicit an attention
from viewers beyond the local claims of form or style or subject matter
alone. What is wanted especially, and Weaver's essay (among others) sug-
gests a route of inquiry, is close study of the points of rapport within
Strand's work as a whole, a phenomenology of the dynamism within and
among pictures. What binds his pictures together? Does his work in fact
achieve the unity he desires? What does he mean by wholeness, and where

and how does he seem to find it? Is the argument of his pictures convincing, important, necessary? Meaningful discussion of his politics properly begins here, in the experience of the work.

The large organizing ideas of Strand's work need to be tracked down into the actual construction of his pictures. What can be said about the recurring patterns in his treatment of space, the openings and closings, the rhythm of movement outward and inward, toward and beyond? His attraction to windows, doorways, thresholds suggests ideas at play about the relation of exteriors and interiors, of light and darkness, perhaps a corollary to the relation between nature and culture which increasingly attracts him after the Second World War. His windows, especially in the most successful of his books, *La France de Profil* (1952), suggest a continuing reflection upon the act of perception itself, on what it means to see, to open one's eyes upon the world. Windows are also elements of demarcation within space. We might ask if his spatial constructions are essentially abstract forms. How specific is Strand's treatment of social milieu, of cultural territoriality? What view of individuals as agents of culture and history might be derived from his manner of posing sitters, typically alone, often close up and tightly framed, in severe frontal postures within doorways or windows or against backgrounds of weathered wood, stucco, or rock? Patterns recur with tantalizing frequency in Strand's work, enough to elicit deep analysis. What do his broad views of street activities tell us about his conception of community? Or his long views of villages in their natural surround? Can we speak of an ideology of his forms? Such questions might open up a serious political criticism, something different from the mere tallying up of attitudes and positions.

Where better to begin such a criticism than in consideration of Strand's books, his efforts in the last half of his career to present images as serial ensembles? As Katherine Ware's subtle analysis reveals, in the sequencing of the separate prints in the Mexican portfolio of 1940 we have the germ of the later books. The portfolio, she shows, draws upon his contemporaneous work on the film, *Redes*, that he made in Mexico. It is entirely plausible, and a subject for closer examination, that Strand drew on his film experience for guidance in translating into sequences of still images his epic conception of the coherence of human societies in nature. In his enlightening discussion of *Time in New England* (1950) John Rohrbach explores ties between that book, Strand's first, and his film *Native Land* (1942). The film helps Rohrbach uncover a hidden nerve of that remarkable book in the covert message that American freedoms were under attack in the witch-hunting atmosphere of the late 1940s and 1950s. In its extracts from New England writing the book links freedom with the New England tradition, and that tradition with the New England landscape. The stoic perseverance and vernacular culture in the book's images celebrate a spirit of resistance and the sanctity of individual conscience.

As Rohrbach remarks, the message is so well hidden that it was missed by all reviewers of the rather shabbily printed first edition of that experimental book.

Because most were produced and published overseas, Strand's books remain *terra incognita* for his American audience. They are not uniform in style or quality, and the French book, *La France de Profil*, leaps out as a stunning example of collaboration between a writer, Claude Roy, and the photographer. By collage and typographic and calligraphic experiment, Roy's texts provide something much different from expanded captions or verbal equivalents. They interact with Strand's pictures and complement them as if in a continuous, unpredictable dialogue. This kind of free and equal collaboration proved unique, however. The other books feature the photographs with accompanying, subordinate, and on the whole independent texts. As a group reaching back to *The Mexican Portfolio* and *Time in New England*, the books pose a number of questions. With all their visual force and beauty, do they really succeed as integrations of picture and text? Strand displays great skill in juxtapositions, and occasionally in interactions with written text, but not the kind of ongoing dialogue among images and with the reader we find in the collaboration with Roy, or in another manner, in the sequencing of images in Walker Evans's *American Photographs* (1938) and Robert Frank's *The Americans* (1959).

There is something in the way Strand's pictures on the whole resist assimilation to their accompanying texts which suggests to me that he lacked the gift of a truly *social* imagination, except insofar as "society" appears as a concept. Whether this deficiency results from his brand of romantic modernism or from something deep within himself is hard to say. Did Strand carry within him too heavy a baggage of ideas to allow him to enter empathetically, as a photographer, into the sociality of daily life among his subjects? His ideas were large and large-minded. He brought to — some might say imposed upon — his pictures ideas of society and culture, rather than eliciting such ideas from his material. Basil Davidson's engaging account of his collaboration on the Hebridean book testifies to the historical breadth of Strand's conception. Yet generally the books show little of how village communities actually work as societies, are too sparse in portrayals of minute interactions — such as fill the pictures of Cartier-Bresson — to carry conviction as portraits of living societies and cultures. Seeking the whole in the part, Strand seems too often to have an idea of the whole already complete in his mind. He shows few signs of irony (and less of wit and humor) and does not allow pictures to qualify or undercut each other or to pose questions to which there may be no immediate or obvious answer. A whole, a totality, is always in place, something for viewers to grasp as already *there* rather than to create or construct on their own. Strand's books leave little left over for the reader to interpret.

Strand's twenty-five years' residence in France, a self-imposed exile and

period of alienation from his native land, further complicates the problem of his books, none of which, after *Time in New England*, takes America as a subject. Perhaps, considering the paucity of images of contemporary life in the New England book and its predominantly allegorical relation to its hidden political subject, the alienation can be said to show its symptoms as early as this work, if not earlier. Strand seemed unwilling to make something of alienation itself, except to flee its negative effects. We miss in his books the sense of contradiction, of forces in opposition, pulling in different directions. Perhaps celebration became a dominant mode and habit too early in his career for him to change course in the fiercely negative years of the cold war. Of course we can hardly second-guess Strand's decision to leave America and devote his astonishingly unstinted energy to photographing abroad. "It was not in any way rejection of America," he would explain; "it was a rejection of what was happening in America just then."[28] Whatever its reasons, the fact of self-imposed exile cannot help but affect our picture of Paul Strand, American artist.

His search for a particular subject is a case in point. Strand long cherished plans for a collective portrait of an American village. He wanted, as he explained in a later interview, "to find and show many of the elements that make this village a particular place where particular people live and work. The idea came from my great enthusiasm for Edgar Lee Masters's 'Spoon River Anthology.'"[29] He never undertook that project in the United States, finally settling on an Italian village and a collaboration with the screenwriter Cesare Zavattini which resulted in *Un Paese* (1955). "Village" itself sounds quaint for anything American, especially in the postwar years. Can one imagine an American *Un Paese* in the milieu of Robert Frank's *The Americans?*[30] It may be that the Spoon River project represented for Strand an *idea* of America which the actual place could no longer satisfy, thus justifying his quest elsewhere for coherence and harmony, and especially a place for the artist his native land withheld.

Time in New England, Strand explained in his preface, arose from a desire to "find in present-day New England, images of nature and architecture and faces of people that were either part of or related in feeling to its great tradition." That tradition, Strand explained, appeared in the "concept of New England," an idea of the region as "a battleground" for religious and individual freedoms, "the rights of man," and "the abolition of slavery."[31] Of the ninety-four pictures included in the book, most made in 1944–46, some in 1922–29, only eleven are portraits of country people. Yet these faces are memorable; they exude a radiant hardihood unmistakably a sign of that "concept" of New England rectitude, individualism, and perseverance. All of the photographs seek the past within the "present-day," the persistence of an old tradition. It is a time and place without cities, immigrants, real industrial factories, spoilation of the countryside, and the indignities of exploitation. A remarkable feat, in fact, to convey

how time *was* in New England by means of a medium inevitably contempo-
rary, bound to the present tense.

The severe editing out of a New England which does not conform to
the "concept" brings to mind another question often asked about Strand's
work: why he abandoned the kind of gritty street pictures he made in
New York in 1915–1916. The portraits and the stop-action crowd scenes
many think Strand's most exciting work. The portraits especially are reve-
lations. "I photographed these people because I felt that they were all
people whom life had battered into some sort of extraordinary interest
and, in a way, nobility," he recalled in the 1970s. The woman in *Blind
Woman* he remembered as having "an absolutely unforgettable and noble
face."[32] It was this picture that fired up Walker Evans, younger by some
dozen years, who wrote in a letter in 1929 that *Blind Woman* taught him
just what he wanted to do in photography: "That's the stuff, that's the
thing to do. Now it seems automatic even, but it was quite a powerful pic-
ture. It charged me up."[33] Strand made these pictures under a mantle of
invisibility, as it were, using a small camera with a fake lens pointing in the
wrong direction and later a prism lens; in Mexico in the 1930s he used a
similar setup with a right-angle prism lens on a larger Graflex. Walker
Evans used a somewhat different rig for his subway pictures in the late
1930s and 1940s, but the principle of covert access remains the same.

Is it farfetched to see a link between Strand's turning away from the
subject of industrial city streets, their chaotic energy and signs of human
persistence amidst wretchedness, and his later turning away from the
United States as his subject matter? Some critics have suggested that
Strand's books embody a deep cultural desire, indeed a very American
desire, for a preindustrial romantic-pastoral landscape, a harmonious way
of life, what his generation called a "genuine culture."[34] There is a good
sense in this view, even if it seems somehow too simple. Strand's convic-
tions about photography and the politics of cultural revolution drove him
to seek images of organic connection and wholeness, images which do arise
as much from the force of myth as from realities before the lens. His re-
fusal of an American subject in the last twenty-five years of his life, what-
ever the personal factors in his choice to live abroad, might well reflect
back upon that same romantic-modernist ideology, which lay behind his
early experiments and led him subsequently to seek communion with
older, simpler, more natural worlds. And to portray those worlds, even in
the cases of modernizing Egypt and Ghana, as allegories of loss rather
than of conflict and struggle. Allegory of any sort diminishes the power of
the particular, the autonomous realm of things, of gestures, and of social-
ity—the realm, in a word, of photography. To the extent that they alle-
gorize, Strand's books dramatize the deepest contradiction of his career:
his wish to engage photography in the process of social change by depict-
ing the unchanging, the timeless, the universal.

Did Strand misspend his final years wandering in search of the perfect timeless American village abroad? The answer can only be that we misspend our own time in improbable conjecture. Strand is strong enough to withstand whatever regrets or wishes his critics may indulge, or carping about this or that course he took here and there. He was an artist who drew strength from the contradictions, the unresolved tensions of his life and work. Strand lived in history; he could not help but live in contradiction, all the more so for his drive to express himself through the "actual factual world" photography so blazingly makes available. Contradiction is the sign of life. There is a living Paul Strand still to be reclaimed from the classic legend.

MILTON W. BROWN

The Three Roads

Paul Strand's early development as an artist coincides with the radical change in American art following the Armory Show in 1913, and in his art and critical writing he reflects the very nature of that change as much as any artist of the time did. He bridged, in a very personal and somewhat idiosyncratic manner, the gap between the so-called Ashcan realism, which emerged in the early years of the century, and the later influx of modernism from abroad. In his very first exhibition at 291 in 1916, the scope of his art was already revealed.[1] The photographs in this exhibition were already recognized as a direct response to the new art and as singularly radical and innovative. Many years later in an interview, Strand recalled:

> [T]hree important roads opened for me. They helped me find my way in the morass of very interesting happenings which came to a head in the big Armory Show of 1913. My work grew out of a response, first, to trying to understand the new developments in painting; second, a desire to express certain feelings I had about New York where I lived; third, another equally important desire — where it came from, I don't know exactly — I wanted to see if I could photograph people without their being aware of the camera. Although *Blind Woman* (see figure 1) has enormous social meaning and impact, it grew out of a very clear desire to solve a problem. How do you photograph people in the streets without their being aware of it?"[2]

In retrospect, and with the perspective of time, Strand seems to have seen very clearly what his early work meant for photography, although, I think, he did not understand it fully or describe it accurately enough within its historical context. In his later years, Strand saw his career in a rather set and logical pattern. He tended, as most people do, to respond with a formulated answer to questions that had by then become repetitious. Having known him for a long time, I can attest that in frequent conversations I could not get behind the facade of his memories. For instance,

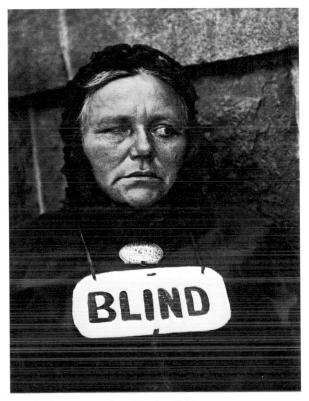

1. *Blind Woman*, New York, 1916

he always explained his involvement with modernism as an experiment to understand what the new art was all about and, having done so, returned to his more central concern with life and humanity. I cannot help feeling that this was a gloss to explain what he later felt to be an inconsistency or flaw in his own monolithic vision of his artistic career. The fact is that at that time practically every progressive-minded artist was dabbling, but very seriously, in the various "isms" without knowing very much what they meant. American art during this period was permeated by a general progressivism that seemed to focus on "living art," identified with what the popular contemporary French philosopher, Henri Bergson, called *élan vital*. The Ashcan school of American urban realist painting as well as the more avant-garde entourage around Alfred Stieglitz and his gallery 291 and the Arensberg circle were all motivated by congruent imperatives such as "life," "creativity," or "modernity."

The urban realism that arose to displace the genteel academic tradition in American art at the turn of the century was an expression of the general progressivism and intellectual ferment of the time. American society was undergoing a searching reexamination and questioning in all fields,

from politics to sex, from education to justice, and reformism was the prevalent mode. It was natural to see the Ashcan school as muckrakers in paint, as equivalents to journalists including Lincoln Steffens, Ida M. Tarbell, and Ray Stannard Baker or to writers such as Theodore Dreiser and Upton Sinclair, or even as social reformers or political radicals. The core of the Ashcan school consisted of a group of Philadelphia artists clustered around Robert Henri, employed as newspaper reporter-artists and studying at the Pennsylvania Academy—George Luks, John Sloan, William Glackens, and Everett Shinn.

Henri had come back from Europe in 1891, working in a current Parisian style based on preimpressionist Manet and imbued with the concept of art as an expression of life. His charismatic personality and teaching transformed the group, raised in an illustrative tradition based on the English popular illustrators Charles Keene and John Leech, by converting them to the critical realism of Goya, Daumier, Paul Gavarni, Jean-Louis Forain, and Constantin Guys and the visual realism of Velasquez, Hals, and Manet. By the turn of the century, the entire group, following Henri, migrated to New York and became known as the New York Realists. Impelled by a new consciousness of what they were about or, perhaps, by the decline in the employment of the reporter-artist with the development of photo-engraving, they gradually moved out of illustration into painting and were soon recognized as a progressive or even radical new movement in American art, even labeled "a revolutionary black gang." There were also other artists working in a similar vein, such as Alfred H. Maurer, in his early years, Eugene Higgins, Jerome Myers, and Joseph Stella; and Henri, as a teacher, attracted a younger generation of disciples that included Guy Pène du Bois, George Bellows, Rockwell Kent, Leon Kroll, Gifford Beal, Stuart Davis, Glenn Coleman, and Edward Hopper. Together and as an identifiable group led by Henri, they played an important role in the transformation of American art leading up to the Armory Show.

Iconographically, the Ashcan artists can be characterized as urban genre painters, very much in the manner of Manet, Degas, and Toulouse-Lautrec, depicting the life and leisure activities of an urban populace. However, the Americans differed from their French prototypes demographically. The Americans focused more on the lower classes, the immigrant and ethnic components of the population who were the new and colorful ingredients in the metropolitan melting pot of New York. However, they were much like the impressionists in describing life in terms of the leisure activities, recreation, and entertainment of people in an urban environment, in its streets, parks, and on its beaches, in theaters, restaurants and cafés. They rarely showed people, except for performers, at work, in trouble, or even sad. Like the impressionists', theirs is an optimistic view of life, more concerned with local color and spectacle seen from a humane, sympathetic, and often sentimental viewpoint.

George Luks and some of the younger men, including Bellows, Kent, Kroll, and Beal, took a more positive and aggressive stance in relation to American urban life, accenting the youthful, raw, masculine vigor of an expanding industrial economy which they expressed directly in scenes of industrial activity and construction and metaphorically in scenes of physical action and performance—boxing, wrestling, circus acts—or in the spectacle of a teeming humanity in the slums. But this was also not a harsh, reformist, or radical indictment of society, although the Realists attracted a good deal of flack as revolutionaries or anarchists. Some of the Ashcan painters were political; Sloan was an avowed socialist, and Henri and Bellows leaned toward anarchism, at least in an intellectual sense, but political ideologies did not appear in their work in any tangible form. The harsher aspects of modern life—poverty, homelessness, exploitation—so startlingly revealed in the photographs of Jacob Riis and Lewis Hine are not found in the paintings of the Ashcan school except occasionally in Luks, Shinn, and Sloan; in the early work of Eugene Higgins, the "Maxim Gorky" of paint, and in the drawings done by Joseph Stella on assignment by the *Survey Graphic* to the steel mills and coal mines of Pittsburgh with Hine in 1908.

In its fight against what it saw as the stagnation of academic art, the Ashcan school flaunted the banner of "truth" as against "beauty," of "life" as against "art," and the "real" as against the "artificial." And they were willing to defend crudity and ugliness as part of life. They looked for the revitalization of art in experimentation, change, contemporaneity. They saw the artist as innovator, creator, leader, and seer. But they were far from radical or revolutionary in art or politics; only by implication and sympathy could they even be termed reformist.

Curiously enough, the modernists, responding to other cultural impulses and different historical conditions, shared with the progressives a fundamental faith in creativity and the primacy of the artist in a social context. It is often difficult to pin down the source or sources of philosophical axioms current at a given time, but the "vitalism" of this era is probably derivative from Bergson, whose concepts of creativity, intuition, and *élan vital* were quite pervasive and influential both here and abroad. It is probably these common attitudes toward art, life, and creativity that held the progressive elements in American art together for a while and even made the Armory Show possible despite the many divergent tendencies among the participants.

The First Road

In general, the understanding of modernism or of the motivations of the avant-garde, even among the most knowledgeable in this country, was rather vague. Except for a few critics who were aware of the historical development of modern art, there was little distinction made between post-

impressionism, fauvism, expressionism, cubism, or futurism. Modernism was defended en masse as art of the time, as living, vital, and intuitive, rather than academic and traditional. As receivers of influence rather than creative participants, American artists responded to the appearance rather than the experience of a movement. Even having taken a class with Matisse was not the same as being a fauve in Paris. At best, American artists could only approximate the appearance of the European avant-garde. My own feeling is that Strand, like many of his contemporaries, was influenced by cubism without understanding its rationale (which, incidentally, was not very clear to the cubists themselves), but he did find exciting visual equivalents in reality. Constrained by his conception of photography and of his relationship to the camera, he could not, as did Francis Bruguière, Paul Outerbridge, or Man Ray later on, manipulate the camera, its materials, or techniques to create an aesthetic object. He had to find his subjects in the real world, and his solution was to manipulate that world through vision by distance, angle, or lighting, but never by the distortion of reality. He found his abstractions in the transformation of reality through an acute observation of the fortuitous juxtaposition of formal elements in space and light.

It is difficult to know whether Strand was responding to the impetus of cubism or the avant-garde in art or to modern technology; it may very well have been an amalgam of all. Strand's new vision was certainly a direct response to the emergence of the machine image in those years and to the rise of a native and original movement in American art, later identified as precisionism. An outgrowth or domestication of cubism, precisionism found its subject in the technological landscape of newly industrialized America and its style in the precision of the machine. Although the movement was never an actual association of artists organized under a manifesto or with an articulated theory, it attracted a large number of artists through the 1920s and beyond — Morton L. Schamberg, Charles Demuth, Charles Sheeler, Joseph Stella, Louis Lozowick, Georgia O'Keeffe, Niles Spencer, George Ault, Stefan Hirsh, Preston Dickinson, and Elsie Driggs.

By the turn of the century, a new world of technology began to arrive in an ever increasing proliferation of new mechanical inventions — the electric light, telephone, typewriter, automobile, airplane, and, not least for Strand, advances in the still- and the motion-picture camera. Through the use of new angles of sight he discovered novel, exciting, and often abstract forms in the most common objects or scenes. By a shift in point of view, he revealed abstract patterns of mass, light, and shade in the city's buildings and streets. And, moving the lens closer to an object, he could change its limits and relationships, achieving a new visual reality by destroying its normal aspects as an organic entity, its normal relationship to the environment, its normal psychological associations, and arriving at a new, formal

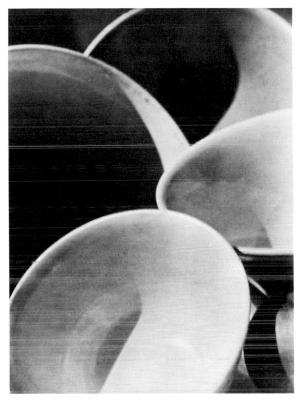

2. *Abstraction*, Bowls, Twin Lakes,
Connecticut, 1916

configuration. By dollying in on objects, Strand, in *Abstraction, Bowls* (see
figure 2), like Georgia O'Keeffe in her flower pieces of the 1920s (they
were quite close in those years), was introducing us to a new world of vis-
ual experience. This microscopic vision is in a sense the opposite of the
high-angle shot that Strand used in his New York scenes. The close-up
heightens our sense of reality; by enlarging the details of a common
object, it brings to attention facts never perceived and increases awareness
but at the same time, in destroying the normal appearance of things,
presents startling formal relationships that have the characteristics of
abstraction.

The traditional concepts of space and scale that had obtained for cen-
turies without change were given new meaning. Many of these innovative
visual devices and formal elements, deriving from camera vision, were
common to the work of O'Keeffe, Sheeler, Demuth, and Lozowick. Re-
gardless of Strand's motivations or intentions, the images he created —
Abstraction, Bowls; *Abstraction, Porch Shadows*; and *The White Fence*[3] (see fig-

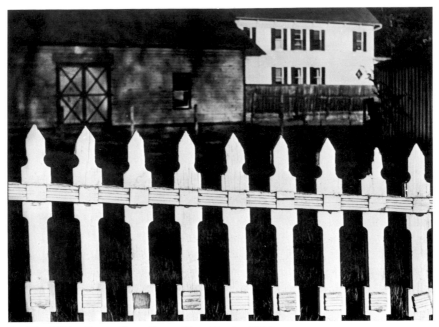

3. *The White Fence*, Port Kent, New York, 1916

ures 2, 3, and 8) — remain as landmarks in the history of photography. What is singular in Strand's work is that, having had the experience, he turned his back on it and went his own way. An indication of the aesthetic ambiguities of the time is Strand's continued championship, well into the 1920s, of 291, and of its artists, especially John Marin, and of a selective modernism, although by then his conception of modernism had become very personal: a combination of Bergsonian vitalism and creative intuition (which Stieglitz had absorbed), his own sense of technology as the basis of modernity, and a faith in cultural nationalism that had become quite pronounced in American art circles after the Armory Show.

A great deal has been written about Strand's modernism, and although this attention may not distort his significance for photography as a whole, it does distort his own artistic profile. Strand's personality was the result of a confluence of somewhat disparate factors. His early life fell within the pattern of the Jewish middle-class child of immigrant families, but his attendance at the Ethical Culture School was an important determining factor in his later development. The progressive educational philosophy for which the school was noted fostered a strongly liberal, secular, and rational stance in his attitudes and thinking. Added to this were the chance circumstances that he attended an art appreciation course with Charles Caffin, one of the most liberal and open-minded art critics of the time, and was introduced to photography by Lewis Hine, who taught nature studies

at the school. It was Hine who took the school's extracurricular photog-
raphy group to 291, possibly affording the first introduction Strand had to
photography as an art form and to modernism. Subsequently, he saw the
Armory Show and, as an eventual habitué of 291, he saw all its exhibitions
and absorbed its credo. Stieglitz had opened the Little Galleries of the
Photo-Secession in 1905 to show photography along with other arts, but by
1908 the emphasis had shifted away from photography, and 291, as the
gallery was commonly called after its address on Fifth Avenue, became the
center of avant-garde art in New York. In the following years it showed
some of the most advanced modern art from Europe and the leading radi-
cal Americans—Max Weber, John Marin, Alfred Maurer, Arthur Dove,
Marsden Hartley, Arthur B. Carles, Oscar Bluemner, Abraham Walkowitz,
Elie Nadelman, Stanton Macdonald-Wright, and Georgia O'Keeffe. Strand
got to know the artists and writers who frequented the gallery and was
especially close to Marsden Hartley and John Marin and in later years to
Georgia O'Keeffe. There is no question that he was well acquainted with
modernism and wrote about it in very strong and personal terms.

Even at that point however, Strand's artistic character was strangely am-
bivalent. His photographic heritage can be traced back to the earlier urban
realist phase of Stieglitz's photography and to the social documentation of
Jacob Riis and Lewis Hine, indicating a clear but unexpressed tie with
Ashcan realism in painting. Strand's underlying faith in and sympathy with
humanity, his belief in reason, and his political progressivism are derived
from this combination of influences. On the other hand, Strand's so-called
modernism, with its source also in 291, was crucially modified by his con-
ception of the machine as the new decisive element in the modern world.
And here he found himself in the ambience of Marcel Duchamp and
Francis Picabia, whom he met in 1915, when they were newly arrived in
this country. It is impossible to know how much if any influence they had
on his thinking, but the fact that they were involved with the machine in a
conceptual and aesthetic sense must have impressed Strand, for, in an un-
published essay, he wrote, "The use of the word 'modern' in connection
with it [modern art], is rather ironical. For the orientation of what they
[Matisse, Picasso, and Braque] express is so much more toward a world
which is anything but modern. As a matter of fact the one European
whose work bespeaks an awareness of today is Marcel Duchamp."[4] This
view, which Strand thought of as particularly American rather than Euro-
pean, is stated despite the contradiction between Strand's optimistic and
Duchamp's ironic view of the machine.

The Second Road
It is curious that in retrospect Strand should have drawn a veil over the
seminal aspects of his early career, first, in treating his excursion into
abstraction as merely an experiment and then characterizing his revolution-

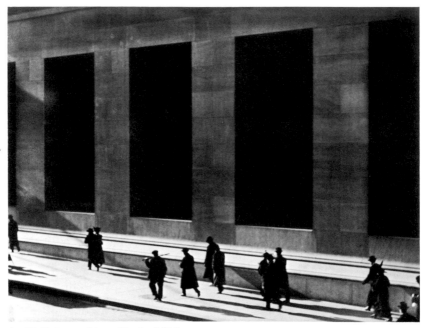

4. *Wall Street*, New York, 1915

ary urban photographs of that time, such as the brilliant and memorable *Wall Street* (see figure 4), as having been motivated by a desire to express his feelings about New York City, when they were in effect a fundamental statement of his philosophical and aesthetic position at that time. These photographs express Strand's true conception of modernism as an embrace of the industrial, commercial, and technological world of the twentieth century in all its aspects. For Strand the iconic image of this complex in all of its ramifications was New York City with its anonymous swarming humanity in coincidental motion. In some ways Strand's position is a rational counterpart to Duchamp's polemical dada mechanomorphism. Strand also saw the machine in its historical context and evolution as the basic component in the modern equation. This series of photographs of New York City embodies Strand's aesthetic statement on contemporary urban existence in all its implications. And it reached its culmination in the short film, *Manhatta*, made with Charles Sheeler in 1921, which was shown in Europe to some acclaim through the intercession of Marcel Duchamp.

Strand's treatment of the machine as an object in itself saw its beginnings with *Wheel Organization*, exhibited in the Wanamaker exhibition in 1918. The apogee of this tendency occurred in the early 1920s, when mechanism in the guise of precisionism was emerging as a recognizable movement in American art, and Strand played an important role in its development. In 1916 he had met Sheeler and Schamberg, painters and

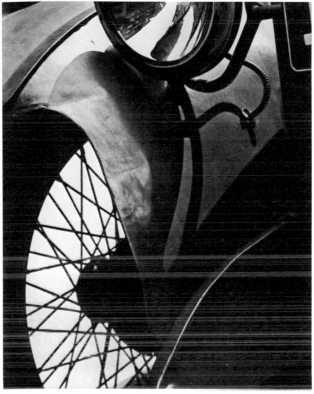

5. *Wire Wheel,* New York, 1918

photographers from Philadelphia, who were part of the Arensberg circle and close to Duchamp and Picabia. Schamberg especially became involved with the machine early on and produced probably the first positive machine images in painting as early as 1916. By abstracting mechanical elements and combining them in new and imaginative relationships, Schamberg created paradigmatic symbols of mechanism, establishing the machine image as a new standard of beauty. It did not matter that the contrivances depicted were nonoperative.

With his *Wire Wheel, Lathe,* and *Akeley Camera* (see figures 5, 6, 10) in the early 1920s, Strand established the machine canon in photography by exploiting the inherent formal elements of a variety of actual mechanical devices. Strand was thus an important contributor to the international mechanist movement of that time, which included, aside from the American precisionists, the Russian constructivists, the Dutch *De Stijl,* the French purists, and the German *Bauhaus.* However, it is strange that Strand was not involved in the historic Machine-Age Exposition of 1927 in New York, with which such American artists as Andrew Dasburg, Demuth,

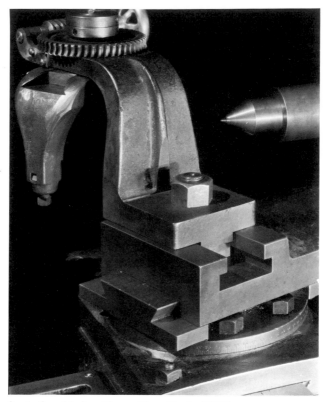

6. *Lathe*, Akeley Shop, New York, 1923

Duchamp, Lozowick, Man Ray, Sheeler, and Ralph Steiner were in some way connected.[5]

The Strand photographs reproduced in *Camera Work* in October 1916 and June 1917 were undated, and the chronology and logic of Strand's artistic development during those formative years remains in question. William Homer has dated the abstractions 1914–15, the New York scenes 1915, and the portraits, 1916; Naomi Rosenblum places the New York scenes in 1914–1915, the portraits in 1915–1916, and the abstractions, 1916 or later.[6] Rosenblum argues rather convincingly that the portraits and abstractions are of later vintage, since they were not in the 1916 exhibition and were not reproduced in *Camera Work* until 1917. It may be asking too much to find a consistent and logical development from one to the other of these facets of Strand's style within so short a time span — from 1914 to 1917 at the outside. Strand might have worked interchangeably rather than sequentially in these modes, responding to experiences and circumstances of the moment, and many years later he could have been unclear about the details.

The Third Road

I have never been able to accept Strand's explanation of the portraits as
the result of his desire to solve the problem of photographing people with-
out their awareness—to make candid photographs long before there were
any candid cameras.[7] It hardly seems possible that this series of memorable
and psychologically probing studies could have been the by-product of a
technical gimmick. He certainly was aware of their significance and power.
The search for the truth in the candid moment goes back to nineteenth-
century realism and the impressionists, and it comes down directly to the
Ashcan realists. I have no doubt that the development of the camera had
something to do with the value placed on candor originally, and it is in-
triguing that photography should again value candor in America in the
twentieth century. This aspect of Strand's art must have had its sources in
the photographic realism of Riis, Hine, and the early Stieglitz, as well as
in the social concern of the Ashcan school.

But all of these ideas were already things of the past when Strand did
his portrait series. Their appearance in *Camera Work* was a revelation. Even
today they are strikingly powerful images; they were then a new stage in
photographic realism. The close-up views and cropping of negatives cut off
the subjects from their environment, sometimes even breaking the frame
and riveting attention entirely on the physiognomic and psychological reve-
lation of individuality, character, and social condition. I would not presume
to describe them verbally, but they remain uniquely intense and unforget-
table. These photographs owe something to the Ashcan school—to the
typological portraits of Henri, but without Henri's idealizing morality—and
to Stieglitz, without his romantic, pictorialist aura. On the other hand, they
owe something to the sociological documentation of Riis and Hine, without
Riis's clinical objectivity or Hine's social and human partisanship. Strand's
portraits combine sociological objectivity with an intense, but dispassionate
and unsentimental, involvement with personality, character, and humanity.
As he said about them: "I felt they were all people whom life had battered
into some sort of extraordinary interest and, in a way, nobility."[8] He did
not moralize, philosophize, or polemicize; he revealed them with compel-
ling insight and power. It is almost as if, to begin with, Strand returned to
the origins of photography, to Nadar and David Octavius Hill, to the fresh
wonder at the image of a face caught for eternity by a camera for the first
time. Straight photography, a record, the truth.

Strand's experiments with abstraction and the machine were his unwit-
ting contribution to the history of photography; the portraits, basic to the
rest of his development, are the first clear expression of his own aesthetic
philosophy. He said repeatedly that his short-lived experiments in abstrac-
tion were not at all fruitless, because he learned that a work of art had its
own inherent structure independent of its content. In a sense, this ex-
perimentation taught him to see aesthetically and informed all his sub-

sequent work. And though the machine as a discrete subject dropped out of his repertory, it remained as a recurring element, especially later in his many photographs of people in an industrial context. In addition, the machine survived as the linchpin of his artistic philosophy. As he wrote to the photographer Van Deren Coke, "The reality of the machine as it was literally changing the world had a wide and inevitable impact on art in many countries. . . . Creative artists do influence each other in various ways. But this is much less deep than the direct influence of the world in which the artist lives and his response to it."[9] For Strand, modernity if not modernism lay in the machine rather than in abstraction.

Strand's later work developed in different directions and under new mandates. As his philosophy, political attitudes, and vision of humanity expanded, he could no longer accept the "objective" view of contemporary society expressed in his New York scene photographs. In 1922 he warned, "We have . . . [the machine] with us and upon us with a vengeance, and we will have to do something about it eventually . . . the new God must be humanized unless it in turn dehumanizes us."[10] Strand's art in time became the expression of his search for a humane society in a beautiful natural world. He never documented disaster, despair, inhumanity, or ugliness. The search is expressed in part in his many magnificent portraits, which serve as symbols for his continuing belief in the universality of human individuality, intelligence, and creativity. On this belief he based his faith that humanity could control its destiny. And one can find the kernel of that faith in those early portraits.

NAOMI ROSENBLUM

The Early Years

"I believe you have made the one perfect and complete definition of photography." So wrote Ansel Adams to Paul Strand in the early 1930s.[1] Even granting the hyperbole of Adams's words, the ability to give inchoate ideas independent visual life, and photography new definition, is a rare gift. Paul Strand's decision to become a photographer was the result of fortuitous circumstances, but once it was made, he pursued the quest to redefine camera expression with high-minded seriousness. His efforts to transform the real world of objects and feelings into the stuff of art drew strength from native and European roots, and marked the emergence of a distinctively modern American style. And in time of stress such as the nation experienced during the Great Depression, a deeply humanist strain asserted itself to further enrich the formal concerns and intuitive resonances of his early work.

Born in 1890 in New York City, Strand grew to manhood during a period of heightened activity in all aspects of photography. Simplified equipment and newly available processes enlarged photography's use for a variety of ends. At the same time that its appeal as a recreational pastime increased, it also became more significant as a tool of communication. Photographs were considered more truthful and convincing than drawings by the illustrated press, which was becoming a major instrument for conveying news, selling products, and instigating social change, as well as providing entertainment. With the gradual improvement of adequate half-tone printing methods, camera pictures in reproduction began to take the place of handmade illustrations, thus enlarging opportunities for professional photographers.

Those who regarded the camera as a medium of artistic expression increased their activities as well. They gained a sense of identity and direction in the 1890s through salons and exhibitions sponsored by amateur clubs and photographic societies, at times presented in concert with art academies and museums. As a result, an art movement in photography

developed, to be spearheaded in the United States after the turn of the century by Alfred Stieglitz. Under the rubric Photo-Secession, this movement promoted an approach that invested portraits, still lifes, and ordinary scenes with elements of aestheticism, symbolism, or mysticism, thus making them eligible for consideration as "art."

Several of these artistic and social vectors coincided during Strand's youth, creating a climate in which the only son in an enlightened middle-class Jewish family might consider photography an appropriate career. He was enrolled in 1904 at the Society for Ethical Culture's secondary school in New York City. There, besides the expected academic studies in languages and sciences, the innovative Ethical Culture School (ECS) curriculum—based on the educational concepts of John Dewey— focused on developing ethical, intellectual, and manual capacities. It offered classes in shop work, printing, mold making, and, in Strand's senior year, photography. The school's moral flavor, deriving from founder Felix Adler's humanist religious beliefs, eschewed sectarian religious doctrine and preached the worth, dignity, and creativity of the individual. It presented an opportune set of beliefs for those of Jewish ancestry who wished to be absorbed into the American experience rather than to maintain their ethnic separatism.

Strand's attendance at ECS was especially fortuitous because it coincided with Lewis W. Hine's tenure as a teacher. Recently arrived from the Midwest, Hine had succeeded in 1907 in having a course in photography added to the regular curriculum by emphasizing the artistic benefits of the medium to a somewhat skeptical administration; Strand enrolled the following year.[2] According to Hine, the medium forced youngsters to "recognize what is good in composition" by selecting "from the infinite variety of objects about them some bit that is pleasing to the eye." He regarded the "sharpening of vision to a better appreciation of the beauties about one" to be the "best fruit" of work with the camera. He went on to write, "When children realize, even to a limited extent, that success cannot be attained by snapping at everything, but by patient, careful, orderly work, they have taken an important step."[3]

Hine might have been describing Strand's later attitude toward the medium, except that for the "beauty" Hine sought in the world around him, Strand substituted "objective truth," holding that "the true artist, like the true scientist, is a researcher using materials and techniques to dig into the truth and meaning of the world. . . . [W]hat he creates, or better perhaps brings back, are the objective results of his explorations."[4]

Granting the influence on his student of Hine's general attitude toward the medium, the extent to which his decidedly reformist point of view impressed itself is a question of considerable interest; indeed, it is one that Strand himself mulled over. Although he eventually acknowledged his debt and may well have felt even as a youth "that things become interesting as

soon as the human element enters in," his earliest work nevertheless shows little connection to the programmatic social ideas or issues espoused by Progressive Era reformers.[5] Throughout the 1910s and 1920s Strand was attracted mainly to symbolic themes and alluded to Hine only as the instrument of a class visit to the Photo-Secession gallery at 291 Fifth Avenue. This, he insisted, was the seminal experience that had "opened up a new world" by showing him "a vista of photography as a medium of expression."[6]

Strand's lifelong curiosity about relationships among all of the visual arts also may be traceable to experiences at ECS. During his final year, a course in art appreciation taught by the eminent critic Charles Caffin probably was instrumental in his decision to visit art museums during a 1911 tour of Europe's major cities. Later, irritated by the continual questioning of photography as "art," he held that all forms of visual expression, no matter what the medium, are capable both of mediocrity and transcendence, a reflection of Caffin's statement that the work of "advanced photographers . . . could be practised with such purposes and results as to place it among the other Fine Arts."[7]

Graduating from high school in 1909, Strand faced an uncertain future. He had embraced photography for its aesthetic possibilities and was unprepared to enter the field at the lowest level—that is, to work in a darkroom or open a commercial portrait business as had such neophytes as Imogen Cunningham, James Van Der Zee, and Edward Weston. How to make a living remained a dilemma. Although it never stated them explicitly, Strand's vocational dilemma probably reflected the bourgeois expectations of his mother and aunt for genteel employment, and it may have been to keep up appearances that his father stepped in with the solution—to work as a clerk in the family enamelware import business. Essentially, this offer of support was an early token of Jacob Strand's unfaltering encouragement of his son's needs and ambitions, which Strand freely acknowledged as crucial to his own ability to regard photography as a spiritual outlet rather than an economic mainstay.[8]

During evenings and free time, Strand pursued his muse at the Camera Club of New York. Today this organization is simply a facility with darkrooms and exhibition space, but in 1909 it was a prestigious body of well-to-do, artistically conservative amateurs who could afford the fifty-dollar annual membership fee. Undoubtedly Strand's admission into this elitist body was eased by the high position of an uncle who not only helped him gain acceptance but also helped defray some of the expenses connected with "artistic" photography.[9]

In its quarters on Sixty-eighth Street, the Camera Club maintained meeting and exhibition spaces, an extraordinary library, and darkrooms, which Strand, like others of his generation for whom private personal darkrooms were a rarity, soon came to regard as "a home away from home." Within this environment he gained technical skills, learned how to

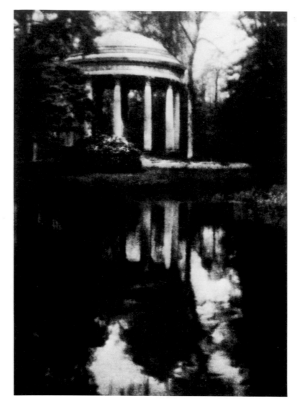

7. *Garden of Dreams/ Temple of Love/
Versailles, 1911*

enlarge by projection the negatives from his Adams Idento and Ensign
Reflex cameras, and perfected printing methods approved by artistic
amateurs, among them bromoil, carbon, gum, and platinum. He achieved
control by watching older members work in the darkroom and from con-
sulting the large collection of technical manuals. Besides serving on the
print committee, which selected and hung work for the annual members'
exhibition, Strand gained notice for his own photographs.[10]

Strand came later to regard his association with the Camera Club as one
merely of convenience and practicality for a novice worker, but initially he
did not question the group's conservative pictorial objectives and standards.
Praise for *Versailles* (also called *Temple of Love* and *The Garden of Dreams*)
(see figure 7)—which won a club prize and was entered in the 1912 Lon-
don Salon—as a work that "partakes of the romance of the rococo" sug-
gests that Strand's thematic aims were not at all antagonistic to the con-
cerns of mainstream pictorialists.[11] A soft-focus gum print produced from
five printings, this work indicates that Strand's treatment of such material

was also entirely conventional. In general, forms were given an agreeable haziness by using a soft lens, at times at wide-open aperture, through enlarging negatives by projection, and through one of several approved methods—platinum, carbon, or gum—to which Strand affixed an artistic monogram. Far from being innovative, works such as *Versailles* and *The Plaza*, both of which appeared as frontispieces in the Camera Club journal in 1911, recapitulated themes, visual arrangements, and treatments that had been explored much earlier by Stieglitz, Joseph Keiley, and others, and that still inspired numerous imitations.[12] In sum, while Strand's technical skills as a young photographer may have been noteworthy, in theme and treatment the early images were unremarkable.

Strand's respect for the Camera Club's outlook on photography began to erode sometime after 1913 when he became aware of modern currents in the visual arts. That disaffection intensified early in 1920 when an incident that today seems ludicrous underscored in Strand's mind the narrowness of the members' attitudes toward photography. As he later recalled the event, he had processed a negative depicting a frontal image of a nude male and had hung it to dry overnight in a somewhat secluded place; for their part the board of trustees held that it had been left "for all or part of two days in full view of any person, male or female, member of the club or guest or visitor."[13] Its presence provoked accusations of impropriety and led to his being brought up on charges of unbecoming conduct and suspended from the club.

Aside from depriving him of darkroom facilities, this action enraged Strand's humanist and modernist sensibilities. Having by this time become part of a group of nonconformist artists and writers who deplored the puritanical materialism of American middle-class society, he had little use for such prudery. And recent experiences handling the bodies of ill and wounded soldiers in the Army Medical Corps must surely have been on his mind. One may speculate, also, that he intended his action to be provocative or, as he might have called it, educational, for after ten or so years of membership he surely realized that staid club trustees would inevitably regard such a work as "made solely or principally for the purpose of showing the private parts of the model."

Strand's *mea culpa* was embodied in a round of letters assuring trustees that his objectives were purely aesthetic and, as with his images of machines and nature, that his interest was "in the organization of forms, each of which is important only in so far as it relates to other forms." He noted that male nudes were part of a tradition of artistic representation that went back to ancient times, and thus the theme could hardly be considered prurient. The lifting of the suspension without the dismissal of the charges left bitter memories, although it did not keep him from continued participation in club functions and exhibitions.

But to return to 1911. Facing bleak employment prospects following the

sale of the family business in the depressed economy of that year, yet buoyed by seeing his work accepted and even purchased, Strand decided that photography might provide a means of livelihood after all. Initially, he expected to sell to American tourists abroad images of popular landmarks made during his fast-paced trip to Europe in that year, but sales (arranged through a friend, Nathaniel Shaw) were disappointing. Next, he embarked on an ambitious project to provide graduating college seniors with camera "portraits" of buildings on university campuses, at the same time doing an occasional personal portrait. In pursuit of college subject matter and prospective clients, he traveled widely up and down the eastern seaboard. In 1915 he made a cross-country trip, which allowed him to photograph at universities in Texas and in the Midwest, as well as to acquaint himself with the scenic wonders of the United States. The prints, on platinum paper and hand-colored (by young women employed for that purpose), were sold for $2.50. But while somewhat more successful than the European work, the prints still brought in minimal income. Nevertheless, with personal expenses kept low as a result of living in the family home, this income enabled Strand to concentrate on photography as personal expression during a time of unusual ferment in American cultural life.

The period around 1913 marked the start of a critical transformation in Strand's style. As it was for others in the visual arts, the Armory Show of that year was a major catalyst, but even earlier, avant-garde artistic currents from Europe had begun to seep into Strand's consciousness. Those connected with the Photo-Secession were inspired (or dismayed) by the cubist and modern art exhibited at 291 and by reproductions of the work of Matisse and Picasso in *Camera Work*. Personal reports of returning painters and photographers, among them John Marin, Charles Sheeler, and Edward Steichen, aroused further interest in the artistic revolution taking place abroad. Together, these developments spurred Strand to question the soft-focus pictorialist style and its preferred themes and to turn his attention to what was new and fresh. He was encouraged in this direction by closer association with Stieglitz and his circle and by the fellowship of artists connected with the Modern Gallery (opened in 1915 by Stieglitz, Agnes Meyer, and Marius De Zayas), in particular the Philadelphia painter/photographers Sheeler and Morton Schamberg, and the French avant-garde artists Marcel Duchamp and Francis Picabia. In this heady atmosphere, Strand struggled to apply the ideological and stylistic aspects of cubism to photography, without, however, draining the image of passion and intensity.

Stylistic experimentation was accompanied by—indeed, energized by—a search for a novel way of representing the New York urban experience in camera images. In itself the urban theme was not new to the visual arts, having come to prominence with the ongoing shift of people from rural areas to cities. Around the turn of the century, the realist painters of the

New York ("ash can") School and the aesthetic photographers of the
Photo-Secession—Stieglitz in particular—regarded New York as a symbol
of the energy and optimism associated with the advance of industrial cul-
ture. Indeed, Secession photographer Alvin Langdon Coburn ascribed the
marvelous new bridges and skyscrapers to the same scientific forces that
had brought forth photography, and he went on to suggest that only the
camera could do justice to the city's spectacular evanescence.[14] Amateurs
and professionals outside the pictorialist camp also turned their eyes to the
remarkable visual variety of city buildings and street life without, however,
embracing the high-minded goals of aesthetic photographers. And in this
same time span, socially concerned photographers sought to make visible
to a middle-class constituency the sordid living conditions of the urban
poor in the hope of using visual edification to avoid social disorder.

 Strand's position in relation to these crosscurrents is complex. As a na-
tive whose free time for working was limited to weekends and whose own
living circumstances were firmly middle-class, the city seemed the most
accessible and acceptable of themes. And while social change may not
have concerned him, he certainly was aware of class divisions among the
populace. Beyond that, he was swayed by the symbolist concepts enunciated
by the Stieglitz circle. Perceiving the city not only as an extraordinarily
vibrant commercial center, this group—in the spirit of Walt Whitman—ele-
vated New York's architecture, tempo, and cultural life to a spiritual plane.
They found in the city a visual metaphor for all they considered forward-
looking and progressive, all that would separate them from the cultural
provinciality of the rest of the nation.

 For the next three years, Strand photographed in his own neighborhood
on the Upper West Side, in Central Park and on Morningside Heights,
and in the midtown and Wall Street areas. Soft-focus images made in Cen-
tral Park and on Riverside Drive in 1913 and 1914 have high vantage
points and open, flowing compositions; the flattened spatial and tonal
handling seems more influenced by the taste for Japanese art than by
purely cubist theory. This treatment, visible also in the work of Coburn
and Karl Struss, with whom Strand exhibited in 1914, enabled the photo-
grapher to control the picture plane without having to deal directly with
the tyranny of reality suggested by ordinary visual perspective. Shortly
afterward, in a series of more geometrically structured compositions,
Strand, still pointing his camera downward, began to emphasize curvilinear
and rectilinear shapes. Involved with the patterns and tonalities created by
both solid forms and insubstantial shadows, these works confound the ac-
cepted reality of solid structures in space and create an arresting tension
from such ambiguity.

 A further step was taken around 1915/16 as Strand discovered the
means to integrate such geometric elements into a seamless statement
expressive of the tenor of urban life. *Wall Street* (see figure 4) is the best-

known work in which the indistinct and fragile human figures counter-
posed against strong architectural verticals suggest both the anonymity and
the tensions of city existence even to viewers unaware that the building
shown is the Morgan Bank, at the time a symbol of untrammeled financial
power. Although in later years this image was sometimes assumed to have
political overtones, it and Strand's other urban views of the time represent
intuitive rather than programmatic political responses to perceptions about
the city's power structure. Denying awareness of underlying economic
structure, Strand wrote that he "knew nothing about cartels, etc." but "was
trying to photograph the rushing to work . . . physical movement expressed
by the abstract spotting of people and shapes . . . [and] no doubt the black
shapes of the windows have helped this quality of a great maw into which
people rush."[15] A view of Forty-second Street from the first-floor window
of the Modern Gallery embodies a similar metaphoric intent: the circular
forms of carriage wheels and manhole covers in combination with the ac-
tive shapes of horses and pedestrians disposed on a field without horizon
line or the suggestion of perspective were intended to symbolize the cease-
less character of urban energy.

A perceptible increase in definition accompanied these transformations
in form and content. The softness made possible by special lenses and
wide apertures, which in pictorialist theory and practice served to differen-
tiate artistic from commercial works, had by 1910 become the butt of
numerous satirical articles decrying such indistinction as "fuzzygraphic."
With urbanism and industrialism acceptable as subjects in all the arts,
sharp definition came to be seen as decidedly more appropriate to the
representation of mechanically produced structures and for the expression
of the relentless tempos of modern existence. How aware Strand was of
the widespread clamor for greater definition is not known, for he attri-
buted his decision to use smaller apertures entirely to Stieglitz's criticism of
a 1914 landscape in which water, sky, grass, and trees all have the same
indistinction. Along with innovative pictorial organization that played up
the essentially two-dimensional character of the picture plane, increased
definition gave Strand's work of the next few years an aesthetic and emo-
tional force for the first time, and it launched him into the upper reaches
of artistic expression in photography — acceptance by Stieglitz.

Strand's relationship with this eminent if controversial figure and his
dependence on him for approval were of major consequence to his de-
velopment as a photographer. This approval had evolved slowly, following
occasional visits to 291 that probably had started around 1911. Inspired by
his encounter as a student with the work of the Photo-Secession, Strand
naturally had looked to its members for advice, but the bland comments of
Gertrude Käsebier and Clarence White, to whom he showed work, were
disappointing. That Stieglitz did not initially consider the early images of
great significance either is apparent from the latter's lament, at the end

of 1913, that "there are no photographers I know doing real personal work."[16] But at age twenty-five, having worked diligently to find his own voice, Strand was himself invited to visit 291 at will and to attend the Stieglitz-circle lunches at the Prince George Hotel. The following year, he was offered a one-person exhibition at the gallery.

"Photographs of New York and Other Places" (the show's title) revealed a photographer on the cusp of change. It included Old World and New World subjects (perhaps in emulation of Stieglitz's portfolio of images published some twenty years previously) and contained soft-focus landscapes and street views as well as some in which geometric structure and greater definition were visible.[17] The images on view, as well as those reproduced in the two final issues of *Camera Work*, clearly disclosed Strand's endeavor to weld together an innovative vision based on avant-garde precepts and intuitive sensibility, in order to find the means by which he might breathe, in Stieglitz's words, "actual life" into representations that functioned effectively as pictorial structures.[18]

Like others in the Stieglitz circle—notably Waldo Frank and Paul Rosenfeld—Strand's outlook incorporated elements of the vitalist philosophy set forth by Henri-Louis Bergson and Friedrich Nietzsche, which held up intuition as a guiding principle in art and life. When coupled with an appreciation of the formal structures of cubist art, the feeling sense served as a counterbalance to what some considered the arid intellectuality of cubist formal procedure. The call for images that seemed to give off a sense of vital force was one that Strand embraced consistently, although he may not have agreed entirely with Stieglitz, who regarded this force as having its wellspring in sexual potency.[19]

The group around Stieglitz had expanded during the mid-1910s to include, besides the American artists shown at 291, those associated with the Modern Gallery and with the publications *291* and *The Seven arts*.[20] With the war in Europe beginning to cast a cloud over cultural life in New York as well as across the Atlantic, the provocative dadaism of the avant-garde Europeans Duchamp and Picabia in particular evoked an interested reaction among a number of the Americans, but Strand's position did not extend to full espousal of dadaist implications.[21] Rather, his cautious nature limited his own experimentation to problems of cubist abstraction and then only for relatively brief periods during summers spent outside the city.

During the first period, spent at Twin Lakes, Connecticut, in 1916, Strand worked out these problems of pictorial structure using architectural elements and household artifacts. Focusing on the verticals of porch railings and the planes of a hip roof, on tables, chairs, and kitchen crockery, he organized these elements into visual entities that would function spatially in all dimensions and that might be viewed from any of several angles. A second brief involvement in which he handled still-life materials in similar (but apparently less ambiguous) fashion seems to have taken place

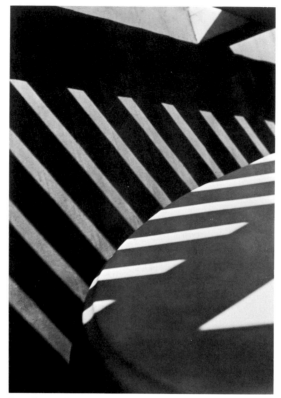

8. *Abstraction, Porch Shadows,*
Twin Lakes, Connecticut, 1916

in 1919.[22] Following release from army duty, he used a sojourn in the
country to reenter his former image world, this time trying out a newly
acquired large-format camera and sharper lenses on arrangements of
kitchen implements. *Porch Shadows* and the series of images with fruit and
crockery—all from 1916—are as close to pure abstraction as Strand was
willing to venture (see figure 8).

 In both years—1916 and 1919—these endeavors terminated as soon as
the photographer returned to New York City, probably because the vitality
of city life, with its bold architecture and spirited street activity, quickened
his pulse. Concern for "the human element," evidenced throughout the
early teens by the presence of fairly undifferentiated figural forms in
many of the street views, broke through with greater intensity in 1916,
when Strand began a series of close-up portraits of unknown persons on
the streets of New York. For nearly all (there are about seventeen exam-
ples), he used a prism lens that allowed him to focus on a particular indi-
vidual without the subject's knowledge.[23] The candid quality (which he

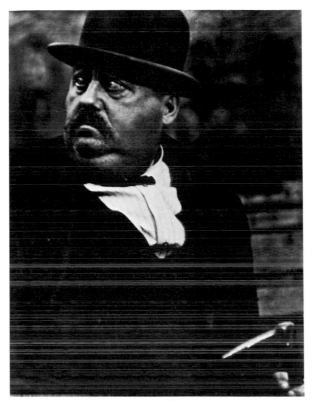

9. *Man in a Derby*, New York, 1916

mistakenly believed to be a "first" in portraiture), appealed because it avoided the forced relationship that frequently develops when photographer and subject not only are strangers, but are of different social classes, a predicament of which he became aware while photographing in working-class neighborhoods such as Five Points.

The unqualified—almost embarrassing—directness of expression in *Blind Woman* or in *Man in a Derby*, (see figures 1 and 9), which validates Strand's perception about the importance of anonymity in capturing facial expression and gesture unmediated by interpersonal tensions, undoubtedly contributed to his theories about the need for objectivity in camera images. And in their abrupt cropping and somber tonalities, these works also exemplify how the organizational and textural concerns of cubism might be made to serve an expressive but less formalistic agenda.

This group of portraits constitutes an anomaly in Strand's early work, for he did not return to this theme or way of working for about fifteen years. One can speculate about the reasons and suggest that perhaps experiences handling torn and diseased bodies in the Army Medical Corps

were too repellent to allow him in the immediate aftermath easily to portray individuals he did not know. A more probable explanation may be found in the potent influence exerted by Stieglitz in the early 1920s; following in his mentor's footsteps, Strand initiated in this period a series of images of his wife and occasional portraits of friends.

Service in the United States Army encouraged a further break with the ideas of the past. Like many in the circle around Stieglitz and the magazine *The Seven arts* — indeed, like the majority of Americans — Strand initially had been unenthusiastic about involvement in the European war. Recognizing the largely economic purpose of American intervention, this particular group of individuals disavowed blind patriotism and objected to the war's disastrous effect on progressive cultural ideas. Strand had written antiwar poems and stories (unpublished), and in an article entitled "What Was 291?" had attributed the demise of this "experimental laboratory" to the "false individualism about which the was is being fought."[24] He had corresponded approvingly with antiwar spokesman Randolph Bourne, but by September 1918, when he found himself drafted into the army, his outlook began to change. In letters to Stieglitz and others, he defended army experience for its character-building qualities, aware also that his viewpoint and skills were about to be extended and enriched.

Such equanimity in the face of what might have been perceived as a waste of time was occasioned by several factors. In the year and a half before induction, Strand had achieved a measure of fame, with favorable notices for the exhibition at 291.[25] His entries in successive Wanamaker Competitions, then the most prestigious of photographic events in the United States, were awarded top prizes. One prizewinner, *Wheel Organization*, was acquired by a collector who hung it in his office, prompting the approving reflection that finally a photographic image of a mundane mechanical subject had attained the status of art outside of galleries or museums.[26]

These small successes prompted Strand to verbalize ideas that had engaged him for several years (and which he no doubt had discussed often with Stieglitz, Sheeler, and Schamburg). Writing in *The Seven arts* in August 1917, he stated his belief in the indivisibility of truth, form, and feeling, suggesting that the unique character of photography rested in its "absolute unqualified objectivity." To these stipulations, Strand added honesty and intensity of vision as prerequisites for "a living expression." This approach, which required respect for the thing before the lens and the avoidance of hand manipulation of any kind whatsoever, forecast a climate that approved the direct perception of the concrete achievements of actuality. Deploring comparisons between the relative stature of paintings, drawings, and photographs, he urged the acceptance of "*everything* through which the spirit . . . seeks to obtain ever fuller and more intense self-realization" (emphasis added).[27]

Thus acclaimed and published, Strand felt that he finally had reached a level where his ideas and achievements merited public attention. Further, over several years a warm personal relationship had developed between his mentor Stieglitz and himself. This bond, which had inspired his eulogy of 291 and its leader, involved him next in a puzzling effort to encourage Georgia O'Keeffe (whose work had been exhibited at the gallery in 1917) to leave a teaching job in Texas and make her future in New York, to be sustained both psychologically and financially by Stieglitz.[28]

Puzzling because the matter was not simply one of acting as an emissary, for Strand had himself become deeply interested in O'Keeffe as a partner. In order to gain a true sense of the situation, he traveled (at Stieglitz's expense) to San Antonio to present all the alternatives. His rather half-hearted hope that O'Keeffe, who had previously expressed interest in his work and his company, might find him a compatible (if financially prob-lematical) companion was disappointed, and he finally accompanied her north in the knowledge that she had chosen his friend and mentor. The termination of the mission resulted in Strand's temporary exclusion from Stieglitz's newly intensified personal life, a rejection that may have made the experiences offered by service in the Army Medical Corps considerably more attractive than otherwise.

Documenting surgical procedures and making X rays — his army chores — gave Strand new respect for the scientific outlook and left him with a hunger to earn a livelihood in this area. He contemplated a career making motion pictures of such procedures after his discharge. Although this ambition was not realized, it did result later in the acquisition of an Akeley camera, with which he earned a decent living throughout much of the 1920s as a free-lance cinematographer. In terms of his attitudes about aesthetics and the purpose of photography, the experience with scientific photography strengthened his conviction about the pitfalls of sentimentality and the importance of "objectivity" as a motive in artistic expression. More-over, the realization that the Allied victory had been gained in large part because of the industrial might of the United States convinced him, along with other forward-looking artists of the time, that machine culture had become a dominant fact of modern life.

The urban theme occupied Strand again after his return from army duty. In 1920, in concert with Sheeler, who had relocated from Philadel-phia to New York City and acquired a Debrie movie camera, he proposed to create a short film based on portions of Walt Whitman's *Leaves of Grass*, at the same time making still photographs — generally without figures — from the same locations. The film and the still photographs were shot largely from the rooftops of downtown office buildings and were aimed at transforming "the towering geometry of lower Manhattan" into "ele-ments . . . expressive of the spirit of New York."[29] Thus, in Strand's first sustained work after being cut off from expressive photography for more

than a year, he sought to reassert control over his medium by returning to the arena of his former themes.

As a photographer on the threshold of an era of industrial expansion, Strand felt especially responsible for clarifying the relationship between a mechanical means of production — the camera — and a visual image full of the feelingness of life. The dichotomy between a lifeless mechanical contrivance dependent on scientific phenomena for its image and the demand that art reflect individualized artistic intelligence had intrigued the art establishment from photography's inception, resulting in spirited polemics. Opinion on one side held that photography could not transcend its mechanical nature, whereas the opposition supported the notion that the camera was essentially a tool, like brush or burin, that might be used to make either mundane or sublime statements. In another view of the same ideological battleground, the demands of science and of art were considered incompatible. This dictum, enunciated in no uncertain terms by British photographer Peter Henry Emerson in 1888, had in fact helped prepare the way for the pictorialist upsurge, which eventually led to softer focus and intervention in photographic printing processes in order to emphasize atmosphere and mood.

By the time Strand explored the relationship between art and science (in "Alfred Stieglitz and a Machine," written in 1921 on the occasion of an exhibit of Stieglitz's own work at the Anderson Galleries), they no longer were considered antithetical by those in the forefront of artistic activity. Rather, a number of these artists acknowledged the power of the machine in contemporary life but sought through art to contain it to achieve sentient ends. In a lecture to students at the Clarence White School in 1923, Strand, couching his argument in language more appropriate to the description of human sensation than of cold technology, elevated the camera to a symbol of all "new and young desire" and championed intuition as a brake upon the uncontrollable tendencies of technology.[30]

This core modernist ideology conjoined a realistic appraisal of contemporary industrial culture with an idealistic view of its controllability by human intellect and feeling. It remained central to Strand's thinking about technology for the remainder of the decade and colored his attitude toward industrial enterprise throughout his life. In the mid-1920s, when machine culture had become a pervasive theme in all the arts and some photographers were loudly proclaiming industrialism the new American religion, Strand continued to maintain, as he had in 1922, that unless held in check by human feeling and social oversight, technology would become arrogant.[31] Indeed, such misgivings may have been one reason his work was absent from the several important exhibitions of machine art that took place in the late 1920s, although personal animosities among photographers probably contributed as well.[32] One may assume also that his growing conviction that industrial capitalism had become unresponsive to human

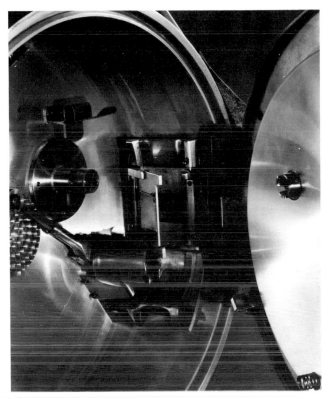

10. *Akeley Motion Picture Camera*, New York, 1922

needs lay behind the gradual turning away in the late 1920s from themes
dealing with the urban, machine-made world to those concerned with na-
ture and primitive artifacts.

But before this disaffection set in, Strand's own photographs of ma-
chines and machined forms reflect a propitious view of science and
mechanization. Prior to entering the army, he had made a number of
close-ups of portions of an automobile. The first of these, *Wheel Organiza-
tion*, produced in 1917 on the threshold of an era of greatly expanded
automobile travel, emphasizes the essential automotive mechanism of wheel
and spring. Interpreted at the time as a symbol of the entire machine, of
the motor industry itself, and indeed of United States industrial vitality,
this image forecast a theme that became more accessible in 1922 after he
had acquired the Akeley camera.[33]

Close-ups of the Akeley (see figure 10), taken immediately after its ac-
quisition, are the visual emblems of Strand's high regard for the functional
excellence and aesthetic satisfaction the camera afforded him, which he
articulated in a letter to Stieglitz.[34] The images of both the camera and the

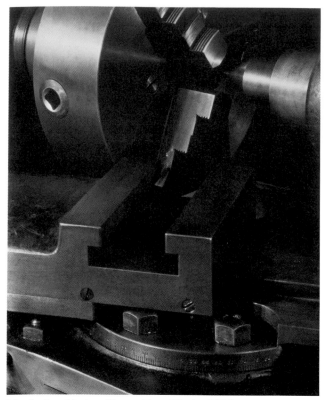

11. Lathe, Akeley Shop, New York, 1923

machine tools (such as lathes and drill presses, to which he had access in the Akeley repair shop) depict these artifacts as elegant and even voluptuous (see figure 11). The machine tools especially are presented as unsullied by metal scraps or lubricating oil — pristine objects quite unlike the real thing, as anyone who has ever seen such tools in operation would recognize immediately. Yet as the eye lingers with pleasure on the precisely articulated shapes with their satisfying metallic sheen, it also perceives the force and potency of such tools and, by extension, the culture in which they predominate. Obviously, Strand recognized as early as 1922 that industrial culture could be both attractive and ruthless at the same time.

In the early 1920s, encouraged by the praise of writers Waldo Frank and Sherwood Anderson, Strand devoted more attention to critical writing about the arts in general. By now intimately involved with Stieglitz, he attempted to publicize the work of those associated with his mentor — work he felt was ignored or misunderstood by the professional critics at the time. An article on O'Keeffe countered the hoary argument about the "weakness of women's creativity" by calling attention to the fact that historically men had far greater opportunities than women for diverse experi-

ences.[35] In other pieces, he dealt with the contributions of Marin and Gaston Lachaise but soon recognized that these efforts to promote a modern yet intuitive approach in American art were not well received and took valuable time from his own work.

By 1921, the close friendship between Strand and Stieglitz had expanded to include, besides O'Keeffe, Strand's wife-to-be, Rebecca (Beck) Salsbury. All dined together frequently while in New York City, corresponded during periods apart, and for a while spent parts of their summers together at Lake George; O'Keeffe and Salsbury eventually traveled to and sojourned together in Taos. At first, the relationship was mutually sustaining during a troubling time for all. Stieglitz supported Strand's attempts to make a living as a cinematographer, suggesting ideas for covering sporting events (in particular thoroughbred races at the track in Saratoga). Stieglitz was especially welcoming to Salsbury as she sought to insert herself into the family ménage at the lakeside. For his part, Strand sustained his mentor by providing a link to the world of photography during a period of vexing isolation for the older man. Besides providing articles on the Stieglitz artists, Paul and Rebecca, now married, helped publish the photography issue of *mss* with which Stieglitz sought to project himself back into public view. They also helped make possible the two galleries that Stieglitz was to open in the 1920s, and Beck Strand helped finance a gift of Stieglitz's photographs to the Metropolitan Museum of Art.[36]

Strand's undisguised admiration of Stieglitz had somewhat problematical results in terms of his own work. From 1918 through the 1920s, Stieglitz had been making a camera portrait of O'Keeffe, photographing her in a variety of poses, backgrounds, and states of dress and nudity in order to create what he considered a profound psychological statement about his companion's character and moods. In 1921, Strand embarked on a similar project, irritating mentor and wife, both of whom found such emulation questionable, with Beck Strand in particular urging that he find his own voice.[37] Matters became even more strained when Strand, turning his attention to nature (which he had occasionally photographed during the 1910s and 1920s at Twin Lakes and in Nova Scotia) and to artifacts of provincial life, focused on an old horse buggy in a barn on Stieglitz's Lake George property. An infuriated reaction on the part of Stieglitz against trespassing on what he considered "part of his life" forced Strand to recognize the derivative nature of this venture and the necessity of seeking out his own themes and situations.[38] The episode also was the opening wedge in the eventual destruction of the friendship, for although the Strands would spend time with Stieglitz at Lake George again—indeed, Paul returned for brief intervals the following summer and again in 1929—the ardor had cooled. For the remainder of the decade, his serious photographic projects took place elsewhere—in Maine, the West, and the Gaspé Peninsula.

Strand sensed in his mentor the absence of a wholehearted commitment

to his work. It had surfaced as early as 1920 in Stieglitz's criticism of Strand's lack of "passion" and had become more explicitly disparaging and provocative (especially in letters to a mutual friend, Herbert Seligmann) as the decade wore on.[39] Until 1929, Stieglitz was reluctant to offer the solo exhibition that Strand so ardently desired, ascribing his hesitancy to ill health.[40] For the next few years, Strand's rancor simmered below the surface, but in 1932, following a joint exhibition of his photographs and Beck Strand's glass paintings at An American Place, for which Stieglitz had offered little assistance and no catalog, Paul Strand returned the gallery key that had symbolized their bond and took off for New Mexico without explanation or farewell. Thus ended a relationship that had become, in Strand's view, "second-rate, corrupt, meaningless."[41]

The abrupt ending arose from more complex reasons than just ill-humor at having his work shabbily treated. They involved an unacknowledged competitiveness between the two men in the areas of both photography and human relationships. Stieglitz's inability to relate to his associates as equals had provoked Waldo Frank to declare him *incapable of a relationship of equality with anyone*" (emphasis in the original).[42] Stieglitz's condescension, unwitting or otherwise, toward the younger photographer, whom he characterized as one of his "babies," and his envy of Strand's vitality, his health, and his ability to earn a living eventually led Strand to think of him as exemplifying Ibsen's "master builder"—as one who could neither acknowledge others' needs nor cope gracefully with age. The situation finally was spelled out for Strand by Group Theatre director Harold Clurman, who observed that "unless you can be close to Stieglitz without being absorbed by him, . . . he is not healthy."[43]

Throughout the 1920s, Strand had struggled to find time to pursue still photography as his schedule of free-lance film work expanded. His personal frustrations were played out against a backdrop of changing social and cultural developments as the extraordinary possibilities promised by events of the 1910s dissipated in the rampant commercialism of the postwar decade. To his own search for identity, one might add the aggravations caused by Stieglitz's and O'Keeffe's recurrent bouts of ill health and their increasing worries about maintaining the Lake George property, which gave rise to his mentor's feeling that his world was "slipping away."[44] Additional irritants were O'Keeffe's displeasure with the lack of privacy in Lake George living arrangements and Beck Strand's frustration with her own living and working conditions.

Of equal significance were Strand's changing political and social perspectives. Although considered a political radical in later years, as a young adult Strand disdained political action including even voting as a preoccupation for ordinary rather than creative individuals. This elitist indifference to the political process gave way slowly in the late 1920s, as the bonds between Strand and Stieglitz loosened. Seeking other mentors and counselors, he turned a willing ear to the ideological positions being discussed

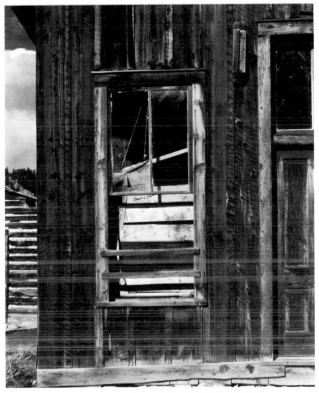

12. *Ghost Town*, Red River, New Mexico, 1930

by members of the Group Theatre, and by Clurman in particular. This professed cooperative of actors and directors proposed that expressive art be it mimetic or visual—concern itself with issues of relevance to the social displacement and unrest engulfing the nation during the Great Depression.

Beyond that, the Group Theatre appeared to embody the ideals of unselfish communion of intellect and feeling that had initially attracted Strand to the concept of the Photo-Secession. In both organizations, a strong individual presence propounded the group ideology and satisfied Strand's apparent need for a commanding figure, which may have blinded him to the improbability that such utopian societies would function smoothly for more than brief periods of time. Although never as psychologically dependent on Clurman as he had been on Stieglitz when much younger, he transferred his loyalty and rethought his positions on art, culture, and politics.

This new vision was reinforced in Taos, New Mexico, where Strand spent considerable time, having first traveled there with his wife in 1926 and then returned for longer periods in 1931 and 1932. Through association with a group of social-minded artists and writers for whom the

paramount responsibility of cultural figures was to address the pressing social issues of their time rather than deal only with purely personal matters, Strand began to seek the causes of the economic and social chaos that deepened throughout the 1930s.[45] As a result, he started to conceive of his own photographs not so much as singular transcendent statements about unrelated phenomena, but as a way of revealing dialectical relationships — of divulging the role the past plays in molding the present (see figure 12). While remaining mindful of the necessity that images (and all structured expression) involve formal elements, he reformulated his approach, disparaging the "esthetic rut" in which artists insulate themselves and claiming that "all vital arts result from the artists' direct and actual involvement in the real world."[46]

In pursuit of a structure whereby he might integrate this newly awakened social concern with his feeling that the real character of the objective world often is obscured by its immediate facade, Strand's imagination was fired by Edgar Lee Masters's epic poem *Spoon River Anthology*, which contrasts appearances and reality. This work may have attracted him for several reasons. In 1915, when it first appeared, Masters had been commended as "the natural child of Whitman," whose paean to urban vitality was familiar ground to Strand. By the early 1930s, however, reawakened interest in *Spoon River* found different messages, among which a rejection of the city as the vital center in favor of the countryside as the "haunt of something universal" in American life struck a responsive chord, especially for those who by the late 1920s had come to regard New York City as a symbol of "terribleness."[47]

Although Strand's attraction to the city as theme had begun to pall much earlier, the regionalist outlook implied by this later interpretation of Masters's epic undoubtedly reinforced his decision to seek a new arena. Having concentrated at first on close-ups of organic matter—tree stumps, rock and foliate forms—followed by tentative experiments with larger vistas in the Gaspé in 1929 and in the West in the early 1930s, he now felt the need to bring social coherence to his handling of these elements. Loath to turn away from the landscape as theme, Strand discovered in *Spoon River* a structure for dealing in a profound way with both nature and the built world, meaning and appearance, and reality and its facades—a way of creating what might be called a societal portrait.

One can conjecture that Strand drew on more familiar sources as well in formulating the idea for a portrayal of socially conditioned entities, for in essence his concept recalls Stieglitz's extended work with O'Keeffe, now recast to include a sociological dimension. Such a "portrait" might be expected to resonate with larger and, to Strand's mind, more humanly significant ideas and feelings than those concerned with just the individual body and soul.

In addition, *Spoon River* was significant as a catalyst for dealing with

perceptions about the complex nature of the human psyche. Such intangibles had long occupied the deeper regions of Strand's thoughts but had become more acute as his relationships first with Stieglitz and then with his wife foundered. The literary work had fused acceptance of the hypocrisies, deceptions, and dark secrets of life with a belief that even the most wretched person aspires to transcendent ideals of love and respect, thus conjoining realism and idealism in a manner that accorded very well with Strand's new sense of social responsibility. In their loving revelation of the distinctive appearance of ordinary artifacts and persons, his images would invest the mundane with a sense of enduring grandeur and suggest inner tensions and mysteries without denying the beauty that exists alongside trauma in the real world.

This charge became a lifelong mission. Despite a ten-year period (from 1932 to 1942) during which he was principally engaged in making politically oriented motion pictures (in Mexico and the United States), Strand pursued this agenda from the early 1930s through the 1960s in travels in Mexico, New England, the Hebrides, France, Italy, Egypt, and Ghana. As he photographed, he continued to harbor the dream of finding a community that would provide the elements of his own *Spoon River*. To this socially directed quest he brought the modern visual ideas and exalted artistic standards that had been his measure from the second decade on and, in so doing, he endowed his social vision with its unique dimension.

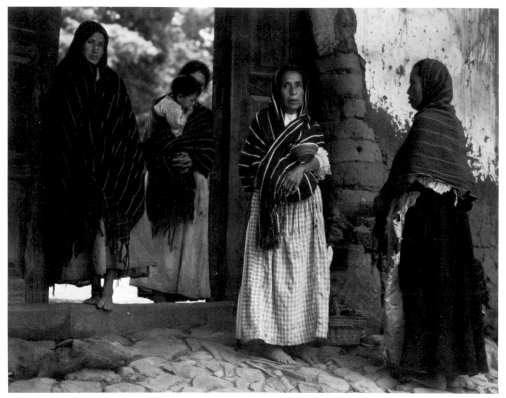

13. *Women of Santa Anna*, Mexico, 1933

GLORIA NAYLOR

Women of Santa Anna, Mexico, 1933

I went in search of the place where these women stood: women of a town named after a woman: Santa Anna, Mexico. Too small to make a mark in the atlas. Women of a hidden hamlet named after a woman. Saint Anne. Men changed her name. It was Hannah in the Hebrew. Hannah when she spoke with her own tongue. Hannah when she first came to the realization that she *was*. Perhaps, from her adolescent face reflected in the deep stone wells of Bethlehem, Judea. Reflected because the air is hot and still, the sun high and cruel. And girls that young are still daring: she would have leaned far over the mouth of the well, curious about the depths; thrilled at the thought of being on the edge of danger; feeling the exhilarating surge of power from the confidence that her bronzed arms were strong enough to hold her high up over the watery abyss. It was Hannah before she knew she was a woman. But then she became a woman—and it was then men changed her name. So it is women of a hidden hamlet named after a hidden woman. Saint Anne. Why was she singled out for such an honor? Because she was pious enough to grieve so bitterly over her barrenness that the heavens took pity on her. And she bore a female child who through immaculate conception bore a male child—she was now the mother of all mothers; because her daughter's son was to become the epitome of all male children. Hannah lost her name but gained immortality when she became the grandmother of the Son of Man. So it is really women of a hidden hamlet named after a hidden woman old and hidden.

Grandmothers. Look closely: regardless of her age that is what each of these women already is—set in her destiny. And the myth of the grandmother is breathed here, because it is planetary and primal: old woman; wise woman; mother woman; sexless; strong—like the stones under their callused feet. A woman to be venerated; a woman of hard-earned worth. A woman woman—who bears and causes to be born. A saint.

Myths always arise, serving a society's need, helping us to live with the

contradictions in our lives. The myth of the grandmother softens the reality that the signs of age in females are equated to ugliness; that the old in general have no useful place, and the old woman doubly so by lack of a useful uterus. Like the witch (the recalcitrant woman) and the whore (the sexual woman), the grandmother (the old and useless woman) is a comfortable stereotype, enveloping facets of the female condition that elicit intense fear or guilt on the part of men. And we believe these myths because, male or female, we *need* to believe them. Or else we might self-destruct in despair under the weight of the inequities on which they thrive.

Yes, the myth is as pervasive in Santa Anna as elsewhere; there is no despair on these faces at the destiny they were born into. They are, instead, faces stilled in a moment of simple and eternal truth: The Women of Santa Anna, Mexico: women of a hidden hamlet named after the patron saint of women in labor.

JAN-CHRISTOPHER HORAK

Modernist Perspectives and Romantic Impulses: *Manhatta*

anhatta, a seven-minute portrait of New York City, is acknow-
ledged by many historians of film and photography to be the first
genuine avant-garde film produced in the United States. Its mak-
ers, Charles Sheeler and Paul Strand, were amateur filmmakers, working
like their European compatriots, outside mainstream, commercial modes of
film production, creating a work of cinema whose primary *raison d'etre*
was not economic gain but rather modernist experimentation in a new
medium. In America the concept of the avant-garde implied a separation
from Hollywood's commercialization and professionalization if creative
activity was to occur.

Manhatta is central to modernism because it deconstructed Renaissance
perspective in favor of multiple, reflexive points of view. Yet at the same
time, this work demonstrates aesthetic concerns and philosophical premises
which are archaic and antimodernist. In its attempt to create non-narrative
and formally abstract cinematic experience, in conscious opposition to
cinema's classical modes of address, *Manhatta* nonetheless never quite re-
linquishes those structures, which manifest themselves most visibly in the
tension between image and verbal text, and between the film's modernist
perspectives and its expression of romantic longing for a universe where
people remain in harmony with nature.

Little attempt has been made to reappraise the American avant-garde
film on its own terms. Similarity in both thematic concerns and formal
applications connects European and American work quite naturally, given
modernism's preoccupations on both sides of the Atlantic. However,
American work seems to display a certain eclecticism, innovativeness, and
naïveté — qualities which make it different from European work. Besides
Manhatta, other early American avant-garde works reveal a "romantic" sub-
text involving the desire to reconcile man with nature, a text totally absent
in European modernism. *Manhatta*, in fact, seems ultimately to construct a
number of conflicting texts, oscillating between modernism and a Whit-

14. *Manhatta*, shot #2, film still, 1921

manesque romanticism, between fragmentation and narrative closure, posi-
tioning the subject in the oblique perspectives of the modern skyscraper
but simultaneously viewing technology as an event ideally in tune with the
natural environment. Furthermore, *Manhatta* actually predates much Euro-
pean avant-garde film and in a sense defines a prevalent style and theme
within both European and American avant-garde practice, the so-called
"city film."

 In his own unpublished memoirs, Sheeler makes no mention of *Man-
hatta*, nor of Strand.[1] In later years his widow claimed that her husband
had been solely responsible for conceiving and photographing *Manhatta*, an
assertion that surely needs correction. The fact that the two collaborators
and friends apparently had a falling out in 1923, most probably over a
review published by Sheeler against Strand's mentor, Alfred Stieglitz,
makes a reconstruction of the film's history difficult.[2] By 1923 Strand and
Sheeler were no longer close, because economic pressures had sent them in
different directions to find work—Strand moving evermore into cinema-
tography, Sheeler working as a gallery and advertising fashion photog-
rapher. Naomi Rosenblum ventures the theory that Strand also worried
about the distribution of credit for their sole film adventure.[3] Indeed, as
early as September 1921, shortly after the film had its first run, Stieglitz
warned Strand:

 All I fear is that Paris will know the film as Sheeler's work, even if
 you are originally mentioned. It will be Sheeler and Strand. And then
 Sheeler . . . out of that, unless Sheeler requests De Zayas to be very
 particular always to mention the two names together. . . . It's one of
 those ticklish questions when one of the two is an "artist" and the
 other is only a "photographer."[4]

 In any case, this eventual rift has complicated the possibility of establish-
ing an exact chronology for the making of *Manhatta*: the Sheeler estate
contains neither letters nor other documents pertaining to the film, and

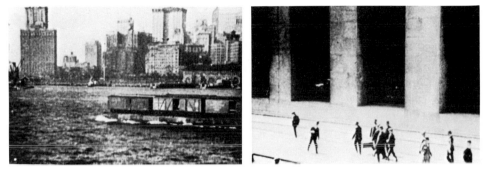

15. *Manhatta*, shot #13, film still, 1921 16. *Manhatta*, shot #4, film still, 1921

Strand's interviews on the subject took place long after the events and are imprecise. All surviving documents (such as correspondence between Stieglitz and Strand, and Paul Strand's press release for the film) thus reflect Strand's point of view. According to Strand, then, he probably first met Sheeler in 1917 at Stieglitz's 291 gallery when Sheeler was still living in Philadelphia.[5] Their mutual interest in straight photography and abstraction may have drawn them together. In 1917 Strand won first prize in the twelfth Annual Wanamaker Exhibition of Photography with his photograph *Wall Street*, and Sheeler's *Bucks County House* won the coveted first prize a year later. When Sheeler moved to New York in 1919, the two artists became closer friends, discovering their mutual fascination for cityscape architecture and its application to visual design. Possibly Sheeler looked to Strand, a native New Yorker who had grown up on West Eighty-Third Street, for the street savvy that the former Doylestown resident lacked. Then, according to Strand:

> One day I met him and he said, "You know I've just bought a motion picture camera. It's a beauty. It's a Debrie camera, a French camera. It cost $1600." I said, "Well that's certainly very exciting, Sheeler. I'd like to see it." So we went to his place, as I recall, and saw this very handsome instrument. I don't remember any of the details, but the upshot of it was the idea of making a little film about New York. Who developed it, whether it was he or both of us together, I don't recall.[6]

Why Sheeler bought the motion picture camera with which he would make only one film remains a mystery, but it is likely that he intended to make a film about the city, since the Debrie L'interview Type "e" was an extremely lightweight, easily threaded and operated, wood cased motion picture camera, very popular with cameramen working "on location" or shooting newsreels outside of a controlled studio environment. It was thus ideally suited to the kind of project *Manhatta* eventually became, and if

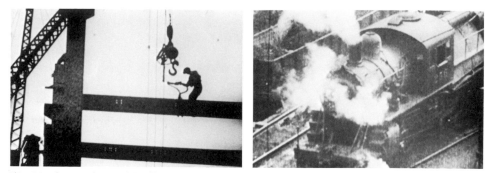

17. *Manhatta*, shot #20, film still, 1921 18. *Manhatta*, shot #38, film still, 1921

indeed it was Sheeler's intention to experiment with urban landscapes as seen through the motion picture camera, he could not have chosen a better camera.[7]

Sheeler and Strand worked on the film from early 1920 until at least September of that year. Whether they had at any point developed a script or whether they shot footage off the cuff can no longer be ascertained. They did shoot from rooftops and streets located in lower Manhattan, specifically within a five-block radius around Battery Park, the Staten Island Ferry docks, Wall Street, Broadway, and Trinity Place. The film probably was edited in early October, apparently with both artists taking part in the process. Lacking experience, they edited at least one shot into the film with the emulsion the wrong way, causing the image to be reversed (although this may have been for compositional purposes).

The film's original title is a nebulous area. Shortly before his death, Strand suggested in a letter to Richard Shales that Sheeler had "proposed that we might make a kind of experimental film about New York together—a silent film carried along by the titles which we took from Walt Whitman's poem."[8] None of the surviving correspondence mentions the title of the film, however, and Strand in later years alternately referred to the film as *Manhatta* and *Mannahatta*, so that its original title remains unknown. Strand's press release makes no mention of Whitman at all but indicates instead that the inter-titles to the film were "by the Rialto," the cinema theater where *Manhatta* premiered commercially. Although some critics have suggested that the inter-titles were added later, just as the title may have been changed later to reflect the film's Whitmanesque content, there seems to be ample internal evidence to suggest that the inter-titles were in keeping with Strand and Sheeler's intentions and were not added solely as a means of legitimizing the film for an intellectual audience.

The film finally was released as *New York the Magnificent*, a title which the Rialto may have chosen in order to emphasize its position in the pro-

19. *Manhatta*, shot #63, film still, 1921 20. *Manhatta*, shot #64, film still, 1921

gram as a "scenic." When the film was screened in Paris in 1922, this title had been changed to *Fumée de New York* (*Smoke of New York*). Finally, the film appeared at the London Film Society in 1927 displaying the title *Manhatta*. That particular print, which was eventually preserved by the British Film Institute, is the master material for all surviving prints circulating in the United States.

After completing the film, Sheeler and Strand first screened the film for friends and colleagues, including Walter Arensberg and Marius De Zayas, the latter the owner of The Modern Gallery where Sheeler now worked. As Stieglitz noted somewhat caustically in a letter to Strand, dated 27 October 1920:

> So your film is in California. I'm glad Arensberg and De Zayas were so pleased. I'm sure the film is way above the "usual" thing. But I do hope you and Sheeler will get more out of it than the applause of Arensberg and De Zayas.[9]

Manhatta opened commercially on July 24, 1921 at the Rialto Theater on Broadway. The long delay between the film's completion and its public premiere surely indicates the difficulty of finding an exhibitor. It ran for exactly one week, sandwiched into a program that included:

Overture: Selections from "Manon"
Current Events: "Rialto Magazine" (newsreel)
Ballet: "Danse Orientale," presented by Lillian Powell
Scenic: *New York the Magnificent*
Vocal: Ceasare Galletti singing "Celeste Aida"
Feature: *The Mystery Road*
Comedy: *The Fall Guy*
Organ: "Marche Pontificale."[10]

As this program illustrates, *Manhatta* was placed in a more or less standard commercial film repertoire, although on this occasion the feature, a British import, may have been slightly more sophisticated than the usual fare.

American avant-garde filmmakers — unlike their European colleagues — could not at this early date rely on any kind of alternative, noncommercial distribution and exhibition organization; film clubs and societies did not exist to show their work. Thus neither the viewing context nor the expectations of the audience were conducive to the reception of the film as an avant-garde, modernist work. Nevertheless, a press release prepared by Strand and the film screenings at the Rialto gained the attention of New York's local film critics. Six papers mentioned the film and at least three local newspapers devoted more than a line in their daily reviews, an unusual occurrence given *Manhatta*'s status as an adjunct to the feature presentation.[11] Although critics praised the film, the reviews also demonstrate that this "scenic" left them perplexed at best. Harriet Underhill's comments in the *New York Tribune* are typical:

> As a matter of fact . . . [*The Mystery Road*] wasn't nearly as interesting as the picture called "New York the Magnificent." This showed scenes and related facts about what every New Yorker thinks is the greatest city in the world. Hugo Riesenfeld had the orchestra play all of the old favorites, like "Annie Rooney," "Sidewalks of New York," "She May Have Seen Better Days," "My Mother Was a Lady," etc. Two minutes more and there would have been community singing — a few intrepid souls were tuning up, as it was.[12]

Neither Underhill nor any of the other reviewers deals with the film's construction or its particular view of New York, and most critics commented favorably on the music, possibly because the scoring by Riesenfeld was for them the most accessible element of the event.

Only one critic recognized *Manhatta*'s importance as a modernist work. Robert Allen Parker, whose perceptive review, "The Art of the Camera. An Experimental Film," appeared in *Arts and Decoration* some weeks after the film's commercial run, wrote:

> In entering the field of the motion picture Sheeler and Strand sought to apply the technical knowledge gained from their experiments and achievements in still photography to the more complex problems of the motion picture. . . . The results have fully justified this daring adventure in a new art. . . . There was no heroine, no villain, no plot. Yet it was all thrilling, exciting, dramatic — but honestly gloriously photographic, devoid of trickery and imitation. They used no artifice of diffusion. They did not resort to the aid of the soft-focus lens. They did not attempt to make pictures that looked like paintings.[13]

In distinguishing *Manhatta* from the kind of narrative commercial enterprise prevalent at the time, Parker recognized the relationship of the film's straight photography to urban modernism: "The city . . . reveals itself most

eloquently in the terms of the line, mass, volume and movement. Its language is plastic. Thus it expresses its only true individuality."[14]

As Strand noted in a letter to Stieglitz on August 3, 1921, *Manhatta* died after its initial run:

> In spite of these [good reviews], I fear we will not be able to distribute it generally. Apparently everybody has been making a reel of New York. Educational, which is the largest company, have done so and I have seen announcements of other smaller concerns. Naturally, they will use their own materials.[15]

This was indeed the case. For example, only one week after *Manhatta* closed at the Rialto, the Kineto Company of America released *Old New York*, a short demonstrating "a series of comparative pictures of New York City."[16] As novices in the field of filmmaking, distribution, and exhibition, Sheeler and Strand may not have realized that independently produced films, whether features or shorts, managed only rarely to break into the commercial market. Nevertheless, *Manhatta* eventually found an art house audience in New York, Paris, and London. In retrospect, it probably enjoyed more public screenings than many European avant-garde films and certainly more screenings than most American avant-garde films made before 1945.

Manhatta is both modernist and strangely romantic, even innocent, in its view of the world. Even before the film actually begins, its inter-titles circumscribe the film's geographical space, without, however, inscribing its style. While the upper three-fourths of the initial inter-title image has been darkened to allow for the credits, the bottom of the frame presents an extreme long shot of the lower Manhattan skyline and the Hudson River as seen from the New Jersey shoreline, including from left to right: New York City Hall, the Woolworth Building, the Singer Building, the Equitable Building, and the Banker's Trust Building (see figure 14). Abstracted to a degree and flattened through high-contrast printing, this long shot of skyscrapers nevertheless creates a unified space, positioning and centering the viewer in relationship to the horizon in the manner of Renaissance perspective. However, nowhere in the film is this image repeated. Nowhere in the film are spatial relationships as clearly established. Nowhere else in the film will a central perspective orient and position the viewer in the concrete and recognizable geographic space of the film's narrative. While the titles signify totality, inscribing the subject in a construction of a unified space and centered point of view, the images of Sheeler and Strand's film seem at first to signify discontinuity.

Manhatta does on first viewing appear to be a random selection of images taken in lower Manhattan, images which emphasize abstract elements of visual design in a manner consonant with the modernist project. As Strand himself noted in his press release:

Restricting themselves definitely to the towering geometry of lower
Manhattan and its environs, the distinctive note, the photographers
have tried to register directly the living forms in front of them and to
reduce through the most rigid selection, volumes, lines and masses, to
their intensest terms of expressiveness. Through these does the spirit
manifest itself. They have tried to do in a scenic with natural objects
what in "The Cabinet of Dr. Caligari" was attempted with painted sets.

Invoking the expressionist abstraction of *Caligari* may have been one way
of establishing the film's aesthetic credentials, but it also points to the
film's usage of oblique angles, collapsed space, and static compositions.
Strand does not mention the film's many references to his own photo-
graphic work as well as to that of Alfred Stieglitz.[17]

Other images precurse the paintings and drawings of Charles Sheeler,
indicating that he, unlike Strand, would continue to draw inspiration from
the film for many years.

Two Stieglitz photographs from 1910, *City of Ambition* and *The Ferry
Boat*, seem to have inspired the shot-reverse angle construction of the
film's opening ferry boat sequence (shots 5 and 8). Both had first been
published in *Camera Work* (October 1911) and may have offered Strand
and Sheeler a blueprint for a number of other sequences in the film as
well. *Old and New York* and *Excavating—New York* (1911), for example, pre-
sage the construction sequence (shots 17–20), and the railroad yard se-
quence (shots 37–39) recalls *Hand of Man* (1902) and *In the New York Cen-
tral Yards* (1911).[18] The *Acquitania* steamship sequence at the end of the
film likewise recalls Stieglitz's photograph of the *Mauritania* (1910).

Naturally Strand borrowed from his own work. His photograph *Wall
Street* (1915), taken from the steps of the Sub-Treasury Building, is literally
remade in *Manhatta*'s shot 13 (see figures 4 and 15), the blurred pedest-
rians of the original still dwarfed by the huge, dark windows of the Mor-
gan Trust Company Building. Strand's still image *Fifth Avenue* (1916)
resembles a film shot made on Broadway both in terms of composition
and in its slightly low angle.

On the other hand, Sheeler was more apt to use images from *Manhatta*,
as evidenced by an image (shot 15) taken from the Equitable Building and
reproduced as a photograph in *Vanity Fair*[19] as the pencil drawing *New
York* (1920), and as the painting *Offices* (1922). Sheeler's painting *Church
Street El* (1920) was based on a film image (shot 59) and on a still photo-
graph published in *Vanity Fair*.[20] *Manhatta*'s image of construction workers
on geometrically arranged steel girders against a neutral sky (shot 21) ap-
peared years later in Sheeler's painting *Totems in Steel* (1935), and the shots
of the railroad yard and factory (shot 37) presage Sheeler's growing in-
terest in industrial landscapes as it was to manifest itself in his images of
the Ford Motor Company's Rouge River plant.[21]

These various cross-connections are interesting clues, establishing Sheeler and Strand's artistic preoccupations and their willingness to translate imagery into various media. They serve to comment on the specific limitations and successes of each medium's formal practice, but they do not in every case establish credit for *Manhatta*'s individual scenes or images. Both artists seem to have been interested at this point in an abstract construction of space in which lines, planes, and solids dominate composition. Both seem to have made extensive use of extreme perspectives in their photographs and/or paintings. By emphasizing abstract and formal compositional elements over the image's iconic signifying functions, and at the same time positioning the subject through straight photography conventions to read those images as "reality," Sheeler and Strand create visual interest. More than half of the film's images are either low-angle shots looking up at buildings or bridges or, more often, high-angle shots looking down at the city from elevated places. In either case these extreme perspectives tend to confound formal spatial relationships and thus contribute to the sense of fragmentation of the subject's perception. One experiences in the first moment of reception a degree of disorientation before recognition and cognition of the image occurs, so that the spectating subject, forced to become aware of his/her own actions, is caught, as it were, in the act of gazing.

Manhatta's extreme camera angles thus contribute to the self-reflexivity of the audience's reception—a goal that is central to all modernist art. In this respect it is a seminal film, predating even the extreme perspectives of European modernist avant-garde films such as Walter Ruttman's *Berlin, Symphony of a City* (1926) or Dziga Vertof's *Man with a Movie Camera* (1929). In still photography such perspectives were more common; Strand and Sheeler had probably seen Alvin Langdon Coburn's 1912 photograph of Madison Square Park, *The Octopus*, taken from an extremely high angle. In a similar manner, Strand and Sheeler position the camera, and by extension the spectator, within the cityscape of lower Manhattan, obliterating the horizon through the construction of vertical structures and affecting one's perception of space. Normal, horizontal views become an impossibility; one must either strain to look up or climb up to look down through the concrete canyons of Wall Street or Broadway. Sheeler and Strand also were interested in capturing the play of light and shadow, which forms geometric patterns of various shades of gray on the surfaces of buildings, highlighted by the dark squares of countless windows.

Frequently the geometry of these patterns is broken up by rising columns of smoke. Smoke from chimneys, smoke from railroad engines, smoke from steamships and tugboats in fact forms a major visual motif; apparently, both artists were fascinated by the motion picture camera's ability to capture its constant metamorphosis and dissipation. A natural play of light and shadow is also captured in images of light reflected off

the waters of the Hudson and in the film's final image of sunlight bouncing off clouds and water. These highly romantic images of nature seem to contrast sharply with views of cityscapes elsewhere in the film, yet both the use of extreme perspectives and the emphasis on light and shadow tend to increase *Manhatta*'s level of visual abstraction.

These formal elements, common to the modernist project as a whole, do little to clarify the syntagmatic structures that ultimately govern the reading of motion pictures as a sequence of shots rather than as individual images. And because film images are embedded in a syntagmatic structure, *Manhatta*'s images have been criticized as too photographic, static, and lacking in dynamism and movement. Nevertheless a number of images do incorporate subtle movement.[22] The opening shot from the Staten Island Ferry, for example, moves slowly to the right while within the frame a barge steams through the image to the left. The juxtaposition of movement within the frame, which Eisenstein termed a "montage of attractions,"[23] increases the dynamic force of the contrasting movements. In *Manhatta* such juxtaposition occurs again later in the film when an ocean liner and tugboat steam past each other in opposite directions. Another sequence of two shots in which horizontal movements of a steam shovel and a crane are juxtaposed from shot to shot is more directly related to Eisenstein's theory of montage. The dynamism of these and other shots, however, is usually bracketed by static composition, so that the overall effect of the film is somewhat less than dynamic.

Camera movement or movement within the frame, however, is only one aspect of cinematic dynamism. Another kind of dynamism, according to Eisenstein, can be achieved through formal contrasts from shot to shot. Strand and Sheeler, for example, juxtapose camera distances from shot to shot, increasing or decreasing the size of objects within the frame and establishing different sets of spatial relationships through the usage of varying focal lengths, as in the views of men on steel girders or the views of the Hudson River taken from the Equitable Building. At another point Strand and Sheeler juxtapose form and volume, cutting from the small square gravestones in Trinity Church cemetery to the huge rectangular windows of the Morgan Trust Building. Interestingly, this last sequence suggests that Strand and Sheeler consciously constructed formal juxtapositions: the image of the American Bureau of Shipping (shot 25) has been reversed, perhaps to accommodate the formal juxtaposition of planes between shots. Dynamic movement is also created by juxtaposing the diagonal thrust of the composition from shot to shot, as seen in the images of Church Street El and the Trinity Church graveyard and Broadway (shots 52–53).

Finally, the film's rhythm—the result of varying the length of individual shots—testifies to the filmmakers' attempts to create another kind of dynamism through a temporal construction of images. Only two shots in the

whole film are longer than twelve seconds (shots 8 and 23), and both involve camera movement. Virtually every other shot in the film varies in length between four and twelve seconds, with shots usually alternating between shorter and longer images.

These formal strategies of syntactical construction, which both give the film its dynamism and add to its visual interest, nevertheless address only one level of audience perception. They must be contextualized within the film's overall narrative (non-narrative) structure if one is to make semantic sense of *Manhatta*'s syntagmas, if indeed one is to make semantic sense of the film's rhythm. On first viewing, the film may seem to be nothing more than an impressionistic sequencing of images, but its overall narrative structure can actually be divided into four distinct movements of approximately equal length. Including inter-titles, *Manhatta* consists of sixty-five shots with individual movements breaking down into sequences of thirteen, fifteen, seventeen, and fifteen shots, respectively. Each movement focuses on a series of visual themes and motifs, and the four together resemble the structure of a symphony. The musical analogy, borrowed from Walter Pater, does not seem out of place in discussing camera imagery, given Stieglitz's exclamations that he wanted his later cloud photographs to recall "music! Man, why that is music."[24] The symphonic organization of visual images would become overt in other European and American avant-garde films, most prominently in Ruttman's *Berlin Symphony* and Herman Weinberg's *City Symphony* (1930).

The first movement begins with the camera approaching Manhattan from the deck of the Staten Island Ferry, followed by a sequence showing commuters leaving the ferry and dispersing into the streets of Manhattan. The second movement centers on the construction of skyscrapers and their architecture. The third movement presents images of modern modes of transportation, specifically railroads and steamships, and the fourth movement returns to lower Broadway and images of the Hudson River (see figures 16, 17, 18, and 19). Even if this reading of the film's structure does not coincide at every point with the filmmakers' intentions, the very fact that *Manhatta* can be analyzed as a series of movements indicates that the spectating subject is positioned in a narrative structure of some kind. Furthermore, the striking similarity between the first and fourth movements, sandwiching the cityscapes of the second and third movements, implies that some type of narrative closure was intended.

Strand and Sheeler take advantage of another means of creating an overall narrative structure by utilizing inter-titles at eleven different points in the film. The inter-titles have been taken partially from Walt Whitman's poetry, although not only from his "Mannahatta" (1860), as one might suppose given the film's title, and they are not all direct quotes from Whitman. In almost every case the inter-titles, utilized to introduce individual sections, are not purely descriptive; rather, they form a lyric counterpoint

to the film's visual imagery. The first inter-title, "When million footed Manhattan unpent, descends to its pavements," is taken from "A Broadway Pageant" (1860), and it inaugurates a sequence of shots showing commuters leaving the Staten Island Ferry.[25] The skyscraper sequence begins with a passage from the poem, "From Noon to Starry Night: Mannahatta": "High growths of iron, slender, strong, splendidly uprising toward clear skies." It is continued (shot 22) with a passage from "A Broadway Pageant": "Where our tall-topt marble and iron beauties range on opposite sides." The third movement, focusing on transportation, is introduced (shot 31) by a passage from the second to last stanza of "Mannahatta": "City of hurried and sparkling waters!" Finally, the second inter-title (shot 53) and the last intertitle of the fourth movement are taken from Whitman's "Crossing Brooklyn Ferry" (1856): "On the river the shadowy group," and "Georgeous clouds of sunset! Drench with your splendor me or the men and women generations after me." The last inter-title is directly followed by two shots of the Hudson River bathed in light and clouds.

As can be seen from these examples, the inter-titles do to a certain extent double the film's visual codings and thus give the narrative cognitive structure. It is this doubling of the film's verbal and visual content that has led some latter-day commentators to hypothesize that the inter-titles were added by commercial interests, against the wishes of Sheeler and Strand.[26] However, a number of factors speak in favor of the theory that Sheeler and Strand themselves chose the stanzas from Walt Whitman and also decided on their placement within the film's text. First, the fact that the intertitles have been taken from a number of different Whitman poems indicates a degree of concern which would have been extremely uncommon for a Broadway movie palace simply needing a short subject. Second and more important, the close correspondence between Whitman's verbal imagery and the respective visual imagery with which it forms a syntagmatic unit creates a narrative structure that suggests conscious effort. Third, Whitman's poetic cadences do seem to counterpoint the film's visual rhythm. Finally, unlike later critics unaccustomed to viewing films with inter-titles, contemporary silent film audiences would not have found them obtrusive.

Why did the filmmakers choose Whitman as a source? Here one might turn to external biographical evidence. As has been documented elsewhere, Sheeler, in particular, belonged to the Arensberg circle, as did the poet William Carlos Williams; indeed the two became friends after meeting in 1925.[27] In the 1910s, Williams was an unofficial spokesperson for a New York-based modernist avant-garde, which suffered somewhat from a cultural inferiority complex in relation to the European avant-garde. Williams had in fact severely criticized the Eurocentric cultural chauvinism of Ezra Pound, H.D., and other imagist poets who had become expatriots in Paris or London, in effect disowning their American heritage. The program of

the New York avant-garde thus included the celebration of American values. Propagating the "independence of art in America," the newly founded and short-lived art magazine *The Blindman* (1917) invoked Walt Whitman as its mentor: "May the spirit of Walt Whitman guide the Independents. Long live his memory and long live the Independents!"[28] Not surprisingly, Williams sought a positive reassessment of Walt Whitman, whose poetry had gone out of fashion even during his final years. Like Whitman, Williams wanted to create and propagate a specifically American—and simultaneously anti-European—perspective and aesthetic. Yet Whitman's hymns of praise to New York and America—often romantically obscuring conflicts of nineteenth-century industrial class relations in favor of representing a homogeneous melting pot of technology, art, science, nature, and humankind—were the antithesis of the alienation and despair often inscribed by twentieth-century poets of the city, whether European or American. Whitman's view of New York expressed in *Sands at Seventy: Mannahatta* (1888) is a vision of the urban environment as a primordial natural landscape:

My city's fit and noble name resumed
Choice aboriginal name, with marvelous beauty, meaning,
A rocky founded island—shores where ever gayly
dash the coming,
going, hurrying sea waves.

The urban cityscape with its tenements and skyscrapers, its industrialization and technology, poverty and wealth, concrete pavements and steel bridges, disappears completely in this poem, subsumed by images of nature. Likewise, in other poems, among them "Crossing Brooklyn Ferry," the city, its architecture, and its people are expressed in anthropomorphic terms, as if they were organic objects in a natural, harmonious environment, unbounded by space and time. This transcendental view of the city as a natural phenomenon is also very much in evidence in both the intertitles taken from Whitman's "From Noon to Starry Night: Mannahatta," with their paean of praise to "high growths of iron, slender, strong, splendidly uprising toward clear skies," and in the film images themselves, making *Manhatta* something other than a modernist vision of the city. In fact, there is an anthropomorphic quality to many of Strand and Sheeler's images because the filmmakers show technology to be independent of human control. Except for the early ferry boat sequence with its masses of commuters spilling out onto Broadway and a later construction sequence in which workers are actually seen in the act of production, *Manhatta* eschews images of human beings and images of the city as a physical manifestation of social relations.

The inhabitants of the city, their interactions and communications, and their labor are reduced to antlike movements, as though they were insects crawling between the skyscrapers. Ocean liners, tugboats, and elevated

trains likewise move through the cityscape like strange living creatures, their technology apparently independent of human control. In this scheme of things, the skyscrapers themselves become natural formations of concrete and steel, like mountain peaks and deep canyons surrounded by the glistening water of the East and Hudson rivers. Indeed, the film's final image is not of the city scape, its man-made technological structure, or of urban squalor, but of natural elements: the river, clouds, and sun. Like Whitman's "hurrying sea waves," in *Mannhatta* this image of nature positions the viewing subject in a transcendental reality inscribed by the preceding inter-title: "Gorgeous clouds of sunset! Drench with your splendor me or the men and women generations after me."

This yearning for a unification with nature, this inscription of technology, urbanization, and industrialization with naturalistic metaphors, was not uncommon in the work of the aesthetic photographers around Alfred Stieglitz, including Strand. However, late-nineteenth-century pictorialists sought to exclude entirely from their work the economic and social discourses of American laissez-faire capitalism with all its accompanying upheavals in class and social relations; whereas in *Manhatta* Strand and Sheeler exemplify straight photography's desire to bridge the schism between city and country, nature and technology, the individual and mass society. In this context the filmic apparatus itself becomes for Strand a fact of nature, independent and anthropomorphic, rather than an instrument for the production of ideology. Strand's images of the Akeley camera (1921), the very camera with which he would earn his living as a documentary and newsreel cameraman, emphasize the anthropomorphic with their concentration on the sinuous curves and the feminine roundness of the camera's metallic body. Likewise, Strand's essay, "Photography and the New God," is not so much a tirade against the machine god, its empiricist son, and scientific holy ghost as it is a call for a synthesis of nature and technology, with the camera acting as a catalytic force:

> We are not, as Natalie Curtis recently pointed out in *The Freeman*, particularly sympathetic to the somewhat hysterical attitude of the Futurists toward the machine . . . We have it with us and upon us with a vengeance, and we will have to do something about it eventually.[29]

According to Strand, pictorialism's crime had been to deny photography's true nature — to *obscure* its technology, rather than embracing it: "At every turn the attempt is made to turn the camera into a brush, to make a photograph look like a painting, an etching, a charcoal drawing or what not, like anything but a photograph." The straight photograph, on the other hand, "has evolved through the conscious creative control of this particular phase of the machine a new method of perceiving the life of objectivity and of recording it."[30] Strand's idealist conception of the camera machine is thus as the pencil of nature, able to capture human emotions

through the science of optics and chemistry, able to overcome the schism between a dehumanizing technology and natural expression.

Paul Strand and Charles Sheeler's closing image in *Manhatta*, an image of nature taken from high above the streets of Manhattan, brings up again the question of narrative and narrative closure. A closer look at the four movements of the film reveals that a number of images or locales actually appear at both the beginning and the end of the film. An image of the Brooklyn Bridge, taken from the Brooklyn bank of the East River (shot 6), finds its counterpart in an image on the Manhattan side of the Brooklyn Bridge (shot 52). This doubling, positioning the subject first on one side and then on the opposite side, inscribing the landscapes as both subject and object, is repeated a number of times at the beginning and end of the film: in the mirror-image pairs of crowds coming and going on Broadway (shots 11 and 61) or the low-angle views of Trinity Church cemetery from opposite sides of the graveyard. Finally, and it is here that a sense of narrative closure is most prominent, the first and last images of the film are mirror images of each other: in the first shot the spectating subject is positioned on the Staten Island ferry as it approaches Manhattan, and in the final image the camera is placed on the Equitable Building, looking over and down the Hudson River toward Staten Island (see figure 20). The subject has thus come full circle: the object of the subject's gaze has become the subject, and the subject has become the object. The filmmakers have inscribed the spectating subject in an actual and a metaphorical journey: in time from morning to evening, in space from Staten Island to Manhattan, in the gaze from an urban cityscape to an image of a natural landscape. The city and country, and technology and nature, "whose coming together might integrate a new religious impulse,"[31] are thus united in the idealized universe of the camera's gaze. Strand's "god-machine" is proven capable of achieving a metaphysical symbiosis.

Strand and Sheeler's visual equivalent of narrative closure (as it was usually practiced in the institutional discourses of Hollywood's classical narrative cinema) violates the tenets of modernism's discontinuous and non-narrative aesthetic strategies. Yet *Manhatta*'s closure is only concretely realized in the gaze, and thus the film seems hardly comparable to Hollywood's over-determined narratives in which the subject is ultimately and necessarily returned to a fetishistic world of order, harmony, and unity, regardless of the chaos that might have preceded. The closure in *Manhatta* merely approaches closure, implying a narrative which allows for the subject's inscription in the film's final transcendental image. This harmonious subtext is both mitigated by and in conflict with the film's overall modernist design, its oblique and disorienting camera angles, its monolithic perspectives of urban architecture, and its dynamic juxtaposition of movement, light, and shadow. *Manhatta* is thus very much a heterogeneous text, both modernist and antimodernist. Its conflicting discourses never quite resolve

themselves, as indeed such issues have never been entirely resolved within the discourses of twentieth-century American art.

This conflict and heterogeneity set the film apart from its European successors. The city films, beginning with Alberto Cavalcanti's *Rien Que Les Heures* (1925) and Ruttman's *Berlin Symphony* and culminating in Vertov's *Man with a Movie Camera* and Jean Vigo's *A Propos de Nice* (1931), are characterized much more unequivocally by the discontinuous structures of modernism. And yet none of the films totally relinquishes narrative structure and suggestions of closure. Many of the city films retain a loose temporal structure, positioning a subject in "a day in the life of a city" documentary narrative. To be sure, such narratives are filled with ellipses, abstractly conceived syntactical constructions, and numerous other subtexts. Apart from the relative homogeneity of an individual cityscape, however, whether Paris, Berlin, Amsterdam, or Odessa, these films also disregard spatial continuities, relying instead on defining abstract concepts and formal design as their principles of montage. Yet it is still open to debate whether such self-reflexive strategies totally eliminate subconscious levels of reception. It seems probable that visual pleasure is still provided through the cinematic apparatus and that the spectating subject still participates in some level of discourse even if the mechanics and quality of subject positioning are different from classical modes of address.

Another difference separating *Manhatta* from films such as *Berlin Symphony* and *Man with a Movie Camera* is the former's lack of interest in human subjects. Considering the humanist impulse inherent in Strand's "Photography and the New God," it seems ironic that *Manhatta* excluded almost totally images of city dwellers in its portrait of the environment. *Berlin Symphony* and *Man with a Movie Camera* devote much screen time to the documentation of social relations in the city, whether on production lines, in the factories, in the shopping districts where consumer services are produced, or in institutions for leisure-time activity, whereas *Manhatta*'s view remains distanced, perching the spectator high up on skyscrapers, away from any day-to-day activity. The later European city films present a discourse about the possibilities of human interaction and communication in public spheres including cinemas, cafés, and sporting events, presenting leisure-time activity as an antidote to the alienation of modern industrialization and urbanization; *Manhatta* presents human beings as antlike creatures crawling along the Broadway sidewalks. It may be that this possibly unconscious visual dehumanization of humankind was the result of the filmmakers' cosmic worldview, in which the larger issues of technology and nature leave little room for microcosms.

Such spatial and emotional distance may also be a function of the collaboration between Charles Sheeler and Paul Strand. Sheeler's later photography and painting, in fact, continue in the direction *Manhatta* first set forth. Strand, on the other hand, largely forsakes his city themes after the

completion of *Manhatta*, turning increasingly to photographing and filming agrarian communities and the natural environment. His later photography concerns itself with pre-industrial, nature-connected forms of civilization, where signs of industrialization, commercialization, and modernity are marginalized.[32] His books on Egypt and Ghana include only a few images of technology, and it is excluded completely from other books. Strand's optimism regarding an idealist synthesis of nature and technology is evident only in these few images. Like Walt Whitman, then, Strand's romanticism is of a particularly American variety, visionary and utopian, yet simultaneously naive, trapped in the norms of bourgeois idealism.

A highly ambiguous, even contradictory work, *Manhatta* was nevertheless the first consciously produced avant-garde film made in America, and as one of the first avant-garde city films created anywhere, its historical importance seems assured. Because of its avant-garde origins, produced as it were outside of the economic and ideological structure of mainstream, classical Hollywood cinema, and because of its urban subject matter, the film has long been misread as an unequivocal work of modernism. The actual heterogeneous quality of the film may have been determined by its utopian aspirations, or perhaps it resulted from the collaboration between two assertive artists. Both Sheeler and Strand, concerned to explore a new medium, may have been unaware of the cinema's power to discover hidden agendas and desires regardless of their own conscious aesthetic intentions.

BELINDA RATHBONE

Portrait of a Marriage:
Paul Strand's Photographs of Rebecca

She knew he loved her, and she was afraid, she was in a strange ele-
ment, a new heaven round about her. She wished he were passionate,
because in passion she was at home. But this was so still and frail, as
space is more frightening than force.
 —D. H. Lawrence, *Women in Love*

In the long and distinguished career of Paul Strand there is nothing
comparable to the series of portraits he made of his first wife, Rebecca
Salsbury.* Although the series numbers well over one hundred nega-
tives made between 1920, the year they met, and 1932, the year before
their marriage ended, it remains on the whole a hidden and unexplored
aspect of Strand's career.

There are reasons why these portraits have been kept in relative obscur-
ity. Strand himself, having been very involved with the making of them on
and off for the twelve years he spent with Rebecca, eventually rejected
them from the final assessment of his life's work. Apparently he wished to
avoid the comparison likely to be drawn between these photographs and
the portraits Alfred Stieglitz made of Georgia O'Keeffe over approximately
the same period. Strand's portraits of Rebecca, more than any other body
of his work, clearly betray the powerful effect Stieglitz had on his art. Like
many close associates of Stieglitz before and after him, Strand sought in
the 1930s to free himself from Stieglitz's domineering artistic presence and
to diminish the impression of his direct influence. Because portraits are on
the whole emotionally intense, it is likely that Strand's reaction to them in

*Throughout this essay I will refer to Rebecca Salsbury Strand James by her first name.
Although the other three artists discussed here (Alfred Stieglitz, Paul Strand, and Georgia
O'Keeffe) often addressed each other and referred to each other by their last names (which
never changed), Rebecca was called by her first name, or by various nicknames or terms of
endearment derived from it, such as Beck, Becky, or Beckalissima.

later years was also complicated by his divorce from Rebecca and his sub-
sequent two marriages. Ultimately, Strand chose not to exhibit the images
together or even to discuss them.[1]

Upon closer examination of the photographs as a group it is possible to
understand Strand's misgivings. As a series the portrait is not altogether
successful—more accurately, the series is a sequence of trials—and as an
endeavor it adds a problematic dimension to the overall impression of
Strand's career. All the same it would be our great loss to dismiss these
photographs, as some have done, as lacking the sense of objectivity that
distinguishes his best work.[2] Their study is vital to our understanding of
Strand at a crucial moment in the development of his art. Furthermore, it
is their very lack of objectivity, so rare in Strand's vision, that makes a few
of these portraits of Rebecca extraordinary.

As Stieglitz did with O'Keeffe, Strand photographed Rebecca close up
and relatively free of props, used an 8×10 view camera and a 4×5
Graflex, and contact printed many of his best images in rich and somber
platinum and palladium metals. Adding significantly to the similarity of the
two series is the striking physical resemblance between Rebecca Salsbury
and Georgia O'Keeffe. Like O'Keeffe, Rebecca was handsome rather than
pretty. She was tall and big-boned, with heavy-lidded eyes, a long nose,
and a wide, thin-lipped mouth. She was full-breasted and had graceful,
long-fingered hands. And in an age that saw the flapper collide with the
last of the Edwardians, both women rejected affectations of fashion alto-
gether, favoring masculine, unadorned dress and starkly natural hairstyles.
In fact, the two women's physical similarity is difficult to accept as merely
coincidental.

The idea shared by the two series—a dialogue over an extended period
of time between photographer and subject that would illuminate the subject's
many "selves"—was entirely new. A general awareness of psychological com-
plexity had become current after World War I, furthered by the publication
of Freud's theories. At the same time, ideas about human sexuality and can-
did self-revelation were manifested in the daring novels of James Joyce
and D. H. Lawrence. Stieglitz was the first to articulate this wave of per-
sonal exploration in terms of the photographic serial portrait. During the
late 1910s, speaking to his close circle of friends and admirers, he asserted
that a portrait must evolve spontaneously with the individual in the flux of
life; photography's objectivity and ability to capture the fleeting moment
made it the most appropriate medium for the realization of this idea.[3]

Stieglitz's serial portrait of O'Keeffe, which began in 1917, was born of
his instinct as much as of his philosophy. The project naturally advanced
from the kind of personal portraiture he had practiced since the 1890s;
almost invariably Stieglitz photographed those relatives and friends he
knew and loved well and with whom he had a dialogue. Strand's instincts
as a man and as an artist were entirely different. The most important and

ambitious of his early portraits, which he made on the streets of New York in 1915, are anything but personal; these are pictures of strangers on the Lower East Side—the beggar, the blind woman, the sandwich-board carrier. True to his reticent character, Strand took pains to avoid a confrontation with his subject, primarily using a prism lens on his Ensign Reflex in order to work inconspicuously. While each man in his own way was seeking to break out of the conventions of studio portraiture, Strand's portraits of Rebecca are a dramatic departure from the direction he was then taking. They must be considered in light of his personal history and character, specifically his marriage and his close association with Alfred Stieglitz and Georgia O'Keeffe.

The friendship that developed between these two couples in the 1920s, and the creative influence that flowed in every direction among them, suggest a subtext to these works of art that can never be made entirely precise but that calls out for further investigation. In attempting to unravel the process of Strand's serial portrait of Rebecca, we are faced with the unreliability of his own retrospective dating of the images, as well as the fact that several examples, in both print and negative form, are altogether missing. The correspondence between Strand, Stieglitz, and Rebecca over these years, however, sheds some light on the portrait, and together with the clues offered by assigned dates, it is possible to piece together a sense of the photographs' chronology and technique, as well as the personal histories and spirit of endeavor that lie behind the project.

As an aspiring young photographer in the 1910s, Strand frequently visited Stieglitz's 291 gallery, eagerly absorbing the shock of the latest European avant-garde art. By 1915 he had won Stieglitz's praise for his experimental street views of New York, and the two men formed at that point what would become a mentor-disciple relationship of intense importance to both. Strand's success at integrating the lessons of abstract painting with photography's ability to arrest the motion of the city street was immediately inspiring to Stieglitz, who described this work as "brutally direct. Devoid of all flim-flam; devoid of trickery and of any 'ism'."[4] Stieglitz's own photographic activity had slackened in the years immediately preceding as he became increasingly involved with the promotion of modern artists from Europe. His desire to photograph was reignited by Strand's example in the 1910s.

Strand was also very much a presence at the beginning of Stieglitz's relationship with O'Keeffe and even helped to shepherd it through its early stages as the lovers' intermediary. Before O'Keeffe's crucial move to New York City in May 1918, Stieglitz sent Strand to join her in San Antonio, Texas, in May of that year, where O'Keeffe was convalescing from a serious bout of influenza. Gently prodding her northward, Strand kept Stieglitz in touch with news about her physical recovery and shifting moods. "It is very clear that you mean more to her than anyone else,"[5] he wrote. It is also clear from their correspondence that Strand himself was in love with

O'Keeffe, and accepting his role of go-between was an admission of defeat.[6] In June, O'Keeffe arrived in New York. Having arranged for her to be put up at his niece's studio, Stieglitz almost immediately left his wife of fifteen years and moved in with her. That summer O'Keeffe visited Stieglitz at his family's estate at Lake George, where Strand was also an occasional guest. In September 1918, Strand was inducted into the army for one year of service.

While Stieglitz embraced his new life with O'Keeffe during the following year, obsessively photographing his lover as he encouraged her own art to flourish, Strand was making the most of the uncreative environment at Fort Snelling, Minnesota, where he was assigned to X-ray photography. By the time Strand returned home in August 1919, the structure of his personal life was considerably altered. His mother had died, leaving him with his father and maiden aunt in the family house at 314 West Eighty-third Street. Stieglitz and O'Keeffe, by now firmly established as a couple, were staying at Lake George late into the fall. Strand's mentor had not deserted him, but he now offered Strand a smaller share of his time and attention. In his solitude, Strand began a group of still lifes: "ransacked the kitchen for bowls, eggs, platters, and god knows what—a real adventure,"[7] he wrote to Stieglitz in October of that year. As early as 1915 Strand had employed kitchen objects in his attempts at photographic abstraction, and by 1919 his adventure in the kitchen was an old idea. It would not be long, however, before Strand found a more challenging subject, and one that would provide the new link he needed, both personally and artistically, to Stieglitz.

It was probably sometime in the spring of 1920 that Paul Strand met Rebecca Salsbury. It is possible that Strand and Rebecca met through their mutual connection with the Ethical Culture School, which both had attended, Strand graduating in 1909 and Rebecca in 1911. Rebecca, known as "Beck," was the daughter of Nate Salsbury, Buffalo Bill's business partner and stage manager. As a person, Rebecca struck some as tough and snappy, perhaps a manner she adopted at a young age around the rough-riders and sharpshooters of the Wild West Show. At the same time, her health was delicate and she was given to frequent nervous depressions.[8] The impression that emerges from her correspondence is of an emotionally complicated woman as well as a lively, humorous, and devoted friend. In 1920 Rebecca was about twenty-nine years old, unemployed, and casting about for a creative outlet. As she was writing her first letters to him in May of that year from various posts on a tour of the West, Strand resided at West Eighty-third Street at work that summer on the experimental film *Manhatta* with the artist Charles Sheeler.[9] Rebecca brooded over her want of a fulfilling career, writing to Strand, "I am singing crazily along perhaps missing the important things. . . . I wonder if I have anything to say."[10] By then it is also clear that Rebecca was in love with Strand, as she

expressed her excitement in this way: "a faint singing warmth and the chill of something so true that I am alternately frightened and at rest."[11]

Just as Strand's portraits of Rebecca are revealing of her character, so her own insight and verbal candor provide a window on the inner life of Paul Strand in 1920. She was quick to feel his idolization of Stieglitz. "Aren't you absorbing too much of Stieglitz?" she wrote to him on June 8. "Don't envy him. No man's life parallels another exactly, and you have enough personality."[12] Her objectivity on this issue may be due to the fact that Rebecca was not to become acquainted with Stieglitz until her relationship with Strand was well under way.[13]

Strand began to photograph Rebecca in 1920, the year they met, and she was his enthusiastic collaborator, easily grasping the notion of the spiritual and psychological potential of the intimate serial portrait. "Some day," she wrote to Strand on September 23, 1920, "will you give me one of each of the prints you made of me . . . ? I truly feel that they will be a source of health, strength, and beauty other times."[14] Based on the character of her own self-expression in letters, and knowing her to be a passionate reader of D. H. Lawrence, we can imagine Rebecca's nearly mystical belief in the portraits. Like Strand but in her own way, she regarded photography as purveyor of truth and her own portraits as an act of communion with forces greater than herself. "Perhaps I will learn some new secrets from them," Rebecca wrote to Strand in May 1920.[15] Thus we surmise that the portraits were for both of them an important ritual in their courtship, an expression as well as a test of their intimacy.

An early example from the series, dated October 1920, results from one of their frequent photographic outings in this first year of their relationship. On November 16 Strand wrote to Stieglitz, "I have been photographing outdoors almost every Sunday — we went the other day. . . . I have two things which seem pretty complete . . . it has given us a fine companionship in the open air and a chance to work together — I want to carry on somehow."[16] Strand's modest and dispassionate report is unequal to the emotional gravity evident in this early portrait (see figure 21). Rebecca, with her bare neck and remote gaze, darkly framed by the tree behind her, appears to be cultivating a union of the sensual and spiritual that would have befitted the heroine she hoped to be.

In both style and mood this portrait is unquestionably influenced by the example of O'Keeffe as she was then photographed by Stieglitz. The less successful portraits Strand made of Rebecca around this time (many of which exist only as negatives) reveal all too clearly an effort, presumably two-sided, to affect the kind of dancelike gestures O'Keeffe made with her hands and arms in several of Stieglitz's portraits of her. But unlike O'Keeffe's gestures, which appear to have been captured spontaneously in the midst of a deep meditation, Rebecca's gestures seem acted and frozen. In the course of the following year the project was a source of tension and

21. *Rebecca at Dr. Stieglitz's,*
Mamaroneck, New York, October, 1920

disagreement, at times expressing the differing temperaments of Rebecca
and Strand as much as their growing attachment. Although Rebecca consi-
dered her own creative endeavors secondary to Strand's art, and her role
as his chosen muse and mate foremost, the making of these pictures often
brought out her strength of character and emotional complexity. She wrote
to Strand in September 1921, "You seemed to want to identify me with a
tree and I wasn't feeling that [in] the last portrait you made. . . . I felt just
the way I stood—and any other position would have been impossible for
me—but it was equally impossible for you."[17] It is clear that Rebecca's own
sense of self and critical response to the portraits presented Strand with a
problem of control that went far beyond his "adventure" in the kitchen
with bowls, eggs, and platters.

Strand's uncertain progress was not only due to a clash of wills. Both
Stieglitz and Strand, now working in tandem on their projects, confronted
the technical problems of contrast and movement caused by lengthy expo-
sures (usually two to four minutes during which the subject had to remain

22. *Rebecca Salsbury*, New York, 1921

rigorously still) on slow-speed portrait films.[18] The challenge of making a
portrait that appeared naturally to catch a passing moment was augmented
by both photographers' dedication to the palpable detail offered only by
large-format photography. These problems were naturally compounded
when the project moved indoors. In one example dated 1921, we can see
that Rebecca's head rests for support against a wall (see figure 22). In this
stark three-quarter view of her broadly sculpted face, she appears primitive
and powerful, like the monumental female heads of Picasso. In another
attempt, Strand experimented with Rebecca's upturned profile; the image
resembles some of Stieglitz's portraits of O'Keeffe made at about the same
time, in which the bone structure of her head and neck suggests the
power and impatience of a racehorse.

In January 1922, Rebecca Salsbury and Paul Strand were married. To
save money they moved into an upstairs suite of Strand's father's house on
West Eighty-third Street, a stark white interior that they furnished sparsely,
leaving plenty of space for the contemplation of recently printed photo-
graphs as well as for their growing art collection.

Stieglitz and O'Keeffe were not to be married until 1924, the year that Stieglitz was finally granted a divorce from his first wife. But with the Strands' marriage in 1922 the two couples became more than ever a tightly integrated foursome, with admiration, competitiveness, in-jokes, and alliances passing in every possible direction between them. Not only were the two photographers devoted friends and collaborators, but also Georgia and Rebecca shared many interests, including their love of the West, and Paul remained one of Georgia's closest friends and confidants. Meanwhile, Alfred and Rebecca, both more gregarious than their partners, were quick to form a personal rapport.

As Stieglitz continued to pursue his portrait of Georgia, he never resisted the opportunity to test his powers on a new sitter, particularly if she were female, and Rebecca was no exception. Inevitably, this heightened the sense of competition between Stieglitz and Strand and intensified their discussion of technical problems, especially the problem of movement during long exposures. Rebecca was delighted with the success of her first portrait by Stieglitz, an image of her hands holding a shiny black ball. "Good old Stieglitz—" Rebecca wrote to him in July 1922, "to get me moveless the first shot out of your Eastman box. I have gurgled and crowed over poor Paul until I am sure he wishes neither of us had ever been born. . . . Better shoot along a proof to show him how superior we are as a working team."[19] The conspiratorial tone of their exchange and its sexual innuendo went still further when Stieglitz suggested to Strand that his portraits of Rebecca would benefit from the help of the "Iron Virgin," a head-clamp steadying device used by portrait photographers since the nineteenth century.[20] Stieglitz sent one down to Strand from Lake George that month, to Rebecca's dismay—"The Iron Virgin has come[;] it seems to gorge [sic] holes under my ears"[21]—and to Stieglitz's own amusement: "Wait until Paul puts you into the Iron Virgin and says, 'Now won't you be good . . . and don't look so darned hurt—smile—be natural.'"[22]

Stieglitz's proprietary role in the Strands' marriage was furthered in September of 1922 when Rebecca, taking leave of her secretarial work in a neurologist's office, went to Lake George for a month's vacation. Although she wrote to Paul almost every day from Lake George, it is clear that she was in her element living with Stieglitz, O'Keeffe, and various members of the Stieglitz clan, swimming, walking, collecting wild berries, and painting. That summer Stieglitz made several portraits of her using his 8×10 camera, some in which she appears introspective and others in which she plays the clown.

Stieglitz also began to take his brand new 4×5 Graflex down to the lake to photograph whatever female relation or guest was interested in a swim, whether suited or, as they put it, "in the altogether." Rebecca was persuaded to shed her suit soon after her arrival. On September 14 she wrote to Paul, "G., S., and I went to the Lake and as it was very balmy

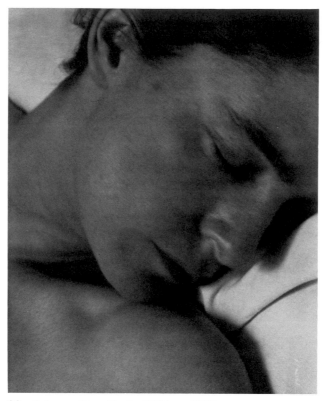

23. *Rebecca*, New York, 1922 or 1923

and warm we went in with nothing on."[23] By the end of September, Stieg-
litz had photographed Rebecca nude in the lake many times. He would
eventually consider at least two of these photographs, probably made that
summer, among the finest of his entire career. These are truncated, hori-
zontal nudes in which the movement of the water, the warmth of the sun,
and the softness of her skin are exquisitely united. "Beckalina," he wrote
to her in 1924, "I have just been going through some of the little prints
made of you in the water summer before last. Some are really very beauti-
ful. Even more so than I had remembered—I am glad that they exist."[24]
From the photographs and the letters she wrote about them, it is obvious
that Rebecca enjoyed the sense of self-expression that Stieglitz so easily
elicited from her.

Somewhat earlier that summer Strand had spoken to Stieglitz of his
struggle to "break through" to a new phase in his photography. "I feel this
period is transitional,"[25] he wrote to Stieglitz. Strand's frustration with the
evidence of movement in his long exposures, and Rebecca's equal discom-
fort with the "Iron Virgin" that was supposed to solve the problem, led in

November 1922 to a new solution. "Paul made some portraits yesterday when I was in bed and resting solidly against pillows,"[26] Rebecca wrote to Stieglitz on November 6. In these photographs her shoulders were bare, suggesting total nudity, and her head indicates a reclining position. The close cropping of her face eliminates depth and contributes to the abstraction of the image. But while these photographs are aggressively formal, they are also frankly intimate. In one that shows Rebecca gazing openly at the photographer, all of the struggles of their three years together seem to have balanced, at least for the moment, into an expression that hovers equally between vulnerability and confidence (see figure 23). Rebecca's feeling for Strand as she expressed it in 1920, "the chill of something so true that I am alternately frightened and at rest," finally seems to have released itself to his camera.

Seen together, a number of these very tightly framed portraits suggest the creative momentum of one or two highly charged photographic sessions. As a group they evoke a sense of continuous movement that reminds us of Strand's knowledge of film.[27] In all of them there is a slight blurring, adding to the sensation of turning and loss of equilibrium that are highly erotic. Because the photographer's 8×10 camera moved around his subject from various angles, the photographs have no certain ground and can be turned in more ways than one and still be read correctly (see figure 24). This loss of ground is reminiscent of Strand's earliest attempts at abstraction, particularly *Porch Shadows* of 1916, in which a round table is turned on its side to catch the shadow of the porch railing. Further to assert its formalism Strand turned the image itself on its side. His application of this dislocating device to portraiture, however, was more advanced. Compared with his early abstract exercises, these portraits of Rebecca seem effortlessly arranged; most important, they succeed in coalescing completely his art and his intimate life.

With these photographs Strand seems to have arrived at his "break through." No doubt the feelings between the photographer and his subject at the moment the pictures were made are largely accountable for their power. But is is also likely that their success results from each participant's developing relationship with Stieglitz: Rebecca had gained greater confidence as a model and Paul had felt continuous pressure to surpass Stieglitz's intimacy with Rebecca and to express himself more openly.

In the Strands' correspondence with Stieglitz at Lake George during the summer of 1923, there is no mention of further portraits being made. Increasingly Rebecca confided to Stieglitz the difficulties of her marriage, and his sympathy and support were constant. In August, when Strand joined Steiglitz at Lake George by himself, Stieglitz reported to Rebecca, "Paul misses you but he's really looking very well. . . . [Georgia] told him that she appreciates you more and more daily, seeing what you have made of him. He wonders what she's talking about and looks most quizzingly

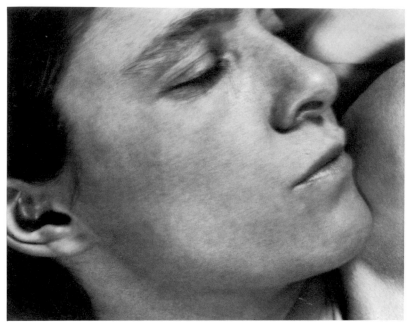

24. *Rebecca Strand*, New York, 1922

and does not know whether he should be pleased or not. Well, both G. and I agree he's an unusually fine fellow."[28]

In the mid-1920s the Strands began to seek alternatives to the Stieglitz camp, spending several summer vacations in Georgetown, Maine, in the company of their friends Gaston and Isabel Lachaise. The scarcity of portraits of Rebecca at this time is perhaps partly due to Strand's new interest in making highly detailed close-ups of nature in the Maine woods. Rebecca's intermittent depressions may also account for a nearly complete break in the series.

In the summer of 1926 the Strands made a trip west, Strand in search of new subject matter, and Rebecca no doubt hoping to find consolation in her western connections. Their first stop was Estes Park, Colorado, home of the first Buffalo Bill Museum. "Beck is not fit yet," wrote Strand to Stieglitz from Estes Park, "but some of the dragged and exhausted feeling is going."[29] Strand made a few pictures of Rebecca there. "Paul made the tree prints when I was so ill in Estes Park," Rebecca wrote to Stieglitz the following spring. "I was frantic and he was trying to bring me to the point where I could decide for myself what to do. . . . He was really very wonderful — very true to himself and to me and that I feel is in these things — strength, and a force that despite everything else, *would be*."[30] Rebecca's long brown hair was already rapidly turning gray, and the line between her eyebrows was deepening. No longer that of a romantically engaged

young woman, Rebecca's averted face in this portrait suggests a maturing sense of loneliness within her marriage. In Colorado, Strand also made photographs of trees blasted by lightning. His greater physical distance from his subject in these photographs represents a departure from the intricately woven close-ups of nature he began in Maine the summer before and anticipates the stark realism of his later work.

From Colorado the Strands traveled on to New Mexico. There Mabel Dodge Luhan, the former doyenne of Greenwich Village radicals who now presided over the Taos art scene, immediately welcomed them and offered them one of her adobe cottages to stay in. Although Luhan proved to be a domineering and meddlesome hostess, the Strands fell in love with New Mexico, and by the time they arrived home in New York in September the trip west was considered a great success.

For reasons still obscure, Rebecca and Paul reached a decision in the summer of 1927 not to have a child. "So you have finally come to a definite decision about a child. I know the inner struggle you have had,"[31] Stieglitz wrote to Rebecca that summer. Rebecca's confrontation with the fact that she would never have a family must have galvanized her that year into a reassessment of the purpose of her own life. Her hopes of reaching a more perfect sense of communion with Strand were by this time modified, and her need to define herself apart from him more urgent. In July 1928, in Maine again with Strand, she wrote to Stieglitz of her efforts to teach herself to draw in pastel. "Life is horribly short and if there is to be no 'home,' no child, I want something that is truly mine—."[32]

In 1928 Stieglitz suffered his first heart attack. O'Keeffe had been feeling increasingly hemmed in by his family scene at Lake George and now, with his failing health, she was even more restless for privacy and new landscapes to paint from. In April 1929 at the urging of Mabel Luhan Georgia O'Keeffe and Rebecca Strand boarded the train to Santa Fe, leaving their husbands behind them for what would be a four-month stay. Predictably, the two women were welcomed to "Mabeltown." "It could not be more perfect," Rebecca wrote to Steiglitz from Taos, as his faithful correspondent. "I wish every day you could see your Georgia! Red cheeks, round face and ready for anything."[33] O'Keeffe's delight in her retrieved freedom that year and her discovery of the New Mexican landscape marked the beginning of what would become an increasingly part-time marriage to Stieglitz. Before long Stieglitz learned not only that she had learned to drive a car but had acquired her own Model T Ford. The car became a symbol of their estrangement; faithful to his pursuit of her photographic portrait, nonetheless, he made several photographs of O'Keeffe gazing defiantly out of the Ford's window or caressing its metal parts.

Unlike Stieglitz, who felt increasingly homebound as he moved into his sixties, Strand shared the two women's love of New Mexico. For the next

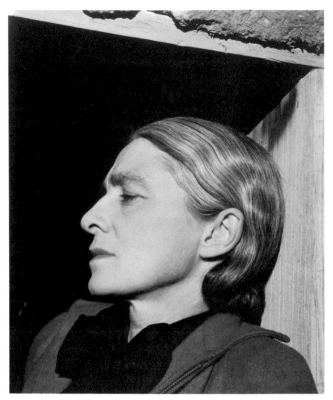

25. *Rebecca*, Taos, New Mexico, 1932

three years the Strands spent their summers in Taos. Prompted into re-
newed photographic activity, Strand made many landscapes as well as por-
traits, work which helped to formulate a theme that would dominate the
rest of his career—the land and its people.

In New Mexico, Strand took up his photographs of Rebecca once again,
perhaps knowing they would be among his last. These late portraits have
an emotional distance that is striking in comparison to those of the first
three years of the Strands' relationship. This seemingly abrupt change of
tone is partly attributable to Strand's gradually shifting photographic style.
But their air of detachment and objectivity must also be appreciated in
light of the continuing motive of the serial portrait, in which the relation-
ship of artist to model is understood to be in a constant state of change.
One of the portraits, in which Rebecca's maturing profile and pained
countenance is unsparingly delineated in a brightly sunlit doorway, can
hardly be considered apart from the reality of their then-failing marriage
(see figure 25). The total absence of confrontation between them in another
photograph, of Rebecca's darkly cloaked back facing a cloudy sky, is, if not

intentionally literal, significantly coincidental with the waning of their intimacy.

Even in the midst of their growing separation then, Rebecca remained the faithful servant of Strand's art. In May 1928, she had assessed her life with him in this way to Stieglitz: "the affirmation of what I believed [Paul] to be the first time I saw his photographs—what I still believe him to be—that has been my greatest happiness—that—and sharing you and Georgia—as friends."[34]

Stieglitz's serial portrait of O'Keeffe numbered almost three times as many exposures as Strand's of Rebecca and was carried out over a slightly longer period at both ends. But this is not the only reason for its greater success. The respective personalities and aspirations of the photographers and their models surely have more to do with the case. O'Keeffe was a more self-assured and independent woman than Rebecca, and her desire for equal power and admiration in her relationship with Stieglitz accounts for her brilliantly controlled performance before his camera. O'Keeffe could be an expressive dancer, a clown, a wild animal, a witch, a psychic, or a siren; the variety of her personae contributes to the continuity and purpose of the portrait as a whole. If Rebecca was unable to compete with O'Keeffe's repertoire, in her own way, she was able to show more of her "selves." She was not inclined to disguise her emotions before the camera, and it is this absence of guile that gives her portraits their singular intensity.

At the same time it is clear that the portrait is to a large extent a mirror of its maker. O'Keeffe wrote about Steiglitz's photographs of her many years later that "he was always photographing himself."[35] Stieglitz's portrait of her represents a re-igniting of his passions in the relative security of middle age, and his confidence was matched by his model. Strand was still engaged in the youthful struggle to define the meaning of his life and his art. As much as he adopted Stieglitz's notion that photography should be an emotional response to experience, he never romanticized his portrayal of Rebecca. As Stieglitz had said of Strand's early street photographs, Strand's portrait was "brutally direct." A full generation younger than his mentor, Strand was essentially a realist.

With the start of the new decade Strand's interests began to shift away from the kind of pure self-expression that Stieglitz espoused. As Stieglitz furthered his obsession with photographing clouds, which began in the 1920s, "to show that my photographs are not due to subject matter,"[36] Strand began to work toward a more narrative imagery with a broader social context. Just as his marriage to Rebecca Salsbury had been influenced by his friendship with Stieglitz, neither the marriage nor the friendship survived his change of direction in the early 1930s. Strand's subsequent portraits portray, without exception, stalwart characters: if elderly, they seem to have weathered life with fortitude; if youthful, they

look forward with unerring determination. Never again would Strand use his art to explore the facets of an intimate relationship.

Stieglitz and Rebecca, in dealing with the rearrangement of their friendship, were reluctant to admit to the end of an era for all of them. "Isn't there something we can do to go back to the warmth and understanding of the 'old days'?"[37] Rebecca wrote to Stieglitz in 1933, the year her marriage ended. Stieglitz replied, "I feel someday everything will clear up naturally—I am conscious of your more than kindness to me at a very critical time in my life and I don't forget the many years of Paul's loyalty, not only to me personally but to something beyond all of us—to the Idea—and the Idea is as alive as ever. That I know. Ever your old A.S."[38]

Rebecca Salsbury Strand married William James, a banker and a rancher, in 1939, and lived most of the rest of her life in New Mexico. She and Strand remained on friendly terms. She continued to paint, developing her own curious technique of oil on glass. After her husband died, and following a long struggle with rheumatoid arthritis, in 1968 she committed suicide.

STEVE YATES

The Transition Years:
New Mexico

The mature photography of Paul Strand flourished during a prolific period in northern New Mexico. Strand first traveled with his wife Rebecca to Estes Park and Mesa Verde in Colorado and then to Santa Fe and Taos in August and September of 1926. He returned, encouraged by John Marin and Georgia O'Keeffe, artist friends working in the area, and photographed during progressively longer periods in 1930, 1931, and 1932. Most of Strand's work centered around the landscape and architecture north of Santa Fe and near Taos. At a time of personal struggle, need for change, and the search for a new direction, the New Mexico visits constituted Strand's most substantial period of photography since his early formative years and his association with Alfred Stieglitz in New York City.[1]

Strand's photography in New Mexico fulfilled past aspirations, such as the lessons of abstraction, while helping to lay the groundwork for the increasingly humanist desires that remained latent in his work. Land, sky, and indigenous architectural forms offered new challenges and working in isolation provided time to explore without interruption. The New Mexico period was a crucial opportunity for self-evaluation and independent artistic development. After leaving New Mexico late in 1932 for Mexico, Strand would return to filmmaking; the trip coincided with the end of his first marriage as well as of his close relationship with Stieglitz.

Described as a place where "the impact of time" is clearly visible and where "history is more complicated than most,"[2] New Mexico offered seemingly endless multiformity, as geologically varied as it was culturally rich. Paul Strand chose to work mainly in the northern mountainous country where, in rural villages dating back to the seventeenth century, lifeways contrasted sharply with urban industrial society.[3] For Strand, the vernacular landscape and architecture and the potential collective portrait to be found there provided ideal subjects.

Beck Strand had stayed with Georgia O'Keeffe in Taos during one of

the painter's longest stays in 1929, undertaken because O'Keeffe had also exhausted a facet of her work and desired change. Both established a friendship with Mabel Dodge Luhan, patron and socialite of the Taos arts colony, who provided lodging and studio space for artists, writers, and musicians. The Strands would benefit from this relationship during the photographer's working trips beginning in 1930, staying in one of her cottages on return trips over the next two years.[4] Strand traveled by car to explore the landscape, setting up temporary darkrooms in the cottage and other locales.

Strand's correspondence with Alfred Stieglitz increased as his travel continued, discussing experimentation with photographic materials, especially problems in palladium and platinum printing and technical advances in equipment and chemistry. From New Mexico, Strand wrote Stieglitz:

> It is a strange and miraculous country, every day brilliant sun and this black violence usually somewhere on the horizon—appearing as though by magic—disappearing as quickly—The days slip by within this magical repetition. . . . So much so that if one had not made a few photographs . . . they might well be a kind of dreamlike mirage. . . . As for myself I feel that I have gotten more into the spirit of the country and so the photogaphs are simpler—more direct. . . . [5]

However, in 1932, a partial separation between the two photographers finally occurred after the joint exhibition of both Strands' artworks—photographs and glass paintings mainly of New Mexico—at "the Place" in 1932. Strand handed back his personal keys to Stieglitz's darkroom and gallery where he had spent much time in his artistic development.[6] The break would remain a sorrowful concern throughout Strand's career. Despite their falling out after years of growing tensions, however, they would continue to correspond when Strand left New Mexico to work in Mexico in 1933, where the lessons gained from work in Stieglitz's galleries were directly utilized in installing an exhibition of his New Mexico photographs.[7]

The direction of Stand's development during this period was influenced by his friendship with Harold Clurman, the founder and one of the first directors of the innovative Group Theatre in New York. He and the individuals of the newly established theater found a natural kinship with Strand that recalled the comradery among the 291 group of artists around Stieglitz, although the group never achieved the sense of mission shared by those artists earlier.[8] Introduced to Stieglitz by Strand, Clurman learned about photography from both artists and first discussed their work in the October 1929 issue of *Creative Art*. Emphasizing Strand's "particular form of sensibility" over technical preoccupations, he wrote: "The artist, by a sort of sensuous sympathy with the body of his material, has somehow become one with it."[9] Excerpts from the essay, devoted mainly to Strand's photographs of nature made in Maine, were later used for the catalog of the Mexico exhibition.

Clurman and Strand corresponded extensively during Strand's New Mexico period; and Clurman stayed continually in contact with Stieglitz and the events of his American Place Gallery, acting as Strand's New York eyes and ears. The photographer would rely on his critical insights during this period of transition. Strand's letters to Clurman frequently sought to delineate his own photography in terms distinct from the interests Stieglitz had established, emphasizing the importance of the New Mexico trials and experiments. Clurman's ongoing study of both artists' aesthetics, personal ideals, and approaches to the medium provides a unique testimony to their increasing differences.

Clurman, a conscientious theorist, sought to articulate the role of art in modern, socially-aware terms. His notion of group theatre included "a conception . . . in which social-cultural factors are organically related to theatre aesthetics and in which all the theatre's elements, acting drama, scene, etc., are considered parts of a whole.[10] Offering an appraisal which thoughtfully distinguished Stieglitz's newest images of New York from Strand's, Clurman wrote to Strand:

> I don't think the Whistlerian formula you quote applies to these photos. They are not sentimental, Paul. They are New York seen by Stieglitz, which doesn't mean distortion or falsification but an interpretation so complete that the result like a perfect marriage is altogether justified. . . . The difference between what you see in New York . . . and what Stieglitz has put down is the difference between Stieglitz and you. Your reaction is sharper, harder, less tolerant, a little aggravated, resentful and cold (in the sense that you will not have any "traffic" with these buildings!) whereas Stieglitz is always intimate with everything, always connected as with a woman. He cannot see anything as an *object* outside, separated, cut off from himself. (You can and do: which is one of the essential differences in your photographs). . . . In Stieglitz there is no revolt, no social attitude: always a spontaneous acceptance—unquestioning—for what is there. In you (your photographs) the object is seen as having a distinct but *separate* life of its own—and a very powerful immovable life, untouched and untouchable by man.[11]

By the late twenties, Strand's formally objective approach and style were thoroughly tested. What had motivated earlier decisions in creating photographs now would also be informed by an awareness of life, culture, and history. If 291 was Stieglitz's "gallery of aesthetic experimentation," New Mexico became the laboratory for Strand to test the potential of his own vision.[12] The increasing diversity of his work during this brief period is particularly compelling because it shows a strong sense of examining another course, with a renewed artistic freedom reminiscent of the early experimental years, except that now the photographer moved from the mastery of experience.

In a letter Strand wrote to the editor of the publication *Modern American Photographers* in 1931, his change in position and rejection of a Stieglitz-like approach appears consummate.

> Artists tend either to think out loud about their problems . . . or . . . frequently erect some romantic "philosophy" — some elaborate and misleading rationalization. Possibly one reason for this is that the creative process involves a balance between conscious and intuitive elements, and a critical analysis of the artist's own spirit of himself, upsets the balance.

Yet, he continued,

> . . . it seems to me to be the business of the critic, not the artist, to get through the latter's work directly . . . [to] the artist's essential attitude not towards his medium but towards his world — life itself. When I look at a painting, a photograph, hear music, read a book, that is all that interests me — what living meant or means to the person who made this thing — not so much how, but why, they made it; whether the thing made is a product of their own vision, their own particular truth. If so, then what are the essential qualities of the vision, and to what extent have they become embodied.

> Photography, so far as I am concerned, is a medium which for some reason I love to work with, which is part of my bones. In common with other media, no doubt it has its potentialities and its limitations. About its limitations in any absolute sense, I know nothing. . . . Camera materials, paint, clay, words, all are what they are — material — until they fall into the hands of someone who having lived deeply and beautifully, utilizes them as a craftsman, to put that living into form as vision, as song, as some kind of clear saying.[13]

For Paul Strand, the progressive, life-oriented commitment articulated here promised an independent future; he had reevaluated his past and relinquished parts of it, so that former doctrine now was perceived as limitations to be renegotiated in new work. He now pursued not only the dichotomy of abstraction and uncompromising, literal realism, but also the balance of formal preoccupations and humanist aspirations couched in more worldly terms that were undeniably his own.

In *Mesa Verde*, a key picture made during his first trip to the Southwest, the spirit of exploration is clear (see figure 26). The photograph sustains the power of abstraction found in his earliest experimental works at Twin Lakes, Connecticut, in 1915 — but with some differences. Here, the mystery of subject and form, and the extraordinary resolution of their balance, provide an unconventional hybrid that functions on various levels. The nature of the primitive shapes represented carries a sense of human fundamentals, even a semblance of structure almost ceremonial. This 8 × 10

26. *Mesa Verde*, Colorado, 1926

inch platinum photograph holds on its surface a faint sense of color not unlike that of the earth that it portrays. Instead of strong reflected light, these walls glow with a quality that emanates from within. Darkness in the surrounding foundation seems to dematerialize the walls' infrastructure, where rectilinear doorways and windows appear suspended.

The weathered earthen wall created by prehistoric culture reveals the mystery of time in its markedly simple form. The repeated zigzag shapes suggest a negative-positive interaction. The small, jagged relief placed carefully within the top left corner repeats other fragmented edges from the open airways, animating the large wall sections. But more important, the small element balances its larger counterparts, vivifying their separate roles.

A pivotal element, also generally repeated in patterns throughout the photograph, remains off center to the right. Isolated in its freedom from ornament or subordinate functions, the smallest square window acts as the fulcrum that seems to embody, more than any other detail, the secret essence of the subject. As viewers, we are looking inward. As a window through a thick stone wall, this square does not allow our eye penetration, so that the once-lived life of this corner in an undesignated room remains the domain of archaeological study.

The small, square window shows as a non-permeating black — the darkest form — which remains as substantial as any rock-laden part of the picture. This window is rendered functionless, yet sustaining. Perhaps more than the vertically fragmented doorways, it is quietly disarming. The door-

ways, placed at angles to each other, seem to counteract reality, because the artist insists on their abstract properties. The window square—without the dimension of perspective—leads a life of its own, emancipated in the imagination. The photographer's equal mastery of reality and abstraction presents us with, at once, the mystery of cultural endurance and the beauty of architectural virtuosity.

Interestingly, *Mesa Verde* exists in two signed, vintage prints, of which one, shown here, is "upside down"—that is, it represents what the photographer saw on the ground glass of the camera—and the other shows the "true" position of its content. Whatever its ultimate intent, the reversal suggests Strand's inventive mood during this fruitful period.

Store Window (Mehle) uses the lessons of cubist collage to create numerous levels of reality (see figure 27).[14] The sundry materials behind the large windowpanes juxtapose fallen remnants including a section of the store name and other bits of remaining yet anonymous history. These are combined with shadows in a lyrical play of light and form—opaque and transparent, reflected and direct, linear and geometric. The screen door swings wide open. The sheer unarranged beauty of the contents in this window, and the spirit of their existence, stand in contradistinction to the building's past. Fragmented shapes create a rich complexity of flat, almost non-dimensional forms, and frames within frames multiply throughout this photograph, demanding that extraordinary attention be given to all edges. Windows within windows refer indirectly to the ground glass of the view camera, and the triangular blocks of black surrounding the drapery lend a theatrical air.

Ironically playful and sad, the photograph seems to speak of the photographer's personal situation at a time when his former experiences were increasingly a burden and he awaited the clarity that would help him step anew into the future. Filled with inventive nuances, this collage of found objects remains an unparalleled transitional work, connecting past with present by implying the reuse of some aspects of personal history with the pride of self-initiated ingenuity.

How much such rendering reflected personal changes cannot, of course, be justly determined. Central to Strand's efforts, however, was the question how to draw on the past with the new freedoms of the present, how to apply new ideas with the benefit of experience. Strand's American modernist way of seeing, and the discipline that sustained it, was sharpened and tested by new subjects and ideas during this time.

Critic and friend Elizabeth McCausland, introduced to Strand by their mutual friend Arthur Dove, visited and traveled with the photographer through the small villages of northern New Mexico in 1931, returning to write a privately printed homage. These photographs offered a "sense of oneness with Nature," she wrote, and Strand's vision was a "clear-eyed look at life" because of the honesty of the photographer's "perceptions and actions." The deserted mining town pictures conveyed life itself:

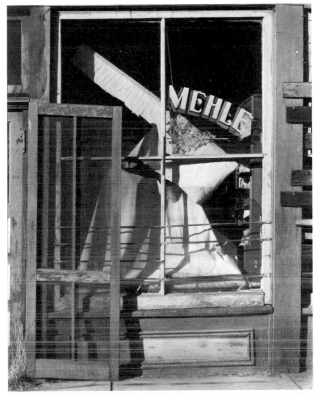

27. *Store Window (Mehle)*, Ghost Town, Colorado, 1932

. . . living gives what nothing else can, the wealth and richness of existence, the births, the deaths, the ravages of time, wooden doors into which years have poured their abundance, blind-eyed windows winking at eternity.

She saw in the work an affirmation of unity, wholeness, and universality:

One feels this as music, waves of intuition flooding the mind and easing the strain, a triple fugue of affirmation, many voices intertwining and fusing till they are one yet do not lose their identity. Ocean can do this to the soul, so can earth and sky, since they are but different aspects of unity. This is the strength of existence, to comprehend its oneness, though the faces it wears are various and baffling. This is the strength of man, to know his oneness, his aloneness, neither to accept or dissent, but to understand.[15]

The orchestrated simplicity of these photographs was balanced by the intricacies found in the subject — a quality that is even more evident in the open landscape work.

28. *New Mexico*, circa 1931–1933

During this period, the cross-influences of filmmaking and photography grow more visible though they would become even more pronounced in the work that followed in Mexico. Several aspects of Strand's work with the Akeley motion camera opened up significant possibilities for still photography.[16] His discovery of faster film materials, such as Dupont's Defender Extra Fast Panchromatic Film and clearer developing chemicals in resolution, offered Strand the right combination of materials to support his new work. Strand began working with new still cameras in various large formats; besides the 8 × 10 inch Korona, he used the more mobile 4 × 5 inch Graflex, and intermediary 5 × 7 inch view cameras. Returning to Gaspé in 1929, the photographer used the lighter Graflex camera for landscape work, as he would in New Mexico. Two years later, he purchased a 5 × 7 inch Graflex camera that combined aspects of the smaller Graflex and the 8 × 10 inch Korona camera, allowing fuller detail as well as mobility and speed outdoors. The new camera allowed quick decisions about natural circumstances such as the quality of light or changing cloud forms to become central to the working routine.

Strand prized both Graflex cameras for their relative portability and their finite capacity for detail; too much detail emphasized minute textures for themselves, which was secondary in seeing the overall patterns of natural correlations. The demands on the viewer are different in these landscapes than in earlier pictures. The smaller scale contact prints draw the

29. *Badlands,* near Santa Fe, New Mexico, 1930

eye closer and their organic structure holds complex ranges of distinct natural forms in balance. Distance becomes less tangible and measurable, so that the horizon line plays a more operative role. The poetic quality found within nature's equilibrium of forces, expressed in the photographer's organization of form, pattern, and line, helps convey the symphony of relationships.

The curving, horizontal cloud in *New Mexico* corresponds with the underlying hills and mountain range (see figure 28). The random, yet cohesive, light-and-dark cloud mosaic in *Badlands,* near Santa Fe counters the irregular geology in the land beneath (see figure 29). Intricate in their traces of opacity and semi-transparent shades of tonality, these photographs venerate moments of change, reflecting the photographer's continuing revelations while emphasizing the grace of reality presented without metaphorical allusion. Strand described the challenge that landscapes presented to him as a photographer:

> This fruitful period for me led . . . to the dramatic vastness of the Southwest — New Mexico. Here a new problem for me presented itself, that of trying to unify the complexity of broad landscape as opposed to the close-up of approachable and relatively small things. There are not only many photographs but also many paintings in which the sky and land have no relation to each other, and the pic-

30. *Dark Mountain*, New Mexico, 1931

ture goes to pieces. For the photographer, the solution to this prob-
lem lies in the quick seizure of those moments when formal relation-
ships do exist between the moving shapes of sky and the sea or
land. . . .[17]

Combinations of architecture with land and sky opened further pos-
sibilities. In *Dark Mountain* (see figure 30), balanced picture elements cor-
respond deliberately. A boarded adobe wall cuts the black triangular
silhouette of the mountain tip, which itself elevates a fleeting cloud. The
slender, pointed wooden pole divides a third of the picture vertically while
equalizing the other dominant horizontal lines. To its right, a small unlit
cloud stands as a negative form that creates further uniformity in the even
contrasts of natural and handmade architectural elements.
Each part helps autonomously to shape this incongruous subject. Door
and windows are further divided by temporary protecting walls standing in
relief against the adobe mud-and-straw dwelling. The position of the cam-
era unites disparate pieces and fragments. Experiments such as this were
essential to the photographer's individual search within the photographic
process for ideas; the photograph becomes an interchange, representing
the evidence of human endurance combined with the artist's prodigious
visual testimony.
The blacks in Paul Strand's prints, especially during this period, often

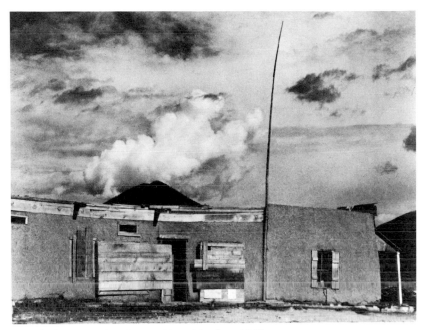

31. *Black Mountain*, Cerro, New Mexico, 1932

have qualities other than those reproductions are capable of showing, shadows convey substance, and unlit areas reveal intangible forms. Like fragments of light, they sustain a certain independence. From the small, square perspectiveless window of *Mesa Verde* to the tip of the *Dark Mountain*, from the interior spaces of abandoned storefronts fronts to the changing light of natural land and sky patterns, black became an ever active component, even maintaining the sense of color.

In *Black Mountain*, Cerro (see figure 31) this quality reaches fuller proportions. The rain clouds above echo the opaque band that defines the mountain's mass and edges without tactile reference, and little attempt is made to render textural attributes. Therefore, our reading is confined to other matters. The mountainous profile no longer represents deep space, distance, or scale. While its outline implies the general identity of this striking terrain, there is little to confirm more specific aspects. Impending clouds and their distributed patterns of tones offset the prevailing silhouette. The central, black, negative form counterbalances the rectilinear lines of the buildings below, but its color establishes another condition. This is not the color of pigmentation, but rather the creation of a property in the absence of light that is unavailable in any other medium. Or, more literally, it is the mastery of printing light through the clear portions of the negative—the reversed values of the world—that gives the mountain an extraordinary quality of flattened substance and character without tac-

tile depiction. The mountain stands as a dimensionless reversal. In contrast, light on the structures below renders distinctly the details of their adobe and wooden architecture.

Such innovation, representative of many of the New Mexico photographs, can be correlated to Paul Cézanne's use of forms in isolated relationships within the picture. A reduction of matter to its essential qualities, without depth or detail, opens the picture to new potentials. A modeling of objects by light is replaced by a schematic attention to formation and a placement of elements that conveys meaning through viewers' perceptions of related appearance. Cézanne's "faculty of seeing both depth and pattern at the same time" is not unlike the photographer's developing vision displayed throughout the New Mexico photographs.[18] As in Strand's photographs, in Cézanne's paintings the nature of the subjects is felt throughout the entire structure of the picture, and their organization becomes the framework for articulation. In the work of both artists, such pictorial inventiveness and acumen offers a more complete expression of life in landscapes, architectural details, and even portraits.

Although Strand was not to realize a collective working portrait of a culture until his filmmaking in Mexico began, pictures from this period such as *Apache Dancers* became the initial lessons for later compositions such as *The Family*, Luzzara (see figure 79). New Mexico's several cultures complicated the possibility of a comprehensive portrait. In regard to individual portraits, there would only be one photograph of his friend Georgia O'Keeffe and several of Beck in various circumstances, suggesting the growing tensions in their relationship. Often in these images parts of the environment were included, offering a more explicit sense of the surroundings than had the early New York portraits.

The idea of studies—re-photographing the same subject or similar themes over time—also provided an important route to discovery, as it had for artists in other media. In re-visits to Ranchos de Taos church in the small village south of Taos, Strand made fifty-eight negatives representing a spectrum of subjects ranging from abstraction to sky and form explorations, to investigations of light and of traces of historical and cultural dimensions. This focus on a single architectural subject reflects the inclusive character of his wide-ranging investigations during this brief period of transition.[19]

Strand's final exhibition at An American Place in 1932 included almost 100 photogaphs, many made in 1930 and 1931, representing his use of all three cameras and various printing methods. The results of his greatest year of activity, in 1932, were shown the following year in Mexico City. This exhibition, which opened on February 15, 1933, was sponsored by the Mexican government's Secretary of Education. Lasting less than two weeks and displaying fifty-four photographs, it included only six made outside of New Mexico—in Canada, Maine, and Colorado. "When I came to Mexico,"

Strand wrote, "I brought fifty-four prints along including last summer's work, with no idea of a public exhibition—anything but. However when Chavez saw these things, he felt Mexico should have the opportunity to see 'photography.' . . . They [were] greatly impressed, for these people are very quick and intelligent."[20]

In response to a letter from Ansel Adams, reminiscing about an earlier meeting in New Mexico that had been instrumental in helping the younger photographer determine his commitment to the art of photography, Strand commented on the public response to the exhibition: "The best part of it was the democratic character of the people who came. . . . Some 3000 in 10 days." He noted as well that "I have worked hard here—started new problems—and have taken up a line of work started way back in 1915."[21]

Strand did not return to New Mexico until 1944, and then only to pass through. The following year, he attended the first major retrospective of his work, created at the Museum of Modern Art by acting curator of photography Nancy Newhall. This exhibition included over thirty photographs from New Mexico, printed on chloride and Japine platinum papers. The exhibition-catalog essay articulated the importance of the New Mexico period: "[Strand's] search for fundamentals that shape the character of all that rises from a land and its people reaches symphonic proportions in the New Mexico series, 1930–32. This is by far his most prolific and varied period," Newhall wrote.[22]

Harold Clurman, reminding the photographer of his own words, once told Strand: "I remember you . . . saying, in 1929, at Child's restaurant on Broadway and 73rd street, 'the difference between my photographs and Stieglitz's is that he has life and I have none.'"[23] By the time Strand had thoroughly developed his work in New Mexico he had opened up his artistic process and ideas to life and become able to perceive and translate it photographically with a new, determined observation and less introspection. Part of his need for social observation and comment would find expression more immediately in Strand's filmmaking in Mexico and elsewhere throughout the thirties. However, the desire for a meaningful resolution in photography proved more difficult.

Through all the lessons, challenges, inventions, and resolutions, it was human existence that was to be best revealed in Strand's photography after leaving New Mexico in 1932. Strand expanded the potential of photography as a major modern art form by broadening the working application of the ideas that he pioneered early in the century, using New Mexico as a kind of laboratory. "I've always felt," he stated later in his life, "that you can do anything you want in photography if you can get away with it," and the comment seems to sum up both the self-imposed demands and the quest for liberation that motivated and fortified Paul Strand's masterful work in New Mexico.[24]

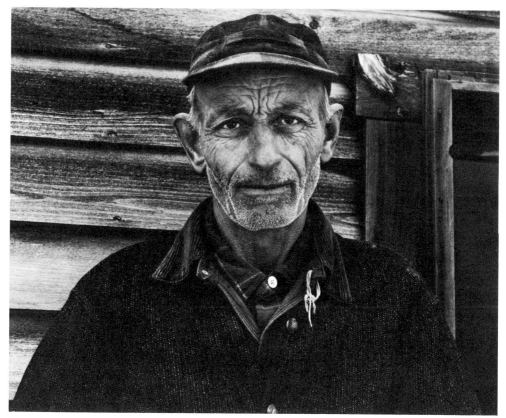

32. *Mr. Bennett*, Vermont, 1944

RUSSELL BANKS

Mr. Bennett,
Vermont, 1944

The photograph refuses to judge the man. There is an interrogatory light on his face, appalling clarifying light, more light than the man wants, or perhaps can stand to be seen in. But it's light that indicts and at the same instant accepts the guilty plea. *J'accuse*, at the saying, is simultaneously answered: *Mea culpa, mea culpa, mea maxima culpa*. So that what we see in this poor man's face is what he himself is condemned to see, too, which only deepens his plight—for while this man knows himself, he cannot love himself for it, as we can, as in fact the photograph insists we do. He can only suffer from his terrible knowledge and, worse, can gain no release from its burden, ever, except through death. And we see that, too, as he does. He is a brutal man too intelligent to avoid knowing it, too sensitive to keep from cringing before it, too honest to deny what happened, but in no way sufficiently free of his brutality to keep from defending it. Which only compounds his crime.

Oh, those charming quaint New England farmers who talk in such a precious delightful way! Those honest tillers of the soil. Those men of few words and high clear principles, like a Vermont winter sky. The photograph is a Robert Frost poem—simultaneously dramatizing a regional cliché and destroying it in a stroke, strangling it with the very hand that offers it. This man has been secretly cruel to people who loved him and he has always put a meaningful construction on his cruelty: he was cruel on principle, consistently, even-handedly, on purpose, by God, *for their own good*. And he knew better, too; he knew it was a terrible sinful thing to do. Even when, thanks to his force of personality and intelligence, his rigorous logic, they did not—the wife, the child, the friend. That's why he's taciturn and tends to speak in sentences that forbid elaboration, utterances that come to full end-stops, which of course permits them effectively to change the subject altogether, and never invite us into a conversation or offer us an explanation, a confession, a plea. Such sad eyes. Yes, but, finally, sad for no one's pain but his own.

My grandfather, my father, my uncles and cousins—all the hard men of that grim unforgiving world: they're always cold, knuckles red and raw from the work they must do, faces scored by weather and depression; and

with their lips sealed against a terrifying need, their eyes must ask what the mouth cannot. Forgiveness. Love. Can we give it, when it's asked for in such a feeble way and so aslant? When we must go on protecting ourselves from them? Yes, but only if we're willing to steel ourselves and stare at them, as this photograph stares, in the harshest light imaginable, and see exactly who they are and know what they have done. We can forgive them only if we cannot excuse them—for that is how cruel they are. We must see that they are cruel to each other as well, and to themselves, these hard men, and for that we can come to forgive and then to love them. This photograph, for the obligation it places on me, terrifies me.

RICHARD BENSON

Print Making

The fundamental problem any artist faces in regard to craft is that it must be largely ignored. This seems to be an extreme statement, but it is surely true. Today we are experiencing a revival of sorts of non-silver, or alternative, systems for photographic printing, and the field is littered with well executed, poorly conceived photographs. It seems to me that this has happened because all these photographers, or printers, are more interested in how they print their pictures than in what these pictures might be about.

If we look at the two classic early portraits of Paul Strand, both by Stieglitz, we see two aspects of the man. In one he sports an apron and rolled-up shirtsleeves, and, we are told, he is at work helping Steiglitz at 291. The picture is every bit the working craftsman in his attire — one can imagine him to be a direct spiritual descendant of William Morris. The second, taken I believe some time later, shows Strand in a fashionably rough jacket (something one could not conceivably work in), holding a cigarette at just the right expressive angle, looking at the photographer with the slight disinterest that only a true artist could aspire to. Something has changed, and I believe it is that Paul Strand has decided that he wasn't really interested in the physical making of photographs, but rather was an artist obsessed with his vision above all else. To me, this is a genuine choice of direction that has made Strand potentially great as well as keeping him from being one more of those boring pictorial photographers who populated the years between the wars.

This choice of role must be understood if we are to consider Strand's craft. The decades-old idea of Paul Strand the great printer practicing techniques of unparalleled refinement is simply not accurate. His craft remained in a strongly secondary position, and he had the intelligence to keep it there. I feel that the reason Strand the craftsman looms as such a dominating figure in photography stems from three factors. The first is that Strand didn't know what to say when a fuss was made about his prints, since he truly didn't care about them simply as prints but saw them

rather as visual means to an expressive end. If someone misunderstands one's work as an artist, then the easiest recourse is for the artist simply to say nothing, and if this misunderstanding is about some imagined inaccessible greatness, then silence only reinforces the impression. The second, and much the most important factor, is that this photographer knew with absolutely no confusion how he wished to distort the literal transcription of the lens into the picture that was his art. As he grew into his maturity as a photographer, this knowledge led to a simplifying tendency that he carried out with long lenses and dark prints, often made with astonishing casualness of craft but remarkable clarity of purpose. The appearance of his prints, resulting from this clear idea, seemed to the audience to stem from some magic craft, and his darkroom work became something that could be focused on and talked about. His great beginning, those 11×14 inch prints made from tiny hand-held camera negatives, showed the grit of working-class life clothed in the sweetness of platinum's pictorial scale. These pictures, thought by many to be his finest work, pose the question so clearly—what is more important, the blind eyes or the tonal quality of the print? There is no contest, and the eyes have it. Already, here at his very beginnings, Strand turns the tables. Platinum, so seductive and rich, was used because it obscured fine detail, or the lack of it, and so made the message of the thing seen much clearer in his pictures.

Throughout his life, Strand used uncommon materials because they suited his purposes best; this third factor is what we must now look at as we examine his craft. Paul Strand's work has a very interesting physical chronology. He started working before the First World War using a small camera and printed this work in enlarged form by making inter-negatives and using platinum as his medium. Platinum paper is a material of very low sensitivity, and it consequently cannot be printed in an enlarger. To surmount this difficulty, photographers have traditionally made enlarged copy negatives and printed these by contact. Following this period Strand adopted two cameras, the 8×10 inch view camera and the 5×7 inch Graflex, and he used these two machines, without variation or exception, from roughly 1920 almost to 1960. This is an astonishingly long period, and it is even more remarkable when we realize that during this time he contact printed exclusively until the 1950s when his eyes began to fail quite badly. Another interesting aspect of this body of work is that Strand always used a Graflex on a tripod to make instantaneous exposures. He put a mask on the camera back and the ground glass to alter the format to approximately 5×6 inches, which he felt, like 8×10 inches, to possess the "right" proportion for a picture. This camera, now a 5×6 rather than a 5×7, used one lens only, a 12-inch Goerz Dagor. This lens length was necessary to allow the reflex mirror to clear the rear of the lens, and it forced the photographer to work with a focal length that was absurdly long by today's standards. This lens was so long that any picture made

with it had a distinctly compressed structure, similar to that created by a mild telephoto lens.

As Strand entered old age he continued to use these two cameras but also began to work with a roll-film machine which made a square negative which he usually cropped to the "right" proportion while enlarging. The enlargements were in the vicinity of 11×14 inches—virtually the same size as his very earliest enlarged platinum prints.

There was a period during the 1960s and 1970s when Strand made enlarged prints from new negatives as well as from earlier ones. These were from Graflex or new roll-film negatives, because he had no enlarger that could hold an 8×10 inch piece of film. These prints, while in many cases very fine, do not, in my eyes, measure up to his earlier work. It is essential to remember that Strand, although quite old and almost blind, was driven to work. He not only labored on new versions of the old but also on new pictures as well. During this time he did a long series on the garden which I feel contains some of his strongest pictures.

What this chronology tells us is that his whole working life was technologically quite simple. It appears even more so when we realize that when Strand used platinum, he never coated the paper himself, and when he used silver paper, only one was his favorite for forty years (Kodak Illustrator's Special). All Strand's fuss about photographic paper was simply trying to find a replacement for this one when it was no longer made. Perhaps this simplicity of craft is an essential characteristic of the great artist—surely in photography all the best work has been done with the simplest means.

The early large prints Strand made are either on platinum paper or on an obscure material called Satista made by the Platinotype company. Both of these materials are contact speed, and both use the sensitivity of iron salts as their basis. These early prints were left in their natural matte condition—that is to say they were not altered, after the print was processed, by varnishing or waxing. When Strand moved out of this stage in his work and began using the 8×10 inch and the 5×6 inch cameras and printing entirely by contact, he still used platinum but in an entirely different way. The new prints were hard-edged and brutally clear, but dark and full of tone. Although his earliest prints were often soft and even light in value, the pictures of New Mexico and Mexico were almost massive in their description of the subject. These platinum prints were also invariably varnished to make their surface more transparent. This practice, a horror to the conservator, is one that Strand clung to for his entire career, with the sole exception of those earliest enlarged platinum and Satista prints. If the print was platinum it was varnished to make it shine with almost the luster of a gloss silver print, and if the print was chosen to be in silver it was made on a semi-matte surface so that this too could be treated afterwards to induce just the right sheen.

Photographic papers have always been made in different surfaces, with the idea that some were more suited to certain subjects than others. The most common has been gloss paper, and Strand detested this surface. He had similar feelings about any fully matte paper because this material was incapable of describing a strong black—the backbone of his visual vocabulary. Between these extremes, though, existed many semi-matte papers, often with an artificial grain of one sort or another. These Strand used exclusively, often cherishing a box of paper which showed this grain less than usual. These papers he varnished or waxed once dried, using different materials but always seeking to achieve a surface slightly more diffuse than the gloss papers. The obsessiveness of this desire on his part becomes clear when we realize that all of his books were made by badgering the printer to put varnish in the ink, and even the great Mexican gravure portfolio was sprayed with a lacquer after the prints were pulled and dried. Throughout all the years of his long working life only one ideal surface was imagined, and he used anything at hand to achieve it.

Photographs of the New Mexico landscape, some of New England nature forms, and pictures made in Mexico appeared as wonderful platinum prints through the 1920s and 1930s. Photographs made on the Gaspé Peninsula, however, were usually printed in silver. When Strand made the bulk of the pictures for *Time in New England* he was leaving platinum and using silver exclusively. Perhaps this happened because the paper was no longer made, or maybe it was simply because the light of the Southwest was consonant with platinum and the gloom of New England suited gaslight. Whatever the case, Paul Strand's work settled into clearly seen, perfectly exposed negatives and straightforward contact prints made in the darkroom. I have often wondered if there wasn't a light meter lurking around in there somewhere, as these negatives seem all to be made on some perfectly illuminated day, with just the right exposure. However they were done, these great negatives were certainly printed in the most straightforward manner possible.

He used any high-energy developer available but was willing to make up a soft amidol-based one if the picture demanded it. There was hardly any dodging and burning—maybe a bit of additional exposure was given along one edge, or a little help was given to a bright sky, but this was minimal. Strand would not hesitate to pull a print out of the developer early, nor would he have had any reservations about using a little bleach to pop the highlights up if the print was a bit too deep. It seemed that a printing session would often yield about three good prints from a given negative, each quite different from the others. Whether yanked, bleached, on this paper or that, all these prints were toned after they were fixed.

I don't know when the toning started, but it seemed to have been a constant in his habits as a silver printer. The toner used was almost always one based on gold, called Nelson's Gold Toner, or Kodak toner T-21,

which are the same. Toning affected the prints in three ways: the blacks became deeper, the color of the silver image was altered, and the surface became slightly less matte. The slight alteration of print surface was probably a result of the toner being used hot (I recall Strand wondering if the temperature actually did this or if he just imagined the change). The strength of the black parts of the picture was extremely critical, and both the toning and varnishing were controls used to make this precise. The print color of many of the papers Strand used, and certainly of Illustrator's, was warm with a greenish cast. A slight bit of toning cooled this off; more toning moved the print to purple, then to brown, and then even to red. All of these are subtle casts, not extremes of color, and many shifted to the less colorful when the print was dry-mounted. Strand paid a great deal of attention to color but had no rigid feeling about what color suited what subject. He knew absolutely what color each picture should have.

Strand's darkroom was not elaborate. The sink was small, there was no timer, there was no idea that things had to be under control chemically or even that there was any right way to do things. When an enlarger finally crept into the darkroom, dodging and burning started to happen regularly. The light source in an enlarger is seldom even, and dodging and burning are necessary to correct slight problems in the negatives which are exaggerated by the uneven lighting. Strand kept careful darkroom records on his negative envelopes of the paper and developer used, the time of exposure, and any manipulations carried out. Toward the end of his life he often made contact prints using the enlarger as a light source instead of using a simple bulb held above the contact frame. This practice caused a lot of extra work because the inherent unevenness of the enlarger affected the contact print. When his sight was less good Strand began regularly to put a red dye on the less dense portions of his negatives, those areas that described shadow information. This helped slightly while enlarging but really had little effect on the pictures.

Paul Strand produced a series of books and one portfolio of pictures in photogravure as well as his long life's work from the darkroom. The portfolio, made by the craftsmen of the Photogravure and Color Company in Manhattan, was a magnificently printed series of pictures from Mexico. The gravure plates were etched from film positives Strand made himself after his frustration with poor proofs from positives the printers had made. This was a radical thing to do—it was virtually unheard of for a photographer to intrude on the secret craft of the professional printer. For whatever reason (probably because this intrusion set up real tension and rivalry) this gravure portfolio is, to me, without question the supreme example of the transformation of a photographer's work into ink and paper. The printing is breathtaking in its depth of tone and clarity, the etching of the entire series of plates is better than I have ever seen elsewhere

in even a single print, and the whole group of gravures fits effortlessly into Strand's body of work. On top of all this, the Mexican portfolio is the swan song of hand gravure; it represents the practical end of the gravure tradition, and it is clearly the peak of it as well.

Strand's books were usually printed in rotogravure, the mechanized rotary beast that hand gravure became. With the exception of the first, *Time in New England*, which is in spare and gritty letterpress, and his last books in photo-offset, Strand chose to work with gravure because it rendered such a strong tonal scale. *La France de Profil* is, to my mind, along with *The Decisive Moment*, one of the two most beautifully printed photographic books (a close third is the first edition of Robert Frank's *The Americans*). After this great beginning, the trial of finding a superb printer made it harder each time to get the quality that was always in Strand's mind, and by the time of the book on Egypt only the rough residue of gravure's glory is visible. No matter how hard the job, Strand labored not only badgering the printers but also being downright difficult, trying to get books that had some connection to his prints. When gravure was no longer available and Strand had to work with offset printers, he sought out Sid Rapoport of New York, a technically radical printer, who not only worked with more imagination than anyone else but also seemed willing to put up with this crusty and opinionated old man. At the very end of his life Strand talked more about his books than his prints, and he really believed the books to be his great achievement.

I was staggered to realize how little Strand cared about craft, and even how little he knew about it. Surely he had chosen to forget all those bits I was so convinced were vital. I must admit that my time with Strand was at the very end of his life, and so perhaps my view was distorted. Maybe I had the great luxury of knowing him when there was absolutely no confusion left in his mind about what matters and what doesn't. Whatever the case, I learned to keep it simple in the dark, do as much as you can with the lights on, and never forget that we are making a picture and not a print. This is the lesson from him to me about craft in photography.

KATHERINE C. WARE

Photographs of Mexico, 1940

Paul Strand had reached a turning point when he left for Mexico City in the autumn of 1932. Prompted by the pressures of living in New York, by Strand's desire to work undisturbed on still photography, and by his wife Rebecca's love of the West, the couple traveled to Taos, New Mexico, for the third consecutive summer, with the idea of relocating there. The move cemented Strand's estrangement from mentor Alfred Stieglitz, with whom he had reached a breaking point that spring. By the end of the summer, Strand and his wife had also separated, and his application for a Guggenheim Foundation grant was rejected.[1] In search of a fresh start, Strand wrote to Carlos Chávez, a Mexican composer he had met in Taos the previous summer, to express interest in visiting Mexico and to ask for help getting camera equipment through customs. As chief of the Department of Fine Arts in the Secretariat of Education—a vital clearinghouse for cultural projects—Chávez was able to arrange for an official invitation. In late 1932, Strand piled his gear into the back of a Model A Ford and started toward Mexico, with Susan Ramsdell and her son.

Strand's sense of independence and his excitement about the trip to Mexico in 1932 are apparent in his claim that he abandoned his usual working methods at the border. He told one interviewer,

> I began to find that the shibboleths of the time were not true for me. It was always said that you really have to know a place before you start working in it; otherwise you would do something very superficial. Another shibboleth was that you can't make a portrait of a person unless you know that person, and then when you know the person you create the moment or you wait for the moment when they are most alive and most themselves. These shibboleths went out the window.[2]

That Strand had indeed forged a new direction for himself is evident in his 1940 portfolio *Photographs of Mexico*, a sequence of twenty gravures of

photographs taken during this 1932–1934 trip. The portfolio is both a prototype and an anomaly in Strand's oeuvre, a transition piece deeply rooted in his early experimentation with formalism and the genres of portraiture and landscape, yet breaking new ground in combining these elements to create work that used fine art techniques to dignify and vivify the human condition while using the human condition to bring meaning and social relevance to the realm of art. Strand's trip to Mexico per se did not cause this change in his approach to still photography but served as a catalyst for the idea that art photography and photography with a social message were not mutually exclusive categories.

Strand was a latecomer to the Mexican scene—artists and intellectuals from all over the world flocked to Mexico City from the 1920s until the mid-1930s to experience firsthand the Mexican Renaissance, a cultural flourishing following soon after the Revolution, which lasted from approximately 1910 to 1920. This renaissance was an expression of optimism and enthusiasm for some of the ideals that had fueled the Revolution, ideals later codified in the Constitution of 1917, which established the presidential system and offered the blueprint for a controlled republic of industry and agriculture. The constitution was a social as well as political document, establishing an eight-hour workday, workers' rights to organize and strike and to receive adequate compensation, and the need to redistribute land and mineral rights widely. The constitution also called for compulsory primary school education for children and determined that all public education would be secular. Though most articles of the constitution were not implemented for many years, in 1920 Minister of Education José Vasconcelos initiated the reform and expansion of Mexico's education system, directing the construction of more than one thousand schools over a four-year period, distributing inexpensive Spanish editions of classic literature, and sending hundreds of teachers to villages where they often met with the distrust of the populace and the animosity of the clergy.[3]

It was through the Secretariat of Education that the federal government became an active patron of the arts during this period, and the subsequent outpouring of music, theater, painting, and architecture inspired by the Revolution promoted a positive national identity during reconstruction as well as providing a smokescreen for the government's lack of initiative on the drastic reforms required to uphold articles of the constitution. A tacit symbiotic relationship developed between artists and the government, whereby artists could express radical ideas in their work and receive support from the government via Department of Fine Arts projects, while the arts in turn lent an air of practical and theoretical progressiveness to the conservative government. European-trained painter Diego Rivera, for instance, declared himself a member of the Communist party yet received government-sponsored commissions for public murals, some celebrating independence and Mexico's Indian heritage and others espousing more overt political themes.[4]

Mural painting was considered a democratic medium that could speak even to the country's illiterate population, and Rivera's adaptation of Italian fresco techniques was embraced by many artists wishing to remove art from its elite gallery context and to create paintings on walls and buildings where they could be accessible to all. This movement in Mexico lasted about a decade, and its impact hit the United States full force in the 1930s and 1940s. In 1940, the year Strand released *Photographs of Mexico*, New York's Museum of Modern Art (MOMA) was exhibiting *Twenty Centuries of Mexican Art*, organized in cooperation with the Mexican Instituto Nacional de Antropología e Historia. An earlier MOMA show, the controversial *Murals by American Painters and Photographers* in 1932, presented the Mexican mural movement as a model to promote the idea of murals for public spaces in New York.

Though Strand reportedly admired the work of prominent Mexican artists such as Rivera, José Clemente Orozco, and David Alfaro Siqueiros, no references to his meeting them or seeing their paintings survive, though Siqueiros did write a preface to the 1967 edition of Strand's Mexican portfolio. Siqueiros found Strand in sympathy with "our Mexican pictorial movement with its plastic concepts and new realism," which rejected abstract formalism for its own sake but applied this pictorial vocabulary to "man, the physical world in which he moves, struggles, and dies."[5] Given this affinity, it is perhaps not surprising that instead of mingling with the cultural elite in Mexico City, Strand was more interested in applying these nascent ideas to his work, and he involved himself in projects that took him away from the capital and into the villages of surrounding states where he could make firsthand contact with native populations.

Strand had been interested in native populations in the United States as early as 1922, when he offered to make educational films at Indian reservations in the Southwest under the auspices of the Heye Foundation. However, this proposal had not been accepted and Strand had felt that without official sponsorship he would have met with hostility as an outsider.[6] In Mexico, however, he was able to work on government-sponsored projects that offered official status, interpreters, and, hence, access to a somewhat insulated population that was reticent with outsiders.

Not long after Strand's arrival in Mexico City, Chávez arranged with Minister of Education Narciso Bassols to exhibit fifty-five of Strand's recent platinum prints of New Mexico at the Sala de Arte of the Secretariat of Education. Strand's friend Marsden Hartley was in Mexico City at the time and helped him hang the prints for the opening on February 3, 1933 in a long room with great windows and an imposing high ceiling. The exhibition, on view for almost two weeks, received favorable notices in at least four newspapers in the city. Ironically in light of the work Strand was beginning in Mexico, the reviewer for *Universal* praised Strand's sensitivity to the nuances of New Mexico but noted that only a few figurative works appeared in the show and that "they clearly advise the viewer that the art-

ist does not feel the same love for the human figure as he does for those images in which an abstract element predominates."[7] Strand certainly considered the exhibition a success and later said that it was one of the most rewarding and interesting shows of his career:

> With the show at street level, people would go in one door, go through the room, and out the other door. It became part of the street. All sorts of people came: policemen, soldiers, Indian women with their babies, and so on. I've never had such an audience anywhere else.[8]

Shortly after the exhibition closed, Strand was invited to travel with Chávez's nephew Augustine Velásquez Chávez, an art teacher working on a government-sponsored study of the teaching of arts and crafts in the state of Michoacán. This travel brought Strand into contact with two of the burning social causes of the day: the concern over educating children in outlying states, and the interest in fostering a native craft tradition uncorrupted by outside influence. Many of the still photographs Strand took in Michoacán were later included in *Photographs of Mexico,* though these images do not overtly reflect the nature of the study, since no workshop, classroom, or crafts are shown. Judging from the titles of his extant work from Mexico, Strand and Velásquez Chávez also traveled through the states of Hidalgo, Puebla, México, Oaxaca, and possibly Tlaxcala by rail, carriage, and horse, but whether this occurred in conjunction with the Michoacán trip and/or later, en route to Veracruz in the fall of 1933, is not clear.[9]

In a ten-page typed report to Chávez dated June 1933, Strand recorded his impressions of the Michoacán trip and commented that in most cases craftsmen were technically proficient but he found their work uninspired and decorated with patterns copied from imported reproductions, comic books, and in some cases from ancient relics. According to his report, Strand believed that it was useless to reeducate adult craftsmen and that the only hope for change would be to educate children differently. He recommended an experimental program designed to stimulate young people's creativity, using basic drawing materials to help them develop an individual creative voice before introducing skilled crafts such as embroidery.[10] To foster this idea, on May 24, 1933, Strand and Velásquez Chávez presented the exhibition *Pinturas y Dibujos de los Centros Culturales* (Paintings and Drawings from the Cultural Centers), a selection of works made by children at cultural centers in Michoacán. In his essay for the exhibition brochure, Strand wrote,

> It is not necessary that the world be full of painters, but it should be full of artists, that is to say, of human beings who consciously bring to their work, whatever it may be, the attitude and qualities which we

find in the free and spontaneous expression of the child. It is precisely the problem of education to prevent the atrophy and corruption of these impulses in the growing generations, if ever we are to have a human society which creates life instead of destroying it and itself — which seeks to give rather than possess, which can meet the problems of adult life with feeling and thinking, uncorrupted by conventional, outworn, and regimented patterns.[11]

Though Strand's interest in children's art was hardly unusual — Stieglitz exhibited children's art at 291 in 1922, and modernist painters had claimed an affinity with the untutored art of children and native populations since the turn of the century — his attitude was not as condescending as most, and his essay suggests the galvanizing impact of his trip to Michoacán.

It was surely this desire to educate with art that motivated Strand to accept the Department of Fine Art's offer to head a film series intended to address the concerns of the country's Indian population. One advantage of this medium for Strand was that a film could be shown to many people in different places, whereas his still photographs were seen almost exclusively in small, infrequent exhibitions in New York City. The possibilities of film as a medium for mass education and social enlightenment was also an exciting new frontier just beginning to be explored in Mexico. Strand's experience as a free-lance cameraman in New York, combined with his growing belief that art should express socially relevant themes, made him a valuable participant.

Strand reports that the crew for the first film in the series agreed to use "the most rich and imaginative film techniques . . . on the theory that the best art was the one which would reach all people . . . most forcefully."[12] This view suggests an affinity with the rhetoric of his contemporaries in the United States and Mexico, such as Orozco, who wrote in the 1920s, "It is a lie that 'one has to be a connoisseur' in order to understand and feel a painting; the roughest and most ignorant man can be attracted and subjugated by beauty, wherever it may be found."[13] Shortly after the film *Redes* ("Nets" or *The Wave* in the United States) was released, however, the proposed five-year film plan was shelved, though incoming President Lázaro Cárdenas wrote to Strand to express his appreciation of the film.

Redes occupied almost a year of Strand's time in Mexico and was a major factor in the formulation of his mature style in addition to influencing directly the sequencing of images in the portfolio *Photographs of Mexico*. Working on *Redes* offered Strand the opportunity to convey information about workers' rights to a wide audience, objectives he sought to achieve with his still work by creating the portfolio, a masterful and sometimes paradoxical balance of abstraction and figuration, craftsmanship and mass production, elitism and populism, art and ethnography. Cinematic devices

used in the portfolio—such as the use of successive images to zoom in on landscape and architecture to establish movement and local color, and focus on a cast of anonymous Tarascan Indians suggestively interspersed with eloquent hand-carved religious figures—are direct borrowings from *Redes* and the work Strand subsequently did at Frontier Films just prior to releasing the portfolio.

Strand recalled that it was Lee Strasberg of the Group Theatre who suggested he make a portfolio of the Mexican photographs.[14] The first edition of 250 copies of the portfolio was published as *Photographs of Mexico* in 1940; a second edition of one thousand copies was published as *The Mexican Portfolio* in 1967, following Strand's second trip to Mexico in 1966.[15] Though by 1940 hand-pulled photogravures had been largely superseded by offset printing, Strand was committed to using the process for the portfolio.

> The thing that was original about this portfolio was that it was a conscious attempt to see if one could make reproductions which were so close to the originals—the originals being platinum prints—that they were good enough to be framed. That I think had not been done before. And I chose gravure as the one medium that I thought was possible to do that job.[16]

By carefully supervising the production of the gravures and, for the 1940 edition, even spending weekends with a group of friends to complete the final lacquering of the prints, Strand perhaps thought he had struck on a way to offer high-quality art to a wide audience without resorting to the commercial mass production he abhorred. In a 1940 review of the portfolio, Jerome Mellquist indeed noted that: "Its greatest advantage is that it will make . . . [Strand] more available to the country at large than his all-too-infrequent New York exhibitions [have done]."[17] Yet if Strand had populist leanings, his decision to raise money for high-quality printing by selling advance subscriptions for the portfolio ruled out an audience much beyond wealthy collectors and institutions who could afford to buy the fifteen-dollar edition, a costly purchase at the time, as Strand himself noted.[18] Strand's decision to issue the prints as a portfolio—more costly and less convenient to view or display than a book of photographs or a single print—was also influenced by the expressive potential of this format. Like a book or film, a portfolio offered Strand the strategy of developing ideas with a series of reinforcing images. But unlike most illustrated books, the pictures in the portfolio were fine prints and unlike film, the multiple images in the portfolio required active involvement by the viewer, who had to open a special box and remove each print successively, necessitating slower, more deliberate viewing and creating a ceremonial atmosphere conducive to contemplation of the images, as well as allowing for multiple viewings.

33. *Landscape*, Near Saltillo, Mexico, 1932

With a single exception, the portfolio images are all dated 1933 and were taken in the central states that cluster around Mexico City where Strand traveled with Velásquez Chávez. One of the first pictures Strand took in Mexico was *Landscape*, Near Saltillo (1932), taken in the northern part of the country on his initial trip south to Mexico City. *Landscape* (Figure 33) is also the first image in the portfolio sequence — a distant view of a white building seen through a cactus-framed clearing — and its composition provides visual entry into the scene and the series. The second image, *Church, Coapiaxtla*, not only carries the viewer south geographically to the region where Strand took the majority of the images in the portfolio but also furthers the entry motif, offering a closer view of another vernacular structure — a gateway framing the entrance to a church. These first two images and the other two architectural subjects in the portfolio provide a context for the human figures that inhabit the portfolio, and the architecture offers a metaphor for their lives by emphasizing the stark, rugged aspects of their built and natural environment. The architectural subjects also lend structure to the portfolio and frame the viewing experience by appearing at the beginning, middle, and end of the series. Having established a physical setting with the cinematic, distant-then-close view of Mexico's indigenous landscape and vernacular architecture, Strand moves still closer with his camera to establish a spiritual climate with the third image in the portfolio, a sculpted Virgin figure from the interior of a

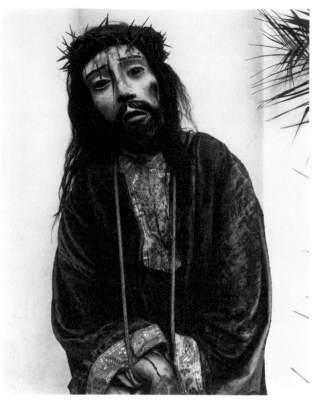

34. *Cristo with Thorns*, Huexotla, Mexico, 1933

church in Oaxaca. This transition to interior space and spiritual concerns is aided by the previous image *Church, Coapiaxtla*, which leads the viewer up to the door of a Mexican church.

Hispanic religious sculpture was a popular subject for artists and writers who visited the southwestern United States and Mexico decades before Strand arrived, and its meaning and associations for this audience was relatively codified by the time he photographed it.[19] Unlike many artists, however, Strand was not interested in figures that were provincial in technique or obscure in subject matter; instead, he concentrated on sophisticated examples of craftsmanship and the most central figures of the Roman Catholic faith. In his 1933 report to Chávez, Strand indicated that he considered these figures and other items that the Indians "made for themselves to be used for religious or fiesta purpose . . . [and which] immediately take on beauty, dignity, and meaning" as prime examples of fine craftsmanship joined with subject matter relevant to the lives of contemporary viewers, a union he sought in his own work.[20] Strand used artistic license in including images of sculpture from Oaxaca—a state not inhabited by the Tarascans,

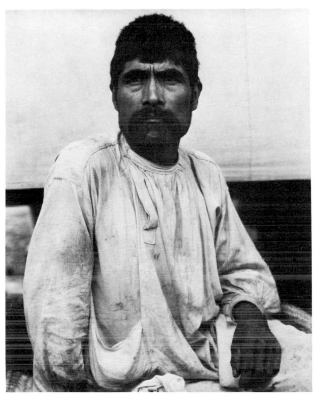

35. *Man*, Tenancingo de Degollado, Mexico, 1933

who live in Michoacán and the west-central region—and in overlooking the foreign origin of both Roman Catholicism and this type of sculpture; however, such distinctions would only have been made by specialists and connoisseurs. Strand chose to show the carved figures in isolation without a hint of the often elaborate and expansive churches that contain them, the better to focus on their power and beauty and their symbolic embodiment of the suffering and redemption of the common man. In her 1940 review of the portfolio for *U.S. Camera*, Strand's friend critic Elizabeth McCausland wrote:

> Behind the inscrutable faces of these men, women, and children, hide centuries of labor, sorrow, and death. . . . In the photographs of *bultos*, the crucified Christ is the figure of every peasant broken in his daily war for bread.[21]

Five years later, in the catalog for Strand's one-man exhibition at MOMA, Nancy Newhall offered a similar, if more circumspect, interpretation of this work, suggesting that the figures "seem to symbolize, like the

brief glimpses of the land and the architecture in this series, the emotional preoccupations of the people."[22]

These carved figures not only help to establish the religious and artistic tenor of life in a Mexican village, but also they are positioned in the portfolio to resonate against Strand's portraits of the Tarascans; for example, *Cristo with Thorns* (1933) and *Man, Tenancingo* (1933) are similar and intentionally paired (see figures 34 and 35). By placing these images in succession, Strand not only juxtaposes the human qualities of the sculpted figure against the sculptured quality of the man but also ascribes a Christ-like nobility, dignity, and humility to the man's struggles, suggesting that his burdens are redemptive and that surviving with tenacity is a virtue. In *Man, Tenancingo*, Strand contrasts the man's erect head and far-seeing gaze with the creases and calluses of his mottled hand, the weave and drape of his soiled white smock, his grizzled beard, bloodshot eyes, and furrowed brow—the subject's nearness and the sensuous textures of hair, skin, and clothing convey a palpable presence. In speaking about his work as a whole, Strand has said, "I like to photograph people who have strength and dignity in their faces; whatever life has done to them, it hasn't destroyed them. I gravitate toward people like that."[23] As a single image, the Tarascan man is essentially neutral and impassive, but by juxtaposing him with an image of the suffering Christ, Strand evokes the man's hardships and suggests that, far from being diminished by them, he is strengthened and ennobled.

Strand attempts further to engage the viewer by establishing an internal rhythm in the portfolio and varying the compositions and genres from print to print. Another technique used to draw the viewer into the world of the Tarascans is the rich detail of the prints. The halfway point in the series is marked by *Plaza, State of Puebla*, which shows another equivalent to the anonymous vernacular structure seen in *Landscape*, Near Saltillo—a close view of perpendicular adobe walls punctuated only by four doorways. Strand's framing of the plaza scene and his articulation of its textures lend an immediacy and a beautiful austerity to the scene—the viewer is trapped in the plaza by the planes of the blank walls, the concrete bench, and the closed doors. One's eyes are directed to the unevenness of the whitewashed clay wall, the dry crumbly earth of the street and the rough stone walkway, the splintery wooden roof, and the dense bench with its curving top, so that the viewer can imagine what it is like to be there. Similarly, the series of twenty images closes with *Church Gateway, Hidalgo* (1933, see figure 36), a detail of a concrete gateway like that in *Church, Coapiaxtla*. The gateway is sharply silhouetted in the dim light; one last ray of sun illuminates a spot on the inside of the arch, suggesting dusk and providing closure for the series with a passageway from Mexico back into the world of the viewer.

The middle passage of the portfolio is composed primarily of portraits

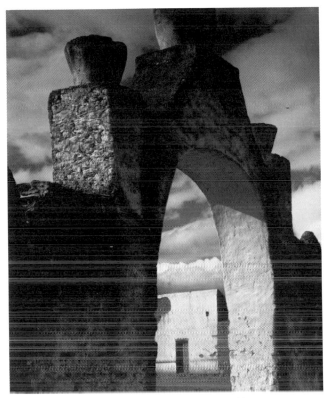

36. *Church Gateway*, Hildago, Mexico, 1933

of the Tarascan people—many of them the children Strand considered to be Mexico's hope for the future—interspersed with religious figures that serve as interpretive guideposts and examples of sincere creative expression. Strand does not emphasize the individuality of his subjects, titling the images only by general subject and location, but he develops a collective portrait of the enduring peasant—strong, full of character, noble. These exemplary folk are pictured outdoors but are apparently unoccupied. They do not interact or go about their routines but are shown as timeless and immobile. These portraits were taken without the subjects' cooperation using a right-angle prism lens to catch them unaware. More than a means to preserve the spontaneity of his subjects, however, this approach may have been the only way to photograph the Tarascans, who were averse to having their picture taken, especially by a foreigner. The ethics of this approach did not trouble Strand, for, as he has said about his New York street portraits, "I always felt that my relationship to photography and people was serious, and that I was attempting to give something to the world and not exploit anyone in the process."[24]

Strand did some commercial portrait work when he first established himself as a photographer and later he took occasional portraits of friends, but he did not begin to explore this genre until 1916, when he surreptitiously made a dozen exposures of poor and elderly subjects on the streets of New York. This early work served as a resource for Strand as he began to explore portraiture more extensively in Mexico. The collaborative work of David Octavius Hill and fellow Scotsman Robert Adamson was also clearly a resource for Strand as he photographed the Tarascans. Many of the poses and compositions in Strand's portfolio images closely echo Hill and Adamson's series of Newhaven fisherfolk to an extent beyond the obvious similarity that both series show subjects who wear native costume and are pictured outdoors. Hill was regarded by Strand and his circle as the first photographic artist, and his work was shown at 291 in 1906 as well as appearing in three issues of *Camera Work*. It seems clear that Strand carefully studied Hill's work before photographing in Mexico, and, in fact, a year before traveling there, Strand reviewed the 1931 English-language edition of *David Octavius Hill: Master of Photography* by Heinrich Schwarz for the *Saturday Review of Literature*:

> [Hill] always emphasized the strength and never the weakness of his sitters, yet the portraits are unsentimental, free from any attempt to prettify. Possibly these men and women were not torn by inner conflict, as most of us are today. For they appear sure of their direction in life to this extent—that they seem to have known what life meant to them and what was truly of value to them in it. This kind of inner strength Hill saw and recorded. And it had its esthetic counterpart in the solidity of his esthetic structure, in the indestructible dignity of his arrangements of light and dark—so simple in effect, so difficult to achieve.[25]

Strand's appreciation of Hill's insight, composition, and craftsmanship is telling in light of the portraits he was soon to make in Mexico, but his references to inner conflict also give a poignant picture of his personal turmoil just before he left New York for Taos in 1931.

And indeed, life was no longer so simple for anyone. As economic depression and industrial development changed the world forever, and the conflicts leading to World War II escalated, Strand devoted himself to recording an enduring, international human spirit that withstood the tests of time, war, oppression, poverty, and natural disaster, offering it as an example for a Western urban population increasingly removed from this spirit. Harold Clurman wrote to Strand in October 1940, praising the portfolio images as "little shining pure symbols of permanence and stability in a world worn with care and the destruction of ages."[26]

It would be easy to read Strand's focus on the "plain people of the world, in whose hands lie the destiny of civilization's present and future

well-being"[27] in the portfolio and in later projects as a rejection of contemporary life and politics in the United States, especially in light of his permanent move to France in 1949. Nevertheless, it is perhaps more accurate to say that Strand's work after his trip to Mexico represents a rejection of prevailing values and, more important, a concerted effort to uncover and present a compelling social and political alternative. The portfolio also represents Strand's own attempt to find an artistic alternative—it offers top-quality fine art with contemporary, socially responsible subject matter treated in an involving and educative manner in a format that could reach a broad audience. Though Strand soon switched to book format, suggesting that the portfolio was not the ultimate vehicle for these goals, his decision to issue a second edition of the portfolio in 1967 offers a final approbation.

ANNE TUCKER

Strand as Mentor

The Photo League was a remarkable and unique organization, at that time or at any other time. It had no equivalent, that I know of, as an important organization devoted to photography and photographers in the best sense. . . . They felt as I have, that the function of art was to speak to people about the world in which they exist.

— Paul Strand[1]

The Photo League was a volunteer, membership organization of amateur and professional photographers who maintained a headquarters, ran a school, directed exhibitions, published a newsletter, sponsored lectures and symposia, produced documentary features, and preserved the Lewis W. Hine Memorial Collection. Guest lecturers and exhibitors included an impressive number of prominent American and European photographers.

Most League members were typically New Yorkers, born between 1900 and 1925 on the lower east side of Manhattan, in Brooklyn, or in the Bronx. Many were first-generation Americans, had attended public schools, and had attended college, if at all, at tuition-free City College. When Paul Strand said, "They felt as I have, that the function of art was to speak to people about the world in which they exist," he meant a much larger world than most League members experienced, at least until World War II took them to all parts of the globe.

The League existed in New York City between 1936 and 1951, and its origins, as well as its demise, were generated in the radical politics of the 1930s. Its history divides into three relatively distinct periods: 1936–41, 1942–47, and 1948–51. Each period reflects the international and national events that shaped the lives of its members: the depression and depression recovery; the Second World War; and the cold war. Although the Photo League was a photographic organization—joined by people interested in

photography, run by members committed to the growth of photography and serious about themselves as photographers—it would be misleading to omit these historical references. The Photo League was governed by its belief in the photograph as a social document.

Sharing this belief was a primary link between the League and Strand, whose advice and participation was regularly sought and received by the League's executive committee. At the League's beginning in 1936, Strand's photographic reputation had been established for twenty years. As photographer and filmmaker Rudy Burckhardt observed, "Paul Strand was a kind of patron saint. He was greatly admired by everybody at the League."[2] His participation assured a well-attended and memorable program (see figures 37 and 38).

Further testimony to Strand's prominence was the fuel his aesthetic ideas and practices offered to various internal League debates. Topics broached included broad questions such as what subjects to photograph and how to bond political beliefs and modern aesthetics in one's work. These discussions involved the degree to which a photographer was compelled to and capable of making images both socially significant and personally expressive. Technical decisions provoked less intricate but equally intense debates. Artisan issues which divided League members included the merits of photographic enlargements versus contact prints, large format versus "miniature" cameras, and flash versus "available" light.

To some extent these issues and Strand's participation had been inherited from the League's parent organization, the Film and Photo League, founded in 1930 as a cultural wing of the Worker's International Relief. The W.I.R. was a leftist Red Cross headquartered in Berlin, which offered international aid to strikers and their families. To publicize its efforts and the causes of the class struggle, the W.I.R. organized Workers' Camera Leagues in major European and American cities. The New York League operated out of the Workers' Art Center on East Fourteenth Street and supplied photographs to leftist publications including *New Masses* and the *Daily Worker*. In the spring of 1930, a W.I.R. representative named Louis Gibarti met with filmmakers Sam Brody and Lester Balog to plan an expansion of the New York Camera League which would include film production.[3] The goals of the Workers' Film and Photo League they initiated were:

To struggle against and expose reactionary film.
To produce documentary films reflecting the lives and struggle of American workers.
To spread and popularize the great and artistic revolutionary Soviet productions.[4]

The New York chapter remained the most productive and acted as unofficial leader of a national organization that eventually included chapters

37. *Paul Strand* (by George Gilbert)

in most large American cities, such as Los Angeles, Chicago, Detroit, San Francisco, and Philadelphia, with a few chapters in small towns such as Laredo, Texas. Each chapter received organizational and financial aid from the W.I.R.[5]

Although the majority of its seventy five to one hundred members were still photographers, the film division of the League dominated the New York chapter. The still section "gave classes, held exhibitions of their work in 1931, 1934, and 1935, and furnished photographs to the workers' press and to other periodicals," including the *New Masses*, the *Daily Worker*, and the W.I.R.'s *Der Arbeiter Fotograf* ("Worker Photographer").[6]

In addition to Brody and Balog, other initial members of the Film League included Robert Del Duca and Leo Seltzer. By 1932 the core group also included Tom Brandon, Leo Hurwitz, Lewis Jacobs, Irving Lerner, David Platt, and Ralph Steiner.[7] The film division initially produced 35mm, black-and-white, silent newsreels about the problems of unemployment and hunger in America, problems that establishment media were still avoiding in the early years of the Great Depression.

By 1934, a division had developed among the filmmakers of the Film League concerning the kind of films to be made by its members. Some members were dissatisfied with making only newsreels or short documentaries and wished to break the aesthetic restraints of pure documentary and to make semi- or wholly dramatized films using actors. Tom Brandon defined the two theoretical questions as follows:

38. *Paul Strand* (by George Gilbert)

(1) Should the League follow the daily struggles with whatever means
we had: creation of newsreels, short documentaries, compilations,
review films, satirical shorts, or parts of newsreels; . . .
or (2) Should the League turn to developing techniques, exploring
different forms, working with actors, lip synchronization, etc. — even
at a delayed rate and timing of productions?[8]

Dissatisfied with the idea of using cinema only for reportage and unsuc-
cessful in redefining the Film League's direction, Leo Hurwitz, Irving
Lerner, Ralph Steiner — soon joined by Lionel Berman, Sidney Meyers, and
Ben Maddow — formed a subgroup called Nykino.[9] "It was," as Hurwitz
explained, "an organization for study and assembling our forces and de-
veloping ways of working, making films. . . . We had a couple of problems.
What are the structures of documentary films? How do you make a
documentary dramatic? What is the binding force in it? Those were the
things we wanted to work out in Nykino. We were headed toward the cul-
mination of some kind of professional organization, to make films
that dealt with aspects of American life that weren't touched on by any
other filmmakers."[10]

Probing the nature of documentary film, plus the time required to make
more sophisticated films, involved ambitions antithetical to the newsreel
approach and to the immediate needs of the class struggle. The efforts of
Nykino to give dramatic form to social analysis were regarded as elitist by

Brody and others, and in 1936 the New York Film and Photo League split over these issues. The prevailing faction of filmmakers—Brandon, Brody, Del Duca, and Julian Roffman—moved to 220 West Forty-second Street and continued to operate as the New York Film and Photo League until the winter of 1937–38.[11] The still photographers reformed as the Photo League and maintained the Film League's old headquarters at 31 East Twenty-first Street. The members of Nykino reorganized with other filmmakers and writers to form Frontier Films. Among its officers and board, Paul Strand was named president and Leo Hurwitz and Ralph Steiner vice-presidents, but Strand and Hurwitz were effectively its co-directors.

Throughout its history, the Photo League was closely associated with the members of Frontier Films. The Photo League screened their films, and the filmmakers, older and generally more sophisticated than League members, were frequent lecturers and panelists at the League. The members of both groups shared a commitment to documentary photography and to its potential as an art form, not just as a tool for mass communication or a "political weapon." The split from which Frontier Films and the Photo League emerged revealed a shift from the expedient production methods dictated by daily journalism to a more disciplined craftsmanship. The best efforts of both groups display a thorough understanding of their media in an attempt to make the camera eloquent, "to make documentary film [and photography] dramatic."[12]

Thus the Photo League had two parents. From the Film and Photo League it inherited its headquarters, its initial membership, and its structure, but the group did not have a source of outside financial support, nor was it associated with a larger organization. The Photo League was completely dependent on membership dues and the fees from classes and lectures for its operating expenses. With Nykino the League shared aesthetic ideas, but unlike Nyinko and Frontier Films, which were select groups of highly motivated filmmakers, the Photo League maintained open membership. As a volunteer organization of both professional photographers and amateurs at all levels, the League needed to respond to a broader range of photographic interests and commitments. As a photographic organization, it was also working with an older medium than film, and one with a rich tradition on which to draw.

Throughout its history, League publications cited various luminaries from photography's past and present in whose tradition the League sought to work. The list varied from time to time, but it included David Octavius Hill, Mathew Brady, Eugene Atget, Alfred Stieglitz, Strand, Berenice Abbott, Edward Weston, Lewis Hine, and members of the Farm Security Administration Historical Section—Photographic (FSA) as exemplary forebears and contemporaries. The admired quality in these photographers was not a matter of style but of an attitude which was, art critic Elizabeth McCausland explained, "an application of photography direct and realistic,

dedicated to the profound and sober chronicling of the external world."[13]

Several of these prominent contemporaries served on the League's Advisory board, including in 1938 Frontier Film members Strand, Hurwitz, and Berman as well as McCausland and Abbott, and two years later photographers Margaret Bourke-White, Robert Disraeli, and Barbara Morgan. In 1918 Beaumont Newhall replaced Disraeli and Morgan.[14] The least forthcoming board members, while favorably disposed toward the League and its programs, lent only their good names; others substantially contributed time, advice, and participation.[15]

As with any volunteer organization, the League depended on a constant, if not always harmonious, group of leaders to keep the doors open and to regulate activities. It was never so organized that tasks, even those assigned for a long period to one person, were an exclusive privilege. Frequently, responsibility was given to whomever would volunteer. An Executive Committee met once or twice a month to discuss and plan the League's programs, but the dominant voices were the leaders, who each put in several evenings a week at the League. For some, commitment to a specific task or office held their interest and secured their energies for the League. Walter Rosenblum was the League's president, in fact if not in name, from May 1941 until May 1942 and, after his army stint, from January 1946 on. Sidney Grossman assumed responsibility for the school from 1938 to 1949. Rosalie Gwathmey edited the League's bulletin, *Photo Notes*, for four years. Other Executive Committee members, such as Sol Libsohn, Barney Cole, and Dan Weiner, served in whatever capacity they were needed. Aaron Siskind led one of the League's production groups for four years.[16] At the heart of their unity was a commitment to photography as an expressive medium and to the League's role in supporting both serious photography and social concerns, although the membership sometimes divided around multifarious personalities and attitudes, both political and aesthetic.

The most active arena for airing differences was the League's school, which was also its most successful component. The school's prewar goal was to train documentary photographers. In 1938 photographers Sid Grossman and Sol Libsohn expanded the school from one introductory class, inherited from the Film League, and one intermediate class to a program of three fifteen-week courses, through which a student ideally progressed to graduate into one of the League's documentary production groups. These courses—Basic Photography, Advanced Photography, and Documentary Workshop—remained the core of the school's curriculum throughout its existence. For the latter two, a syllabus, reading list, and bibliography of books and periodicals were prepared with the assistance of the Advisory Board. The reading list included both previously unpublished lectures and reprints of published articles by each of the advisors (except Berman) as well as by Ansel Adams, Edward Weston, Ben Maddow, and Beaumont Newhall. Class lecturers in summer 1938 included Abbott, Hurwitz, McCausland, and Strand.[17]

Over the years, Strand graciously participated in other classes. That he believed in the school's curriculum is evident from his introduction to the 1939 exhibition of League member Morris Engel. After citing the work of FSA and Works Progress Administration photographers, Strand praised the League as another group which has "turned their cameras upon their environment and . . . begun to document both America and the time in which they themselves live." He continued by praising

> the production by the Photo League, not only of photographs, but of photographers. For the Photo League, now numbering some seventy members, has been a center in which many young and talented photographers have received their training, where they have been able to get both technical knowledge as well as a contact with the whole historical development of photography as a medium of expression.[18]

As developed by Grossman and Libsohn, the documentary class was structured to get the students out photographing immediately and then to work on their comprehension of what, why, and how they should photograph. Strand employed a similar method in initiating Morris Engel to film work. When Strand casually offered to look at members' work, Engel called him:

> He agreed reluctantly; he was busy making *Native Land*. I came back to see him after he had looked at them. . . . He asked me if I wanted to make movies. I said yes . . . [so] he loaned me a camera and tripod and said to first shoot without film to get familiar with the equipment and then to come back and he'd give an assignment. . . . I worked for a couple of days and went back. He gave me $10 of film and said little else except, "Don't pan; don't jerk. Let action go into frame." I shot on my own and with him. It was a great emotional experience when I saw the rushes. The stuff looked great and he did use three seconds of footage for *Native Land*.[19]

Though Strand and the League shared the approach of throwing students into a task and then helping them refine their vision and technique, he was much more exacting about improving technique than anyone else associated with the League. Morris Huberland remembers that in Grossman's class "we didn't stress so much the technical," but Strand maintained high technical standards in both his criticism of students' work and in the example set by his own prints. Strand was distinguished by the meticulousness of his prints which, one critic said, he "polishes to a point of steely perfection."[20]

This difference is rooted in Strand's exacting tutelage with Alfred Stieglitz and his circle. Throughout the teens, Stieglitz challenged and encouraged Strand, periodically critiquing his photographs.[21] Talking with Stieglitz and viewing the exhibitions in his gallery, Strand slowly realized that

modern art, which had at first puzzled him, was a re-examination of real-
ity, a process of searching for new, twentieth-century forms of expression.
Strand's work never fails to offer the aesthetic pleasure of commanding
craftsmanship and formal beauty that reveals his debt to Stieglitz and mod-
ern art. While he felt an obligation to factual truth, and he wrote that "a
photographer must develop and maintain a real respect for the thing in
front of him,"[22] he also responded to truths expressed through beauty and
classic form. The beauty of his prints, as well as his emotional engagement
with their subjects, made viewers acknowledge their importance.

Some League members sought to emulate Strand's painstaking stan-
dards, including his preference for contact printing rather than making
enlargements. Others found themselves more in sympathy with photograh-
ers whose printing standards were less exacting. They preferred the care-
ful but more serviceable prints of other heroes such as Dorothea Lange.
Grossman, for instance, agreed with Strand that one must give dramatic
form to social analysis, but he found Strand's prints too precious and his
emphasis on print quality when teaching disproportionate to other values.[23]
Grossman's and Strand's conflicting views were manifest also in their
method of presenting prints. Grossman flush mounted his photographs on
Masonite and hung them without frames or protective glass, which
Grossman felt distanced the pictures from their viewers. Strand mounted
prints on clean white boards with generous margins around the image.
Like Weston and Stieglitz, Strand preferred this traditional way of present-
ing graphic arts, and he knew that prints on Masonite were more vulnera-
ble to damage.

One consequence of Strand's meticulous care with his prints was his
reluctance to make them widely accessible. He might graciously show stu-
dents his platinum and silver prints in his home but decline to lend them
for exhibition. Describing Strand's position, Elizabeth McCausland
explained, "The reasons are simple; in many cases he has only one print
from a negative, because he has not been able to afford time and labor to
make more, and he does not wish to risk this single print to the dangers
of careless handling."[24] Besides his concern for the prints, Strand dis-
trusted exhibitions as exploitative. "I have little interest in exhibitions [of
my work]," he wrote Ansel Adams in 1933, because they are "just a mean
and meaningless affair; mean in that they exploit the artists to entertain
the public free of charge — meaningless in that they seldom establish any
standards. . . . I can never get used to the idea that pictures are free enter-
tainment in the U.S., elsewhere too, that the people who claim to enjoy a
thing never support the individual who makes what gives them pleasure."[25]

The publicity for Strand's 1945 retrospective at the Museum of Modern
Art announced that this was his first show in New York since his 1932
exhibition at An American Place. Actually, in 1941 he allowed the Photo
League to exhibit his recently published *Mexican Portfolio* and his gravures
from *Camera Work*.[26] Photogravures were Strand's solution to the problems

of making his prints more available and selling individual prints at afford-able prices.[27]

Besides print quality, other issues which Strand usually discussed at the League were the need for an organic unity in the photograph, the relationship between photography and the other graphic arts, the potential relationships between texts and photographs, and the distinctions between what he called "expressive" documentary photographs and average photo-journalism. Each topic was discussed in terms of the compelling need for contemporary photographers to make highly crafted images that were both socially significant and personally expressive. In essence, these discussions continued the debate which previously had split the Film and Photo League.

Strand specifically addressed the issue of combining words and images in March 1940 when he reviewed Dorothea Lange and Paul Schuster Taylor's *An American Exodus*. He compared the relation between Lange's photographs and Taylor's social commentary with that between dialogue and photographic images in a documentary film. (Because Strand was in the midst of co-directing the film *Native Land*, these issues were fresh and pressing.) He proposed that in either a book or a film the structural foundation must be provided by the photographic images, while the text heightens and extends the individual and total meaning of the pictures. However, in *An American Exodus*, he observed, "many of the photographs do little more than illustrate the text. Or vice versa, the text at times simply parallels the information given explicitly by the photograph. Thus there is a tendency towards negation rather than active interaction between word and image."[28]

Though Strand applauded the collaboration as a valuable document of contemporary America, he also wished for more photographs possessing "that concentration of expressiveness which makes the difference between a good record and a much deeper penetration of reality," regretting that more of Lange's best pictures were not used.[29] He closed hoping that his criticism provided relevant considerations for Lange and Taylor's future books and for other collaborations between writers and documentary photographers or filmmakers.

Strand's review followed a symposium at the League on the subject of photographic books such as *An American Exodus* and Margaret Bourke-White and Erskine Caldwell's *You Have Seen Their Faces*.[30] At the heart of the discussion was the question how members could best distribute their photographs to "the great mass of people." Getting the prints out to the League's public and beyond was of immediate and constant concern. Although the symposium concluded that magazines were the best possible means for distributing photographs, the League never succeeded in acting as a photo agency to place the League's project photographs in magazines.[31] The only serious and sustained League effort to publish a book was made by Aaron Siskind's Feature Group, which included a writer

as well as a half-dozen photographers. During the symposium Feature
Group member Morris Engel commented that "it seems to be so very easy
to knock these books down, but all I know is . . . [the Feature Group is]
having a heck of a time putting one together."[32] Despite the limited audi-
ences attending the League's exhibitions, its exhibition program consistently
offered members more exposure than did publications.

Although the majority of the League's exhibitions used words only in
introductory passages, prints were occasionally juxtaposed with text and
mounted on panels, which were exhibited at the League and then circu-
lated to theater lobbies, union halls, libraries, and any other interested
community centers. Strand's remarks were also relevant to these efforts,
one of which had just been exhibited at the League. A month after
Strand's book review in *Photo News*, Elizabeth McCausland reviewed the
exhibition *The Chelsea Document*, with photographs by Grossman and Lib-
sohn arranged in a five-panel display. Although "text has been used ad-
mirably to knit together the photographic material," McCausland wrote,
"the written and painted material comes off better than the photographic."
Like Strand, she attributed weakness in the collaboration in part to the
uneven quality of the photographs, both conceptually and technically. And
she agreed that photographers should use only their best work regardless
of the point they wished to make. In praising photographs which were
excellent, she used the same word Strand favored, "expressive." Both writ-
ers meant expressive in the fullest sense, including personal, social, *and*
aesthetic content.[33]

Photography as a medium of expression was also the subtext of Strand's
review of Weegee's book *Naked City*.[34] In 1941 the Photo League gave
Weegee his first exhibition, and henceforth he was a member and resident
character. In 1945 *Photo Notes* republished Strand's review of *Naked City*, in
which he separates Weegee's work from most photojournalism because its
"poignant truthfulness" had the capacity to move, disturb, and even
frighten its audience. Instead of reportage, which Strand said "seldom does
more than describe what happens on a purely informational level and with
varying degrees of accuracy," Strand found in Weegee's book evidence of
an artist who had "produced a large and consistent body of work, . . . tied
together by an individual attitude." Therefore, he counted Weegee in the
tradition of documentary photography which he listed as passing from
Mathew Brady to Lewis Hine and Eugene Atget and then to photo-
graphers in the FSA and the Photo League. Strand identified the primary
unifying aim of this lineage as investigating the lives and environments of
people and explaining what was found in terms of its human conse-
quences. By this he meant that individuals should be shown undergoing
the social forces that shape their lives. Weegee's photographs, Strand
wrote, "seem to say, over and over again, 'Life should have some dignity.'"[35]

After World War II the League changed its mission statement. Its new
goal was to become a "Center for American Photography." Still predomin-

antly an organization of documentary photographers who believed in photography's persuasive power, throughout its new by-laws the League referred to "creative" rather than "documentary" photography, and Grossman dropped "documentary" from the title of his advanced workshop. The school no longer publicized itself as a training base for America's future documentary photographers; rather, it more nebulously offered "an opportunity for its members to develop an interrelated and personal creative approach to photography." Strand and other prominent photographers encouraged the League's new ambitions to broaden its outlook, but Strand also continued to emphasize how the artist is "affected by life, by the events of the world around him."[36]

To remind the group of its obligations as social chroniclers—and to raise money for its new headquarters—Strand screened his film *The Wave* in the summer of 1947. He stressed that the film had been made to "show the struggle of the people to better their social conditions" and identified two aims of the film that he felt were equally relevant to the League's own work. One was that film (and still photography) should reach its intended audience—in this case, Mexican Indians should be able to recognize themselves. And a film should be able to use aesthetically sophisticated elements and still remain intelligible to its intended audience.[37] Once again this discussion of artistic intent expressed Strand's commitment to embody both social concern and formal beauty in his work.

In concluding his thoughts on *The Wave*, Strand noted that making such a film in 1947 would be more difficult. "Culture," he said, "is moving backward in America today (as it always does in times of social and political reaction) and . . . the climate makes it difficult for the artist to work creatively and freely." These were prophetic words. Four months later, the League was blacklisted by Attorney General Tom C. Clark, who included the League with the Communist party, the Klu Klux Klan, the Veterans of the Abraham Lincoln Brigade, and ninety other organizations and schools on a list of totalitarian, fascist, communist, and subversive groups.[38]

Strand was the principal speaker at the special meeting called to discuss the League's response to the listing. Beginning with a historical account of America's increasingly reactionary post-war policies, he cited various political attacks on American art and artists, including the cancellation of a State Department tour of abstract expressionist paintings to South America and the recent indictment of the "Hollywood Ten."[39] The League, he said, was "honored by being placed in the front ranks of the fight for the Bill of Rights. It is our job to defend it, not only for ourselves, but for all the American people today. . . . As citizens we must do our part to change the complexion of a Congress and administration which permit and participate in the curtailment of basic American liberties."[40]

Following Strand's address, letters and telegrams were read from filmmaker Leo Hurwitz, artists Ben Shahn, Jack Levine, Philip Evergood,

and Robert Gwathmey, and photographers Eliot Elisofon, Dorothea Lange, Edward Weston, and Ansel Adams. They were indignant, supportive of the League's programs, and adamant that the League take action in its defense. Before the meeting's end, Strand and Nancy Newhall had drafted the following telegram to send to the Attorney General, New York congressmen, and local newspapers:

> We one hundred and three members of the Photo League assembled tonight at the Hotel Diplomat categorically deny the charges of disloyalty you have made against us. We consider your action made without specific charges, fair trial and opportunity to defend ourselves in the American way a grave violation of constitutional rights. We call upon you to retract the charge against us and restore these rights not only to us but to all Americans.[41]

Further defensive actions included an exhibition of the best League work, an article placing the League's documentary style of photography in historical context (Beaumont Newhall was appointed chairman of a committee to carry out this project), a letter to the Attorney General to be drafted by W. Eugene Smith and other members of the executive committee, and joining with other blacklisted organizations to send a delegation to Washington.

On January 29, 1948, the League rented the basement of the Hotel Albert on Tenth Street and began converting it into offices, exhibition space, classrooms, darkrooms, and storage for the Lewis Hine Memorial Collection.[42] Strand, continuing to lend support as a participant and advisor, showed *Native Land* in May, afterwards discussing the movie and its message about civil rights violations in America in relation to the Mundt Bill recently introduced in Congress. At the meeting's conclusion, members voted to send a resolution to the House of Representatives opposing the bill.[43]

In its fall issue, *Photo Notes* published excerpts from the Progressive party's plank on fine arts, authored by Paul Strand, which proposed a federal bureau of fine arts "to cultivate and disseminate our cultural wealth."[44] The goals of dissemination were to encourage American artists by helping them to reach potential audiences and to achieve economic security, freeing them to work. The plank also urged a revival of photographic projects similar to the F.S.A. Strand was still committed to the profound and sober chronicling of the external world and, as he stated in his lecture on *The Wave*, to reaching the audiences whose lives have been documented. In campaigning for the Progressive party candidate Henry Wallace and contributing to its platform, Strand was also following his earlier advice to the League members — "As citizens we must do our part to change the complexion of Congress and [the] administration."[45]

In "Paul Strand Writes to a Young Photographer," appearing in the same issue of *Photo Notes*, Strand expanded his discussion of an artist's need for an audience. As a consequence of a lecture by Ansel Adams at

the League in 1947, an exhibition titled *Two Schools* was organized, contrasting work by League members with that of students at the California School of Fine Arts, where Adams and Minor White taught.[46] Responding to a California student who had written Strand for a critique, Strand suggested that the young man lacked a point of view. Like many artists, Strand wrote, the student was uncertain what he wished to say "about the world of things and people in which you live. . . . The reasons for this lie, I think, in the social order: the lack of a definite audience and contact with such an audience, leave the artist somewhat out in space, almost a vacuum."[47] In the League, Strand had found not only a sympathetic audience for his work, but also a group that shared his belief in photography as a powerful medium for communication. For Strand, the accusatory atmosphere of the cold war was closing avenues of communication and creating an increasingly hostile and frustrating working environment.

One of Strand's last gifts to the League was to teach a class in spring 1949. In his critique of the California student's work, he had asked why landscape had been the sole interest of the entire class. "The life of the cities and the small towns, the water front, the farms etc," he wrote, "is conspicuously missing — what people do, what they build, what they work at." These were precisely the subjects to which Strand guided his own class, choosing an area of Manhattan situated between the Brooklyn and Manhattan bridges. "The people living in the area, its environs, and the relationship of the people to that environment" would be examined photographically.[48]

This project was more in the style of the pre- rather than post-war League. In the thirties, training documentary photographers to graduate into one the League's documentary production groups had been a major objective; numerous League members had staked out New York neighborhoods to photograph individually or as a group, producing such projects as "Chelsea Document," "Harlem Document," "Pitt Street," and "Park Avenue: North and South." But Strand's class was the only documentary group formed after 1947.

Strand stressed that the class must understand their subject matter and move beyond direct representation to an increasing awareness and intensity of experience, which he believed could be achieved through two primary tools. The students must first understand the roots of their art, not only in terms of photography's history, but also the history of all arts. Strand had often addressed this point at the League. In 1949 a symposium which accompanied the exhibition *This is the Photo League*, Strand had spoken from the audience, urging members to "go to the Metropolitan Museum. Aesthetics started in the cave and there are fundamental aesthetics that run through all art. We must utilize the medium in all its richness. A photographer must look at art of the past."[49]

Another point about which Strand was adamant: the whole space of the picture must be unified. Members of the class remember a specific instance

when he rejected a photograph by Sol Libsohn which did not meet that standard. The top half of photograph was very beautiful and touching, remembers Arthur Leipzig, but someone had created a blur across the bottom. "Libsohn defended his photograph," said Leipzig, "by saying that moments before or after there would have been no photograph; there was nothing he could do about the person who had walked in front. Strand's answer was, 'we will all take out the crying towels and weep with you and offer our condolences, but when you put a photograph on the wall it either works as a totality or it doesn't and all the excuses, rationale, and captions underneath will not make it any better.'"[50]

As Sam Mahl remembers, near the end of the class Strand said that he could no longer work in the atmosphere that prevailed in America; he was moving to France to begin a new book. In late June 1949 the League gave a going-away party for Strand. His class continued to meet informally in members' homes.[51]

By the League's end in 1951, Strand had been in France for two years, where the Rosenblums kept him informed of the increasingly grim details of the group's demise. As cold war tensions had increased, the pressures of the blacklist forced increasing numbers of League members to withdraw. Through the spring of 1949, the League managed to continue its exhibition and lecture programs with income from the school, but in April there were further public and highly publicized denunciations of the League's "un-American" activities. During the federal conspiracy trial of Communist party leaders, a witness who had once belonged to the League identified Sid Grossman as having inducted her into the Communist party.[52]

The knowledge that some of the League's members were also members of the Communist party and that some of the social changes and political causes the League had supported were also supported by the Communist party was more than was necessary to damage the League in these times, now known as the McCarthy era. Newspapers and magazines would no longer review League events or publicize its classes, and without media coverage, it was impossible to reach the new audiences the League had so optimistically courted. Membership continued to decline and the priority became not growth, nor even political change, but staying alive. Without membership dues or school tuitions, the League was unable to pay its rent or support its programs; it disbanded in the summer of 1951.

Whether or not the Photo League could ever have realized its post-war goal of becoming an influential center for American photography, there is no question that it did encourage and stimulate those who participated in its programs. Many fine and some great photographs were made by its members and under its auspices. But the compelling value of the League— as Paul Strand recognized and which he actively encouraged—was the education, not solely photographic, that it gave to a generation of young photographers in New York.

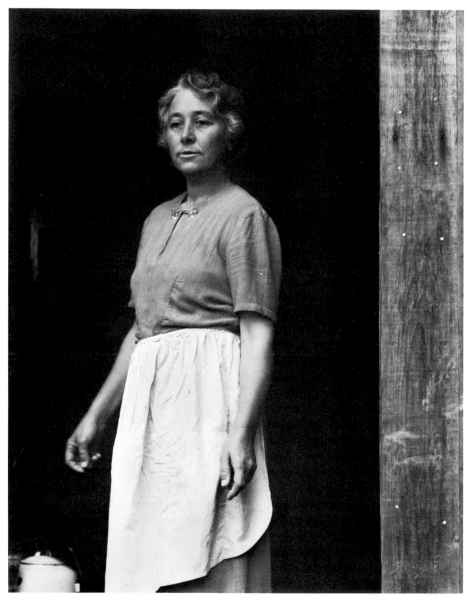

39. *Susan Thompson*, Cape Split, Maine, 1945

JIM HARRISON

Susan Thompson,
Cape Split, Maine, 1945

When I look at the photographs of Paul Strand, as I have done since the 1960s, I am invariably reminded of an old Buddhist adage, "ashes don't return to wood," which is to say, as an artist one must consume one's "self" entirely in the work. Basil Davidson pointed out of Strand, "The photographs seem to have come into existence without the camera. . . ." The photographs have been passed on to us as facts of nature, austere and somehow in an arena beyond the artful and humane, informed as they are by an unforgiving sense of authority. We are left wondering how work that so massively bespeaks genius may arrive in so utterly fragile a form.

When I look at Susan Thompson, the wife of a Maine fisherman, she effortlessly transcends my notions of lover, mother, sister, daughter, nor is she the academic abstraction known as the Eternal Feminine. She is Susan Thompson, and within the gift Strand has offered to us, she owns something of the Venus of Willendorf, Botticelli's Venus emerging from a shell, and the representations of the Brazilian goddess Imanja. But foremost she is Susan Thompson, and in this portrait a great artist has captured the immutable mystery of human personality. Susan Thompson, whoever she is otherwise, has become immortal, and while looking at her we only remember with specific effort that Paul Strand has created a photograph in which he neither dominates or obtrudes, but evokes.

I have often thought that any night I may be lucky enough to have Susan Thompson enter my dream life. Within the crush of our time it is fatuous to think of what we would take to a desert island where we are likely to find cigarette butts or theater stubs in the sand and hypodermics on the beach. But if I were condemned to whirl alone to death in a space capsule for an unnameable crime I would take along the photograph of Susan Thompson. I would look at her and remember the true character of longing, wondering if, indeed, she was the twin sister I was forced by my culture to abandon at birth. Perhaps while looking at her I would hear from the unknown peripheries of the photograph a crow calling, a screen door slam, a distant dog's bark. I would look at Susan Thompson and think, what a fabulous memory of earth. What more can any artist give us?

WALTER ROSENBLUM

A Personal Memoir

The year 1938 was, to paraphrase Dickens, the worst of times and yet the best of times. The Civil War in Spain was ending with a victory for fascism. Hitler and Mussolini were planning to conquer the world, and Japan had invaded China. The United States was in the midst of a dispiriting economic depression. On the Lower East Side, where I lived, my father supported a family of seven by peddling fruit from a pushcart. I was eighteen, trying to survive on a five-dollar-a-week job with the National Youth Administration. But 1938 was also the year that changed my life, for in that year I joined the Photo League, met Paul Strand, and discovered in photography my emotional center—the force that gave meaning to my existence.

I had been introduced to photography at the Boys' Club of New York, where I manned the switchboard. The Boys' Club sponsored a free photography class, which I joined, using an old roll-film camera that someone had loaned my sister. The class was on the most primitive level, without facilities or equipment. But my mother had just died, and I found the camera to be a true friend as I wandered the city seeking solace for my grief. When the class at the Boys' Club ended, I needed a place to work, and someone recommended the Photo League, a cooperative group of photographers that had darkrooms available to members. The League was easy to join; there were no membership restrictions. The only addition to the $5 annual membership fee was the ten-cent charge for chemicals used in the darkroom.

Located in a second-floor loft on Twenty-first Street and Fourth Avenue (now Park Avenue South), Photo League headquarters was not much to look at; the wooden floors sagged, the tin ceiling was in disrepair, and the walls were cracked and scarred. The Photo League, I soon discovered, had benefits other than darkroom facilities. It ran a school, issued a mimeographed bulletin called *Photo Notes*, exhibited photographs in a small gallery, and sponsored monthly meetings. Until it ended its existence thirteen

years later in 1951 (it was founded in 1936), the League was the center of my life.

Sid Grossman was the organizational genius at the League. Mostly self-taught, he was a talented photographer who understood the need for a group that could act as a center for an urban documentary movement. He saw the League as a place where young photographers could develop their talent and be brought into contact with progressive trends in photography. Under his direction, the school expanded, exhibitions reflected the best in contemporary photography, *Photo Notes* eventually became a significant publication of national merit (Edward Weston was to call it the best in the United States), and membership meetings featured a "Who's Who" in American photography. Sid, as well as guest speakers and faculty, did this without recompense and with no thought of personal reward. A superb teacher, Sid's educational philosophy and style influenced my own teaching for fifty years.

Paul Strand provided another dimension to my League experience. Even though he was involved at the time in film (as president of Frontier Films), Strand had remained close to still photography and had become a member of the Advisory Board that Sid had organized to provide guidance and support as we tried to find our way. As a beginner, I knew little about him—and nothing of his friendship with Stieglitz, his exhibitions at 291, the two issues of *Camera Work* devoted to his photographs, or his accomplishments as a major force in American photography. Nor did I realize at the time that while Sid was still gaining experience, Strand was already an acknowledged master.

In 1940, an irrelevant and out-of-date pictorialism, practiced by hobbyists more concerned with garnering awards than with portraying the life of their time, seemed to dominate the photographic scene. By contrast, our interest as photographers was to document our desperate time as best we could. It may be crude to say that for us art was a "weapon," but we hoped to strike back at a system that denied us jobs and a decent way of life. In Sid's view, the story was the important focus. All that made the photograph into a lasting image—the formal control, the sense of architecture, the aesthetics of print quality and color, were of lesser significance. Although he paid homage to the significant figures of history, he was convinced that our primary responsibility was to be true to the trauma of our own time.

Sid was not alone in this view. Elizabeth McCausland, a critic and theoretician for the documentary movement in the 1930s and 1940s, reinforced his position. In an article entitled "Documentary Photography," which appeared in the January 1939 issue of *Photo Notes*, she wrote:

> We have all had a surfeit of pretty pictures, of romantic views of hill-top, seaside, rolling hills, skyscrapers seen askew, picturesque bits of

life torn out of their sordid context. . . . [W]e want the truth, not rationalization, not idealizations, not romanticizations. . . . That truth we receive, visually, from photographs recording the undeniable facts of life today, old wooden slums canting on their foundations, an isolated farmer's shack, poor cotton fields, dirty city streets, the chronicles written in the face of men and women and children.

On the other hand, Strand, with his rich and varied experience, urged League members toward a less doctrinaire view, presenting photography as a medium in which everything becomes photographable provided something of significance is communicated. Strand made us aware of an aesthetic and philosophical overview we would not otherwise have known. His task was not a simple one, for a small, intractable faction in the League regarded his ideas and images as escapist. Influenced by the Andrey Zhdanovian view of "formalism," which had become popular in the Soviet Union at the time, this group questioned the value of photographing, for instance, a cobweb in the rain when people were without jobs or viable futures. Strand had lived through the early days of cubism at 291; the pictorial language of Picasso, Braque, and Matisse were part of his aesthetic background. Zhdanov's narrow view of art was held in great disdain by Strand, who recognized that this parochial "socialist realism" would be of little value to the development of art in the Soviet Union. When Strand went to the Soviet Union to work with Eisenstein, it was the "Zhdanov" viewpoint that kept him from getting the necessary work permit.

As a kind of graduation present, the final session of Sid's class was held at Strand's apartment, where we were to meet this magical personage and look at his work. Strand, who greeted us warmly at his home near Washington Square Park (in a lovely neighborhood that was a far cry from my tenement home on the Lower East Side), was of medium height, with thinning gray hair and unusually long sideburns. He had a slow and considered manner of speaking and a strong sense of self. As young as I was, I recognized that Strand knew who he was and what he had accomplished. This knowledge gave him a kind of strength and inner dignity, qualities I had not experienced often in my own uneasy environment, which impressed me greatly.

Strand wore a fine British tweed jacket, a dark blue finely woven woolen shirt, a colorful paisley tie, and good gray flannel slacks. I recognized that he was truly well dressed because before the Great Depression my father had been a machine operator on men's clothing and had made me aware of fine fabric and tailoring. I later learned that admiration for fine craftsmanship was a hallmark of Strand's character and that he extended the love and respect he brought to his photographs to all the material things of life. For him, there was no room for the shoddy or the meretricious.

My nonexistent art background did not prepare me for walls that were

covered with watercolors, drawings, and paintings, or for the sculpture and other art objects. Works by John Marin, Arthur Dove, Marsden Hartley, and Georgia O'Keeffe hung alongside a Strand portrait of Gaston Lachaise. I recall that a Lachaise sculpture and two pieces of driftwood were arranged on a chest.

Seating us around a straight-back chair set up as an easel, with a reading light for illumination, Strand displayed his photographs. He started with a 4×5 inch landscape from New Mexico, which depicted some sagebrush, sand, and clouds in the sky. There followed an image of a window in an old barn, a close-up of driftwood, a fisherman's house in Gaspé (which would be my wedding present some ten years later), and a cobweb in the rain (see figures 40, 41, 42, and 43). But while I now recognize the significance of this event in my life, it would be false to say that a lightning bolt descended from above or that I was transfixed by what I saw. No instant revelation occurred, because I really did not understand what I was looking at. I knew about life on the Lower East Side, and all else was a mystery. In retrospect, I realize that Strand knew that his subject matter was not ours. He might have shown us the blind woman newsdealer, Five Points, or Forty-second Street, but he wished instead to lead us beyond our limited experiences, to show us that there was more to life than the tribulations of living on the Lower East Side.

Strand did not attempt to denigrate our experience; in fact, he was to devote more than a decade to producing films with serious political content. He was certainly not an escapist and, throughout the many years of our friendship, he was sensitive to political issues. But since he was a gifted teacher, he was trying to speak to us of the fullness of life, of its richness, of the vast canvas it provides the photographer. He was offering us the gift of his vision and taking us places we had never before visited. And he did so in prints of such a range of gradation, tonality, and print color as we had never before seen. His words lifted us beyond considering photography as a mere tool in the class struggle.

Strand spoke to us of the photographer as an artist who could create original works that might live on a wall alongside a Goya or a Rembrandt. He spoke of the complexity of form and shape and value, of controlling these elements within the frame, of the beauty of print quality. He spoke of the photographer's need to explore all aspects of life. I understood little of what he was saying, but subconsciously his words and presence affected me deeply. This was a new area of knowledge and experience that I was soon determined to explore more fully.

When Grossman showed Strand the work of our class, I waited eagerly to find out what he thought of the photographs, and even though this event occurred more than fifty years ago, I remember vividly both my disappointment when Sid returned without our photographs and my determination to find out the master's judgment as soon as possible.

142

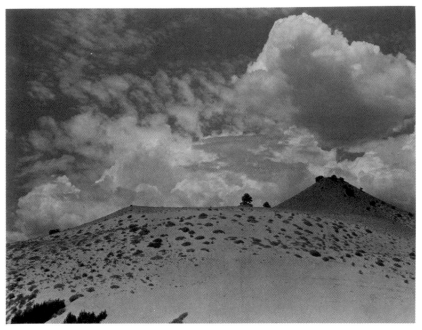

40. *Dunes near Abiqui*, New Mexico, 1931

The folly of youth: early the following Sunday I returned to that art-filled apartment, rousing a tired-looking, unshaven Strand, who appeared in a rumpled bathrobe. When I reintroduced myself and asked about my photographs, he offered to fetch them; but with an arrogance that I had not thought part of my character, I inserted myself into the doorway and asked to discuss them. I suppose he recognized the emotional overtone in my voice because he invited me in, and the visit initiated a friendship that, lasting until his death, helped me to become a better photographer.

Again the chair and the lamp were set up, this time for my photographs. Strand was a gentle man, but where photography was concerned, there was only the truth as he saw it. The first photograph, one I was especially proud of, was of a group of people seated in front of a synagogue on the Lower East Side. It had been made as part of a class project, a series called "Pitt Street." Taken on a Sunday morning on a summer day, it depicted two young women sunning themselves, their eyes closed as they faced into the sun, and two young men, very much "on the make," who were ignored by them. Older women on each side of the four figures were engaged in conversation with each other. Looking at the photograph, Strand remarked that the spiked forms of the fence distracted the eye from the figures. This observation surprised me because I had not noticed the fence either when I took the picture or printed it; my interest had been in the casual relationship among people relaxing in the warmth

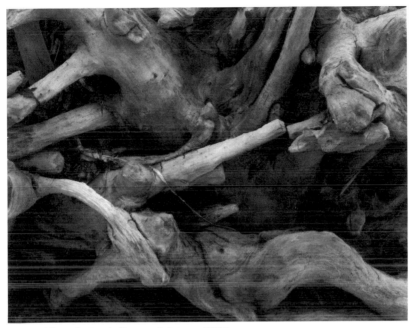

41. *Driftwood*, Dark Roots, Maine, 1928

of the sun. Does he want me to remove the fence before I can make the photograph? was my unbelieving reaction. This was the first of many lessons that I was to be given over the years. As I later recognized, I was being told that a photograph is more than just a snapshot, that the photographer's responsibility is to see that everything in the image is fully integrated into the final statement.

In another photograph, women were seated around a baby carriage. Strand spoke of the rhythm of forms in this image, pointing approvingly to the use of space and my control over the organization of the formal elements. And so we went through the "Pitt Street" group, photograph by photograph. "Visit museums," he said. "Study paintings. Study El Greco's *View of Toledo*, for it is a perfect resolution of the landscape problem. Photography is just another way of organizing a two-dimensional space." Most of this was new to me, and my first reaction was disbelief at the nature of his criticism. I was upset that he did not seem to understand my attempt to be true to the life of the street. But in time, as a result of this experience I began to think of photography in a completely new way.

The relationship of subject matter to form and philosophical content had been Strand's concern ever since Lewis Hine had introduced him to Alfred Stieglitz at 291. If the term "documentary photography" was to have any precise meaning, he said, it involved the relationship of the photographer to his environment. But its weakness was the tendency to

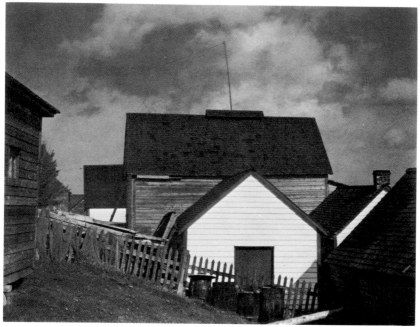

42. *White Shed*, Gaspé, 1929

rely entirely upon human interest while ignoring basic aesthetic problems. In his view, the failure to be concerned with the elements of form, texture, line, and the full tonal scale of the print produced too many photographs that exhausted themselves quickly. Strand believed that however interesting documentary photographs might be in journalistic or even historical terms, they often were insufficiently realized.

Strand's interest in documentary photography was more than superficial. It prompted him to write a review of *An American Exodus* by Dorothea Lange and Paul S. Taylor (*Photo Notes*, March/April 1940) in which he used his own background in documentary film to analyze the problems of combining images and text. Publications that combined pictures and text in this manner were comparatively new and, in my view, Strand's analysis was the most provocative of its type to appear in print. In fact, Lange was so interested in Strand's comments that she went to see him with her work and has been quoted as saying that the visit was important to her development as a photographer.

There were many ways in which Strand contributed to the education of young Photo League members. He was always available to young photographers for help and assistance; Morris Engel, Jerry Liebling, Dan Weiner, and others had experiences similar to mine. For example, the catalog introduction Strand wrote for an exhibition of the work of Morris Engel at the New School for Social Research (reprinted in *Photo Notes*, December

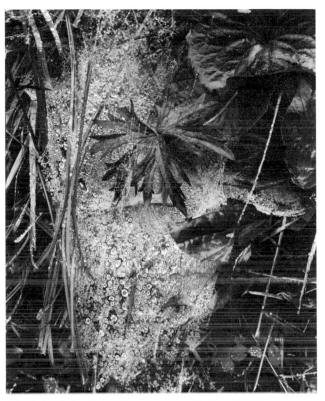

43. *Cobweb in Rain*, Georgetown, Maine, 1927

1939) was both supportive and helpful because it allowed Engel a clearer perspective on his own work.

That Strand was held in high esteem by League members is seen in the many references to his activities in *Photo Notes*. *Native Land*, the film on which he and Leo Hurwitz collaborated, was reviewed in the May 1942 issue of *Photo Notes*. In October 1946, *Photo Notes* reprinted the speech Strand had given at a memorial meeting for Stieglitz, and the May–June 1947 issue reprinted an article he had written for *Camera Work* in 1916. In 1947, Strand wrote again on Stieglitz, and in the July–August issue, Leo Hurwitz's introduction to Strand's portfolio of Mexican photographs appeared. In June 1945, *Photo Notes* announced a meeting to celebrate the opening of the major Strand retrospective at the Museum of Modern Art. The August 1945 issue reprinted his review of *Naked City*, which had appeared earlier in the newspaper *PM* and was the first critical recognition of Weegee as an important American photographer. In each of these instances, Strand's writing helped clarify our understanding of the relationship between social themes and photographic matters.

On December 4, 1947, an event occurred that was to shape the future of the Photo League and ultimately cause its demise. A special board appointed by President Harry S. Truman to examine the loyalty of federal government employees released to the press a list of "totalitarian, fascist, communist or subversive groups" prepared for its guidance by Attorney General Tom Clark. In what constituted the first blow in the cold war, the Photo League found its own name on this blacklist together with the Communist party, the Ku Klux Klan, the Civil Rights Congress, the Joint Anti-Fascist Refugee Committee, the Veterans of the Abraham Lincoln Brigade, and groups that no longer existed. Since we were active as a photographic group, limiting our endeavors to our own field of interest, we could not understand why we were associated with political organizations. The executive committee of the Photo League promptly issued a press release categorically denying "totalitarian, communist, fascist, or subversive activities" and called a special membership meeting to discuss the action the League might take, at which Strand was the featured speaker.

Strand's remarks can be read in their entirety in *Photo Notes* (January 1948). In my opinion, his talk was (and remains) one of the very finest defenses of civil liberties. He enumerated the frequent violations of civil liberties taking place in the United States (which he had documented in *Native Land*), the cancellation of exhibitions of American painting in Europe by the State Department, the banning of books, the imprisonment of the Hollywood Ten, and the use of "red-baiting" to divide and confuse people. Strand discussed the general onslaught against liberal culture and urged that the League and its activities be expanded in response.

The Photo League rallied from the attack. Its membership grew stronger; it moved to new headquarters; the school expanded and so did *Photo Notes*, becoming a printed publication. But as the cold war continued and members began having trouble securing passports or were denied jobs or made uneasy by the political climate, they felt forced to resign. Notables who did so were Ansel Adams, Barbara Morgan, and Beaumont and Nancy Newhall; others such as Edward Steichen and Roy Stryker promised support that never materialized. Strand (and Weston and Lange) continued the struggle up until the end, resisting the atmosphere of fear that descended not just on the League but on the nation. But by 1951, the League had lost too many members to maintain itself physically and was forced to close its doors. By that time, Strand himself had left the country, taking up residence in France.

In concerning himself with the Photo League, Strand had found a means to help a group of inexperienced photographers to understand photography as a significant means of expression. Unlike most of us, he had a sense of history. He spoke to us with reverence of David Octavius Hill and Robert Adamson, of Eugene Atget, of Stieglitz and Hine. He proposed photography's value to be, in his words, "as a medium of expression

in the sense that paint, stone, words, and sound are used for such pur-
pose. In short, as another set of materials which, in the hands of a few
individuals and when under the control of the most intense inner necessity
combined with knowledge, may become an organism with a life of its
own."[1] Strand set for us the highest standards and provided a goal to
which we could aspire. He recognized the potential of documentary photog-
raphy but also realized that we were not giving it its full measure. He
made it his business to see that the concerned photographers of that era
were involved with the picture as well as the cause.

WILLIAM ALEXANDER

Paul Strand
as Filmmaker, 1933–1942

Whearly 1935 Paul Strand began to attend meetings of
Nykino, an outgrowth of the New York Film and Photo League,
he was beginning an association that would last seven years. He
felt "welcomed" and was "very glad to be close to them, because what they
felt about filmmaking and what they wanted to do with films was very
near to my own feeling."[1] In a time of political ferment, he was seeking
in film to bring his work and politics to a wider audience.

Strand had recently returned to the United States. Late in 1932 he had
traveled to small Mexican towns to photograph what he considered the
impressive spirit of the Mexican people, and he mounted an exhibit in
the Sala de Arte of the Secretariat of Education in Mexico City, a long,
awkward room forming a natural passageway between two downtown
streets. Through this room passed "Indian women with their babies,
policemen, soldiers, workers, businessmen, all kinds of people," who
would stop and scrutinize the photographs, an experience new to Strand
and one he found "very satisfying." This contact with a popular audience
led him to assent to Carlos Chávez's request that he become chief of
photography and cinematography in the Department of Fine Arts in
Mexico's Secretariat of Education and that he make a film, the first of a
projected series on Mexico.[2]

It was a return to filmmaking. Eleven years earlier, in 1921, he and
Charles Sheeler had created *Manhatta*, a fascinating, sometimes tantalizing,
lyrical documentary on New York City, carefully built into exquisite vari-
ations of movement, angle, and pattern. He had gone on to become a
sports cameraman for Fox and Pathé and a maker of background shots
for Famous Players and Metro-Goldwyn. Since the late 1920s, however,
his work and his growing reputation had been in the field of still
photography.

Aware of the recent revolution in Mexico and fascinated by the way
José Clemente Orozco, Diego Rivera, and David Alfaro Siqueiros, the great

muralists, had committed their art to its service, Strand quickly decided that the films should be made primarily for the sixteen million largely illiterate Indians living in Mexico and that they should focus on exploring the problems they encountered when attempting to realize the objectives of the Revolution. Chávez and his superior, Narciso Bassols, agreed, and they suggested a series of films treating the production of wealth in Mexico, "the raising of corn, cattle breeding, mining of silver, fishing, and so forth."[3] In the first days of February 1934, Strand moved with his film crew into quarters in the tiny fishing village of Alvarado, taking a rickety streetcar ride there from Veracruz, traveling forty kilometers "through a bit of jungle and past a few scattered Indian villages,"[4] to work for the next eleven months on *The Wave* (*Redes*).

The story line of *The Wave* to some extent follows what is known in proletarian literature as the conversion formula. The fish have not come in, the pay is so low that there is nothing to tide one over from haul to haul, and Miro's son is ill and needs hospitalization, which Miro cannot afford. There is no more work in town. The fish buyer, Don Anselmo, refuses to help, and Miro's son dies. The fish finally come in, and in the excitement of the detailed and magnificent full-scale fishing scene, we thrill to the beauty, skill, and vigor of the fishermen and also learn how difficult and demanding their work is. Their joy in the catch vanishes when they each receive but seventy-two cents for the ten hours of work, at which Miro explodes into an argument with Sanchez, the politician friend of Don Anselmo. Miro gathers the workers at the dunes, speaks to them about their exploitation, and advocates united action. Sanchez struggles through the crowd to make a divisive speech that affects Miro's nonpoliticized co-worker Miguel. Not hired onto a boat the next day, Miro joins his friends at the weighing-in to advocate dumping the fish in the river if the price remains low. Miguel and his companions refuse, are called scabs, and a fight breaks out. Under cover of the combat, Sanchez shoots Miro and the bosses weigh the fish, then offer Miguel and his men the money for them. These events and this further, blatant effort to keep the fishermen divided, convert Miguel, who joins the protagonists in brotherhood and takes on the group's leadership. The fishermen of Alvarado gather as Miro's body is carried to the boat. As the boats move, united, toward town, the scene is accented in numerous shots and some lingering dissolves with Miguel depicted against the clouds. The final shot holds on a wave that piles up very slowly, forms, and then breaks, a perfect reflection of the film's pace and a moving symbol of the slow but inexorable rise of these people to revolt.

Although Fred Zinnemann directed, Gunther von Fritsch edited, and Henwar Rodakiewicz played other significant roles, Strand conceived the film, supervised the entire production, and served as cameraman on all except the water close-ups.[5] The film is very much a Strand film. During

44. *The Wave*, film still by Ned Scott 45. *The Plow That Broke the Plains*, film still

the funeral procession for Miro's son, when the camera captures for a moment a woman standing in a doorway with her children, it is possible to feel that Strand is quoting his own still photographs of the Mexican people (his *Photographs of Mexico* portfolio, for instance) and implying that through movement and story he is now exploring what lies behind those faces and buildings. True or not, Strand's photography is evident throughout *The Wave*, for he composes with light, line, and frame very carefully, he lingers, and his actors move slowly. In fact, one frequent compositional method imposes upon the film a specifically static sense: many shots begin with a single, posed figure in close-up or medium close-up; movement in the shot then consists of a single movement of the head. Variations on this composition occur in shots containing two or three people as well as larger groups (see figure 44).

His moments of relevant yet pure composition make us catch our breaths and draw us in toward the film, the village, its people. And the slow, sensitive, molded treatment of faces and figures—what Archibald MacLeish called Strand's eloquent and moving respect for his material— also absorbs us, creating sympathy and identity. Sidney Meyers, connecting Strand's still work and this film, found that Strand had "always spoken of one thing predominantly—the dignity of human life and of the things man has made that reflect his image."[6]

That Strand's respect for people had a new edge during the worldwide Great Depression is clear in the film's insistence on change. As Miguel leads Miro away from his dispute with Sanchez, he observes with acquiescent, bitter philosophy that "the big fish eat the little fish." Miro replies, "Yes, but *we're not fish*." As they exit the frame, the camera holds on the weighing hook. This image may undercut Miro's exclamation and foreshadow his death, but it also asks the direct political question—will the fishermen allow the fish to be weighed under present conditions?—and connotes men now being weighed in the balance. Consciousness of this issue and the explosiveness of events prepare the viewer both to *will* the

46. *Native Land*, film still

confrontation implicit in those boats heading toward shore and to be op-
timistic about the outcome.

We know Strand's aesthetic and political purposes. He told the Secretar-
iat of Education that he would follow Robert Flaherty in making docu-
mentary stories about human struggle, although now not against natural
but rather social and economic forces. The drama would engage the
fishermen, farmers, and miners, making it easy for them "to find in the
films some reflection of their own lives, and above all their own problems,"
"struggles and aspirations." Like Flaherty, and consistent with his photo-
graphic work, Strand would approach his subjects "as a fellow human
being, not as a superior example of the white race who found them 'in-
teresting, picturesque and acute.'"[7]

Soviet films such as *Potemkin*, *Storm Over Asia*, and *Road to Life* inspired
Strand because of their content and especially because they used all the
elements of filmmaking. With his own finely tuned photographic sensibil-
ity, the most developed techniques of film montage, and the effects of
pace and the juxtaposition of shots of varying angles and movements, he
intended both to convey a respect for the subject and to heighten the in-
tensity of the audience's participation, the "dramatic impact." Thus his
films would speak "to people about themselves in a way in which they are
moved and activated to do something about their lives." Filmic beauty was
compatible with a certain bluntness of content. "We assume," he told
the Secretariat,

that these pictures are not being made for subtle and sophisticated
people or even very sensitive minds accustomed to follow the intricacies
of esthetic nuance. On the contrary, we assume that these films are

being made for a great majority of rather simple people to whom elementary facts should be presented in a direct and unequivocal way; a way that might even bore more complicated sensibilities, though we believe otherwise. We feel that almost a certain crudeness of statement is necessary to achieve the purposes of these films.[8]

Strand returned to New York in December 1934, where several conversations with Harold Clurman and Cheryl Crawford sparked his interest in a trip to the Soviet Union. Before he left in May, he joined Leo Hurwitz, Ralph Steiner, Lionel Berman, Irving Lerner, Ben Maddow, and Sidney Meyers at several Nykino meetings. Upon his return from the Soviet Union, where work-permit difficulties frustrated his attempt to work with Sergey Eisenstein on his newest film,[9] he joined the organization, commencing an affiliation that would endure until 1942.

Nykino drew Strand because the members shared his progressive political views and were political activists in the filmmaking field. Their theory about the kind of films that needed to be made was remarkably close to his own. In a September 1935 article, Leo Hurwitz and Ralph Steiner laid out Nykino's developing aesthetic, which would take them beyond "the present low level of the revolutionary film," the level at which they felt the Film and Photo League newsreels had remained. They criticized the 1920s film, which had been "depersonalized, inhuman; the THING, technique and formal problems were supreme. Even people were considered externally," and "the audience got next to nothing out of it." Such experience had led them, as they moved to social-political documentary film in the 1930s, to concentrate on shot construction and especially on montage.

> In brief this was our approach: you were going to do a film about the Scottsboro case, or New York Harbor. You knew what the film was going to say. Then you took your camera and attempted to capture [as] completely as you could the most meaningful visual aspects of reality. Then, to the cutting room, where you pieced the film together in a brilliant and cogent montage to make it a moving document of life. Only somehow it was never really moving.

A Lee Strasberg course in theater direction, which Strand and Hurwitz had attended in early 1935, had taught them that "film as a dramatic medium cannot merely concern itself with external happenings . . . but must embody the conflict of underlying forces, causes," that film must emotionally involve the audience, and that dramatic structure and three-dimensional human understanding, complexity, and realism would make that involvement possible. Only with these characteristics, they said, in words remarkably similar to those of Strand in Mexico, could "our revolutionary viewpoint" be carried "to an increasingly receptive audience, one that is really moved because in the life on the screen it finds its own aspiration and struggles, its own failures and successes, its own truths."[10]

In September, Strand, Hurwitz, and Steiner went west as cameramen for Pare Lorentz's United States Resettlement Administration film, *The Plow That Broke the Plains*, a traumatic experience that both clarified Strand and Hurwitz's vision about America and strengthened their determination to consolidate their own collective work. Lorentz, no sympathizer with the radical left but an admirer of Steiner's and Strand's photographic skills, solicited from the Nykino trio an initial, advisory outline for the film. The outline they submitted was very direct in its indictment of the ranchers for the exhaustion of midwestern soil and far from what Lorentz intended for his film. He delivered his own shooting script to the three as their train headed west, a script they found "wild and private" and technically useless, departing as well from their own anticapitalist line. Wiring Lorentz that they could not shoot from his script, they wrote up their own with great excitement, drawing on the principles of their original outline: it was a chance to "put into practice the ideas [they] had been germinating," to design the film "with image and word and sound—as a chain of interactive needs progressing toward a resolution." Lorentz, however, was "fit to be tied," tore up the script, and gave Hurwitz and Strand the choice of a paid trip home or recognition of their subordinate position on the project, a position they accepted begrudgingly. Lorentz sent the two off to film dust storms and their effects, and he himself teamed up with the more pliant Steiner for the filming of other sequences.[11] Hurwitz, Steiner, and Strand told Lorentz they were not certain they wanted credits on the film, but when they saw how brilliantly *The Plow That Broke the Plains* was put together, they agreed to have their names on it. The film had private showings in the White House, in Hollywood, and in New York in early March 1936, and a Washington, D.C. official premiere on May 5; then it went into general distribution, gaining high praise and a very substantial audience (see figure 15).

Lorentz's film was, he said, "a melodrama of nature. . . . "Our heroine [is] the grass, our villain the sun and the wind, our players the actual farmers living in the Plains country." Critical of land waste, *The Plow That Broke the Plains* nevertheless fully admired the United States and the resourcefulness of its settlers, inventors, and industrialists. Nykino did not lack appreciation of the resourcefulness of immigrants and settlers, but they had other villains in mind, and Strand told Lorentz that "it was a pretty picture, but . . . the guts had been taken out of it."[12]

The difference was a very basic one. Lorentz, from a comfortable family that had settled in Virginia before the American Revolution, was appalled that the Nykino trio wanted the film to be all "about human greed, about how lousy our social system was."[13] But most of those who had gravitated to the Film and Photo League and Nykino had lived in another America than the one Lorentz lived in. Most had suffered poverty, discrimination, and alienation, and Strand, though his background was more affluent, was in complete empathy with them. They were all far less likely than Lorentz

to cherish the United States as *their* country. Rather, they were devoted to changing it in the interests of the oppressed. Members of the Communist party and fellow travelers, they understood their work as part of a movement for revolutionary change in this country. Thus, like Lorentz, they struggled against what they disliked about the United States, but their backgrounds, temperaments, and political solidarity endowed them with slightly more cynicism and bitterness, and a sharper eye for evil. Such a vision would underlie especially the films dominated by Hurwitz and Strand.[14]

Nykino produced two sequences of a newsreel, *The World Today*, an answer to *The March of Time* intended to move the audience to political action. When *The Wave*, delayed by the new Mexican government, arrived, the two productions were previewed at the end of 1936 for an audience interested in progressive films. The enthusiastic response brought enough money and moral support to launch Frontier Films.[15]

Both films went to public theaters, and Frontier Films published a brochure. On its cover were a quotation from Archibald MacLeish ("a bold new step in the field of American movies") and a description of Frontier as "an independent, nonprofit motion picture organization devoted to the production of realistic films of American life." The brochure attacked Hollywood's avoidance of poverty, celebration of individualism, and glorification of "the racial barriers, militarism, imperialism and nationalistic chauvinism" that "have succeeded only in bringing us to the brink of another world war." Frontier would wield film's power "consistently on the side of progress." It would reflect truthfully "the life and drama of contemporary America" and incorporate the "great new mine of material" Hollywood neglected. Strand was president of this new organization, Hurwitz and Steiner vice-presidents.[16]

Why the shift from Nykino to Frontier Films? For one thing, it was a new start, an effort to grow, to solidify "all progressive film forces in the East," to bring in writers including Vera Caspary, George Sklar, and Donald Ogden Stewart, and a new start merited a new name and new organizational structure. And why "Frontier Films" in particular? While on location on Lorentz's film *The River* on February 1, 1937, Willard Van Dyke, a new member of Nykino, posed a rhetorical question then familiar to people of many political persuasions: How, in a country of "scheming merchants," was one "to re-create the vision of the pioneer?" For the newly formed film group, this vision was to be re-created in labor's struggle for equal rights and in the discovery, through that struggle, of cooperation as a way of life. Accordingly, they would make films on the frontier of the labor battle, in support of industrywide unionization under the CIO. And they were, after all, film pioneers: left independent production had never before succeeded in the United States; the industry had barely touched their material and point of view; and, scornful of Hollywood art, they were devising an original film aesthetic. Dovzhenko's *Frontier* influenced

the name as well, for they aspired to the poetry and depth of his political art. And the name reflected certain political realities. The Communist party had moved from the hard-line into the popular-front era: Nykino was a name derived from Soviet cinema, whereas Frontier Films was a name that echoed both general United States aspirations and the popular "front" itself. Furthermore, the name was in part a response to the increasing anti-Communist attacks against the left. As Hurwitz has explained in relation to Frontier Films's *Native Land*, the name asserted vitally American roots and was meant to challenge the assertions of those who were eager to brand them "un-American."[17]

It is not easy to distinguish Strand from Nykino and Frontier Films: the group worked collectively and shared convictions, and thus in large part Frontier Films represents Paul Strand. Yet he was a particular force within the group, and we have testimony about the part he played.

He brought with him the revolutionary viewpoint and cinematic method of *The Wave*. He also brought the qualities that had gained him stature as a major American photographer. In Leo Hurwitz's words:

> He had the feeling . . . that once you took an idea, you put your teeth in it, you worked with it, you took responsibility for all its corners. . . . I learned from Paul that you don't let the first, second, or third brilliant idea say it's done. You constantly question it, let it talk to you.[18]

Almost legendary for the time he devoted to print character and to the quality of a single still photograph, Strand on location for Frontier's final film, *Native Land*, would put the same time-consuming perfectionism into the composition of each shot.[19]

He also brought the forcefulness of his personality, a certain distance, and a definite dominance. The younger people in Frontier Films were very close friends and spent their spare time together, whereas Strand was seldom present at social activities and remained a bit removed, an elder statesman the younger filmmakers looked up to. He and Hurwitz were seen as the "upper house" of Frontier Films, as "two fathers" (and Strand "a rather remote father") to whom the decisions of the others "were essentially the contributions of promising sons." They were the "motor force" of Frontier Films and it was their "fierceness of decision" that moved the group forward.[20]

This dominance also took its toll. When Hurwitz, without consulting them, completely changed a montage sequence for *China Strikes Back* set up by Meyers and Van Dyke, in 1937, Van Dyke was enraged. He was angered a second time when Strand took him off camera for Frontier Films's major project, *Native Land*. When Hurwitz and Strand unilaterally converted Vera Caspary and George Sklar's shooting script dialogue for *Pay Day* into "stilted expository lines," a slam-bang fight ensued and the film was never made.[21]

Frustration with their subordinate positions and the difficulty of living hand to mouth led Van Dyke and Steiner to a bitter split from Frontier Films. An underlying cause of their departure was a difference in politics and in vision. According to Hurwitz:

> [T]hings were getting hot. The Dickstein Committee, the Dies Committee nearly formed, the right-wing unions: there was much in the air. The ACLU was reluctant to sponsor *Native Land*: they feared it was too left, too labor conscious. And Steiner and Van Dyke felt it all was too dangerous, too left, too scary.

Both Van Dyke and Steiner in later statements suggested strong Communist-party control over the films. Steiner, for instance, told James Blue that "everything had to be approved by the party," and he told me that the extra footage required for *People of the Cumberland* consisted of "revolutionary shots" insisted upon by the party, an assertion that enraged Strand when I questioned him about it. It is probable that Steiner and Van Dyke attribute to the party a degree of influence it did not have. When I asked Van Dyke for evidence of a heavy political hand in the films, Van Dyke confessed it was not there.[22]

Hurwitz has another explanation of party influence:

> My feeling at the time was that the Communists had the best grasp of the world, the fight against fascism, and so forth. This didn't mean I was not critical of various things, as many Communists were. So having a central set of political values to estimate things was an important part of *my* work at Frontier Films. . . . On the other side, in terms of party politics and control, there was no external influence or manipulation. I knew of such manipulation on magazines like *New Masses*. . . . We never had that. And one of the reasons was that we never asked for it. . . . The work of Frontier Films became highly valued in party circles. . . . But we were rather severely left alone.[23]

All the members of Frontier Films (including Van Dyke) shared with the party a commitment to a Loyalist victory in Spain, a Chinese victory over Japan (although interest in the eventual control of China by the Red forces would vary among members), the growth of the militant trade unions, and other general domestic struggles against social inequality. Because of this commitment, the party valued the work of Frontier. But the same commitment was also shared by many anti-Communists (like Van Dyke) who also valued the films. Although party member John Howard Lawson's name was on the Frontier roster from 1936 to 1941, so was Archibald MacLeish's. The fact that the films were not hard-line politics and the fact that they were admired by a wide spectrum of people on the left suggests the relevance of Hurwitz's statement that, at the time, the party seemed to offer the best grasp of the world.

But Steiner, who was not very politically aware, and Van Dyke, who

disliked the Soviet Union after his 1935 trip there, also tended to see the
political differences in the group more in terms of outlook than in terms
of party. According to Steiner, what happened to him and Van Dyke "was
that we saw they wanted to say everything's terrible in America." And
according to Van Dyke, Strand's worldview held an undemocratic bitter-
ness.[24] There is much to this: the outlook of *Heart of Spain* and *Native
Land*, the two films dominated by Hurwitz and Strand, *is* different from
the Nykino and Frontier films, involving at least three of the following
people: Elia Kazan, Irving Lerner, Jay Leyda, Sidney Meyers, and Ralph
Steiner (Maddow worked on all of these films). *China Strikes Back*, for
example, manifests a relaxed, easy-going humor, a particular quality of
sympathy lacking in those two films. In the Hurwitz-Strand films, Spanish
country children jump rope, an American farmer plows his land, a city
girl washes windows and sings. In each case one feels warmth toward the
people, feels how beautiful it is to do such things and to be happy, but
always there are ominous undertones, for these scenes are almost inevitably
permeated with dramatic tension: the bombers will come, the thugs will
drive up, the corpse will be found, and the movement to such events is
implicit in the presentation of the happier moments.

Hurwitz, however, defends the work and vision he and Strand fought
for. Steiner and Van Dyke, not realizing what was at stake, were not
strong enough to stick with it:

> Frontier Films was starting something new. It was a collective, with
> people working together, individual strengths being very important. It
> was a collective venture based on the idea that much was wrong with
> American life which required radical change socially, and that much
> was wrong with the movies which required radical change.[25]

To stick with it took the incredible determination of Strand and Hurwitz
and the loyal staying power of the others. *Native Land*, based on the U.S.
Senate's La Follette Committee findings concerning union busting and the
tactics of massive corporate labor spying, took four and one-half years of
the creative lives of Berman, Hurwitz, Maddow, Meyers, and Strand. Film-
ing began in 1938 with only $7,000 of what turned out to be the final
budget of $60–75,000 (they had estimated $40,000). A constantly growing
body of material, some significant new decisions about content, and
Strand-Hurwitz perfectionism also delayed the work, but money was the
key. Fiercely independent, Frontier Films avoided all links with Hollywood,
the government, and corporations, and it thus depended on sporadic fund-
ing from individual donors and sponsors who would give them a free
hand. Several times production halted and fund-raising went into high
gear: by the May 11, 1942, premiere, fifteen thousand people had seen
some portion of the film and five to six thousand had contributed to its cost.
"It was," Strand sourly remarked, "like making a film in a goldfish bowl."[26]

This effort, as Strand put it, "to do the impossible," to complete this

"monster" that gobbled the money and devoured everybody's time, caused great tension (for Hurwitz "an immense emotional problem"). In explaining the tenacity it took, Strand reveals the influence of his own strong, central personality:

> Either we had to make that film or we would have the biggest flop that ever came down the pike. With two or three very good films, yes, but not for five years. We *had* to finish it. . . . What if we had failed to finish the film and had been left with a bunch of footage, after working three years and spending, say, fifty thousand dollars I had a name at stake. And I'm a very stubborn man: I never like to start things I don't finish. . . . So we finished it. And it's a world classic, whatever you say about this or that. . . . Thank God it got made, I say. That is, I thank our tenacity, because it took a terrific amount of tenacity.[27]

Native Land's opening sequence poses the film's challenge. Over images of the American Revolution and the Civil War, of the American landscape and architecture, of immigrants and pioneers, of the American flag and the Statue of Liberty, we hear that we "built liberty into the beams of our houses," built "the old words, the historic documents" into "bridges and dynamos, concrete cities," built democracy "into the steel girders of America." Yet two dangers are posed: the degeneration of those ideals, documents, and words into clichés that are no longer lived, and a careless belief that the victories are permanent.

Three powerfully acted, directed, and edited sequences follow: a farmer who spoke up at a meeting is murdered, a window washer finds the body of a murdered union organizer, and black and white sharecroppers in Arkansas are chased from a meeting, hunted down, and killed in the woods (see figure 46). A seven-and-one-half-minute documentary section shows Americans getting up, going to work, performing on their jobs, and then attending rallies and union meetings. But union members have become smug, unalert. And we have a long dramatized story about Harry Carlisle, a labor spy who successfully infiltrates a union, feels rotten about it, yet is forced to carry through. The unions win some temporary victories against this, but other murders follow, then other struggles and victories, arriving at "the newly won rights of the people, collective bargaining, unemployment insurance," now "backed by the strength of organization." The film closes with a militant graveside speech by a friend of a Chicago Memorial Day massacre victim, concluding, "We don't forget that, never!" words repeated by Paul Robeson, the film's narrator.

The sequences embody the careful and stunning eye for composition — the beauty and clarity — of the Strand camera. And they are edited, for the most part successfully, to achieve for the viewer a "tight fistful of emotion."[28] Strand's advocacy in Mexico of dramatic documentary combined

with bluntness of statement had carried through the work of Frontier
Films. We find in Frontier filmmakers' writings of the time calls for films
of "impact" and "force," of poetic intensity, of "skill and passionate organi-
zation," of "overwhelming quality," of dialectical structure.[29]

This tight fistful of emotion was to serve as more than a call for alert-
ness and for labor's continuation of the great battles of the past. Hurwitz
saw recent American history and *Native Land* as "dialectical—the reforms,
defeats and victories are all part of one developing process, towards a radi-
cal social transformation."[30] In a popular front film aimed at a large audi-
ence, it was inadvisable to picture this vision militantly or explicitly, yet the
film makes it clear that in union growth Frontier saw the possibility for a
new social order.

Native Land was first presented to the public on May 11, 1942, five
months after Pearl Harbor. But Frontier Films probably knew well before
December that they had passed the end of an era, that it had become un-
popular to find anything wrong with the United States. They tried to fore-
stall the all too evident fate of their film, adding an epilogue spoken by
Paul Robeson that in later years was removed from the prints.

> This end is our beginning. Today, as never before, we must stand
> up for our rights as Americans. Together with the peoples of the
> world we are fighting the greatest enemy of our liberty—the Hitler
> axis. This scourge of mankind must be destroyed. We Americans
> have had to fight for our liberty in every generation.
>
> *Native Land* shows this struggle in our own times. A great and in-
> tense conflict. There were many casualties, many wrongs. Yet Ameri-
> can labor and the American nation are stronger for having passed
> through this fire. Labor is producing for victory. We are becoming
> an organized people, a united people. No appeasers, fifth columnists
> or native fascists can divide us. With the united power of field and
> factory and arms, we will deliver the blows to crush fascism.
>
> For only absolute victory over Hitler and Japan can safeguard our
> democratic gains and preserve the independence of America.

Needless to say, the epilogue could not save *Native Land*. Nor was the far
left any help with distribution. When Hurwitz screened the film for Earl
Browder and William Z. Foster, their reactions were very favorable, but
they too were committed to the Communist party's policy of national unity
and quietism for the duration of the war.[31] Unfortunately, *Native Land*
received very little notice in 1942 (it is now distributed by the Museum
of Modern Art in New York).

In the dignity, courage, and resistance at the center of *Native Land*, we
are reminded of something potential in ourselves. This reminding is at the
heart of Strand's aesthetics, underlying the feeling for people and need for
justice in his films. In a 1950 article in which Strand associates the Fron-

tier productions with Roberto Rossellini's *Open City*, he argues that artists and their audiences must take sides and that dynamic realism should be devoted to changing the world "in the interests of peace, human progress, and the eradication of human misery and cruelty, and towards the unity of all people." The brutal, ugly violence in *Open City* is "not isolated," is not intended "to entertain the audience, but to revolt them, and more important, to remind them of their own heroism as it was expressed in the resistance leaders who were tortured and killed."[32]

Strand and Frontier Films, Hurwitz especially, shared this intention. They also shared a conception of their films as films of witness, telling the untold stories, films of pride in human dignity, courage, and resistance, films of solidarity and kinship, stressing the links between themselves and people fighting on other fronts, and films trusting that people would not always simply accept injustice and that artists could be effective in changing attitudes and forwarding a cause.

What do I make of *The Wave* and of the work of Frontier Films, especially *Native Land*? The prolabor, antifascist position of these films is powerful, and the quality of the filmmaking, the commitment woven through the sequences, and the heroism draw me in. But there is a dimension missing. Although Strand in particular, and the others too, stood for "the dignity of human life," as Meyers wrote in praise of *The Wave*, and for respect for people and their ability to overcome their oppression, these films lack a certain profound quality, a tone, an attitude, a depth of love for humanity. It is a quality we find in the films of Marcel Ophuls, a tragic sense not dissociated from the will to political commitment.

Possibly this lack derives in part from Strand's distance, dominance, and stubbornness. At the same time, the power of these films may be traced in good part to his artistry, to his respect for personal strength, and to his determination to speak movingly against social injustice.

And therein lies Strand's legacy as a filmmaker, which is also the legacy of Frontier Films. It is his legacy of combining a troubled vision of American experience with political art, his refusal to compromise art for the sake of funding, his achievement of significant form in support of a vision, his understanding of the need to work collectively and communally, his wish to bear witness to contemporary injustice, and his sense of the need both to make people central and to treat them with respect. It is a legacy of strength, integrity, and commitment, of refusal to buckle to reactionary forces and to personal hardships. It is a resource for contemporary filmmakers and for other artists seeking to make responsible art.

JOHN ROHRBACH

Time in New England:
Creating a Usable Past

In October 1943, Paul Strand submitted an application to the John
Simon Guggenheim Memorial Foundation for support to create a
photographic portrait of New England. "This might be described as a
portrait of a particular American environment in terms of the character of
the land itself, the people who live in it, the things which they have made
and built . . . ," he wrote. Justifying this project, he explained that "I feel
it is important that artists who are not being used in the war effort should
continue to function by recording (in all mediums) the essential character
of those American traditions we are fighting to preserve."[1] Although
Strand was not awarded a Guggenheim, the application anticipated his
first book, *Time in New England* (1950), a collaborative project with Nancy
Newhall that was central to Strand's artistic development. The book
provided a new structure in which he could successfully portray, in both
documentary and artistic modes, the cultural landscape that had long
interested him.

Paul Strand's social conscience had been evident in his depression-era
film work, in his leadership of Frontier Films, and in his art and photo-
graphic criticism, but in the 1940s he had not yet similarly used his still
photographs to address social issues. *Time in New England* accomplished
the task in an innovative way. Though the book resembles a number of
photograph-and-text books of the Great Depression, Newhall's selection and
inclusion of historical texts juxtaposed with Strand's contemporary photo-
graphs created something unique. Portraying New England's present in
terms of its history, they answered Van Wyck Brooks's long-standing call
for a "usable past," a past meant to provide lessons for the present, thus
fitting the book into an ongoing discussion among intellectuals evaluating
United States political and cultural traditions. Other influential photo-
graph-and-text studies, such as Dorothea Lange and Paul Taylor's *An
American Exodus* (1939), had emphasized immediacy and documented spe-

cific current social upheavals; but Strand and Newhall drew from the past to offer historical dimension to long-standing social and political currents.[2] Clearly Strand was satisfied with the concept. He went on to produce five other books, each combining image and text to reveal his sense of a traditional culture and place in terms pertinent to that culture's contemporary social concerns.

Time in New England presents the authors' particular history of the Newhall's native New England. Loosely chronological, Newhall's passages take the reader/viewer from John Winthrop's speech made aboard the *Arbella* in 1630 as it approached the New World shore to establish the Puritan colony at Massachusetts Bay, to the final letters of Sacco and Vanzetti before their executions in 1927. Strand's photographs tie in symbols associated with New England's early history and terrain, particularly highlighting the region's agrarian and sea-oriented past and its Puritan and politically democratic traditions. The book's dedication proclaims that these texts and photographs have been combined to evoke the "Spirit of New England."[3]

Yet *Time in New England* is more than a patriotic paean.[4] The book came together within a politically charged period in American history. Despite the successful end of World War II, the tension of readjusting to a peacetime economy had been complicated by renewed foreign concerns. The Soviets' extension of their domination over Eastern Europe, the ousting of Chiang Kai-shek by a Communist regime in China, and the invasion of South Korea were, by the time of the book's publication, contributing to a reemerging "Red Scare" in the United States. Fear had spread throughout the country about the influence of socialist and communist ideologies on both American leaders and on the general public, leading to efforts to limit dissent. *Time in New England* seems to express Strand and Newhall's criticism of these developments, hidden in a format acceptable to conservative tastes. Focusing on New England and replaying its history, the authors suggest that free and open dissent was the core of New England's foundation as progenitor of American democracy and moral culture.

Film Precedents

Strand did not suddenly adopt his interest in history and place during World War II. On a trip to Canada's Gaspé Peninsula in 1929, he had attempted to define a sense of that region by photographing its landscape. In sharp contrast to his earlier abstractions and isolations of natural elements or machine forms, in these photographs he had begun integrating sky and land into single unified landscape images. He further refined these efforts in Colorado and New Mexico in the early 1930s, where he photographed buildings, including the famous Ranchos de Taos church, abandoned mining towns, and landscapes.

Through much of the 1930s and early 1940s Strand turned to motion pictures to accomplish and develop these expressions of history and place. Increasingly politicized by this time, he probably felt that film—combining sight, sound, and action—could provide a more dynamic portrayal of his concerns. The resulting cinematic elucidations were created primarily under the auspices of the film cooperative Frontier Films, which he helped form and run through its almost six-year existence (1937–42). Specific ideas tested in these films became central components of *Time in New England*.

Heart of Spain (1937), Frontier Films's initial release, celebrates both the first use in combat situations of the technology of blood transfusion and the cause of the Spanish partisans against Franco's rebellion; in it, Strand and his coeditor Leo Hurwitz dispensed with a narrative structure and central characters. Instead, they built dramatic interplays by emphasizing oppositions between war and peace, virtue and evil, and town and country-side, an experimentation with dramatic form designed to elicit the audi-ence's sympathy for the Spanish partisan cause as a whole rather than for one or more specific "heroes."[5] It provided a structure that Strand and Newhall later used in *Time in New England*, where they rejected the con-cept of a central character or characters and built contrasts between people, events, and landscapes.

Native Land (1942), about 1930s corporate repression of the rights of labor, was the other Frontier Film release on which Strand worked exten-sively. Here, fictional dramatic episodes were intercut with newsreel foot-age, re-creations of actual events, and extended evocations of American history, all intermittently broken up by a range of portraits of American landscapes urban, rural, and wild. Foreshadowing a number of the images in *Time in New England*, the opening credits and commentary of *Native Land* are set against close-ups of objects and places such as rocks, woods, a church, statues, and gravestones. Moving from agrarian to industrial scenes, the film plays upon the contradiction between a traditionally de-fined American heritage and current conditions. As would later occur in *Time in New England*, *Native Land*'s commentary set the film's multiple stories against a patriotic historical theme, taking the viewer on a rapid-fire trip through American history from 1620 to the present. Opening with the line, "This is the story of the struggle for liberty in our own time," *Native Land* suggests that each generation has actively to engage and assert the ideals of America's democratic heritage if these ideals are to be protected, a theme central as well to *Time in New England*. Yet despite the depressing aspects of its main subject, *Native Land* remains an optimistic, patriotic film, emphasizing both the acts of individuals who assert their democratic rights, and the federal government's recognition and support of those rights.[6] Like the message of the film, the book's proclamation of New England's

heritage is optimistic despite the turmoil that, it shows, recurs throughout the region's history.

Strand and Hurwitz received the final print of *Native Land* just after Japan attacked Pearl Harbor, and they were not able to show the film publicly until the following spring, when Americans were focused on foreign rather than internal attacks on their liberties.[7] Unfortunately, *Native Land* encountered little public recognition and support at that time, so that Frontier Films never recouped even a semblance of the time and money that the organization had invested in the feature. This film was to be the cooperative's final production.

Further Collaboration

In 1943 Strand was using his Guggenheim proposal as a means to secure public recognition and financial support for his return to still photography.[8] In recent years, several publishers had initiated book series, often combining illustrations and text, that portrayed American places and regions.[9] But Strand was intent on creating a broader and more provocative portrait than those in other books. In a lecture at the Museum of Modern Art (MOMA) in April 1944, Strand's comments concerning the role of art in supporting democracy indicate the philosophy he would bring to *Time in New England*. Strand called for recognition of the arts as an international language helping people in their effort to understand the world; art combated totalitarian regimes such as the Nazi and Italian fascist states by elucidating the "basic truths" of humankind.[10] Strand's stance derived from his active support for leftist causes starting in the early 1930s; by the late 1930s this meant support for the popular front of left-wing groups against fascism.[11] The "basic truths" to which he referred were conveniently open to interpretation—they were acceptable to mainstream Allied proclamations regarding the defense of liberty as well as a more communitarian ethic of humanism that Strand believed was being put into practice in the ongoing Soviet "experiment."

At about the same time, Nancy Newhall, who had become acting curator of photography at MOMA because her husband Beaumont Newhall was in the service, offered Strand a retrospective exhibition of his still photographs at the museum. The first such exhibition that MOMA would give a photographer, the occasion marked the museum's recognition of the important contributions Strand had made to the development of art photography. While working closely with Strand on this retrospective, Newhall came to the conclusion that his New England photographs were among his strongest work. As she was later to write in her foreword to *Time in New England*, Newhall found that Strand's 1920s photographs of the Maine coast "struck with the force of a revelation. Here was what I had known and felt as a child close to the same earth and had never found expressed

in any medium." Enthusiastic about his most recent imagery, she added, "in the winter of 1944, Strand photographed in Vermont stone walls and churches which embodied that New England from whose hold few New Englanders—or Americans—have ever wholly escaped."[12]

By the end of the exhibition the two were discussing the possibility of creating a book about the region. Their original notion, supported with a contract and advance from the publisher Duell, Sloan and Pearce, was a book of Strand's photographs with just enough text drawn from historical passages to tie them together.[13] Therefore, from late August to mid-October, Strand traveled through Vermont and visited his friend John Marin at Cape Split, Maine, adding to his collection of New England imagery, while Newhall "ransacked" libraries collecting an "autobiography" of the region. Periodically they would get together to compare the results of their work and sketch out sequences.[14] The project was proceeding smoothly even as late as August 1947, but as the increased role for Newhall's selected texts became apparent, Duell, Sloan and Pearce began having second thoughts, expressing concern about production costs, and questioning whether there was sufficient market for the book they had in hand.[15] By June 1949 the publishers had become sufficiently nervous that they were negotiating to turn over the project, then named *Of New England*, to Oxford University Press for completion.[16] On October 26, 1950, Oxford published the book as *Time in New England*.[17]

Formulating an Expressive Structure

Newhall and Strand split *Time in New England* into four parts, creating a chronological review of the region's history since 1630. Each of these parts was subdivided according to issues that confronted the region's residents at specific points in time and the whole tied together by a careful interweaving of text and photographs, each amplifying the other. The authors' self-consciousness regarding how their book's structure compared with other image-and-text books of the period is suggested by Newhall's statement in her foreword:

> The usual pairing of text and photograph or the insertion of a sheaf of photographs at regular intervals struck us as monotonous. Apt or literal juxtapositions we avoided as static. We wanted an integration so complete that either medium could state or develop a theme . . . creat[ing] a portrait more dynamic than either medium could present alone. (TINE, p. vii)

Newhall offers a direct critique of the standard format of documentary photograph-and-text books that had become popular particularly since Erskine Caldwell and Margaret Bourke-White's *You Have Seen Their Faces*

(1937). Caldwell and Bourke-White's book presented an innovatively con-
structed exposé and call for government action to alleviate the desperate
conditions of tenant and sharecropping farmers in the South. What made
their book different and striking in its time was that it broke away from
the standard photograph and caption format, juxtaposing instead first-per-
son "quotes" expressing "the authors' own conceptions of the sentiments of
the individuals portrayed" with Bourke-White's photographs.[18]

Playing upon Caldwell and Bourke-White's success, other writers and
picture editors had also sought to make use of formats interweaving image
and text. In 1938 Archibald MacLeish published *Land of the Free*, a similar
sketch of the problems of rural America during the depression, in this
case creating, he suggested, a "sound track."[19] And in 1939 Dorothea
Lange and Paul Taylor published their contribution to this depression
genre, *An American Exodus*.[20]

Although Paul Strand was concentrating on his film work during the
late 1930s, he was well aware of these photographic books. Much of his
attention to still photography during these years involved an active liaison
with the Photo League in New York City, including periodic speaking
engagements, exhibition jurying, and membership on the Photo League
school's advisory board. The Photo League published a monthly newsletter,
Photo Notes, and in April 1940 Strand took time off from work on *Native
Land* to publish a review of Lange and Taylor's book in the periodical.
Federal policies supporting the implementation of machine farming
methods had driven people off the land, primarily to Lange and Taylor's
home state, California, where they often lived in dire conditions as an
unwanted labor surplus. The authors' goal in *An American Exodus* was to
elucidate those conditions and suggest possible solutions such as increased
government housing and farmer associations.

Strand called the book "a valuable document and a work of integrity
and honest feeling" that gained added strength by drawing from the same
subject as John Steinbeck's popular *Grapes of Wrath*. Of particular appeal to
Strand was the book's form, which combined photographs, an expositional
text, and the speech of the migrants themselves, creating complexities, he
suggested, similar to those encountered in documentary film. Yet *An Ameri-
can Exodus*'s integration was not successful, he thought, preventing the
exposé from making a full impact upon its audience because in a book
as in documentary film the imagery must take precedence, with the text
heightening and extending that imagery's meaning. In *An American Exodus*
Lange's photographs often remained subservient to the text or the text
simply paralleled information presented more explicitly in specific images.
Both cases created, he explained, "a tendency toward negation rather than
active interaction between image and word."

Strand singled out three of Lange's portraits—a cotton picker, five dis-

placed tenant farmers, and a woman—for a "concentration of expressive-ness which makes the difference between a good record and a much deeper penetration of reality." These images particularized their subject, "clarifying and creating a new art form—with the camera." The general problem, he suggested, was that many of Lange's images were not as strong as these portraits and clearly not among Lange's best work.

> [I]f books like this are to have their maximum value, then it is clear that the basic material, the photographs, must be more than docu-mentary records. They must contain in themselves (and in a book in their juxtaposition to each other) that unity and intensity of expres-sion which give all works of art their impact.[21]

This kind of expression was what Strand and Newhall tried to accomplish in their own book. Their recognition of the importance of the direct power of Strand's photographs meant making sure that each photograph could stand on its own in giving a sense of New England. In addition, the inclusion of predominantly first-person texts was designed further to draw the reader/viewer into *Time in New England*. Most important for the book, as Newhall suggested in her foreword, was the equal entwinement of text and photograph. By making sure that each photograph and text did not repeat but rather added to the meaning and feel of the other, they al-lowed a new, more general statement to come to the fore. And finally, rather than focusing solely on an immediately topical issue, as had most of the books drawing on the endeavors of the Farm Security Administration (FSA), Strand and Newhall used the immediate to transcend itself. *Time in New England* was designed to be relevant beyond the date of and imme-diate issues surrounding its production.

A Past that Challenges the Present

Time in New England opens with the Puritans' arrival in the New World, highlighting their difficult first years establishing settlements along its shores. "The source of New England's character lies in the seventeenth century," Newhall wrote in her foreword, a suggestion that subscribed to then-current cultural interpretations which saw in colonial New England a definition of American attributes.[22] Since the beginning section was meant to set the book's tone, beginning texts as well as text and photograph combinations needed to be both fluid and powerful. Newhall approached her goal by selecting and carefully editing a variety of texts that build a dynamic tension between good and bad and activity and rest, tension simi-lar to that found in the commentaries in *Heart of Spain* and *Native Land*.[23] For example, an early passage by Francis Higginson mentions both a gale that prevented his immediate landing upon reaching the New England

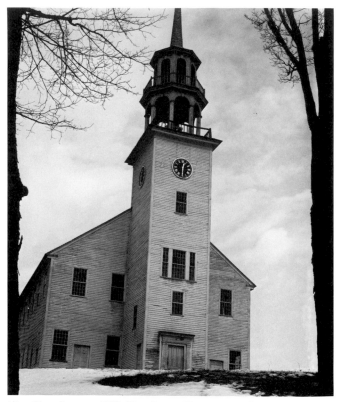

47. *Church on a Hill*, Northern Vermont, 1945

coast and the abundant bounty of both the coastal sea and the island upon which his men gathered berries when they landed (*TINE*, p. 3).

Once a "Foothold" is gained, Newhall's texts include notations of the colonists' establishment of colleges and provision of teachers for the young. William Wood publishes descriptions of native fauna in 1639. Captain Edward Johnson marvels at the diversity of trades already established in Boston in 1654, less than twenty-five years after its original settlement. Yet serious conflicts also periodically arise, particularly several near the end of the century, reflected in passages describing concerns about Quaker heretics, Salem witches, and skirmishes with Native Americans. As with *Native Land*, the conflict between personal liberties and societal demands proves to be an early and constant issue of concern.

Visually reflecting the seventeenth century, Strand's photographs intertwining these passages primarily present desolate views of forests, plants, and buildings. By portraying the proliferating towns and activities men-

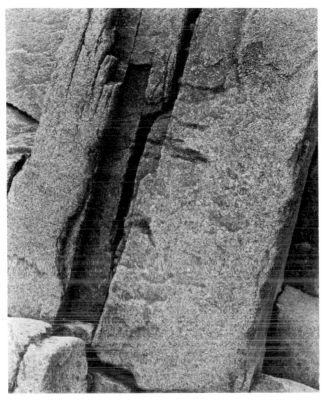

48. *Splitting Granite*, New England, 1945

tioned in the texts only indirectly, Strand's photographs suggest that it is the land and climate, not its people, that primarily define New England at this early date. People are merely implied in a few close-up shots of gravestones, deserted buildings, a stone wall, and a striking portrait of a church at the top of a snow-encrusted hill (see figure 47). As they do elsewhere in the book, Strand's photographs here present a symbolic landscape rather than documenting specific places. Sometimes the images become metaphors for the activities and feelings evoked by the surrounding texts. The authors leave the image titles in the table of contents at the beginning of the book because the descriptive and locational grounding that these titles supply is only incidental to the interaction of text and image that forms the book's base. Together, the texts and images suggest the difficulties and fortitude central to New England's settlement by the European colonists.

Part Two of *Time in New England* takes us up to the American Revolution, incorporating views of farms and towns into the landscape and sym-

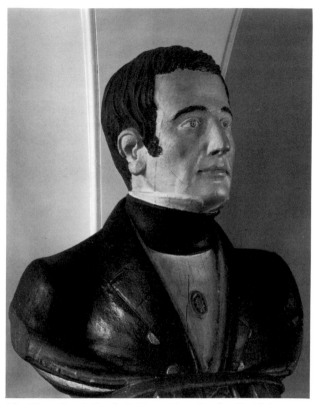

49. *Figurehead, Samuel Piper*, New England, 1945

bols of the Revolution including a town hall and an eagle. Interspersed texts include James Otis's assertion of the political rights of the colonists and accounts of revolutionary actions. One of the most striking of the photographs included in this section portrays a wall of granite split as if by lightning, placed opposite an account of the Boston Massacre and a letter "written by" Crispus Attucks to Governor Thomas Hutchinson blaming him for murder and warning him of the future (see figure 48). This rock symbolizes the splitting asunder of the colonial relationship manifested by the British attack. It escapes becoming a trite metaphor for the meaning of its surrounding texts because, like the rest of Strand's images, it stands on its own as a portrait of a bulk of granite, composed to reveal its solidity and its interplay of cracks, pieces, texture, light, and shadow. We can feel its heaviness, its "graniteness." Such is the photographic strength that Strand said he missed in *An American Exodus*.

Part Three, the book's longest section, opens with a summer view of the

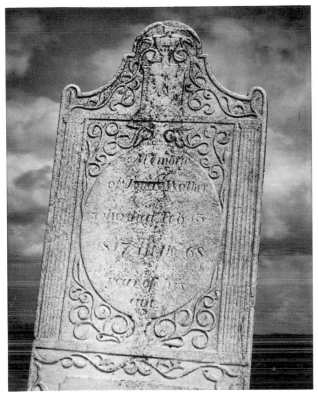

50. *Tombstone and Sky*, New England, 1946

West River Valley filled with sun-laden farms. The book has now shifted into the nineteenth century, engaging issues of sea commerce, transcendentalism, and abolitionist protest. The growth of cities still remains in the distant background; not one photograph of Boston is included. We also have yet to come upon photographs of people. More than midway through the book, only ship figureheads appear, attuning the reader/viewer to the pull of the sea and counterposing "the beauty of a ship under full sail" with the danger and deaths brought by storms and the whale hunt (see figure 49).

The text section on transcendentalism, entitled "Fine Auroras," is interspersed with photographs of delicate forms such as plants and a cobweb covered with raindrops and dew. Its balancing section, "Abolition," is introduced by an abstraction of driftwood that seems to portray a reclining figure tied down by seaweed and weighted by a jumble of other logs (see figure 41).

Actual people are photographically introduced for the first time with a portrait of Edward Bennett, opening a section entitled "Protest" (see figure 32). Mr. Bennett faces us opposite Henry David Thoreau's commendation of a life simply lived. That this union of text and portraits for the first time occurs in a section entitled "Protest" highlights the significance of this section. Showing much more sympathy for the working class than for the elites, Strand introduces here Beatrice Albee and Harry Wass, who seem to proclaim the rights of women and labor in photograph and text. Each of these three portraits of a person standing close against a wooden building is taken close in, from the chest or shoulders up. Each individual peers seriously and directly into the camera, challenging the viewer to relate to him or her as an individual rather than an anonymous actor enveloped by the currents of the surrounding text.

Part Four, the final section, points out the desertion of the region's countryside that occurred through much of the nineteenth century as people seeking greater fortune moved west and into cities. Instead of suggesting the gradual dilution of the moral base of the region's heritage, the authors imply that New England gained strength from the affirmative tenaciousness of those residents who remained behind. Part Four intermixes snowy views and graveyards, Oliver Wendell Holmes's Memorial Day call to live active and passionate lives, and Nicola Sacco and Bartolomeo Vanzetti's hope-filled reactions to their impending electrocutions (see figure 50). Vanzetti emphasizes the positive aspect of their accomplishment, and Sacco turns his predicament into a lesson for his son: "help the weak ones that cry for help, help the persecuted and the victim, because they are your better friends; they are the comrades that fight and fall as your father and Bartolo fought and fell yesterday for the conquest of the joy of freedom for all" (*TINE*, p. 244). These texts recall the sentiment of Winthrop's speech on "Christian Charity" which opens *Time in New England*. The spirit of justice combined with community remains central in both situations, yet unmistakable is the righteous independence of each individual. Facing these statements is Strand's close-up of an iris, its leaves curving back upon themselves under their own weight and their crowded surroundings. Touches of light highlight the apex of each curve. Strand and Newhall's decision to place this photograph here is most appropriate, for this perennial flower flourishes in New England's sometimes harsh climate. Here, its knifelike leaves rise up, only to curve back to earth under the weight of their own assertion, in the process creating beautiful curving forms.

The book's final passage and photograph return specifically to the region's Puritan heritage, as central to America's self-perception. The heritage includes and implicates all Americans, Van Wyck Brooks's text suggests, and, like it or not, we must all come to terms with it. On the

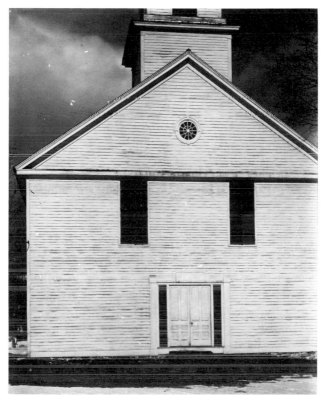

51. *Church*, Vermont, 1944

facing and last page, a massive white clapboard church stands as a potent symbol of this heritage, the sun reflected from its facade melting back the snow that surrounds the building even as clouds billow up behind it (see figure 51).

Newhall, in a draft for her editor's foreword, called the Puritans both "arch-revolutionary and arch-conservative."[24] As their book makes clear throughout, the concept of liberty came to be defined in New England not only as the freedom to practice Puritanism but also the liberty to dissent, whether under the aegis of Quakerism, abolitionism, or the rights of labor. Efforts by established political or religious leaders to limit such dissent, Strand and Newhall show, often unloosed cruel and misguided repression, as in the Salem witch controversy and the executions of Sacco and Vanzetti.

The Critics Respond
The year before *Time in New England* was published, at the Czechoslovakia Film Festival, where Frontier Films's *Native Land* had been awarded a prize,

Strand had predicted "that now, when once again these liberties of ours are under severe attack, the historic American love of freedom will assert itself."[25] He obviously hoped that *Time in New England* would contribute to that assertion. Instead, along with a variety of their film colleagues, his Frontier Films associate Leo Hurwitz would soon be blacklisted. Strand also had hoped that *Time in New England* would be only the first of his American cultural studies. His work on the book had rekindled his long-standing interest in creating a photographic portrait of a single village, a project inspired by his regard for Edgar Lee Masters's *Spoon River Anthology*. Yet the rise of widespread political persecution led him to change his plans. He later recalled: "The intellectual and moral climate of the United States was so abused, and in some cases poisoned, by McCarthyism that I didn't want to work in an American village at that time."[26] Therefore, in the spring of 1950 Strand and his wife-to-be Hazel Kingsbury traveled to France seeking an appropriate village to document there. They were in the midst of this project when Nancy Newhall sent word on October 27 of the publication of *Time in New England*.

Beyond the excitement of finally having the project completed, Strand and Newhall expressed to each other their satisfaction with the job that Oxford had done with the production. Their main complaint was with the printing, which both agreed had particularly muddied the smaller landscapes, despite what they felt were good-quality plates provided to the printer.[27] Another problem was Jacob Deschin's important early review in the *New York Times* the week before the book appeared. Deschin compared Strand and Newhall's book unfavorably to Ansel Adams's just-published *My Camera in the Yosemite Valley*. Whereas Adams's book was an "attractive and inspiring handbook and guide to the parks," meticulously printed and holding broad appeal, *Time in New England*, he complained, had not achieved its ambitious goal of balancing text and photograph. "Too frequently the text is so much stronger in content than the pictures that the latter seem disappointing by comparison, even when by themselves the pictures are impressive and deeply moving."[28]

Despite Deschin's complaint, public reception of *Time in New England* initially seemed to be good. Within three weeks of publication, Strand and Oxford University Press were already discussing the possibility of publishing an American edition of his upcoming *La France de Profil*, a book that Strand was by than creating with the French poet Claude Roy, celebrating the resilience of small-town French culture. But by March clearer figures were in. Despite laudatory reviews by long-time New Englanders, only 3,500 copies had been sold by Christmas, well below estimated sales figures. Making matters worse, Philip Vaudrin, who had been the editor for *Time in New England*, had resigned from Oxford University Press.[29]

That fall, the *Photography Journal* of the Royal Photographic Society of

Great Britain weighed in with a similar complaint about the strength of the book's text in comparison with its photographs. Like Deschin, the review decried the difficultly of identifying the photographs, complaining about Strand and Newhall's decision to place the titles for the photographs together at the beginning of the book rather than alongside the images themselves.[30] Balancing these mixed reviews were the comments of Strand's and Newhall's friends. Beaumont Newhall suggested that the book made him reexamine Strand's photographs ever more critically and wrote enthusiastically that the Rochester Historical Society had asked him to read the book's texts while projecting Strand's photographs.[31] Dorothea Lange liked the book, and Minor White suggested that it revealed to him a function for photography for which he had long been groping.[32]

No one, however, commented on the political connotations of the book, and one reason for this may be the book's layout, rather than weakness in the photographs themselves or titles that are separated and at the front of the book. The book's division into many short sections filled with diverse texts encourages intermittent reading of passages or sections. Especially because of the mediocre printing of many of the photographs, such reading tends to make the text predominant, creating the problem Strand himself cited with Taylor and Lange's *An American Exodus*. For the intermittent reader, the extended historical flow that carries the book's real message and strength can be lost, as Strand must have realized, for his books after *La France de Profil* intersperse his photographs with the texts of only a single author.

A further problem is that, neither strictly history nor strictly art, the book asks special patience from the reader approaching it from either discipline. By joining an active account of New England's history with classically framed, often understated, photographs, the authors demanded attention to the role of the photograph as metaphor rather than illustration. Such a demand may have asked too much of their audience.

The most crucial problem for *Time in New England* is that both its message and its tone of self-assertion ran counter to the sentiment toward conformity that the "Red Scare" had engendered by the time of the book's publication. By emphasizing human connections to the past and the land, the book also implicitly questioned the country's postwar forward-looking preoccupation with its commercial, technological, and military achievements. These disjunctions are conducive to misinterpretation that sees the book as merely a conservative celebration of New England for its heroic past, ignoring its suggestion that this past might provide important lessons for the present.

Continuing Visions
Strand and Claude Roy's French project, published by La Guild du Livre in 1952, replaced the halftone offset printing method used in *Time in New*

England with more luminous rotogravures, thus remedying Strand's main complaint with the previous book. But an American edition was never published, and like *La France de Profil*, Strand's next three books, also cultural studies, would not attract American publishers. In part this may have been due to the expense of the gravure reproduction which Strand insisted upon in his subsequent books, in each case working closely with the printer to assure the finest reproductions.[33] Also, in light of *Time in New England's* lack of popular appeal, it is not surprising that American publishers would have shied away from books presenting complex evocations of the traditional foundations of foreign cultures. Only with Strand's introduction in 1965 to Aperture publisher Michael E. Hoffman would his work be reintroduced to the United States, in a major retrospective exhibition plus the publication of a two-volume retrospective of his work, a book about Ghana, a second retrospective volume, and several new print portfolios.

As with *Time in New England*, each of Strand's subsequent cultural studies developed out of collaborations with an author familiar with the place being studied, who was in charge of providing a text to be integrated with Strand's photographs. Each collaboration would evoke the spirit of the culture under study, emphasizing its rural roots and tenacious independence. *La France de Profil* offered a playful celebration of rural and small-town French life. *Un Paese*, a book Strand created with the Italian cinematographer Cesare Zavattini, portrayed the ambience of Zavattini's home village Luzzara, still coping with the ravages of World War II. The authors created characters of the people Strand photographed, having them tell their own stories, dreams, cares, and concerns. *Tir a'Mhurain*, which Strand authored with the novelist and historian Basil Davidson, tells the story of the persistent inhabitants of the Outer Hebrides, struggling to live in a harsh, treeless landscape, regaining their land from English overseers, and working against English cultural hegemony to retain their language and heritage. *Living Egypt*, created by Strand and novelist James Aldridge and published in 1969, contrasts that country's industrial expansion with its traditional culture. And in *Ghana, An African Portrait*, Basil Davidson rejoined Strand to restate the message of his Egyptian study, set in a black African culture.

Each of these monographs expressed Strand's deeply felt humanistic spirit, always tinged with political sympathy for people who maintained traditional relationships to the land while continuing to assert their right of self-definition. Each book was structured like *Time in New England*, with images and text of equal standing creating in their relation to each other a more powerful statement than either could accomplish separately. Even in 1971, after six projects, Strand was far from finished investigating cultures and sharing his humanist philosophy through books, as he remarked to his friends Milton Brown and Walter Rosenblum:

[I]t's an inexhaustible world. And I would say that very little of it so far has been photographed. People have made photographs here and almost everywhere in the world. But they certainly have not photographed everywhere in the world, what is really there, and with any degree of finality and completion. That's why I say it's not a problem of how to work, where to work, because there's so much work to be done.[34]

At the time of this death in 1976, Strand was in the midst of projects on Morocco and Romania, looking for authors fluent in those cultures to create texts that pulled together photographs he had almost finished taking. Even then, he was continuing to build upon the foundation laid by *Time in New England*.

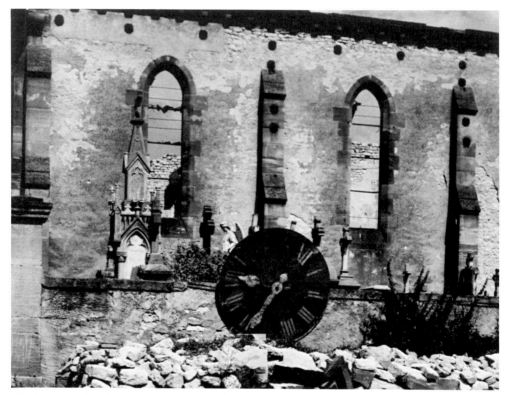

52. *Bombed Church*, Host en Moselle, France, 1950

CAROLYN FORCHÉ

Bombed Church,
Host en Moselle, 1950

This is Moselle: a mosaic of sunlight and desecration. Broken hands, pitted wings. Knowledge of the future is forbidden to us, *mais comment vivre sans inconnu devant soi?* We walk in the ruins, hoping to retrieve a few shards and with these piece together what we call our memory of the past. But isn't it possible that these ruins are to the future what the past is to us?

We thought we were strong, that we learned the lesson of Austria. We believed until then we could resist—but the Maginot Line didn't hold, and they had their tanks, and in hours they were upon us. So we made the house ready for war. We emptied the cellar of coal and piled the coal somewhere else. We taped the windows. That is how you prepare a house for war. My uncle who was in the army came to us: you must leave, he said. You can't remain here. You must leave at once. And so we walked away from our house, leaving it as it was, and in that sense walked away from everything.

We went first to Paris and remained ten days, where I worked for relief among the refugees who came by trains, so many by trains that there were refugees everywhere, so many people with nothing. In Bordeaux there were even more refugees. And we among them with money but no place to go. There wasn't a room in the hotel, so the hotel-keeper gave us his bed, and two chairs pushed together for my father. A lawyer who had been inspired to offer a little *maison* to a refugee family sent his maid to visit us. A little *maison-de-vigneron*. Do you understand? As she described the house, it was a palace. But when we arrived of course, *maison-de-vigneron*, there was nothing. A toilet in the garden. No water.

I remember walking up the hills. And Andrée. If I am seventy now, she is seventy-four. I used to ride my bicycle to her house. We were only seven kilometers from the Gestapo. They used to come on their motor-cycles through Gironde-en-Gironde. I remember them as they were. Hand-some. Horrible. So they were there, even in the free zone. And we were that close to Vichy France.

When did we know? It's almost as if I can't remember. In 1914 we knew them, machine-gunning whole villages. As a child we were taken to the trenches where the war had been fought. *Trenche?* Do you understand?

I remember seeing the bodies of men, and also the body of a horse, what would have been the corpse of a horse: the wound in its flank a soup-bowl of worms. That would have been 1918. I would have been four years old. Even if such bodies were there, they would have decomposed. So I ask — why do I remember this?

When I left Paris for Bordeaux, Bordeaux for Nice and America, I didn't think very much about my life. But I did believe I would see Jura again. And another friend in the resistance whom they arrested, and who from prison wrote something about how sad he was at what had developed and I thought: Sad! His life was coming to an end. . . . From the Red Cross three years after the war I learned that Jura had been captured and executed. Yes, I loved him. I thought I would see him again if only once. And I remember seeing the body of the horse, and the bodies of men in the trench.

In Nice we lived among all exiles, Anna Freud among them, painters and intellectuals among them, composers and writers. We all went to the Centre de Mediterranée and followed lectures. That is where I became a painter, in the life studies class in Nice, where we lived on the Promenade des Anglais.

It was the war. I was young. It bothered me to see the sun shining. You tell me that in Amsterdam the Anne Frank house is for tourists. But *why?* You think as I think. Even to tell you this much is horrible. That I would say to you now: would you like more tea? Or some of these biscuits? Is there anything else you would like? Oh, yes. The sea. Beautiful from here, of course. We had this deck built recently. I wanted it white. I wanted to be here. I chose to be here. For seven years I watched my husband die; for a few moments three years after the fact, Jura. And when his death arrived, in that instant, was I in Nice painting life studies? Or where?

Yes, this was the Church of Moselle, the river that flowed into the Rhine at Koblentz. It must have been half past eight in the morning or night. And I would have been in Paris, Bordeaux, or else Gironde-en-Gironde. In these ruins, one is able to discern a face: empty-eyed, brutally scarred, with debris for a mouth opening around a cry that no one hears. Look how the graves are scattered as if the dead had abandoned them. Nothing of value remains. But the horse? The corpses? That would not have been possible.

ESTELLE JUSSIM

Praising Humanity:
Strand's Aesthetic Ideal

How does an aesthetic ideal come to be formulated? Is it an act of conscious will, imitation of admired artists, or a subconscious mélange of favored content and representational strategies? Can such an ideal manifest itself equally in both portraiture and landscape? A review of Paul Strand's prodigious output indicates that his aesthetic ideal remained remarkably consistent from 1945 to his death in 1976. In each of his successive phases there is a fundamental aestheticism that seems surprising in so political a man, surprising, that is, until you begin to examine the concordance between the aesthetic ideal and his socialist ideologies.

If Strand's first teacher was Lewis Hine, an avowed humanitarian, his first major influence was Alfred Stieglitz, then the leader of the symbolist and formalist avant-garde in photography and one of the first American exhibitors of the moderns — Picasso, Braque, Matisse, Rodin, Brancusi. Strand wholeheartedly embraced Stieglitz's modernist aesthetic program: straight photography, unmanipulated, with imitation of other media absolutely forbidden.

By no means Stieglitz's invention or discovery, the idea of straight photography derived from the insistence of all modernist artists that each medium had its own unique characteristics, the rejection of which wrecked the potential for art. The aesthetician John Dewey went as far as insisting that "[S]ensitivity to a medium as medium is the very heart of all artistic creation and esthetic perception."[1] For Stieglitz and later for Strand, the specific characteristic of the medium of photography was its presumed objectivity coupled with an immensity of detail. Furthermore, what was required of any representation on a flat surface was the necessity for the "unified statement of the theme of a picture by repetition of forms, lines, and textures related to each other."[2] This unity of a flat surface was proselytized by painters from Cezanne to Picasso and led to the subjugation of content — indeed, the elimination of content — in favor of abstract forms. Strand noted: "This I think was the important aesthetic contribution of

abstract experiment, one that was very helpful to photographers, for it gave them a new awareness pointing toward the solution of their need to integrate the very complex objective reality which they must control."[3]

Whereas both Stieglitz and Strand agreed that photographers must be sensitive to their medium, and that distortions and other selective deformations of nature were acceptable so long as the overall picture was "objective," they balked at the complete elimination of subject matter other than pure constructions of lines and colors. The inherent realism of photography could be organized into significant form. Stieglitz continued, through his *Equivalents*, to pursue symbolism; Strand quickly left pure abstraction in favor of constructive principles in which interior shots of his Akeley motion picture camera offered a geometry of mechanical forms of considerable beauty (see figure 10). This close-up investigation, in which every dense detail of the print was carefully composed relative to the four sides of the frame's rectangle, continued in Strand's studies of rock and plant forms. These were rendered in a manner somewhat similar to Edward Weston's, but with little hint of that artist's occasional lapses into melodrama. Overt passion, such as we find in Weston's grandiloquent seascapes, was seldom revealed in Strand's work. Although he was as emotionally intense as Weston, his was nevertheless a quieter soul with different objectives.

Strand began separating from Stieglitz during the latter's *Equivalents* phase, saying, "I'm a politically conscious person. . . . I've always wanted to be aware of the world around me, and I've wanted to use photography as an instrument of research into and reporting on the life of my own time."[4]

It was undoubtedly the political climate of Mexico that attracted him and encouraged him to move there to seek new directions. The social consciousness of early-thirties Mexico still reverberated with socialist ardor, and the Mexican culture and people elicited some of Strand's most powerful artistic responses. Yet, with the publication of his magnificent folio of Mexican prints (1933), including some of his unquestioned masterpieces, such as *Cristo with Thorns*, Strand seemed to have arrived at an aesthetic plateau (see figure 34). In October 1933, Ansel Adams, himself no slouch at craftsmanly photography, wrote to Strand: "I believe you have made the one perfect and complete definition of photography."[5] No greater accolade could be afforded a photographer in the early phases of his midcareer; Strand was only forty-three at the time.

At the height of this perfection, however, Strand abandoned still photography for motion pictures. Actually, while in Mexico, Strand had already begun work as a cinematographer. A land recently convulsed by revolution and civil war, Mexico offered vivid new subjects and complete sympathy for his socialist tendencies from artists such as Diego Rivera and David Alfaro Siquieros. Strand also found unswerving admiration for the Soviet filmmakers, whose work dazzled him. The films of Sergey Eisenstein—

Battleship Potemkin, Strike, October (Ten Days that Shook the World)—with their powerful images created by the master cinematographer Edouard Tisse were undoubtedly an important influence on Strand. Eisenstein had developed an aesthetic formula that stressed frontality, posing his characters parallel to the picture plane and filling the frame. (*Que Viva México*, Eisenstein's aborted master film of 1932, is implacable in its frontality, as is the later *Alexander Nevsky*.) Image after image by Strand, from *Mr. Bennett* (Vermont, 1944) to *The Family* (Luzzara, Italy, 1953), verify his admiration for the tightly framed frontal pose (see figures 32, 79). Eisenstein's method of crosscutting montage (editing), which "depended very much on the strength of a succession of *single*, strong images for their impact,"[6] would find an echo in Strand's arrangements of images in his books.

Sometime in the early 1930s, Strand made the acquaintance of Robert Flaherty, the pioneering filmmaker whose *Nanook of the North* and *Moana* had received worldwide attention. Flaherty and Strand agreed on many issues of film theory. As Strand observed: "We would use the most rich and imaginative film techniques on the theory that the best art was the one which would reach all people most forcefully."[7] If this sounds suspiciously like Sergey Eisenstein's aesthetic dogma, it is not related to that Russian's deliberate propagandizing. In Strand's still photographs, as contrasted to his films, little evidence can be found of what Richard Barsam called "the sociopolitical didactic film." Strand was closer to Flaherty's humanistic tradition, "which freely, spontaneously, and poetically celebrates man and his life."[8]

Eisenstein himself was certainly eager to reach all people; in fact, he wanted to manipulate their emotions so that they would acquiesce in revolutionary goals. This was hardly Strand's objective. He worked in a more indirect manner, presenting exemplary individuals rather than castigating their oppressors. In still photography, Strand was not a polemicist but was a great admirer of Eisenstein's aesthetic achievements.

In 1935, when Strand visited Russia in the hope of meeting with Eisenstein and perhaps working with him, Eisenstein briefly discouraged him by remarking that Strand's film *The Wave* demonstrated that the American was essentially a still photographer rather than a filmmaker. This was ironic, for Eisenstein himself was notorious for his meticulous design of each frame, a practice that produced strikingly composed images that could just as easily have been still photographs.

A rather long quotation from Strand's comments on his Russian trip seems useful here; he is talking about having been taken out into the country by Edouard Tisse:

> Along the way I saw a fence against dark woods—it was a very special fence, containing the most amazing shapes. And I felt then if I'd had the camera with me I could have made a photograph that had

something to do with Dostoievski. That fence, and those dark woods, gave me the same feeling you get in reading "The Idiot." You see, I don't have any aesthetic objectives. I have aesthetic *means* at my disposal, which are necessary for me to be able to say what I want to say about the things I see. And the thing I see is *outside* of myself — always. I'm not trying to describe an inner state of being.[9]

This is one of the few times that Paul Strand mentioned aesthetics. Accepting for the moment the dubious proposition that Strand actually believed that he did not have "any aesthetic objectives," we have to wonder at his insistence that he was not trying to describe an inner state of being. Was he trying to convince himself that he was not a formalist aesthete, which would have been contrary to his humanist convictions? Was this a hangover from his early adherence to the principle of strict objectivity? He often likened art to science. Frequently, he seemed to be denying his own personal response to phenomena. For example, when questioned by interested amateurs about how he selected his subjects, Strand replied, "I don't pick them out; they pick me out."[10] He insisted that "subject matter is extremely important to the artist, because until he talks about something that really means something to him, the audience cannot see anything important or very interesting."[11] Strand's subjects, therefore, become of prime importance as clues to his aesthetic ideology, despite his insistence that he had no aesthetic objectives.

Strand constantly insisted that the "material of the artist lies not within himself nor in the fabrications of his imagination, but in the world around him."[12] Just as he had proclaimed about his experience with Tisse in a Russian forest that he was not trying to communicate a subjective response, he seems to have been persuaded in every possible way that he was purely objective. Yet he could also say: "The decision as to when to photograph, the actual click of the shutter, is partly controlled from the outside, but it also comes from the mind and heart of the artist. The photograph is his vision of the world and expresses, however subtly, his values and convictions."[13] We can only wonder how he reconciled the two contradictory notions; first, that the internal subjective feelings of the artist are in no way involved; second, that the mind and heart of the artist are, in fact, involved in the decision of what to photograph.

Obviously, if a photograph embodies an artist's vision of the world and expresses his or her values and convictions, are these not internal philosophies that govern any response? Wherever values and convictions originate, they are incorporated into the mind-set of individuals, and once established and habitual, they tend to screen out new perceptions as well as new conceptions. The world around him, as Strand labeled phenomenological reality, was no more — *could be no more* — than what his values and convictions allowed him to see. And Strand admitted, "There are a lot of people

in the world I have no desire whatsoever to photograph. . . . I like to photograph people who have strength and dignity in their faces; whatever life has done to them, it hasn't destroyed them. I gravitate toward people like that."[14]

What Strand had fundamentally unchanging and unchangeable convictions about was the enduring dignity of what he called "the plain people of the world, in whose hands lie[s] the destiny of civilization's present and future well-being."[15] The art historian Milton Brown, who knew Strand personally, observed, "He believes in human values, in social ideals, in decency, and in truth. That is why his people, whether Bowery derelict, Mexican peon, New England farmer, Italian peasant, French artisan, Breton or Hebrides fisherman, Egyptian fellahin, the village idiot, or the great Picasso are all touched by the same heroic quality—humanity."[16] This presentation of the plain people as heroes was a characteristic of much documentary filmmaking of the 1930s, as well as of Soviet art and, curiously enough, of Nazi art as well. The object was to endow ordinary citizens with importance in the world struggle, whatever side they were on. The object was also to persuade ordinary citizens that their government was working solely for their benefit, whatever national ideology they supported.

Strand, however, never indulged himself with these tricks of hero making as practiced by Eisenstein, Margaret Bourke-White, and others, such as John Grierson. He did not shoot from below to make his subjects seem larger than life. As his life progressed, his portraits pressed his subjects into tight relationships with their surroundings. As Milton Brown observed, with Strand, "man's condition is stated elliptically and with reticence."[17] There was no doubt, however, that "his choice of subject is an act of metaphor, of raising common humanity, common sights, and common methods to a higher power."[18] In that ideal he resembled no one so much as Flaherty, whose glorification of the lives of the natives of the Aran Islands in the film *Man of Aran* (1934) was recognized at once as a willful romanticizing of actuality. Flaherty was a genius at dramatizing the hard lives of plain people. His ultimate ideal was to ennoble humanity, to elevate ordinary humans to the stature of heroes and heroines. The difference between Strand and Flaherty was that Strand saw his beautiful people in a "dignified and well-functioning environment," whereas Flaherty notoriously saw people in a continuous and heroic battle against nature, a condition he had no compunctions about arranging artificially, if need be. This was in contradistinction to Strand, as Ulrich Keller has decided: "Purged of sophisticated Western trappings, as well as of common misery and servitude, Strand's picture cycles become utopian projections of free human existence in harmony with nature."[19]

Was Strand's aesthetic ideal simply a utopian projection of free human existence? Ulrich Keller's substantial research into Strand's subject matter led him to what now seems an obvious observation: "Strand does not

represent misery."[20] If an artist is devoted to portraying the enduring dignity of the plain people of the world, how could he or she avoid documenting the enduring misery, oppression, desperation, and helplessness of the masses? How could Strand avoid, or rather *why did he avoid* recording the unspeakable conditions of poverty, filth, wretchedness, disease, crowding, and gnawing hunger that characterize the daily life and environments of so many of these so-called plain people? We have seen Strand's admission that he was attracted primarily to persons of undiminished dignity. The truth, according to Keller, is that Strand's aesthetic ideal demanded that he portray only "free, dignified, healthy, beautiful men and women in a simple but dignified and well-functioning environment."[21]

True: there are no Strand pictures of, say, construction workers in Ohio or of giant oil industries in Texas or of any other technological trappings of Western capitalism. Only in developing countries did he photograph power plants or steel mills or mechanics themselves. According to Keller: "Evidently the purpose of these pictures is to underscore three things: that the machines are under intelligent, human control, that they are rationally organized, and that they are integrated in the natural environment, rather than destroying it."[22] There would seem to be a superficial resemblance between this kind of presentation and Soviet socialist realism, wherein happy maidens drive tractors and muscular men smile as they build factories or harvest wheat. This is the Aristotelian third choice: that everything must be presented *as it should be*, not *as it is* or *as it could be*. If Strand's choices are so conspicuously utopian, than a conclusion about his work would seem to be inescapable: *his aesthetic ideal and his social ideals were in perfect isomorphic relationship*. Accordingly, his pictures could not deserve to be called, simply, "realism," because they function as panegyrics to the nobility of humanity.

Unlike Keller, John Berger has only admiration for Strand. He likened Strand's *The Family* (see figure 79) to the paintings of the seventeenth-century master Louis Le Nain, claiming that both Le Nain and Strand are "moralizing artists. Both wish to make a protest, but a protest so sweeping that it cannot be made directly by illustrating any single incident." Both present "*the moral contrast between those who are likely to look at their pictures and those whom their pictures depict*."[23] Both illuminate the simplicity and moral superiority of peasant life for the edification of affluent, decadent elites, not in the manner, say, of Walker Evans, whose pictures often called for social change through compassionate outrage, but rather in the manner of a Sermon on the Mount, wherein the poor — intrinsically good — shall inherit the earth.

It seems clear that Strand did not depict human misery because he was offering his viewers his conception of human excellence as role models, presenting the strength, dignity, and moral superiority of individuals who have not been corrupted by the exigencies of survival. But whose face

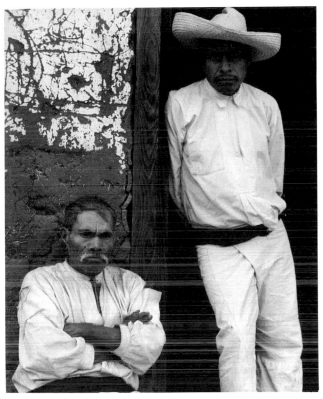

53. *Men of Santa Ana*, Lake Patzcuaro,
Michoacan, Mexico, 1933

could show more stress and pain than *Mr. Bennett* (see figure 32)? Surely,
he cannot serve as a role model or a moral exemplar, not can those
depicted in *Men of Santa Ana,* be regarded as graceful, dignified peons
proudly displaying their honor and incorruptibility: Strand captured too
much suppressed rage there (see figure 53). The famous *Cristo with Thorns*
is the Son of Man, bearing on his exhausted shoulders the burden of our
sins and suffering mightily in this onerous task. Only saints can withstand
such tribulation, guilt, and sorrow (see figure 34).

Strand, of course, was involved not only with portraits but also with
landscape. He had been deeply impressed by Edgar Lee Masters's *Spoon
River Anthology* as an evocation of place. In 1935, the filmmaker Joseph
Losey observed that "Strand has now begun to photograph people with
particular attention to their surroundings. One of the chief characteristics
of his later work is the drawing of people, nature, materials into a close-
knit composition . . . of textures, light intensities, line, mass. . . . "[24] Any
examination of his books, from *Time in New England* (1947) to the less

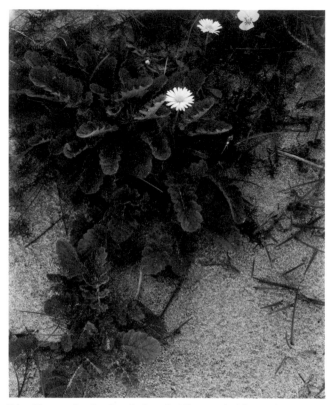

54. *Flowers in the Sand*, South Uist, Hebrides, 1954

familiar *Ghana: An African Portrait* (photographs, 1963–64, published 1976), reveals Strand's intense desire to make connections between the inhabitants of a place and place itself.

Perhaps the most successful of the books is *Tìr a'Mhurain: Outer Hebrides* (1962), with its beautifully developed suites of pictures of rugged people in a rugged terrain. The locale of South Uist, off the west coast of Scotland, was not very different from Robert Flaherty's Aran Islands. Paul and Hazel Strand wandered over this island stronghold of Gaelic culture and language for thee months in 1954, gathering their impressions until Strand was ready to photograph. Primarily *Tìr a'Mhurain* ("Land of Bent Grass") offers alternating pages of people and landscape, or sequences such as a long shot of the roiling sea/a close-up of sea wrack covering a fisherman's lost shoe; a medium shot of three children/a long view across the rockbound shore; an old woman's knitted shawl surrounding her wrinkled face/a close view of what might have been her cottage window, with its thatch held down by roped stones and a bit of lace against the glass; scudding clouds hanging over tiny seaside houses/a close-up of someone's china shelves, where Christianity is pinned up in the form of saintly postcards; a

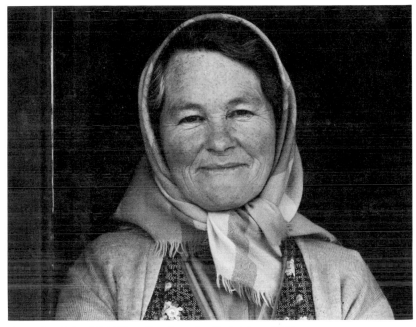

55. *Mrs. John McMillan*, Benbecula, Hebrides, 1954

bold young girl, with braided hair, thumbs tucked into the pockets of her
corduroy coat/a brilliant view of rocks and sea; a shepherd boy
grinning into Strand's camera/three vulnerable calves weighted down by
clouded skies.

One of the loveliest pairs consists of flowers emerging from the ubiquit-
ous blown sand facing the page of a gently smiling woman — Mrs. John
MacMillan — in a wool kerchief and a flowered dress (see figures 54 and
55). To have maintained such a sweet disposition in the face of the rigors
of that landscape seems a minor and most welcome miracle. The finest of
all the landscapes in this book is probably of Loch Bee, with its dramatic
luminous cloud, sparkling tiny dots of sea birds floating in a purely hori-
zontal line of water, and dark near and dark far strips of land (see figure
56). It is a composition that can stand beside the finest views by Minor
White or Edward Weston, and indeed, it seems to prophesy what Harry
Callahan would do with his strictly horizontal divisions of sky, sea, and
land.

Strand was known for his frequent exasperation with clouds. They had
to avoid any suspicion of being cottony; they had to have body, fullness,
and the threat of storms. They were the most turbulent elements in
Strand's pictures, elements that permitted him to express the drama of the
life his portrait subjects experienced. Above all, Strand's clouds and skies
had to arouse an aesthetic response, a response that signified that the
world was dangerously beautiful. In *Tir a'Mhurain*, the people and the

56. *Loch Bee*, South Uist, Hebrides, 1954

landscape matched each other, reflected each other, explained each other, as perhaps no other Strand group did. This was Strand's stated ambition: to interweave the elements of nature and habitation so as to evoke the rich inner life of even the simplest folk. He had succeeded brilliantly in weaving such tapestries in *La France de Profil* (1952) and *Un Paese* (1955). Unfortunately, *Living Egypt* and *Ghana, An African Portrait*, his last books (except for the uncompleted *On My Doorstep* and *The Garden*) have neither the cohesiveness nor the pictorial brilliance of the earlier volumes.

The aesthetic power of Paul Strand's images is such that the beauty of his formal compositions seems about to overwhelm some of his subjects. Was he too perfect? A master craftsman whose platinum prints are undeniably magnificent, a disciple of modernism's demand for formal beauty, Strand all his life revered David Octavius Hill, who, with his associate Robert Adamson, proved very early in the history of photography that artistic effects were within the capacity of the then-new medium. In Strand's opinion, Hill had never been surpassed, but it should not surprise us that he spoke more about Hill's subjects than of the aesthetic compositions, the admirable balance of forms and the suppression of unnecessary detail.

The outstanding character of Hill's photographs is the honesty, dignity, and serenity they reflect. They speak of that individual human worth which men had fought for in the French Revolution and in

our own struggle for independence ... Hill was able to see and to photograph the gentleness and determination, the sensitiveness coupled with strength which were in people, their remarkable wholeness of personality.[25]

Such a description fits Strand himself remarkably well.

Strand believed that it was the "profound feeling and experience of life" that gave birth to art.[26] While he argued for objectivity, he saw the world around him and the people in it with sensitivity, with feeling. His aesthetic ideal was the depiction of strength, wholeness, and the inner dignity of humankind surviving nature and repressive society alike. Besides David Octavius Hill and Alfred Stieglitz, he was greatly impressed by the Italian Renaissance painter, Piero della Francesca. Like that artist, Strand wanted to go beyond the ephemeral or the sensational. In Strand's pictures, we find the work of a quiet but intense man who transmuted the real into the ideal, "the ordinary in man and the transitory in nature converted into eternal symbols."[27]

NAOMI ROSENBLUM

The *TAC* Cover

In 1939, Paul Strand made his only overtly propagandistic photograph and one of the very few images, aside from early still lifes, that he himself constituted rather than found. Depicting a swastika with a human skeleton hung on it, the work appeared in 1939 on the cover of *TAC*, a review devoted to progressive activities in the theater. Unusual enough at the time to have been reproduced in a number of newspapers and journals following its appearance on the magazine's cover, the image was forgotten after World War II and has come to light again only recently (see figure 57).

In 1975, while Strand—then eighty-four years of age—was in New York receiving medical treatment and I was preparing my dissertation on his early years, I asked him about the circumstances surrounding this work. Strand could only recall that an idea had come to him to find a human skeleton and crucify it on a swastika. He remembered that while occasionally visiting a childhood friend living near Guilford, Connecticut, he had come across two young men who owned a barn in which they repaired and refinished old furniture, several pieces of which he had purchased for his apartment in New York City. They agreed to build him a fifteen-foot-high swastika and to drive it into the ground in a designated position so that it might be photographed against the sky from down hill with a black line of trees at the base.

A medical doctor with antifascist sentiments loaned Strand the articulated skeleton without, however, informing his partner, who he felt would be unsympathetic to the project. He stipulated that it was to be photographed and returned on the same Sunday. Strand and his wife Virginia Stevens drove to Connecticut in a Ford convertible car with a rumble seat that held the skeleton, which had been packed in a box originally meant to hold a fur coat. In Connecticut, he borrowed a ladder, arranged the skeleton as if crucified on the swastika, and made the exposure (I neglected to ask how many).

On the way home, the skeleton, repacked, was transferred to the front

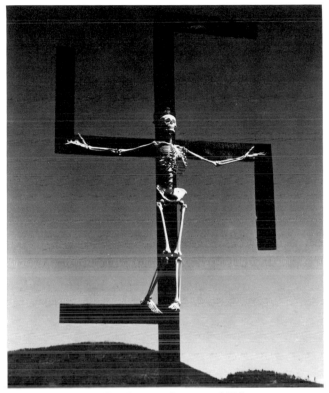

57. *Skeleton/Swastika*, Connecticut, ca. 1936

seat of the car when the couple stopped to visit a friend at Eighty-sixth Street and Riverside Drive, but the plainly visible fur coat box proved to be an inducement to an easy theft through the convertible's canvas roof-top. Unwilling to report the theft to the police or to advertise for its return, Strand and his doctor friend eventually split the cost of replacing the skeleton.

As anomalous as this photograph of a skeleton and swastika seems in view of Strand's emphasis on objectivity, crucifixion iconography played a significant role in his earlier experiences. Photographing in Mexico in 1932 and 1933, he was drawn to the carved figures of the Passion that could be seen in the village churches of Michoacán; five of the twenty images included in the Mexican portfolio are of Christ or the Virgin Mary. His interest in these icons seems to have originated many years before; during a trip to Europe in 1911, examples of Christian art claimed his attention as he scoured the museums of France and Italy. But the intensity with which he looked at and photographed these carvings in Mexico suggests that his interest was based on more than their aesthetic qualities.

Strand worked in Mexico under the aegis of composer Carlos Chávez, whose high position in the Secretariat of Education allowed him to conceive of producing a repertoire of films that might embody a socially oriented ideology in an artistic format or style. Having met him in Taos, where both had participated in discussions of how art might serve the needs of the people, Chávez must have recognized that Strand would be helpful in achieving this purpose. While waiting for the movie project to be approved, Strand and Augustine Velasquez Chávez, a nephew, traveled to villages in Michoacán to collect children's artwork for a show to be held in Mexico City.

Strand's interest in native arts and crafts is evident in a report he filed concerning the quality of weaving, pottery, and lacquer work in Uruapan, Pátzcuaro, and other nearby villages. While praising the skilled craftswork, he found the traditional designs and decorations to be unimaginative and, in his words, "mechanicalized." According to this report, articles prepared for "religious or fiesta purposes," such as the black pottery flower holders, candelabras, and incense burners made for the Feast of the Dead, were the only well-designed crafts to be produced, because, Strand surmised, they had been made for "human" rather than commercial purposes.

During the travels in Michoacán, Strand made photographs for himself of the people and architecture and of religious objects that to his mind had not been travestied by commercialization. Carved in a style that combines sophisticated European ideas of realistic representation with traditional Indian folkloric conventions, the figures of the Passion embody a sense of gravity and profound sorrow. With their attenuated limbs and tortured expressions, they seem especially appropriate vehicles for the tensions and anxieties Strand himself was experiencing.

Nineteen thirty-two marked the beginning of a period of difficult personal adjustment on several levels for Strand. To his relief, as the film business became more firmly ensconced in Hollywood, his employment as a well-paid free-lance cinematographer had come to an end; although he could now concentrate on still photography, he also was left somewhat at loose ends economically and psychologically. This development coincided with the end of a long and close relationship with Alfred Stieglitz, his former mentor. Following an exhibition of Strand's work in April and May of 1932 at Stieglitz's An American Place gallery in New York City, Strand returned his personal key to the gallery and left for the West without good-byes or explanations—an action that must have been accompanied by feelings of antagonism and regret. This rupture was followed at the end of 1932 by the dissolution of Strand's ten years of marriage, and all these personal upheavals were accompanied by the social and cultural dislocations in the larger scene brought on by the Great Depression and by changes in ideas about the nature and purposes of art. Furthermore, experiences in Mexico City and in provincial villages undoubtedly acquainted

Strand with a degree of grinding poverty with which he was unfamiliar and which the Mexican government, despite its social vision, was not in a position to eradicate quickly. Thus, while the trip to Mexico may have appeared to be pregnant with new possibilities, it also was fraught with sorrows and tensions.

What better image to convey this complex of ideas and feelings than Christ, the Man of Sorrows? Embodying concepts of suffering, mercy, and redemption, this icon in particular provided a "readymade" that allowed Strand to deal with inner turmoil and the dislocations of contemporary reality and to relate them in turn to the universal human condition. As a result of the sensitive handling of space and light in *Cristo with Thorns* and other images of *santos*, the folkloric religious artifacts on which he focused both retain and transcend their original religious role, becoming in the process metaphors for more current personal and societal trials.

The remainder of Strand's time in Mexico was spent working in Mexico City, Acapulco, and Alvarado on the film that bore the title *Redes* in Spanish and *The Wave* when released in the United States. While dogged with problems, the film project had clear social goals, which may have acted as a brake on expressions of personal anguish.

From both the documentary record and the image itself, one would have to conclude that the *TAC* crucifixion image is of a different nature from the photographs of Mexican *santos* figures. But the choice of this particular metaphor for Nazism, perceived by Strand (along with many others) as an anguishing political reality, undoubtedly is related to these earlier experiences.

One of my first questions to Strand concerned the origin of the idea; I was curious to know if he had seen the antifascist montages made by John Heartfield during the late 1920s and early 1930s. In designs for posters, book jackets, and the newspaper *AIZ* (*Arbeiter Illustrierte Zeitung*), skeletons and swastikas figured frequently in the German artist's graphic denunciations of Nazism. A poster entitled "Wie im Mittelalter—so im Dritten Reich," produced in May 1934, seems especially relevant because its upper half is composed of a photograph of an early Gothic carving of a single human figure entwined in the spokes of a wheel that forms the circular window of the collegiate church of Tübingen, and its lower half has been constituted to portray a similarly garbed figure entwined in the angles of a swastika. Translated as "As in the Middle Ages, so in the Third Reich," this image is a reference both to the use of the torture to break the will of the nonconformist individual and to torturous times. Another montage by Heartfield, produced in August 1933, depicts a prone and bleeding man lying on the horizontal member of the swastika, and bears the legend: "Das Morderkreuz" (The Murder Cross); still another shows Christ carrying a cross which a uniformed Nazi is turning into a swastika.

Strand did not mention Heartfield, but it is more than likely that he

was familiar with the work of this well-known graphic artist. Since *AIZ*, which carried Heartfield's images in just about every issue after 1929, was the most prominent illustrated weekly of the left not only in Germany but in all Europe, he may have seen it during his travels to the Soviet Union in 1935. In 1937, Heartfield's work was shown in New York at the Photo League, where Strand was not only a member but on the Advisory Board; because the League magazine, *Photo Notes*, did not start publication until the following year, no detailed account of this exhibition is available. On the basis of a 1942 League show of Heartfield's antifascist posters, one can surmise that among the images were those containing the symbolic elements of cross, swastika, and skeleton.

Strand admitted to having mixed feelings about the image. He never exhibited the original print and seems to have considered it a piece of necessary propaganda for perilous times. In the overtly political sphere, his only later work with still photographs took the form of a large photomural based on the positive effects of twelve years of Franklin D. Roosevelt's tenure in office. This effort, which was completed in six weeks in the fall of 1944, was created by a group under the direction of Strand and Robert Riley and involved enlarging and montaging photographs obtained from a number of public and private sources; eventually it was destroyed. By 1975, however, Strand felt that leaving the swastika image out of exhibits and books had been a mistake, and he commented that "the more I look, the more interesting I find it." This change in attitude may account for his next constituted image, which in fact turned out to be the last photograph he took before his death in March 1976. Toward the end of the previous year, while living in a ground-floor apartment on the Lower East Side during medical treatment, he placed a small wooden bird on the metal grill of the window of an adjacent building. Time and dirt had created a patina with the configuration of a death's head on the glass. Imprisoned, as it were, by the bars, the bird seems to symbolize the creative spirit, which in the face of impending death was unable to soar. Possibly, at moments of great inner stress, Strand felt that if the world as it existed within his purview was insufficiently expressive, he needed to call upon art to make a transcendent statement about the nature of life—and death.

MIKE WEAVER

Dynamic Realist

A s a realist, Paul Strand never allowed idealist philosophy to over-
come his respect for the objects before his lens. In spite of his
early reading of Nietzsche, who claimed that the existence of the
world was only validated by aesthetic experience, and of Schopenhauer,
who conceived the world as the object of man's will and desire, Strand's
unusual capacity to think dialectically about the problem of expression
gave his work an organic core. As he saw from the beginning, ". . . objects
may be organized to express the causes of which they are the effects, or
they may be used as abstract forms, to create an emotion unrelated to the
objectivity as such."[1] He was therefore well prepared conceptually to en-
gage himself in the great battle between realism and abstract act which has
characterized our century. Faced with the political and economic events of
the thirties, he had no choice but to photograph objects to express the
social causes of which they were the effects. However, he chose to do this
with an idealist awareness that art consisted of the emotional vision of the
artist transferred to the mind of the viewer through images raised to a
symbolic value.

This concept of a balance of forces in Strand's work was present from
the beginning of his career. Strand himself interpreted the black windows
of *Wall Street* (see figure 4) both in terms of human alienation ("sinister
windows — blind shapes") and in terms of social destructiveness ("a great
maw into which the people rush").[2] *The White Fence* (see figure 3) can also
be given two different emphases: the photograph may be felt as formally
producing an emotional *Stimmung* unrelated to the objects in the picture as
such, or the individual pickets of the fence may be thought of as brokenly
but sturdily ranged against the dark buildings beyond. In other words, the
repoussoir element in the composition also expresses the underlying social
condition of which it is the visible effect, enacting the paradox that the
liberty to take a plot of land implies the exclusion of others from it.

In the late 1920s, Strand introduced Harold Clurman, the Group

Theatre director, to Alfred Stieglitz at Lake George. In letters to Stieglitz, Clurman poured out his ambition to rid the world of the idea of the artist as "a prank of nature, an isolated phenomenon, a separate jewel." He stressed his determination to build a new society through consciously directed activity and through leadership. Returning from Moscow in the summer of 1934, he wrote to Stieglitz to say how dynamic Russia was: "It is a world in the making—and it looks it! It is not pretty but neither is a birth, and it is not literary comparison but an actual *visible* fact that a new world—and a world that I believe in—is being made there."[3] The essay Clurman contributed to *America and Alfred Stieglitz* on the group idea was a political campaign document in favor of collectivism. He criticized Stieglitz's romantic individualism, which had failed to create the kind of healthy tension between the leader and the group which he believed he was achieving in the Group Theatre. According to Clurman, the 291 gallery had been a protective association, a safe harbor rather than a frontier outpost, where a certain impotence had been introduced by aesthetic perfectionism and social isolation. Instead, groups ought to link up with other groups:

> We cannot [consider art] without considering the whole structure of society. We must finally find a political equivalent for the ideal we discover in our artists. And to the political group whose aims are consonant with ours we must give our support and lend our talents. An art that cannot be integrated with every human activity is a sick art.[4]

In July 1934 Clurman stated his firm belief: "The only really classic culture in the world today is that of the Soviet Union: or at least it is that in the making: if you like, in the seed."[5] That Stieglitz and Strand supported the group idea is evident from the presence of their names on the Group Theatre's letterhead as sponsors. That Strand agreed in principle with Clurman is indicated as well by Strand's becoming president in 1937 of Frontier Films, an association modeled on the group idea.[6] Theatre and film groups—even a critics group—all confirmed Clurman's belief that no single group could exist by itself: "To live, one group must link itself with another, doing in another medium what the first has begun to do. Each group thus complements and clarifies the other."[7] In 1934 Clurman wrote to Strand, "The campaign is for Groups or collectives of every kind (and not unrelated to political movements)."[8] Less than a third of the members of the Group Theatre belonged to the Communist party, according to Elia Kazan,[9] who insisted that Clurman was not one of them. In retrospect, Clurman's attitude towards groups was probably based on Peter Kropotkin's anarchist ideas, but for some others in his group such collectives entailed Communist party affiliation.

After the 1929 Wall Street crash, Strand, no longer so sure of the independence that a small private income often brings, was becoming increas-

ingly aware of the insecurities of the capitalist system. In 1932, sickened with the escapism of New Mexican artist colonies, but encouraged there by the Marxist writer Philip Stevenson and the former Irish Republican Army captain Ernie O'Malley, his thoughts turned toward Mexico, which he arranged to visit at the end of the year. Buoyed by the revolution of 1920–1924, the country's arts were flourishing. When Fred Zinnemann arrived in Veracruz in January 1934 to direct Strand's production of the film *The Wave*, he found Strand completely politicized — as he recollected later, "the most doctrinaire Marxist I had ever met."[10] The popular front to broaden Communist influence had not yet been launched by the Comintern, so that in Mexico a hard-line attitude still prevailed in the Partido Comunista. But Strand's six-week visit with Clurman to Moscow in 1935, which just preceded the softer policy of the popular front, found the Comintern still no less exigent with regard to the implementation of socialist realism in art. Sergei Eisenstein was already under severe suspicion as a formalist in an atmosphere which was soon to produce the Moscow Trials. Strand had hoped to work with him on the uncompleted film *Bezhin Meadow*, but Strand's visa was refused because Eisenstein's film group was regarded as ideologically unreliable. Equally indicative of the ideological atmosphere was the question posed by Moscow theater director Boris Alpers; looking at Strand's "tragic landscapes," he asked the photographer why there were no people in them.[11] When Strand returned to the United States this criticism rankled enough to make him want to rephotograph the Gaspé area, this time with fishermen.[12]

In 1937 Strand registered in New York as a member of the American Labor party (ALP), which had been formed in 1936 as a new third party. He continued to register, according to the New York Board of Elections, in 1938, 1942, 1943, 1944, 1946, and 1947, despite the fact that Communist party influence in the party (an estimated twenty to twenty-five percent of ALP members had Communist party ties) had caused a split resulting in the formation of the Liberal party in 1944. For over a decade Strand affiliated himself with more than twenty organizations later to be cited by the attorney general of the United States as "subversive" and "un-American."[13]

In 1948 Strand's continued interest in third-party politics led to his sponsorship of Henry A. Wallace as presidential candidate of the Progressive party, for which the American Labor party had become the New York unit. The New party, as Strand called it in *Photo Notes*,[14] offered itself as the true successor to the New Deal. It stressed civil rights, accused the Truman administration of warmongering, and proposed co-existence with the Soviet Union despite the recent coup in Czechoslovakia. Throughout his campaign Wallace had been backed by the National Council of the Arts, Sciences, and Professions (NCASP), whose chairman was Harlow S. Shapley, the Harvard astronomer.[15] The NCASP had been formed from the

amalgamation of the Independent Voters Committee for Roosevelt and the Progressive Citizens of America (PCA) organization, to both of which Strand had belonged.[16] Strand was co-chairman with Ben Shahn of the PCA's arts division and spokesman on the fine arts of the Progressive party.

The year 1949 was for Strand one of mounting political crisis. In January he sponsored a conference at the Hotel Capitol, New York, on the discriminatory system of selecting juries in the Foley Square trial of eleven Communist leaders including Ben Davis,[17] and in February he joined others to denounce their prosecution as unconstitutional.[18] In March, the NCASP organized the Scientific and Cultural Conference for World Peace at the Waldorf Astoria Hotel. Aaron Copland, the third member of an old trio including Strand and Clurman, spoke on "Effects of the Cold War on the Artist in the United States." In June Strand joined Ben Shahn and Clifford Odets in a call for a Bill of Rights conference to be held at the Hotel Hudson "bluntly [to] speak up against the police state methods of certain Army and FBI officials."[19] On June 30 the Photo League held a farewell party at the Hotel Albert for Strand, who was about to leave to attend film conferences in Europe. On July 7, 1949, the first Alger Hiss trial ended in a hung jury, eight to four for conviction. The same month, Strand introduced *Native Land* at the Fourth International Film Festival in Marianske Lazne, Czechoslovakia. In his speech, he defended the Hollywood Ten—specifically John Howard Lawson, Dalton Trumbo, Edward Dmytryk, and Alvah Bessie—and attacked such "un-American activities" as blacklisting.[20] In September 1949, Strand gave a talk on dynamic realism at the International Congress of Cinema in Perugia, Italy.

Describing this personal synthesis of two descriptions of realism current in the period—socialist realism and critical realism—Strand denied that realism was either the impartial recording of things as they are or the description of the exceptional or sensational:

> We must reject both this venal realism as well as the mere slice-of-life naturalism which is completely static in its unwillingness to be involved in the struggle of man towards a better and fuller life.

> On the contrary, we should conceive of realism as dynamic, as truth which sees and understands a changing world and in its turn is capable of changing it, in the interests of peace, human progress, and the eradication of human misery and cruelty, and towards the unity of all people. We must take sides.[21]

It was Maxim Gorky who coined the term "socialist realism" to imply the artist's solidarity with the aims of the working class at home and abroad. But as soon as such art came under the administrative control of the Comintern and was theorized propagandistically, it was doomed to become the approved art of the Soviet establishment. Critical realism,

which was the formulation of the Hungarian aesthetician and critic György Lukàcs, implied an art which criticized social reality but did so in a historical context which was still bourgeois. Because Sir Walter Scott, Honoré de Balzac, and Leo Tolstoy criticized their times, they could be regarded as critical realists — even though ideologically unprogressive they were profoundly critical of social reality. This attitude allowed the Marxist critic to remain a traditionalist without subscribing to establishment values.

Strand's insistence on the value of the art of the past may be seen in this political light. At a symposium in 1949 at the Photo League the question came, reported Sandra Weiner in *Photo Notes*, "'Where do we go from here?' [and] Mr. Strand's terse reply to this f64-dollar question was, 'Go to the Metropolitan Museum,'"[22] an answer in line with the commitment of his socialist friends to the art of the past. Oliver Larkin had written in the late 1930s on Gustave Courbet and Honoré Daumier, and Milton Brown on the painters of the French Revolution.[23] Meyer Schapiro's pupil, Stanley Meltzoff, showed that the Le Nain brothers had been symbols for the social struggle both of the Revolution of 1848 and of the *Front populaire* in the France of the 1930s.[24]

Lukàcs' critical realism was presented in the United States in three major journals, *Partisan Review*, *International Literature*, and *Masses & Mainstream*. Essays such as "Propaganda or Partisanship" (which probably gave *Partisan Review* its name) and "The Intellectual Physiognomy of Literary Characters" presented his concepts of typicality and totality.[25] These three principles — partisanship, typicality, and totality — coincide with Strand's "taking sides," specificity, and dimensionality.

For realism to be dynamic it had first to be *partisan* — committed to social change and never defeatist. It was the photographer's task "to find what is important in life to him and then find the form which will give content heightened reality."[26] However, deep insight into the overall connections between peoples, places, and things was not easy to achieve. Strand's admired friend Robert Flaherty had a deep desire to make such connections but, for lack of political awareness, could only utter an agonized cry of bewilderment and pain in his film *The Land* (1941).[27] Strand implied just such a criticism of Flaherty's work in a talk about *The Wave* at the Photo League: "The film workers knew that they did not want to make [a film] based on the principle of the struggle between the individual and his physical environment. A film about Mexico should show the struggle of the people to better their social conditions."[28] To achieve this, the dynamic artist, like the organic intellectual, had to go beyond naturalism, which represented reality in fragments, in order to provide a critical key to the cause of which they were the effects. Strand's review of Dorothea Lange and Paul Taylor's *An American Exodus* offered a similar criticism in recognizing that they were not fully prepared to identify the system of exploitation which had produced the Dust Bowl: "the total im-

pression does not have the impact upon the eye and the mind which the subject surely contains and which the authors clearly were deeply moved to give us," he wrote.[29] Certain realities of the world had to be made clear—to be deeply moved was not enough. In Strand's view, social pessimism was not a dynamic expression of life but a kind of sentimentality: "It doesn't tell you, as a rule, the underlying forces that cause people to do things."[30]

If the first requirement of dynamic realism was that it should be partisan, the second was that it should be *specific*. This quality of specificity did not mean individuality but typicality, which embraced both the characteristic and the particular; the dialectical relation between the two terms guaranteed a quintessential image. In his review of *An American Exodus*, Strand wrote: "That Dorothea Lange has solved this problem [of specificity] in some of the photographs in this book, there is no doubt. The cotton picker is an unforgettable photograph in which is epitomized not only this one man bending down under the oppressive sky, but the lot of thousands of his fellows".[31] Without such epitomization or specificity, photography swiftly collapsed into record making, emphasizing the exceptional at the expense of the universal or soaring into allegory to do the opposite. Realism, in Strand's mind, implied, besides authentic detail, truth in the representation of specific people in typical circumstances.

In 1946 Strand wrote: "We do not photograph some large conception of humanity, but rather go very deeply into a single person, and penetrate very deeply and derive a larger meaning. One person who has been studied very deeply and penetratingly can become all persons. Therefore, it seems to me, that art is very specific and not at all general."[32] In April 1949 the cover of *Masses & Mainstream* carried Strand's portrait of Ed Bennett, a Vermont farmer (see figure 32). Genevieve Taggard, the poet who gave *Time in New England* its title, wrote a poem based upon Strand's *Mr. Bennett*, which read in part:

Marvelous now is man
Wrinkles next his eyes . . .
Moral, lofty, in him, the human spirit
Repeats, repeats, petitions not to die . . .
Now he is closing,
In mystery withers away.[33]

Opposite the picture in *Time in New England* there is a text by Thoreau which includes the sentence, "It is not necessary that a man should earn his living by the sweat of his brow, unless he sweats easier than I do." Separated by almost a century, these dissenting voices in the American tradition stress, on the one hand, the vital core of one man's being and, on the other, the general condition of humanity under capitalism.[34]

Strand's third requirement of dynamic realism was that it should be

dimensional. Dimensionality was a metaphorical rather than a literal quality, referring in part to the plasticity of the print but also to its social content. It represented a totality, which was not flat and static but fully rounded and dynamic:

> The best pictures satisfy you. It is because they have an internal movement, and that is why they satisfy you. In the visual arts it is a sensation of movement through the eye, and this is simply a reflection of the material fact that everything is in movement. There is nothing that is completely static. So the necessity and desire for that feeling in art is, I think, the counterpart of the truth and the essential human need to feel that things are moving and changing. A tree, for instance, is not a static thing. The sap is moving, the leaves are growing or falling, the branches are stretching out to the sky. This is true of every object and every form of life. This element of movement in the picture is the counterpart.

> The other element of movement is the element of relationship and unity. It is the reflection that in the world things are actually related to each other even though sometimes we cannot readily see it. There is a balance of forces which moves towards that kind of unity, even though it might be a unity of opposing forces. This unity of opposing forces is the dramatic aspect of picture, plays, books, and music.[35]

In his essay "Narration versus Description," which appeared both in *International Literature* in 1937 and in *Masses & Mainstream* in 1949,[36] Lukàcs contrasted narration with description, the difference being that the first required a *Weltanschauung* whereas the second was an unthinking substitute for the lack of such a worldview. Narration portrayed the actual process of life itself, whereas description resulted in reportage, "a series of static pictures, of still-lifes, connected only by their objective unity. These pictures, according to their intrinsic logic, just stand alongside one another, in no integral sequence, and have no causal connector."[37] But to narrate or portray was to create a montage which reflected the complexity of life in its totality. Strand learned this principle from film just as Lukàcs did from the novel and from drama. He knew that the addition of voice-over in the film, or of text in the book, could change the meaning of a shot: "That's why I want text with my photographs because I think text properly used or properly written—a text that doesn't say the same thing at all as the photograph—adds to the photograph, and they both get a new dimension that way."[38] Montage of this sort embodied a dynamic of counteracting forces which was completely dialectical. Only in his books and films could Strand hope to overcome the naturalistic limitations of documentary.

In the section of *Time in New England* headed "Revolution," an extract from the diary of John Adams refers to the dedication of a Liberty Tree

58. *Bell Rope*, Massachusetts, 1945

in Rhode Island. It is followed three pages later by Strand's *The Bell Rope* (see figure 58), a picture no less revolutionary in symbolism: the great pillar hewn and shaped from such a tree of liberty and built into the beams of the meeting house reaffirms the opening sequence of Strand and Leo Hurwitz's film *Native Land*, released in 1942 . However, just as New England resistance to English rule was portrayed as accompanied by a certain Puritan destructiveness in Nathaniel Hawthorne's story "Endicott and the Red Cross" (1838), so in Strand's view resistance to Nazism had by 1945 ended in cold war with the Soviet Union. In Hawthorne's story the building reflected in the daguerreotype-like breastplate of John Endicott is "an edifice of humble architecture, with neither steeple nor bell to proclaim it,—what it nevertheless was,—the house of prayer." Among the evil-doers whom Endicott judges is one "with a halter about his neck, which he was forbidden ever to take off. Methinks he must have been grievously tempted to affix the other end of the rope to some convenient beam or bough." In the context of another extract, this time from Samuel Adams, the rope is less the bell rope of a Liberty Bell than the hanging rope of some fu-

59. *Haying*, Haut Rhin, France, 1950

ture McCarthyite lynch mob. The American Revolution was in danger, so far as Strand was concerned, of succumbing to the very forces it had so manfully opposed. In September 1951, the Subversive Activities Control Board (SAC) in Washington, D.C., which was tracing individuals connected with the Communist party of the United States, began a search for information on Strand. Following investigation by the FBI, he was placed on SAC's security index in 1954.[40] At that time in Italy, Strand made *Workers' Bicycles*, in which he may have suggested that the vehicles convey the people collectively into the dark woods not simply for rest and recreation but for meeting and planning, as in the forest sequence of Eisenstein's *Strike* (1925) The individual bicycles which lean against each tree together may represent the masses who receive the protection of the forest as a whole.

Strand's brief interest in the early twenties in mechanism or machine aesthetics was checked by the vitalist movement—the belief in the power of constant growth by which all organisms maintain their integrity as living things. Vitalism was received by members of the Stieglitz group through the works of D.H. Lawrence and Havelock Ellis. The destructive influence of mechanistic thought in American culture had been satirized by Stieglitz in his notorious photograph of a gelding in harness (*Spiritual America*, 1923). Throughout the crisis years of the thirties Strand was seeking some principle by which he could discover the inner unity of relations between

60. *Near Dompierre*, Charente, France, 1951

things in nature and in society. Dialectical materialism offered him a mid-point between mechanism and vitalism. Proposing itself as a science of interconnections between things in nature and in society, it asserted that the interpenetration of opposites was the moving principle of the world. This contradiction could not only bring about such qualitative changes between men and women as vitalists desired but also change relations between classes in the way socialists demanded. Strand's inclusion in *Time in New England* of close-ups of nature showed how vitalist attitudes could be recuperated for historical purposes. *Cobweb in Rain* embodies the first law of dialectical materialism in that a qualitative change takes place in a quantity of rainwater when transformed into a crystalline structure by an encounter with a spider's web (see figure 43). The buttercup leaf, less crushable than the rain-bejewelled cobweb, embodies the second law of dialectics in that, together with the cobweb, it represents the interpenetration of opposites within the same habitat. Strand's vitalist adaptation of Engels's general theory of dialectical materialism offered further underpinning to the key concept of dynamic realism.

In France, in *Haying, Haut Rhin*, a single woman harvests the blooming grass into a great mound of hay, related in bulk to the boscage behind it, the coppice behind that, and the clouds above (see figure 59). Every part of this fertile, ordered world is in Arcadian harmony with its counterpart. *Near Dompierre* works in a similar way, only this time the woman is not physically but symbolically present as the arch created in the center of the

picture by two trees and a hedge (see figure 60). Beyond this metaphorical gateway we see baled hay and farm buildings ranged on either side of the picture in perfect social equilibrium. Such an emphasis on relationship and unity is as characteristic of Strand's work as it was of that of Camille Pissarro, of all the French realist painters the one closest to Strand's intentions and expression.[41] Like Pissarro's peasants, always small farmers or villagers, Strand's people have the robust vitality of things in nature — of plants and trees. Whether in markets, harvesting, or simply being with each other, his peasantry embodied his rejection not just of bourgeois life but also of the urban proletariat of industrial workers. In *Native Land*, his attention was inevitably drawn to the social turpitude of cities, but in his photography he did not have to follow a party line. However, his choice of countries to photograph affirmed his basic political attitude: Egypt rather than Israel because of the Suez War, Ghana because of its socialist president Nkrumah, and Romania as part of the Eastern Bloc. He had gone to France and Italy in the fifties because those countries had the largest and most viable communist parties in the West, where he could count on the collaboration of communist friends such as Claude Roy and Cesare Zavattini. His Egyptian and Hebridean books were printed and published in East Germany.

The pattern of ideological change which marked Strand's life from the end of 1933 was by no means unique. György Lukàcs had also grown up as a vitalist to become a dialectical materialist. Claude Roy, Strand's celebrated French collaborator in *La France de Profil*, a member of the Parti Communiste Français from 1943 to 1956, had followed a not dissimilar development.[42] Strand himself, influenced in his early life by Lewis Hine as well as Stieglitz, by ethical culture as well as romantic modernism, lost neither his original social concern nor his vitalism, to which he returned late in his life, most movingly, in *The Garden* portfolio (1976).

At the time of the Hungarian uprising Strand was sixty-six. By the time of the Prague spring he was almost seventy-eight. Confronted with increasing evidence of state terrorism, Strand still stubbornly maintained his obdurate political stance. Faced with the "repentance" of those who testified before the House Un-American Activities Committee in the fifties, resolute impenitence may have seemed preferable to displays of abject self-abasement and betrayal. To change his position relatively late in life would have been to call that life into question and to reject his own life's work. It was not in his stern and inflexible character to do this. He often said he would have liked to have lived on to see what would happen to the world. Today he would surely be puzzled at the extent to which the October Revolution is now seen to have been betrayed. The evils of Stalin's regime can no longer be denied even by hard-liners. Yet Strand's work remains the magnificent culmination in photography of a great realist tradition in art which must be seen in the context of his socialist vision if it is to be fully understood.

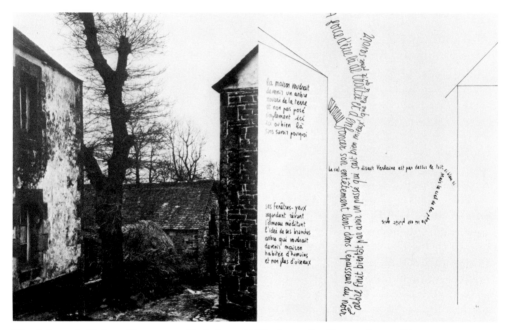

61. *Arbres et Maison*, Botmeur, Finistère, 1950, from *La France de Profil*

JEROME LIEBLING

Arbres et Maison,
Botmeur, Finistère, 1950

Paul Strand sent me a copy of *La France de Profil* just after its publication in 1952. I was teaching at the time and had not seen Paul since the class he taught at the Photo League in the spring of 1949. He had already met Hazel Kingsbury and together they were planning a move to France later in the year. In turn I was to leave that fall for Minneapolis and my first teaching position. We were not to meet again until I visited him in Orgeval in 1966. *La France de Profil* reinforced my feelings about his work and his ideas about photography; it created a culmination of many of Paul's pursuits in photography so continuously expressed during the time I had spent with him in New York City. Particularly the book brought together Strand's photographs with a most visually imaginative collaborator, Claude Roy. In *La France de Profil* Strand and Roy succeeded in accomplishing a new integration of more than just words and pictures, creating the strongest of all Paul's publications.

The photograph *Arbres et Maison* with Roy's accompanying hand-drawn, animated text is a striking fusion of both of their strengths moving toward a new expression. The collaboration includes texts uniquely designed, ranging from hand-printed poems, to reproductions of ledgers, to newspaper excerpts. Strand also produced stunning juxtapositions of his photographs, not only combining the meaning of two facing prints, but also relating to the complex needs of Roy's text. Though many of the photographs have been reproduced as individual prints, for me the original book has indelibly fused the print and text.

The vertical print "Trees and House" echoes many of Strand's photographs in New Mexico and New England in the way he edges the frame with the sections of the houses and allows the tree to fuse the sky and buildings. The patina of the years darkens all and lies in layers over all of the seemingly inarticulate material, but how articulate and important Strand makes it appear! The dark tonal modulation is juxtaposed to Roy's animated, high-key poem that reads horizontally and vertically and follows Strand's original form for the photographs. Listen to Roy talking about Strand's "Trees and House":

The house would like to be a tree fed by the earth and not simply placed here or there without knowing why.

Its window-eyes look dreamingly by at the elm that is meditating the idea of its branches. The tree would like to become a house inhabited by human beings not birds.

By dint of being there, of growing, and of plunging its slow obstinacy in the thickness of blackness, the tree soon ends by having a past that knows better than what it thinks it knows.

The photograph, the text, the pages together make a new meaning.

Paul Strand's early photographs — *Blind Woman* (1916), *Wall Street* (1915), *Sandwich Man* (1916) — are considered to be among the finest examples of his early work. They contain a spontaneity and explosiveness that challenged existing ideas about the making of photographs. Rather than continuing in Strand's work, that explosiveness was absorbed and took a different direction in later years. *La France de Profil*, Strand's first book published after he left the United States for France, has the same explosiveness as those early photographs. The most challenging of all that he published, it reaches combinations of meaning and new textual structures that other photographers have attempted only recently.

BASIL DAVIDSON

Working with Strand

Cesare Zavattini, the Italian writer, first showed me that Paul Strand, about whom I had previously heard little, must be an artist it would be a great thing to work with. It was not Zavattini in person who suggested this, for I never had the luck to know him, but Zavattini's words in *Un Paese*, words in which those marvelous photographs acquired for me a directly personal connotation. Zavattini wrote that he had encountered Strand at a get-together of filmmakers in Perugia during 1949, an occasion devoted to "the duty of modern people in relation to the cinema" at which Strand, offering his *Native Land* in evidence, argued "in his calm ancestral voice" that this duty was "to love one's own country and risk something for it."[1]

That may sound a trifle mawkish today in very different times, but I knew just what Zavattini had in mind when he quoted Strand. In Europe in the late 1940s we were still shoving out from under the ruins of war, ruins of the mind or spirit as well as of the fabric, and trying with blurred vision to see how far we might still be alive. The times then were good neither for hope nor absolution. Too much was destroyed; too many were dead, unbelievably many. In that situation a "new realism," whether of the cinema or any other art worth the name, had to spring from an act of faith in civilized ability to build as well as to destroy. This had to mean a "standing on foundations," a relation with the severely practical and every-day and so a dismissal of whatever might be rhetoric or dogma.

Do I mean then, some kind of "return to the source"? No, not that: in such times as those no one could sensibly think of returning anywhere. If there was life after death—and on top of our fighting experiences we were only then learning the full horrors of the Holocaust—then it would be in the vigor of new beginnings. One should therefore "love one's own country"—one's own humanity wherever it could be found—and "risk something for it." That would be a way of having hope again. We called it *neo-realism*, but the term itself doesn't matter.

Later on, much later, I understood that Strand had long risked all that he had in him for this saving conviction. But for the moment, once I had seen *Un Paese*, what I knew was enough to be going on with. Introduced by cinematic friends in Paris, I called on Strand and his wife Hazel Kingsbury, then living in an apartment on the Boulevard Auguste-Blanqui. But for one reason or another it wasn't till they moved to their village house in Montamets, some fifty kilometers from the capital, that I really got to know Paul and Hazel.

Strand wrote to me to ask if I would be interested "in doing the text for the South Uist book"; at that stage the photographs had been partly assembled. If so, would I come over for another visit?[2] Liking the idea, I went again to Paris and this time caught the train for Saint-Germain-en-Laye. Paul was waiting for me with his car, and we drove the fifteen minutes or so to Montamets, a hamlet rather than a village tucked modestly between the forest of Marly on the south and that of Saint-Germain on the north. Montamets proved to be a withdrawn but sympathetic place where La Briardière, the Strands' house, stood in a garden behind ornamental railings and a pleasant wall.

They had bought the old farmhouse and done much good to it, adding convenience and sound American comfort while removing interior walls so as to make hospitable the space downstairs and, above on the only upper floor, the bedrooms and a wide working space for the photographic processing on which, as I now discovered, they were each other's unfailing critic and observer. We talked and listened, but of that encounter I chiefly recall their warmth of hospitality and their determination that the visitor should settle himself into an ease of friendship. That was helped along by the excellent food that Hazel cooked, offering famous American dishes which Europeans, to her amazement, had never heard of.

Paul was then around sixty-five, a sturdy figure rather heavily built, slow of movement—though svelte enough on his *boules* pitch, where he would demolish the visitor with a disarming modesty of expertise—and measured rather than slow of speech, picking words in his own style. Hazel was younger but no longer in strong health, suffering from what she preferred to call "wear and tear" but more exactly from the punishments of insomnia. They were very close and hard to imagine apart. In 1971 he wrote of her in the dedication of the second volume of the *Retrospective*—the first had been dedicated to his father Jacob—that for twenty years she was his close companion in all aspects of work, helping to resolve the "technical, esthetic and above all human problems which our explorations together raised"; and it became my own experience that this was exactly the case. Nothing Paul and I did together was without her creative interest and support. In 1955 they had what I imagine they had achieved long before, a profound mutual trust given lively edge by the affectionate abrasions of companionship.

Over days we talked about the "Hebridean problem"; not of going there or working there, neither of which offered problems, but of what kind of published outcome there should be. This would depend on essentials about which it may be useful to say something here. Paul had come to Europe so as to continue the presentation of his work in a form that *Time in New England*, as he explained, had particularly shown him to be effective and congenial. This meant selecting subjects which would meet his human and aesthetic criteria, and about that more in a moment; but it would also depend, somewhere down the line, on finding writers who, as he afterward wrote to me, would have "similar sensibilities and feelings about life: or it won't work."[3]

A number of rebuffs from European publishers — Giulio Einaudi in Italy, then at the summit of his splendid publishing career, being a fortunate exception — had led Paul to the view that "a big mistake was being made in showing photographs without text," for in that way publishers "just cannot visualize it." So writers were necessary, even if more time must be lost in finding them. As it transpired, Strand repeatedly found the writers whom he judged he wanted; and of their competence the books say whatever may need to be said. But why should writers wish to write for him? They have explained their reasons, none so well as Zavattini, but I will say a little more about myself because it may throw light on the nature of these "explorations."

These were not nor could they be in any primary sense political reasons any more than financial reasons. My royalties from the text of *Tir a'Mhurain* were exactly $300, which I joyfully spent on buying a tapestry from the Harania workshop in Egypt; certainly none of us worked with Paul for the money we might make. Something better was available. But in defining this something better one has to bear in mind the context of the times. Just what had brought the Strands to Europe was not discussed, that I can recall, or even wondered about. Clearly, they were some kind of victims of the cold war, but there was scarcely anything strange about that. Western Europe — east of Spain and west of Stalin — received many such victims from many places in those years. That they should also come from the United States was unexpected but was only, as it increasingly seemed, another misfortune of those gelid years when, for us survivors in Europe, so much that we had fought for seemed so likely to be lost in a new catastrophe.

The prime need in that plight, at any rate for those working in the arts, was to find and rivet oneself to something like "neo-realism," one of those ambiguous terms that mean a lot or a little but — in my case, and I think in our case — certainly meant arriving at perceptions able to move beyond and outside of *idées reçues*, conventional wisdoms, or whatever stereotypes might stand in the way of the truth as we knew it. I thought from my first awareness of Strand's work and of himself that he possessed these perceptions to a rare degree of creative originality; of course, this simply did me

the credit of being right for once. Others had understood long before. Comparing Strand with Piero della Francesca, a master remote in time but not in temperament, Milton Brown has remarked that "Strand's art, like Piero's, is the expression of a nobility of mind as well as of style"; I would add, to accept the absolute rightness of this comparison one needs to look, for example, only at Piero's *Dream of Constantine* in San Francesco at Arezzo. Brown is further right in holding that Strand "reflects a tradition of affirmation" that "believes in human values, in social ideas, and in truth."[4]

That again needs putting into the context of the cold war at its worst, which was just about what it was when I first met the Strands. "In these dark days," I find that I wrote in my diary for 1955 (having reread it now for the first time in decades), "we have had, and we have, to fight for simple things—for the right to live, to be honest, to be innocent. . . ." And if that sounds rather high-flown to readers who live in blessedly later times, consider only this newspaper fragment that I also put in my diary: the *Sudbury Daily Star*, of Canada, reports on June 4, 1955, from Ottawa that, "the vice-chairman of the tariff board said Monday that a large scale potato production could eventually lead to the Communist way of life": presumably, with nothing else to eat? Fighting "to be innocent" in that kind of madhouse atmosphere could seem an elementary need. In quite another key, but in the same sense, Leo Hurwitz has written of the springs of Strand's art—a great art, Hurwitz insists—as flowing from a "profound obligation to the truths and abundance of experience."[5]

Such values are embodied in whatever the viewer takes from Strand's work, but also in whatever she or he brings to it, and they were, for those who worked with him, the crucial determinant in deciding what the words would be. That said, the words should project his work without in any sense repeating it. They should reflect the qualities that Strand carried to his "explorations." As James Aldridge has written in *Living Egypt*, "what dignity he gives to people is simply the dignity that he is willing to find there," and whereas "Egypt might have been an alien land to a man with his old American tradition . . . these photographs prove conclusively that his contact was perfect." Zavattini has said, concisely: "a tree for Strand is never solitary; he is the other tree."[6] In fact, nothing and no one is extraneously placed between the viewer and what is seen, for Strand has waited and watched and empathized until his presence has become identified with the subject or the scene.

I guess he chose his writers quite largely from whomever was at hand who could, as he judged it, meet his requirements of character, attitude, and skill. He chose me, having tried to persuade a far more fashionable writer only to repent that choice, because he had read some of my early novels and books of African reportage. I thought he was doing me too much honor and demurred to no avail. Having decided, Strand-like he never wavered or grew impatient with unavoidable delays. It was months

before I could get to the Hebrides and the writing of my text. Never mind: the project was under way and the voyage in prospect.

But why this particular voyage, this selection of a small island in a remote archipelago anchored somewhere in the northern seas? Who had heard of South Uist and its neighbor Eriskay or would be wanting a book about them? As for me, I had my own Scots background, but for Strand, I think, his distant meeting with Robert Flaherty may have planted a seed of interest in the "far-out Gaelic fringe," the Hebrides being as much a part of that as western Ireland. But sheer chance, in the end, had a lot to do with his choice.

"How did we come to go there?" He replied to my question: partly, the Strands went to South Uist because the balladeer and radio producer Alan Lomax had just put on a BBC program—television yet to come—with five women singers from homesteads in South Uist, and Lomax had then "talked glowingly of his experience there."[7] Then it became clear that South Uist and Eriskay could be ideal subjects, being handily small places with scattered inhabitants who did, indeed, represent a culture as well as themselves. As other essays in this volume make evident, many of the threads in Strand's working life could support the choice of this otherwise eccentric-seeming destination.

So we began.

As with most of Strand's books, the writer came into the Hebridean work when the photographs were already taken though by no means finally selected and arranged. Advised that I was ready to visit the islands, Strand wrote me that "Hazel has been hard at work digging out and typing the information for you from our old notes. You will find it pretty complete"; so I found it, with "stars" next to the names of those persons whom it might be most worth meeting and interviewing, together with extended notes on sundry others.[8] I on my side had background of various kinds, oral or written, that I could and did call on, not least the Gaelic specialist John Lorne Campbell of Canna, and I made my visit with a fairly comprehensive dossier of historical and economic data.

But Paul now thought that I should have at least a preliminary look at the photographs, and he had them sent to me from Scotland, where they then were "packed up in their own little suitcase, a bit heavy but not too bad."[9] This was the assemblage, a good deal larger than could eventually be used in the book, from which the final choices were to be made by the three of us, after quantities of discussion and many second thoughts. The "little suitcase" got safely to London, where I then was, and I took it over to La Briardière when next I went there.

But the assemblage in its suitcase, though beautifully put together by Hazel, was left at La Briardière. Paul was too much the tried professional to suppose that any useful end could be served by a preliminary handing

round of photographs. "If you take a dummy"—the assemblage in its covers—"along to Uist for reasons of need," he had written to me, "I would not show any photographs to the people directly involved in the book. People and their families seldom like pictures of themselves. It would probably only give us some headaches."[10] He had to be right about this, and so I left the assemblage behind while knowing that the same problem would arise in a different direction with the text when published. As it turned out, I think that everyone in the islands was pleased with the final results; at least, I never heard anything to the contrary.

We discussed at length what the text should try to do. *Time in New England* was evidently the formative original in Paul's conception of the other books he afterward envisaged; but the later texts could not be largely anthological, if only because the subjects and their literary contexts were so little known to any wide audience or even not known at all. Nor could they be largely anecdotal and personal, as Zavattini's in *Un Paese*. But they should certainly be explanatory: in short, they should be strongly attached to history. "So to sum up," he wrote me in 1957, "here are fine people born of a rich culture hundreds of years old, tenacious in the face of all hardships, rooted in their island. So where do they go from here? How can they make this island and their own lives part of the world as it develops? Can we not ask the question not only of their culture but of their very existence, if we establish through their history, and their struggles of past and present, the fine basic character of these folk?"[11]

That sort of approach suited me well, for it was my own, whether in the Hebrides or in Ghana later on. So the first need, I thought, was to establish the fact and validity of the Gaelic culture within which the people of South Uist, as of Eriskay and Barra, have clothed their lives: just as it had been the songs of the five women of South Uist, in the radio program created by Lomax, that had fired Strand's initial interest in the islands and their Gaelic-speaking people. We had some argument on this point, Paul being apprehensive of a nostalgic approach, but I think in the end that we found an effective balance between "history" and "the modern world." We could not reproduce the sounds of Mrs. Archie Macdonald's mother chanting old songs with the "hint and music, faint as a rustling amid dry leaves, of a time when the Romans were settled in Britain," but we could at any rate project in brief history this "oldest living culture in Europe": a reasonable description, though probably it may be true that the culture of the Basques and possibly the culture of the Albanians are older still. But that would be immensely old.

As my text took shape, gradually because of interruptions for other work as well as ponderings and discussions, Paul and Hazel were working toward their preferred choice of photographs. This choosing entailed much of which I could know nothing, since they worked on final prints for many weeks according to criteria beyond my grasp. By this time, draw-

ing on previous experience, they had devised their technique for selection of prints. It proved to be hard work of its kind. Given our objectives and their philosophy of selection (and I will return to this), the great requirement was not only to choose the most effective prints, but to see, in Paul's words, "what these photographs do to each other." So we should lay out photographs on the floor at La Briardière and "try them out against each other." For me this was something new: I had never looked at photographs this way but had always seen them as though "fixed upon the page." Later on, when Michael Hoffman brought his genial gifts to the work, the Strands could have a trained eye in steering through this process.

We did our best, in my case with the Strands having the last word but invariably with deference to second thoughts and other thoughts that I might have. With this long selection process I am sure that I became nearer to understanding Strand's aesthetic thinking than I could have done through any amount of theoretical discussion. "Don't you feel," he would come back to me at breakfast after a previous day's labor on the floor, "that the Highland piper should be at the end instead of in the middle?" or some proposal for rearrangement, and back we would go to the prints on the floor. In all this he treated his work with critical distance as though looking at the photography of someone else.

We inspected and shifted for hours, and then we did it all over again. *Ars longa* . . . but no "pairs" in these books are in the least accidental or shoveled in as "good enough together." Nothing for Paul was ever "good enough." But at last it would be over for the day, and if the sun was shining in his admirably wild garden, we would go out there and play *boules* till Hazel called us in to eat.

Then publishing, and the trouble had to begin. One might suppose, given Strand's reputation in these later years when all the world of photography knows his mastery and many people outside that world know it too, that publication would be easy and even automatic, or at least free of major anxieties. And so it would become when Michael Hoffman came upon the scene and set about clearing away obstacles to publication as though these barely existed. But in those years of the 1950s and along into the 1960s, such obstacles bulked high and hard to move. In the first place, high-quality printing in gravure was difficult to find in Europe, and eventually Paul found it with Kunst Verlag in Dresden and Leipzig. Happily he had the time to visit those cities and ensure that he was going to get the quality he wanted, even if this carried the disadvantage, from the standpoint of distribution, of having his books produced outside Western Europe and the United States.

Still there were crotchets and confusions in this publishing experience of the 1950s and 1960s. Writing from Marrakesh in 1962, where Hazel and he were building their Moroccan assemblage (not published until the great

Retrospective of 1971, and then by Aperture in the United States), he warned me: here "enclosed is a real headache of a letter"; and so it was.[12] The otherwise conscientious Kunst Verlag in Dresden had incautiously signed an agreement with another continental publisher for a French-language edition of the Hebridean book. Skipping all mention of royalties in this deal, Kunst had printed five thousand copies together with a text not by me but by a French writer who, as we saw when we read it, had no more notion of the Hebrides than we had, for example, of Colombey-les-Deux-Eglises — rather less, in fact, since we at any rate had visited Colombey-les-Deux-Eglises. But a French-language book must evidently have a French writer.

I mention this annoyance because it provoked in Paul every bit of the stubborn fury with which he was accustomed to defend the integrity of his work. "Your account of this publisher's latest demand to be free to have the text rewritten by some obscure French writer," he wrote to Kunst in Dresden (sending me a copy), "has shocked us very much. As I wired you, I will not consent to this insult and violation of the unity and integrity of the book. No matter where the book is sold or in what language, it must have on the cover the names of Strand and Davidson. There are no other authors."[13] And he went on to point out, for good measure, that in his belief this other continental publisher would pay this substituted author "the royalties he is not paying to us." In short, it was a point of principle, and on points of principle Strand could be intransigent. I advised him that he must weigh up the advantages one way or the other, since the five thousand French-language copies were evidently vital to Kunst's costings, but the substituted text when I saw it certainly left a lot to be desired. "With a few of my passages and phrases quoted," I commented to Paul, "this has meant dispensing with most of the history of South Uist in the form that I had written it, and with all the day-to-day details and most of the individual descriptions. . . ."[14]

Paul's outrage was long and lasting. This was partly to defend my text, which he and Hazel felt at home with, but still more in protest at the mangling of an artistic process which stemmed from the core and center of his beliefs and practices. That some unknown and unwanted hand should be introduced to the outcome of all that discussion and intimate concern seemed to him a barbarous violation. He would not have it. "We are not willing to give up the integrity of our work," he lectured Kunst in Dresden. "It would be dishonorable for all of us to do so. I will not let [this other publisher] seize control of the form and content of our book or in any way change its spirit."[15]

Irrespective of my own feelings on the matter, I was sure that Paul was right in all this, since this book—like all his books—was, indeed, the product of a uniquely integrated experience; this, I think, has been well recognized. Years later I had fresh confirmation from the Curator of

62. *Sea Rocks and Sea*, The Atlantic, South Uist, Hebrides, 1954

Photographs at London's Victoria and Albert Museum, the critic and con-
noisseur Mark Haworth-Booth, who wrote to me of the Hebridean book
that it "has given me great pleasure—it is one of the finest things ever
done with words and photographs."[16] I repeat this with some pride, which
I hope will be allowed to us; but it testifies really to Paul's unbending de-
termination.

Strand's philosophy of work, in so far as he had a definable body of
ideas on the subject, was always for me an insistent but pragmatic
humanism. And in this respect, I used to think of him, as I still do, as a
quintessential American in the liberating tradition or, better said perhaps,
as a messenger from the New World bearing gifts of reassurance to the
Old. Problems were there to be solved, not left to rot in helplessness. The
past was there to be left behind, not dragged along on a chain of regret
or defeat. Having quit the United States because they would no longer let
him work there, he took the world for his stage and, pilgrim-like, carried
his message of solidarity wherever chance or good fortune might send
him. There were, for Strand, strictly no foreigners anywhere, and foreign
languages—of which he knew none, not really even French—were just
another of history's nuisances.

"What then is the central theme of these islands?" he wrote during our
Hebridean discussions. "Perhaps I can best suggest it by what impressed us
most in the people themselves: their dignity and sturdiness, and the *tenacity*

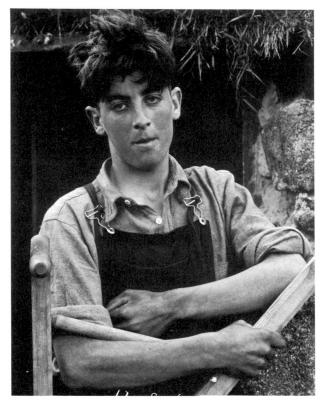

63. *Ewan McLeod*, South Uist, Hebrides, 1954

with which they hold on to their barren wind swept isles."[17] He often came
back to that word: tenacity. It was easily understood. The Hebrideans are
stubborn people because they have to be, and at that time, as later, there
were economic stresses that seemed likely to be ruinous to this population,
at least in the smaller islands such as South Uist and Eriskay (see figure
62). In the 1950s a priest of South Uist, Father Morrison, was even prop-
osing that there might need to be another mass emigration to Canada, as a
century earlier during the infamous "clearances"; in addition there was
now a British governmental decision to erect a rocket training range on
South Uist, a step that Strand feared might prove a deathblow to the
people's future.

"What one feels," he explained to me in his round and legible hand-
writing, "is not how you can get the people off this land"—which is what
he guessed that "they," the authorities, really had in mind—"but how can
they be helped to stay there, and make a living from it, as part of the
modern world." However, he was quick to add "I don't like the concept
'help': as you know yourself, this sort of charitable attitude towards raising

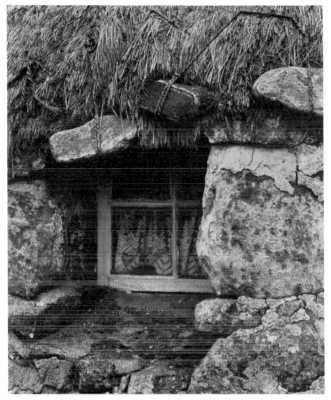

64. *Window*, Daliburgh, South Uist, Hebrides, 1954

other people's standard of life is phoney." For Paul, I think, the key words in that sentence were "part of the modern world." He was nothing if not a "modernizer." This, too, was part of his—and our—"neorealism."

As I suggested earlier, he had no faith in the saving virtues of ancestral culture, in this case the culture of the Gaels. One should respect it, but that was all. "I agree," he argued, "that the ancient culture is very important: the people have shaped it, and to a degree it has shaped them, together with their pride and self-esteem." But "I think it belongs to the past." It could be "conserved by scholars and other interested parties, and that conservation is important and necessary. Yet to say that this culture is dying, and that the people can only survive through its continued development is to me a romantic and unreal view of historical development."[18] I though that this was understating and even misunderstanding the living influence of Hebridean culture, and we reached an amiable compromise.

His repeated insistence was that the old culture clothed in Gaelic possessed the potentials of a more viable and useful culture "in the modern world" and that these human potentials were what we should portray in

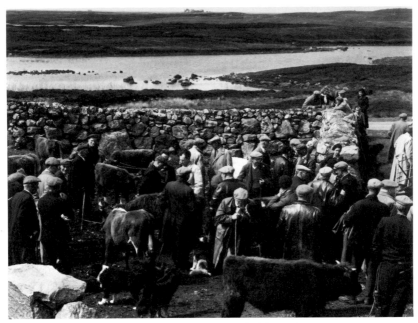

65. *Cattle Sale*, Loch Ollay, South Uist, Hebrides, 1954

every way that might be possible. This was the humanism, I suggest, that made it aesthetically mandatory for Strand to "think himself out"—one might better say "wait himself out"—of the subject he meant to photograph. He was immensely strong at this "process of waiting," unbelievably patient, once he had settled to identify with a subject. He would wait until his presence, usually with a large and always visible camera, should be absorbed and forgotten, whether or not with human portraits in mind. The form and molding of Uist's weather-beaten rocks should be seen from the inside, as it were, as well as from the camera's eye. They had their own immanence of potentials (see figures 63, 64, and 65).

Consider only the famous photograph of six peasants at and around a doorway, used as the cover picture for volume two of the *Retrospective Monograph* as well as for *Un Paese* itself. Early in knowing him, I remarked to Paul about this photograph that it had been "a happy accident that they were standing like that": to which Paul, patient with my innocence, replied that they were standing like that because he asked and arranged them to stand like that. But do you see signs of this arrangement (see figure 79)?

And then consider the fact that most of Strand's human portraitures have the subject looking straight into the camera. Here there has been no thought of catching some kind of *action-realité*, a "snapping" of an unexpected moment or gesture, a clever intrusion on privacy. We are looking at subjects, not objects; but these same subjects are also looking back at us,

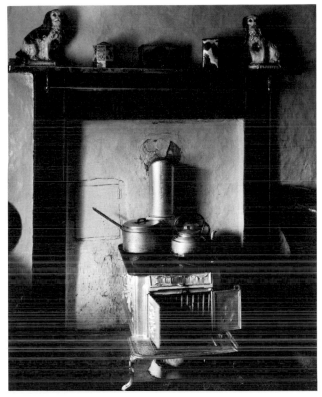

66. *Kitchen*, Loch Eynort, South Uist, Hebrides, 1954

again at us as subjects, and with the same intense equality of interest. It was in this sense that Strand, wandering with Hazel Kingsbury in remote and altogether foreign places, never discovered any foreigners, not even in the mighty forests of Ashanti or the mirrored delta of the Nile. And it was in this sense that these two Americans journeyed with their message from the New World—which had perversely thrown them out—to the Old: to the Old World that had taken them in and given them a home. Here was one of the vivid contradictions of those times.

For all these peoples had accepted the Strands as having the right to come among them, take portraits of them, arrange them in groups whenever the wish might move this man, and set up his camera in their shrines and private festivals and again around their hearths and family gatherings—just as if he had been one of themselves (see figure 66). In Ghana, for example, he traveled with appropriate letters of introduction and explanation to officials and persons of note, something that I had been able to help in making sure of. But none of that, nor even the aid of his stalwart driver as interpreter, would have opened doors and hearts

unless there had been Paul with his patient and patent honesty of pur-
pose; slowly explaining himself to these Africans, even if few or none
could understand what he was saying, and being at one with them in the
ways that I have tried to convey in this essay.

Working with Strand was a fine experience in personal terms. As to
artistic or aesthetic terms, I believe that a judgment stated in 1987 will
carry a consensus among all who enjoy his art as well as among *cognoscenti*,
whether on one side of the Atlantic or the other: "For Strand, technical
prowess functioned as a kind of justice towards his subject, his medium,
and himself. . . . As in all great art, the photographs of Paul Strand trans-
cend their own immediacy, a feat of eloquence that makes their presence
enduring."[19] These are high claims. But I doubt if anyone will think them
too high who had the experience of working with Strand.

BREWSTER GHISELIN

Hilltown

In strict simplicity, concentrating manifold shapes in a single impression, Paul Strand's photograph *Hilltown*, Sicily, 1952 is exemplary of his art at maturity (see figure 67). It rewards analysis. Many components of its force are discoverable, but their number and diversity baffle summation and suggest, what is finally evident, that there is no end of them.

Understanding why that is true requires more than a glance at the picture itself. A sunless cone of close-clustered buildings under a sky mottled and streaked with storm cloud rises from a foreground almost entirely unbuilt. A few paths and roadways of access curve to a transverse road at the base of heights mounded on an undulant skyline uplifting in jagged symmetry a cathedral dome under a cope of clouds. Dark and pale vapors dappled and stroked in a sky five times the area of earth below it define the weather.

Neither weather nor crowded hill suggests anything extraordinary. The vista is stilled by the click of a shutter, but that illusive arrest is ignored as we look on a scene that persuades our whole sensibility of the ceaseless flow of phenomena. Inference and bodily sensation inform us of life that continues in the town, as concretely as we know the tread of our feet on pavement, paths, grass, or gravel, the crackle of trodden forest. Whether or not what we know in that way of the town brooded over by cloud is true of the actual place, the scene is shaped into life by subjective supplementation such as we all rely on for guidance moment by moment in a world that would be dangerously unintelligible without it.

No living being is in sight. The mute stillness of the scene is almost as absolute as if the town were a tomb. Yet the image is astir with implicit life. Nothing signals an absence of humanity, or cancels expectation of return of the traffic of other hours that the whole spread of the hill suggests in its roads and buildings. The preemptive dome covers possibilities as cloud covers a peak where there might be climbers in view if vapors were blown aside. All but certainly it shelters worn pavement, and stone

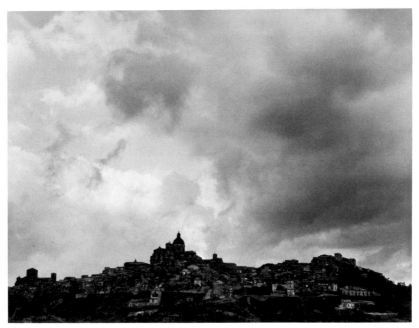

67. *Hilltown*, Sicily, Italy, 1952

and plaster and wood of familiar images attended or in solitude, and such objects as candles lit or extinguished or at the moment of taking the flame.

A single impression is not final in any work of art. In range of potential evocation Strand's photograph is virtually inexhaustible. Our fabrications are testimonial of drives and passions. The climbing culmination of slopes may suggest the City of God, or their declivities the alleys of nightmare. But such excursions are peripheral, or eccentric. Strand's *Hilltown*, a typical old Sicilian town of specific name and individual character, separate in differences from every other, stands at the heart of human circumstance. Its least extraordinary features, hardly arousing notice, are compelling in concord. Above clutter of roofs and walls, the ultimate dome and long ridges sinking away right and left to towers on the brink of low ground overlook also landscape beyond, shaped in surmise and attested by sensations in the unreflecting flesh that has ascended heights and stood looking.

We are living flesh: our basic orientation in the world is sensory and of the whole body. It begins as early as the first moment of light—before the cradle. Prompting and conditioning our movements among living creatures and natural objects and human artifacts, it grounds and secures us in communion and community and in concord of civilizations.

A building, a village, or a city is a construct eloquent of human mastery and human limitations. So too is a work of art: Paul Strand's image of a Sicilian hill town, its particularity intact, irrefutable as a thumb mark, only the specific name withheld, in intimation of universality.

What then of the sky, that was shaped by no human agency? It too takes the mark of our human intelligence and sensibility, which discriminate — tentatively and even while we look, variously — those shapes in its spread that impress attention. They are a multitude of tones and transitions of light and dark, precise in outline and texture or blurred or indecipherably elusive, sometimes lost in overlap or fragmentation, and thus assignable to one or another connection or group — or to none.

Yet there is no lack of discernible order in the great diversity spread low and high above the town. On the right a long soot-dark banner of lowering aspect leans over a brighter band along the horizon. From its downward edge, ravels of rain fray over towers and walls. Above it, darker and lighter vapors drift like smoke in diffusion. One, far over the cathedral, hangs gathering or in dispersion — image of transition, and under it around the height of the building the brighter clouds of the sky are fanned. A trace of cloud directly over the dome is a blur on a fraying aureole in the drifting weather.

In contrast of dark on light the cathedral is stronger than anything else; the clouds around it are most luminous on the side toward the blackest sky. The effect is not of a sign, however, a message, a meaning put forward, least of all of an idea. The image, in short, is not contracted to special service. It is neither referential nor "expressive." It is not detached from immensity.

Discrimination of features of a prospect, pictured or actual, can contribute to grasp of the whole, so long as they do not fix attention in preemptive arrest. The object superficially resembling a spike on the lantern that tops the cathedral is a cross. Against the sky, below and to the right, half way down cornice and roof that slant toward pale cloud beyond the drop of the hill, a similar object even less clearly defined counters in motion and departure the emblematic shapes overtowering the town. In intimation of change, of movement, it conspires with the sky it is outlined along.

Images of sufficing force are formed for ultimate use in the same way that they are made: not piece by piece parceled out, yet with concern for every element of the whole — free of care for critical opinion or any extrinsic reward. To the viewer as to the artist, they come with intimations recalcitrant to language.

Knowledge so kindled lights up the world: sheer report of it is ash fallen after flame. Epithets of praise or dispraise of a photograph, offered in lieu of illuminating evidence of its character, are testimony of personal experience: "I was warmed" or "The hearth was gray."

Turning away from judgments and expressions of opinion, and from explications however useful as preliminaries, one may see the work of the photographer, perhaps for the first time.

Patience! *Pazienza!* as they say in Sicilian towns. No hurry to slip the leash and halloo over ground redolent of the beast in cry, through crisscross and backtrack to come to the unicorn. In Paul Strand's *Hilltown, Sicily, 1952*, there is no end of revelation.

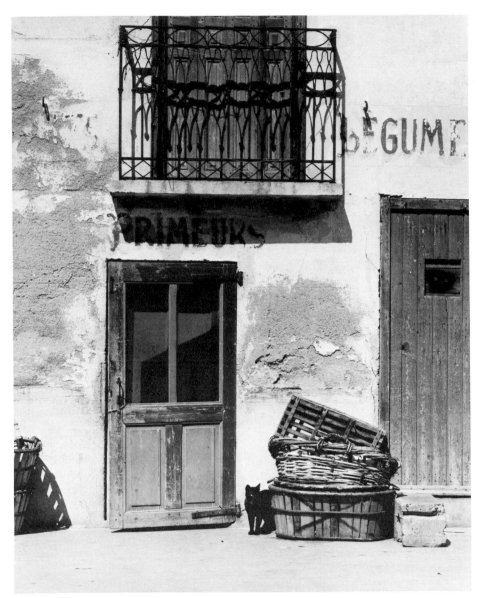

68. *Shop, Le Bacarès*, Pyréneés-Orientales, France, 1950

CHARLES SIMIC

Shop, Le Bacarès,
Pyrénées-Orientales, France, 1950

At the moment the writer realizes he has no ideas he has become an artist.

Gilbert Sorrentino

A shop in a town of twisting streets. The hour of siesta and immense heat. The street as empty as Sahara.

"I didn't meet a soul," says the madman who walks in the midday sun.

A greengrocer's shop with its signs almost faded. A shop inviting revery with its empty crate and baskets, its three closed doors and a black cat.

They were selling beans for cassoulet here while Napoleon was retreating from Russia, dunking bread in the wine while the Arabs were still in Spain, one thinks.

How cool must be the leaves of young lettuce in the dark shop with its low ceiling and thick walls! Are there baskets of eggplants and peas still in their pods left unsold? I'm sure there's an old-fashioned scale in there with its golden pans balanced and empty in the half-darkness.

The one who feeds the cat is lying down in the upstairs bedroom. She is a huge fat woman with enormous naked arms and one eye open. She has heard steps.

The eye is wiser than the tongue even in the land of Descartes and Mallarmé. "The eye has knowledge the mind cannot share," says my friend Hayden Carruth. That knowledge must have made the photographer stop.

What photography and modern poetry share is the belief in the chance encounter. The subject matter is unimportant. Anything clearly seen is always extraordinary. The image is presented without commentary—as in this old poem by William Carlos Williams, which Paul Strand, too, must have known.

BETWEEN WALLS

the back wings
of the

hospital where
nothing

will grow lie
cinders

in which shine
the broken

pieces of a green
bottle

The painter De Chirico says: "Then I had the strange impression that I was looking at these things for the first time and the composition of my picture came to my mind's eye. Now each time I look at this painting I again see the moment. Nevertheless, the moment is an enigma to me, for it is inexplicable. And I like also to call the work which sprang from it an enigma."

He is talking about familiar things restored to their strangeness, becoming, indeed, a school of metaphysics. The image is what we think about in its all-night classes.

It is not so much that all ages are contemporaneous as Ezra Pound claimed, but all present moments certainly are. The trust in the present moment and the visible truth is what American poetry shares with photography. The present is the only place where we experience the eternal. The eternal shrinks to the size of the present because only the present is humanly graspable.

Peeling walls, a worn out sign, nothing prosperous about the shop except for the balcony with its wrought iron railing and the finely carved heavy door. Did the house once belong to a rich merchant?

One must resist this temptation to "read" the photograph further and further, for its power lies precisely in its remaining always on the verge of being "read." With Baudelaire we say that a closed door is much more interesting than an open one.

Just then, as if on cue, a black cat came out to look at something to the side of the photographer.

The cat is the X in this equation. I expect never to get her out of my mind.

CATHERINE DUNCAN

The Years in Orgeval

Waking in the big bedroom upstairs as it filled with early light, Paul could see the shadow of leaves projected on the white walls. "Ah! the tree . . ." Hélène remembers, "For him the tree was sacred. Like a person. We were never allowed to touch it even the dead branches. They stayed till they fell."

Hazel was still asleep. For her, the beginning of the day was always a slow return from some profound lethargy that had weighed on her since childhood. It was Paul who got up and went down to make the coffee. His eye already noted the place of things, pictures and books, objects collected during their journeys, observing where a flower had shed its petals during the night from one of the vases. Doors opened directly on the garden, but his tour of the garden would come later. For the moment, he recorded only those changes that no eye is quick enough to detect until they have already happened: the sudden explosion of spring or the frosting of trees in darkness.

When the mail came he took it up with the coffee to share with Hazel. She filed and dealt with most of the correspondence, and the day began with a discussion of current work.

Downstairs, they could hear Hélène moving about. Her presence for Paul was always reassuring. If there had been a dispute or Hazel had had one of her sudden flare-ups, Paul would say: "When Hélène comes everything will be all right." And Hazel agreed. From the beginning, Hélène seemed to know how to smoothe out the ruffles in their daily life. She was their intermediary with the village and a source of knowledge in the garden; she cared for the house and little by little took an active part in whatever creative work Paul and Hazel were doing.

A new photograph was always submitted to both Hazel and Hélène; once the final print was ready, usually Hélène did the spotting. From the studio window she could watch Paul inspecting the garden. He himself never did any gardening, but he missed nothing. And Hélène would smile

quietly, knowing that at teatime there would be questions about the planting and strict orders not to cut back a bush or displace the fallen leaves. The garden was Hazel's domain only so far as layout and upkeep were concerned. For Paul it was a place of meditation, where he and the camera became part of the processes of living matter. What he sought, perhaps, was an underlying order, the emergence of form from multiple relationships . . . a research that had begun way back in New York and found its mature expression in the ultimate photographs of the garden at Orgeval.

With the end of World War II, an extraordinary displacement of artists and intellectuals began all over the world. Many Europeans who had found refuge from Hitler in Allied countries returned home, hopes high for a new beginning. In such countries as the United States and Australia, where the stimulus of revolutionary ideas had been particularly fecund, artists — and I was one of them — were acutely aware of the reflux. Once the exiles departed, the intellectual and artistic horizons they had opened for us threatened to shrink back to prewar insularity. The exiles were returning to the mythic countries of their origins, to the building sites of a new world, leaving us to a more lonely exile in the tightening grip of the cold war.

It was Europe where everything was happening, or likely to happen, and Paris was the halfway capital between two worlds. From Paris, the Orient Express still set out for Prague, Belgrade, and Sofia. Through Paris, international delegations made their way into East Germany and to Poland and the Soviet Union. In Paris, ideals still flourished on the Left Bank, and every afternoon you could drop into the Café Flore or the Deux Magots, catch a glimpse of Sartre and talk your head off over a pot of tea with men from the Resistance, dadaists, surrealists or, crossing the Seine, swap the latest political news with journalists from *Combat*. On Saturday afternoons, a stone's throw from the American Embassy, Elsa and Aragon animated discussions at La Maison de la Pensée.

Sooner or later, then, a disparate group of world citizens, as we liked to think of ourselves, converged on Paris. We took it for granted that we were all there for the same idealistic reasons, and no doubt we were. But as the years passed and the cold war diminished, instead of returning to our respective countries, some of us stayed on; so perhaps there were other reasons. When I try to imagine what they were in Paul's case, I have to rely on small signs and snapshot images I had almost forgotten.

There is the round box of Camembert cheese on top of the fridge at Orgeval — Paul's cheese. Ugh! Hazel wouldn't tolerate that overripe smell in her icebox. But it was Paul and Hélène who usually did the shopping in the village, and during their excursions, Paul had learned a great deal about the art of French cuisine. Although his French was never very

fluent, the ritual salutations between customer and *commerçant* rolled off his tongue with just the right intonation. At the butcher's he knew the French cuts and ways of preparing meat, and at the greengrocer's he could see through the camouflage of tired vegetables and select those fresh from the market gardens that morning. But when it came to the *fromage*—ah! there he was a real expert, prodding the Camembert to judge its elasticity or sniffing with appreciative fervor the effluvia of a Pont l'Evêque. I used to say, as we savored one of his odoriferous selections while Hazel fled to the kitchen, that I'd come to France to eat French cheese, and Paul—taking a little more cheese to finish up his bread, so that I could take a little more bread to finish up my cheese—agreed that it was an excellent reason.

Another image: a sunny afternoon in the garden at Orgeval. It must have been the housewarming. What year was that? Sometime in the 1950s. By that time Paul and Hazel had already lived several years in Paris and formed a wide circle of friends. We're all there—the French and international contingent from Paris, friends from London and Italy, good neighbors in Orgeval, accents and nationalities *à gogo*. The French builders, plumbers, and electricians who worked on the house are also among the guests, with their wives and families (a precedent causing much comment in the village).

Who's that girl in the kerchief? Why, of course, it's Hazel. What a beauty she was! No wonder Paul was mad about her. American cookies and pies, ice cream and games to amuse the children—she and Hélène must have worked for days beforehand. And now Paul's getting up to make his speech. He must have said all the right things, but underneath the words we understood that Orgeval was "home," perhaps the first real home he felt was his—the home where he would live and work for the rest of his life, and where, in the big upstairs bedroom on such an afternoon as this, he would die.

In each of us is a native land that is not necessarily the one where we were born. Although Paul never ceased to be profoundly American in his affections and attachments, from the time he and Hazel settled in Orgeval it became his native land. From there he set out to Italy and the Outer Hebrides, to Egypt, Romania, Morocco, and Ghana, bringing back the photographs for his books. So many journeys, so many new discoveries, yet it was always to Orgeval he returned, to the upstairs studio overlooking the garden, with its adjacent darkroom, where, one by one, the prints emerged, luminous and quivering.

The making of these books was discussed to the last detail, with special reference when I was there to the relationship between text and image, which is the basis of my own work. The creation of a third dimension of meaning sent us off on long detours of exploration into cinema, television, publicity, and the comic strip, as well as Paul's own books.

La France de Profil (1952), the first book Paul made after his arrival in

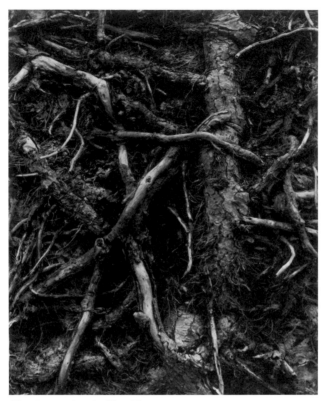

69. *Roots, Gondeville*, Charente, France, 1951

France, is an interesting example. The text, by the French writer Claude Roy, is a rich and lively account of what it means to be French, a *pêle-mêle* of evocative information in parallel—one might almost say in conflict— with the image. Not only does the text recount an experience that, culturally, the photographer does not share, it also competes for attention visually with its layout and composition.

For me, the interest of this book is Paul's relationship with France, and here no text is required to sustain what the photographs tell us. The resulting conflict between text and image splits the book in two and can be disturbing, unless we see this confrontation of cultures as the third dimension of meaning that underlies the relationship.

Paul, in his French beret and used tweed jacket, traveled all over France to make the photographs, obstinate as a peasant. It was quite useless for Hazel to draw his attention to a picturesque landscape or an interesting objective, he only grunted and drove on, looking for the invisible. He knew that in the villages, behind the flowering boxes on the windowsill, behind the starched lace curtains, there was always an eye watching, a tongue none too tender in its comments on the "foreigner." All his por-

70. *Pathway to the Gate*, Orgeval, 1957

traits respect that distance, not necessarily hostile, but watchful and wary. His camera takes what is offered: the façades of cafés and shop windows, harness hanging on a wall, tombstones in the graveyard, narrow streets, cold and surly, from the Middle Ages. They are the outer signs for the history and passions that run underground, forces that hold calvaries and vines in place, toppling walls that somehow withstand. And out of this confrontation, Paul's relationship with France drove downward, earthy, gnarled, in an interweaving of roots. *Roots* is the first major photograph of *La France de Profil*, and the same theme can be found again and again among the last great photographs of Orgeval (see figure 69).

While Paul did his own developing and printing, Hazel was one of the few people allowed in the studio when work was in progress. I don't remember ever seeing Paul actually work on a print. He rarely showed anything but the master print finished and mounted. How many prints and negatives he destroyed, we don't know. Paul was rarely tolerant of anything that failed to clear the exigencies he set himself. Presentations of his latest work therefore had a certain solemnity.

Such occasions usually took place in the small sitting room where

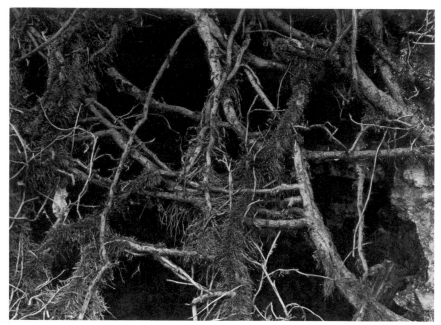

71. *Great Vine in Death*, Orgeval, 1973

finished prints were stored. New prints came straight from the studio, and as each one appeared from its chrysalis of wrappings, we had the impression of participating in a metamorphosis. No one was in a hurry. We could look at the print as long as we liked, and make comments or simply explore its implications in silence. Sometimes Paul would add a few details on technical aspects of the print, such as how he had used twelve different exposures to achieve the mystery of a little path that disappeared somewhere through the trees in the garden (see figure 70). If anything, such practical explanations only deepened the mystery, because we knew that little path, we knew exactly where it led, we could even see it from the sitting room window. Yet the path in the photograph was not the same path. It led elsewhere, to some invisible garden, perhaps within ourselves.

When I began working on *The Garden Book*, Paul wrote to me from their apartment in New York on March 31, 1975:

Dear Catherine,

My first chance to acknowledge your thoughts, ideas and some of the lovely, lovely words which reached us and delighted us. The delay in answering still remains the same. I cannot yet do much more than sign my name. In fact, the shoulder is very slow in healing. After a

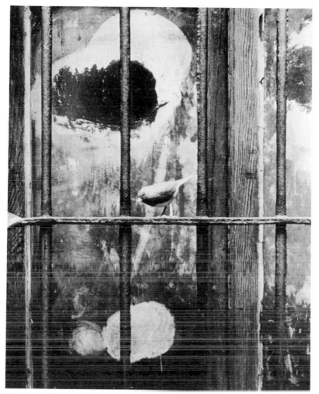

72. *Bird on the Edge of Space*, New York garden,
55th Street, 1975

great deal of radiotherapy and chemotherapy, on Friday of this week
we will probably know more about what lies ahead before we will be
free to return to Orgeval. We are very eager to do just that. Ruth
and the Golds and Marion, all good friends in France, and you your-
self of course, help a great deal to endure this sort of existence. We
are very eager to get back to the dark-room to print the many nega-
tives which are still very possibly to be part of the book. Also to get
out of storage the prints of the garden I made over the years since
we bought the place, some of which will be very necessary and impor-
tant to the book's development. Before all this is done it is going to
be difficult both as to text and as to image to develop a clear idea of
the inter-relationship of both to each other. That is I think nothing
to worry about at all and will not, I hope, prevent you from letting
your rich and beautiful imagination play. Sherwood Anderson, who as
you recall wrote *Winesburg, Ohio*, once referred to himself as a "word
fellow." That is a little bit self-conscious, and I'm sure you would
never refer to yourself as a "word girl," but I can.

On their return to Orgeval, we began to put the book together, Paul in bed while Hazel and I set up the prints round the bedroom. Positioning and repositioning the photographs in different constellations brought out unexpected meanings, creating new relations and shifting the sense of both word and image. As we worked, the early photographs of flowers grew more and more evanescent, giving way to *The Last Candles of a Dying Sun*. Grave, almost austere, the *Revelations* became his testament, witness of an order to which we are all committed (see figure 71).

We never arrived at a final version of *The Garden Book* — perhaps because we were still too close to grasp the dimension of these last photographs. Perhaps also, while the book remained unfinished it represented tangible proof that a future stretched ahead for Paul, allowing him time to complete the portfolios to be edited by Aperture.

During those last months the house was full of young people, and somehow the pain became tolerable while he was supervising prints as Richard Benson brought them from the darkroom, while he dictated ideas and texts to me or handed on his technical and philosophic wisdom to young photographers. Michael Hoffman came and went, watching over the portfolios, organizing the first major retrospective of Paul's work at the National Portrait Gallery in London. We pinned the Order of Arts and Letters on the lapel of Paul's bathrobe, a decoration awarded by the French government for the first time to a photographer. We celebrated his birthday with a party, when I, as usual, composed the commemorative verses. This time they took the title of the last photograph he made: *Bird on the Edge of Space* (see figure 72). And one sunny afternoon, while Hélène and I sat with him in the big bedroom, his breathing·ceased, and all we could hear were the sounds of the garden.

ROBERT ADAMS

Strand's Love of Country:
A Personal Interpretation

Who can say what amalgam of memory, dreams, study, pain, and discipline brought Paul Strand to photograph Mr. Bennett and to record him so perfectly? The picture is almost as unaccountable as the fact of Mr. Bennett; we are left with our little cosmologies and the certainty that we will never fully know. But we continue to speculate, as we do with all great art, because the picture is clearer than life and in this consoling.

In the case of Strand's work, which seems to me especially important not only because of its high quality but because it is out of fashion among photographers, my guess is that the most shaping force in his creative life was his devotion to America, a commitment as deep and troubled as that of his teacher, Alfred Stieglitz, and kept as faithfully to the end.

Such a thesis, from the perspective of most artists who have lived through the recent history of the United States, seems almost categorically unbelievable. Could anyone have loved this sad country with its unnumbered ironies so much that a regard for it would be the foundation of a life's work? If we explore the widely held and I believe defensible judgment that *Time in New England* contains Strand's finest body of pictures, it becomes clear I think not only how important but also how indirect a devotion to country can be in art.

It is the indirection on which I wish to focus, but there is the obvious with which to begin: when Strand did most of the photographs for *Time in New England* (1943–1947), we were at war or just recovering from it, and he was an idealistic humanist who shared many of the country's goals. What could have been more appropriate than picturing the area where the United States began, a place geographically beautiful, rich in traces of the nation's past, and inhabited by citizens of evident character?

Having acknowledged the logic in his choice of subject, however, it is another matter to account for the art. What separates *Time in New England* from hundreds of calendars and illustrated books showing the same mate-

rial? Generally, it is the freshness, depth, and scope of Strand's pictures, but how was this achieved, and why did he take the pains?

Photographs as exceptional as Strand's originate, I think, in personal need, in an urgency to find what the artist has to have to be at peace (the mediocrity of much assigned work results from the lack of this compulsion). The necessity builds, sometimes from wholly private, individual factors, but often from the way these relate to the social context, until the artist is forced to take the risk of making something untried.

A part of what brought Strand to make the New England pictures was presumably psychological. Those to whom I have talked who knew him describe him as difficult—which suggests, as do his three marriages, that like most artists he was driven by inner and idiosyncratic burdens. But of these we can know little in the absence of a major biography.

Even if most artists work first from a sense of obligation to themselves, however, they usually believe that if they answer their private demands they will in the course of doing so also fulfill their duty to others. It is a risky and arrogant proposition, defensible only after the fact of successful pictures, but it is an attitude as common to the calling as is the brittle behavior of its adherents.

Strand's need to make the New England pictures was, it seems to me, both personal and altruistic. He had spoken lifelong in support of America's emphasis on the worth and dignity of human beings and had worked in the 1930s and early 1940s as a filmmaker, trying there to address the crisis in values that the nation had experienced through the Great Depression and the Second World War. He had, however, participated neither in the Farm Security Administration's (FSA's) successful documentary photography program nor directly in the war, and he must have realized that his motion pictures were not going to reach a continuing audience. He needed, presumably, to do better. Like many of the best photographers who came of age professionally in the 1920s and 1930s—Ansel Adams, Dorothea Lange, Walker Evans—he seems prophetically to have sensed that America was in danger of dying from within, of giving up. Temperament, ideals, and depressing news stories combined to push him to make the best photographs he could of a place where his and the country's hopes coincided.

If the work in *Time in New England* resulted from Strand's need for it, how does the urgency appear in the pictures?

There is, to begin with, his evident compulsion to record what he saw as astonishing light. Everywhere. Strand was one to whom an unusual sensitivity was given, and there is a striking luminosity in all but his earliest pictures. He seems to have observed a charge running through the world, a current that suggests, without the theology, passages from Gerard Manley Hopkins. The remarkable thing about finding this in the New England

pictures is, of course, that we expect there a weakened, even drab illumi-
nation. In fact, the photographs are filled with deep grays, but the grays
are energized by accompanying blacks, and many of the views contain bril-
liant if small highlights, especially the close-ups of vegetation and stone.
The geography is recognizably ours except that it seems to glow almost in
the manner of El Greco.

There are, too, preoccupations in *Time in New England* that are not as
consistently apparent in the rest of Strand's work, particularly in that
which followed the book— his concern to show specifics and generalities
together, and his resolve to present these compounds in formally innova-
tive ways.

Strand, I think, understood that combining the concrete and the univer-
sal is at the center of what makes art important (certainly it is what makes
it of more value to more people than interior decoration or philosophy).
He knew, as William Stafford was later to write, that "all art is local" but is
saved from being trivial by its wider applicability. And he must have seen,
from the evidence of an "art world" not wholly unlike ours, that there was
not much of this alloy around. He was committed to it, nonetheless, be-
cause only it was worthy of his subject.

The generalizations—that nature is beautiful if harsh, for example, and
that human beings are, though small, potentially honorable—are apparent
not only within single pictures but as themes that emerge from the whole
series. But if generalizations are in a sense the final reward for our atten-
tion, it is the specifics that are the pleasures. There is, for instance, the
wonderful peculiarity that accrues from dilapidation; what we build gets
differentiated as it comes apart—boards loosen to crazy angles, window-
panes fall out, and rain and snow streak white clapboards. People too be-
come marked and thus individualized as they age, and Strand's portraits
are never better, as a whole, than they are here (he made telling portraits
from the start of his career, even as he was otherwise struggling through
various early exercises in formalism). The New Englanders are types, but
like those of whom Edwin Arlington Robinson wrote (and Newhall in-
cludes one of his sketches), they are typically eccentric. Mr. Bennett is
every Yankee, but every Yankee is by definition his or her own person,
and Mr. Bennett has his little piece of string looped there in his collar. We
know these people in part by expressions we judge to be characteristic—of
alertness or resilience or contentiousness or resignation—but we see these
attitudes on unique faces and always together with how the person fixed a
tie or chose a print blouse or failed to comb down windblown hair. No
one is wholly interchangeable with another. It is in fact the strength of
these portraits, coming as they do toward the close of the book (appropri-
ately, since it is roughly chronological) that accounts most for its affirma-
tive conclusion. Much modern history ends with elegy, but not here, with
Strand's believably living and importantly representative people, citizens as

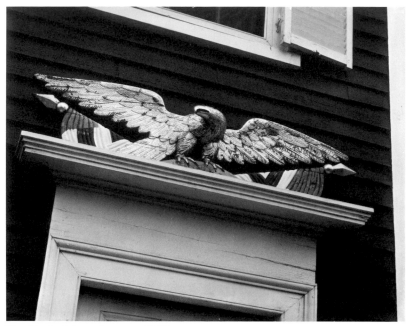

73. *Eagle*, Massachusetts, 1946

particular as a name on a mailbox and as general as those of whom the Constitution speaks—we, the people.

The second kind of evidence within the New England pictures that suggests Strand's especially acute need for them comes, I think, in the meticulous but daring way he structured them. He took large risks, the kind one does not take unless one has to. When set against the documentary conventions built up in the previous decade by FSA photographers (theirs was a generally four-square approach), Strand's later New England pictures are the sort that, though attracting a diverse audience because of their subject, puzzled many observers on second look. I can imagine him being asked even today why he took pictures *that* way.

Strand had tried some of what he did in *Time in New England* elsewhere, but he never pushed it as far. In the book he worked off-axis as if it were a moral principle (in a way it was), but usually just *slightly* off-axis; occasionally the vantage point was even chosen in the face of a symmetrical subject, as in the case of a wood stove [217].[1] He off-centered portraits (Harry Wass, Bertha Moore, Leo Wass, Susan Thompson), but only part of the time for reasons that can be explained in terms of bringing in additional relevant subject matter. And he off-centered symmetrical buildings, occasionally going so far as to frustrate simplistic documentary expectations by shaving away the smallest edge of the subject, as in the view at the end of the book of the Vermont church (it is, I think, among the greatest ar-

chitectural pictures ever made). One comes to wonder if there is anywhere
in the volume a picture of a doorway or window in which the subject is
distributed equally within the frame; many are close, but only that. Other
pictures surrender a significant part of their foreground to what looks to
be, by common standards, not the subject: a tree stands in the way of a
perfectly balanced house [200], and a telephone pole interrupts our view
of a symmetrical town hall [92]; any competent amateur with a view cam-
era could better have minimized these seeming distractions. Then there is
the wild tipping (these were not the days of Gary Winogrand) of a church
and town hall, and of an eagle over a doorway (what kind of patriotism is
this?!). Not to mention pictures framed by large quantities of the appa-
rently irrelevant, as with the photograph of the little fragment of a view of
birches seen from inside what appears to be a barn [243]; the photo-
grapher seems not to have taken the necessary step to get close enough to
the opening and for his laziness gotten a picture two-thirds boards (and
what a wonderful picture it is . . . I think it changed my life as a photo-
grapher). There is, too, the question of why Strand made several of the
portraits as horizontals (Mr. Bennett, Beatrice Albee, Louis Cole, Bertha
Moore, Belle Crowley), since the human face and figure are by nature
perpendicular, and since the character of the walls against which the sub-
jects stand could be established with less space. (See figures 73 and 74.)

Strand was daring even in some of the pictures where he chose or-
thodox composition. The seascapes, which tend to be conventionally di-
vided into thirds (apparent when one notes divisions within the sky, as
opposed to the placement of the horizon), are, however, mostly without
centrally placed subjects (the expected ship, bird or wave), and thus even
today scare many viewers into resistance. Paul Metcalf suggests in his intro-
duction to the second edition of *Time in New England* that there was an
affinity between Strand and Melville, and the seascapes support his obser-
vation, allowing us only the light on clouds and over the ocean's surface as
consolation for the anxiety of being left alone in such an expanse.[2]
Though the traditional, decorous proportions within the frame induce
a calm.

The pictures are, in any case, not predictable, and they succeed. Con-
sider a photograph like the skewed view through an interior door into a
parlor in Prospect Harbor, Maine [204, see figure 75]. What could have
compelled an artist to look hard enough to bring those fragments into
such an unexpected indivisibility? It and other pictures are informed by
photographic history, but their maker was, as Rilke said of Cézanne, "heed-
less." The New England photographs are the work of a disciplined artist
who, in order to share what he valued most, took the risk of being free.

Among the reasons I believe that Strand's finest pictures came from his
love for America is that they came less frequently once he left to make his

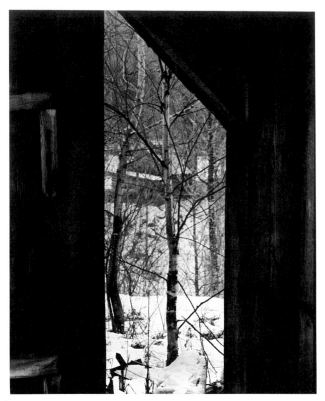

74. *Toward the Sugarhouse*, Vermont, 1944

home in France in 1950. Away from the United States, the urgency
seemed to fade.

To attribute this decline to his emigration may at first seem inconsistent
with the success of his earlier pictures in Quebec and Mexico. Those
places, however, were not as distant, his time there was brief, and the
scope of his work was relatively narrow. More important, both places were
strikingly similar to regions he already knew well in the United States —
New England and New Mexico. And in Mexico he worked under official
government sponsorship, which presumably reduced the isolation he would
otherwise have experienced.

There were, it is true, other factors besides moving to France that prob-
ably contributed to the slackening in Strand's achievement. He was ap-
proaching old age when he emigrated, and he must have had less strength
to work (photography — *taking* pictures — is kinetic). There is as well the fact
that he had just finished unquestionably great work; it would be human
for him to have felt, even as he probably resisted admitting it to himself,
that he had completed what he most needed to do. He appears, as well, to

have been unusually happy in his personal life, a condition that seems—
alas—to slow many artists down. With his marriage to Hazel Kingsbury in
1951 he gained a particularly sympathetic partner, something one can see
in a sweet book published in Italy in 1989 (Paolo Costantini and Luigi
Ghirri, *Strand. Luzzara*), which reproduces seventy-one pictures, many in-
formal, that she took while they were there; they suggest her respect for
him and the pleasure and relaxation they found together.

The central explanation, though, for the change in the quality of
Strand's work after he moved to Europe is, I think, to be found in his
own description of events. When he was asked by an interviewer why he
decided to go to France, Strand began by noting that in America, at the
time of his departure, "McCarthyism was becoming rife and poisoning the
minds of an awful lot of people. Then there arose the question of where
do I go from here. The decision finally took shape in a very old idea, that
I would make a book about a village, a small place. I liked the idea of
being confined to a small place and then having to dig into its smallness.
But I did not want to choose a village in America during McCarthy's time,
when his ideas were doing very bad things to my fellow countrymen. It
isn't that I am disloyal to my country—I had just finished a book on New
England. . . ." In France, however, he and a writer friend discovered that
"there were many villages, but we didn't know how to go about it. The
French have a way of closing up their shutters about seven o'clock at
night, and we never saw a soul outside on the street. It was very depres-
sing. We felt excluded from what was going on. . . . The upshot was that
we made a book from photographs taken all over the country. . . ."[3]

Inevitably, the results were less than originally hoped. How could he
explore the general through the particular when he was so distanced from
the particular?—he spoke neither French nor Italian. And how could he,
under the circumstances, compose as carefully as he had in New England?
In a foreign country it is far from easy to study a scene at length when
you know that at any minute someone may appear and ask what you are
doing and that you can't answer, and you haven't many references and
you don't know the law. Neither is it easy to find and know the subjects
for portraits or comfortable to make such pictures when you cannot apply
an anesthesia of small talk. In Europe and Africa Strand simply did not
share enough to enjoy the privilege of working from within. As Wallace
Stegner has written, you are at home only when you live in a place with
"complete participation," a condition remote from Strand's.

There is, as a result, a superficiality in some of the later work. The por-
traits, for example, become more and more idealized; there are greater
numbers of younger people, and when he shows the old he allows fewer
of the complicated expressions he recorded in New England. It is instruc-
tive as well to compare the pictures he made of famous French per-
sonalities with the supple, revealing portraits he had done of American

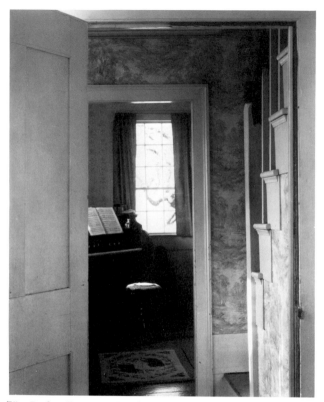

75. *Parlor*, Prospect Harbor, Maine, 1946

artist friends such as Marsden Hartley, John Marin, and Stieglitz. Malraux looks vaguely as if he had been told to impersonate himself, and others as if they might be captioned "European intellectual" or "European artist."

Strand's drive to compose inventively and with precision also tended to subside (though there are, happily, beautiful exceptions to this generality, like the picture *Water Wheel and Colossi* from Egypt). Off-centering is used less, and when it is it begins to seem formulaic. Tipping is abandoned. And the edges of pictures become less critical; the all-important slivers of subjects that used to lie at the borders of the frame—the inch more of a door casement at one side than the other, the trees at the extreme edges of *Church on a Hill* [62]—are not as often there to lend subtlety and weight. One recalls, too, the many close-ups in *Time in New England* where Strand's construction is so exact that nothing could be altered without losing the whole. Little of this fanatical attention is to be found in work afterwards, except where Strand composed in the manner of Piero della Francesca, an admirable painter but, to my eye at least, no more enabling for Strand than Cézanne had been for Hartley.

There begin to appear in later work, too, hints of weakness not in evi-

dence before—sentimentality and tendentiousness. His admiration for trad-
itional cultures, which in America had brought him to picture anachronis-
tic but more or less freely accepted lives of hardship, brings him close,
when he is abroad, to exalting Third World deprivation, as if it had been
embraced in the same relative liberty as his subjects in the United States
had adopted their austere ways. Strand's idealism also began, in the ab-
sence of an opportunity to embody it in less heavy-handed pictorial
strategies, to assume didactic form—views, for example, of new dams and
of stalwart figures riding combines, pictures easily overtaken by events, as
are some from Romania now.

But this brings us back to the most moving aspect, I think, of Strand's
life. He did care, passionately, always. The problem was, as it has been for
many Americans, what to do when the United States goes beyond what
one can tolerate. Strand's answer was to leave, which is not everyone's, but
it deserves respect and compassion. Strand was a thoughtful, informed
person who surely understood what exile can mean to an artist. He knew,
for example, that Hartley had done major pictures in New Mexico and
then had sunk into confusion in Europe. He knew that Stieglitz had come
home after a time in Europe, apparently convinced that to be an expat-
riate was to be crippled.

Some kinds of artists seem, it is true, to be relatively unaffected by relo-
cation, but these tend to be the more abstract varieties like composers,
architects, and nonrepresentational painters. Others, perhaps the majority,
find that they cannot survive as artists out of the context that originally
fostered their art. Childhood experiences, for example, which are of criti-
cal importance to most artists' work, are of reduced application abroad.
All the years, in fact, that an artist has spent in his or her native country
are the basis for important judgments about what is characteristic and
lasts; to have the relevance of that framework lessened by moving is a seri-
ous handicap. And there is the matter of language; few are able to make a
second language fully their own in the way that Conrad and Nabokov
managed. The problem is not just of importance to professional writers,
but to all artists who think—which is to say, use language—in order
to consider their work. Strand was articulate and it must have been
vaguely debilitating not to have his English kept sharp against that of
others.

Photographers can be especially vulnerable to dislocation. It is not possi-
ble for them to carry to a new country, as can writers or even in some
cases painters, the fundamental ingredient of their particular art—the sur-
face of life. A photographer is impelled first by a love of the appearance
of things, and this affectionate interest in outer fact cannot always be
quickly rekindled in a new place. One thinks of Kertész, for instance,
many of whose European pictures express such open delight, but who
never found when he left, on the evidence of the pictures, a way equally
to love us here.

Time in New England was the summation of one person's efforts to bring his nation back to the best in itself. When he left it was, among other things, an admission that he suspected it could not be done, and his departure still has the power to test those of us who have stayed. By what right do we compromise and stay?

Strand's own motives were presumably mixed, as are all human inclinations. There are those who think it likely that Strand, because of long-held radical convictions, may have had reason to fear what might be in store for him if he remained. On the other hand, there is no evidence in his life that he was a coward, and it does not seem unreasonable to credit him with leaving at least in part on the basis of his respect for the American ideal and his desire not to compromise it. In fact his devotion sometimes seems to me almost as worn and self-searching as the expression on Mr. Bennett's face. Strand knew, I think, though he did not often allude to it or perhaps even consistently confront it (what would have been the use?) that leaving was a kind of death. But the alternative was worse—a betrayal of principle. Had he been one to see life as tragic, he might have come to a different conclusion about what he ought to do, but he was by conviction an idealist.

To whatever extent his going was also an act of despair—inevitably it was this too—it calls into question the affirmation he made in the New England pictures. But the photographs have now, as they deserve, a life of their own. What artist has not, after all, seen more deeply and patiently than he or she has lived? Cézanne's erratic behavior was the reverse of the geometric stability he painted, and Rembrandt's lavish personal taste was in ironic relation to the humble ways of most of the people he so affectionately depicted from the Bible. A saint's gift to us is a life but an artist's is mainly a vision. In Strand's case we have as well the example of his love for our country, a dedication sufficiently complex to challenge our current weariness with the place and with ourselves.

EDMUNDO DESNOES

Paul Strand, Dead or Alive

"What does it mean to be a classic?" Spanish poet Juan Ramón Jiménez, the Nobel Prize winner in literature, was once asked. He answered: "To be a classic is to be alive."

To be a classic, therefore, is something more than having a niche among the immortals. We already know Paul Strand has a place up there with Alfred Stieglitz, Edward Weston, Henri Cartier-Bresson, and a couple of others whose preeminence is still in dispute. But there are two kinds of classics — those in the Pantheon and those on Mount Olympus. In the Pantheon they are immortals. On Olympus they are forces that still influence our lives. Each generation must answer the question of whether its classics are dead or alive. This is an attempt to discover if Strand's platinum ashes, those black and white images, hide a phoenix.

In the 1990s, to begin with, one must question the validity of too desperately seeking a classic. These days the very notion of a classic, together with its mirror image, the genius, is in question. How often has one heard the declaration that someone is attempting to write "the great American novel" or the question, who is the Albert Einstein of the decade? For many, it is clear that we are asking the wrong question. At best one's life is like "a poor player that struts and frets his hour upon the stage, and then is heard no more"; more recently Shakespeare's idea was rephrased in terms of Warhol's fifteen minutes of fame. Not Strand's historical importance but rather his meaning to us and his generative powers are in question.

Today, as the twentieth century draws to a close, we can say that Paul Strand is an old master. He had a vision both deeply serious and almost religious in its hunger for a new reality. Every one of his prints is ripe and centered in space, every image seems at the center of the planet, whether in New England, Mexico, Egypt, or Ghana. "We conceive of realism as dynamic," Strand declared in messianic terms, "as truth which sees and understands a changing world and in turn is capable of changing

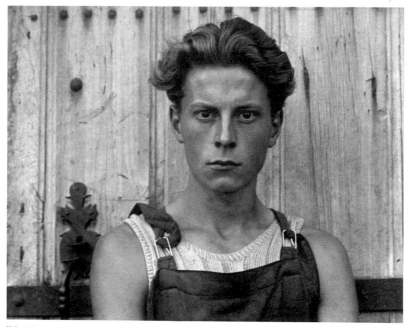

76. *Young Boy, Gondeville,* Charente, France, 1951

it, in the interest of peace, human progress and the eradication of human misery and cruelty, and towards the unity of all people." And "what is the role of the artist-photographer?" he asked with the full scope of the prophets. "The artist is one who makes a concentrated statement about the world in which he lives and that statement tends to become impersonal—it tends to become universal and enduring because it comes out of something very particular."[1]

The owl of wisdom, as Hegel put it, only takes flight at sundown. As the century comes to a close, we can clearly appreciate the discoveries of the revolutionary artists born at its dawn: James Joyce, Pablo Picasso, Igor Stravinsky, Virginia Woolf, Pablo Neruda, Sergey Eisenstein, even Albert Einstein. They wanted to change the world, capture reality, enrich our lives, and give us a new certainty. Paul Strand is squarely within that *Weltanschauung.* And his greatness lies as much in what he attempted as in what he achieved. Today we are more skeptical and less ambitious. We accept a more modest, perhaps degraded role; we may grasp more but we embrace less.

Paul Strand held a generous vision; his eyes saw each person as both singular and yet interchangeable. His portraits show both respect and material density. The intense French farmer from Gondeville and the concentrated woman at Larteh in Ghana are particular yet equal (see figures 76 and 77). There is, given the sculptural gravity of his men and women,

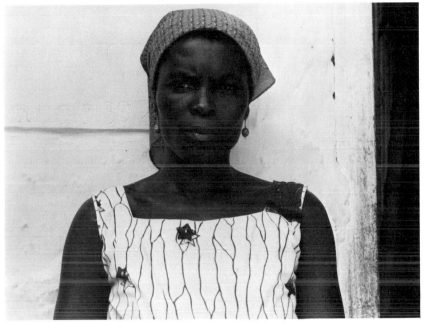

77. *Ekuwah Mansah*, Larteh, Ghana, 1963

something that goes beyond the slightly frivolous unity found in Edward Steichen's Family of Man. Strand's portraits are not only socially equal, they are humanly equal in rights and possibilities.

Consider how people face the world in Strand's family shots. They stand forever looking from the doorways of their homes. Two families, one from Italy and the other from Ghana, reveal themselves with almost identical gravity and intensity. The Italian portrait is from Luzzara, taken in the 1950s, and the Ghanians gathered before Strand in the 1960s (see figures 78 and 79). Both families apparently are rural, both glance at us with the ambiguous power of concern and indifference. The African garments are textured, draped, and rich in design; the European garments, on the other hand, are weathered, wrinkled, and abused. The women, in both instances, are guarding the doorway. The Italian mother is in black, and the shadow from the interior surrounds her silver mane; the African mother holds her child against her hip. There are six Italians and seven Ghanians. If one were inclined to generalize, the main difference would be that having no children, the Italian family faces a limited future, whereas the African, with two children, has a future project going. Both families are stubborn, enduring. Equal.

The *other*, the nonhuman, whether it is a piece of machinery, a weather-beaten fence or a rock, is also seen bathed in a certain universality; things are not cheap or expensive, old or new, large or small—they are absolute.

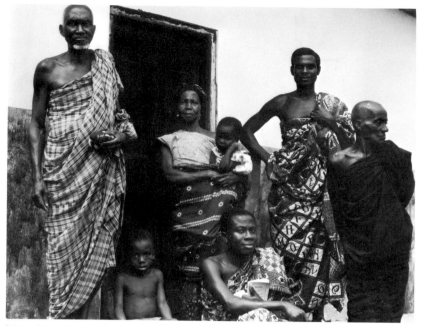

78. *Oko Yentumi*, Omankrado of Tutu, and Family, Ghana, 1963

And they relate only to the onlooker; they address us with the reality of nature.

Even nature becomes a subject, something individual, a portrait. Nature, things, houses, leaves, sculptures, and wheels become intimate acquaintances—you are related to the other and you must understand its presence. An oil refinery in Ghana, a wire car wheel, a ship's figurehead in New England, a wall with hieroglyphics in Egypt, an early- morning fern in Maine, a rock, Rebecca's hands, or the garden plants Strand saw from his doorsteps are portraits of strong individuality.

Everything for Strand is an archetype, the physical manifestation of a universal soul. What bridges the distance between the organic and the inorganic world is Strand's physical hunger. "His best photographs," as John Berger discovered, "are filled with an unusual amount of substance per square inch."[2] His density brings to life the inanimate.

Images exist in stubborn, motionless eternity. Both humanity and nature—in a duality that is at the root of Western art and values—are pulled out of time by Strand. His work is rooted in separateness and intense proximity, almost at the antipodes of the floating world of Eastern art. The unity of all things, of humankind and nature, which dominates Eastern perception, floats like clouds or foam above the earth-bound images of Strand.

There is, nevertheless, an ideal. The substance, the physicality of Strand,

overwhelms you, but it is no accident, no passive awareness; rather, it is the deliberate pursuit of an ideal. In the late 1920s, as Strand attempted to photograph nature from cobwebs to trees, he found the wind a disturbing element. He was using long exposures of up to two minutes. Here Strand pursued solidity, ideal physical density. "Did that growing plant always come back to exactly the same position that it was in before the wind struck it?" Strand asked himself as he attempted to stop the exposure while the wind was blowing and start again when it calmed down. "I found it did. There was absolutely no movement in the photographs as long as I waited for the growing plant, bush, tree or whatever it might be, to stop moving. One could open and close the shutter ad infinitum and still have a sharp picture."[3] In this epiphany of his method, eternity, Strand shows an extraordinary closeness to the greatest master of the deep, dense, powerful presence of the physical world. Paul Cézanne was also after the gravity that would help his paintings endure. It is to this tradition of the great painters that Strand squarely belongs.

He was not a photographer of the fleeting moment; he did not want to paint the air, like Corot, or the changing light, like the impressionists. He wanted reality, the objects before his camera, to construct themselves, to address us in as concentrated a fashion as possible. "The landscapes of Cézanne are the greatest of all," Strand wrote, "because not only is every element in the picture unified but there is also unity in depth, there is this tremendous three-dimensional space that is also part of the unity of the picture space."[4] Both Cézanne and Strand were after a "unity in depth."

Movement is alien to Strand and with movement, time. Light does not express temporality but carves shapes into solid structures. "It's a dye," Strand said of color, with little interest in the amount of information that it could carry or the degree of irreality or fantasy that color conveyed. "It has no body or texture or density, as paint does. So far, it doesn't do anything but add an uncontrollable element to a medium that's hard enough to control anyway." Texture, density, and control—three basics in the work of Paul Strand, the old master.[5]

Strand contemplated things in nature and people in society as a unified field. Social justice was central to his visual production. Although he was consciously guided by a sense of social justice, one can see its principles coalesce with a very strong poetic image: the "noble savage." In Italy and the United States, he focused on farmers, workers, and social outcasts. In the Third World, where class differences are of dubious utility, his Mexicans, Egyptians, and black Africans emerged as noble savages. Strand would never have photographed the equivalent of *Blind Woman* in the so-called underdeveloped world, where romance joined social awareness.

In the struggle between the noble savage and the soulless cannibal, Strand stands with Rousseau, who saw patriarchal communistic societies as

ideal. "The state reached by most of the savage nations known to us" was seen by Rousseau as "the best state of man." And "the example of the savages . . . seems to afford further evidence that this state is the veritable youth of the world: and that all subsequent advances have been so many steps, in appearance towards the perfection of the individual, but in reality towards the decrepitude of the species."[6]

In his books on Egypt and Ghana, Strand presents an idealized image of change. Since all people are equal and have equal possibilities, the only difference between the West and the Third World is the degree of technical development. Equality seems a matter of machines—as if industrialization were simply a mechanical process. In Egypt the process is a *deux ex machina*; suddenly in the last twenty-five pages of *Living Egypt* we see a transformation of the ancient landscape. Port Said is filled with tankers and ships unloading development, machines, and merchandise. The Aswan Dam is the new pyramid, a monumental work of engineering for the benefit of the people of the Nile. There is a steel mill in Helwan, a workshop in Cairo, the hydroelectric plant in construction—painless progress thanks to the Nasser revolution. This is a book of the 1950s, showing all of the processes of a new international order and justice. The Egyptian workers are as idealized as the frontal figures of an ancient bas-relief. A decade later Strand moved south to work on his Ghana book. Again, the final pages are graced with the promise of powerful or glittering industrial installations. It is the socialist realist view of heavy industry and engineering changing the course of rivers, bringing about abundance and happiness. The oil refinery Strand photographed in Tema, Ghana, shines like the jewel of progress.

The reification of machinery runs through Strand's work. These man-made artifacts appear almost as portraits of deities—mysterious and loaded with promises. They also share the same density with which the photographer endowed people, houses, trees, and rocks. In 1922 he was fascinated by a new Akeley film camera he had purchased. "I wish you could have seen the camera," he wrote Alfred Stieglitz. "It's really a piece of craftsmanship, different from anything our friend George Eastman makes."[7] His photographs of the Akeley camera are close-ups made with respect and curiosity that bring us into intimate contact with a new source of production and beauty.

Strand rejected, as an American, the excessive trust in machines he found in other artists. "We are not . . . particularly sympathetic to the somewhat hysterical attitude of the futurist towards the machine. We in America are not fighting, as it may be somewhat natural to do in Italy, away from the tentacles of a medieval tradition. . . . The new God must be humanized unless it in turn dehumanizes us."[8] Strand believed he was humanizing the machine when he showed it at the service of humankind. But his eye was never critical. Very little changed from his early wire

wheel or his drilling machines of 1923 to the construction of the Aswan
Dam in 1959, the Ghana oil refinery in 1963, or the Iron Gate Dam in
Romania in 1967. Machines grow in size and importance, and they seem
to be in good hands, where they will benefit workers and the victims of
colonialism.

In the last twenty years, the democratic movement in both the socialist
world and in the Third World has put the machine and heavy industry in
a different perspective. The trust in progress, industrialization, and
socialism has suffered a serious setback, and the ecological movement has
introduced new concerns and priorities. It is easy for us, from the perspec-
tive of the 1990s, to read Strand's ideology and assess the casualties. Social
justice, one of his most cherished dreams, has not come from socialism
or from the machine. Strand's stubborn faith in the individual is still our
best hope.

Many, nevertheless, have moved from the noble savage to the soulless
cannibal. Fear, disillusion, and greed have taken the place of social justice
and material well-being. People seem to have moved—and many photo-
graphs of the last twenty years chronicle the change—from Rousseau to
John Locke. Locke, in his defense of property and individual accomplish-
ment, believed "in the beginning all the world was America." "America"
being native, savage America. Locke saw Peruvian cannibalism as an in-
stance of how far the "busy mind of man can carry him to brutality below
the level of the beasts when he quits his reason."[8] Recent images of ter-
rorism contribute to the notion of Third World cruelty, as do portrayals of
radical revolutions as involving unnecessary violence and destruction.

Strand's image of humankind is, if anything, a strong antidote to the
growing tendency to neglect the problems of the less-developed world and
to believe that nothing can be done to rescue a vision of a unified human-
ity. No one can look at Strand's portraits of Mexican peasants, Egyptian
women, New England fishermen, Italian villagers, or Ghanian workers and
have any doubt that the only way to deal with our planetary problems is
to see humanity as a dense, singular, yet unified field.

Paul Strand is alive and well through his living portraits.

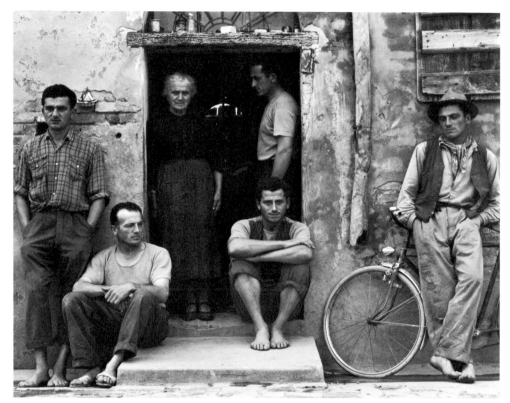

79. *The Family*, Luzzara, Italy, 1953

REYNOLDS PRICE

The Family,
Luzzara, Italy, 1953

Like its sisters, fiction and poetry, photography comes in two main kinds —
narrative and lyric. It shares with the prose tale a bent to imply, through
"realistic" images, the unfolding of a story. Or as with the lyric poem,
through the use of realistic or surreal images, it may generate the power-
ful air of song — the song of praise, reverie, or blame. Recall two pioneer
artists of the nineteenth century. The staged Arthurian tableaux of Julia
Margaret Cameron have a narrative intention — we're invited to tell the
story she rigs, a story she trusts we already know. In contrast, the cos-
tumed (or bare) girls of Lewis Carroll come to us as intimately personal
songs. Even a viewer possessing no knowledge of Carroll's tangled fascina-
tion with female prepubescence is likely to hear a high-pitched note in
every image — the keen of baffled longing at the sight of its nourishment.

Of more recent masters, Paul Strand's austere but lyrical pictures are
seldom charged with narrative potential. A story-telling viewer can search
almost any of the images of his great contemporary Henri Cartier-Bresson
and deduce an interesting, even a mysterious, tale — this ecstatic child,
striding along this painted wall, has come from such and such an en-
counter and is fleeing or gladly moving toward such and such a future
event. But of Strand's best-known pictures, only *The Family* seems pregnant
with narrative intention in the carefulness of its arrangement (we can't be
expected to believe that six human beings randomly aligned themselves
into such complex sets of geometric figures).

In the thirty years I've known the picture, my own predilections — as
man and writer — have often set me on a search for the story that best
explains the core of this family, their kinship bonds and why they've let
themselves be spread in gray daylight for this American stranger. Note for
instance how easy but impoverishing it is to accept a title like *The Family*
as sufficient guide to its human content — an Italian family, obviously
poor but borne on the strength of a powerful matriarch, pause in what
seems midday light (they cast no shadows) from whatever chores consume
their lives.

Pause, though, as firmly as the subjects here. Six people, only two of
whom touch — five men, a woman. Is there in fact a way to read them as a

family? The woman may well be sixty-five. The oldest man is not yet forty; and though he stands closest to her in the door, he cannot be her husband and the father to the other four men. Are all five men then brothers and she their mother, say, or grandmother, or aunt? The man in profile inside the door may well be brother to the man on the right (they share a likeness of eye and nose), but what of the seated men and the youngest there on the left? I see no common physical feature, no common psychic molding in their solemnity. Are some of the men brothers and some cousins? Is any of them a genetic outsider? Whose is the battered array of toilet articles above the doorjamb, and when are they used? To our left of the door, beside the standing man's head, is that a holy-water font? Is it full and in use still? Of the four men with visible feet, why does only one wear sandals? Does each of them sleep inside that door?

To ask even those few questions is to hint at the human richness implicit in a single moment—random or fixed but caught and held for any mind that shares the ancient craving for narrative news: the chance to make a whole new world and rule its creatures.

A Narrative Chronology

1890–1904

Born October 16 in New York City to Mathilde Arnstein and Jacob Strand (changed earlier from Stransky), whose forbears came to the United States from Bohemia around 1840. While not rich, the family is financially comfortable from an enamelware importing business; household, including maternal grandparents and aunt, moves in 1903 to brownstone home at 314 West Eighty-third Street, where Strand resides until early 1930s. An only child, Strand is beneficiary of gifts and considerations from an extended family that includes an affluent childless aunt and uncle.

Attends public elementary school; is enrolled in 1904 at financial sacrifice in the private Ethical Culture School; ECS caters to the children of enlightened, non-parochial, middle-class Jewish families.

1906–1908

Lewis W. Hine, teaching at ECS, writes Alfred Stieglitz that he wishes "to introduce the camera work into our high school as a regular course." In spring term of 1908, Strand studies photography in Hine's class (perhaps in ECS photography club as well). Exposed through Hine's efforts to work of the Photo-Secession, he becomes aware of the possibilities of artistic camera work.

1909–1912

Graduates from ECS, works briefly in the family enamelware business and joins the Camera Club of New York in order to become more proficient in photography. Uses a soft-focus lens (first with an Adams Idento and then with an Ensign camera), learns bichromate, bromoil, carbon, and platinum printing techniques from watching other members and taking advantage of the excellent club library. Is active between 1910 and 1912 on committees at the Camera Club, has work reproduced on covers of the club journal, *Photoisms*, receives honorable mention for *The Garden of Dreams*, entered in

the London Salon of 1912, makes first sale (of this image); also seeks critical advice from Secessionists Gertrude Kasebier, Stieglitz, and Clarence White.

Embarks on European tour in 1911, planning to make commercially saleable images for tourists. Covers twenty-five cities in fifty-three days; on return, prints at the Camera Club, hires colorists, and attempts to sell the works abroad through a friend, but is largely unsuccessful. Next sets up a more successful business making photographs of university buildings for sale (at $2.50 each) to college seniors as souvenirs; for about five years travels throughout the United States to major colleges and universities. Processes work (including printing on platinum) at Camera Club, has prints hand-colored. In pursuit of business, travels across the country in 1915; in California, visits Anne Brigman and initiates a correspondence with Stieglitz, which will last until 1934.

1913–1915
Personal work, done mainly in the neighborhoods adjacent to family home and in lower Manhattan, begins to show influences of avant-garde ideas. Has been visiting 291, is acquainted with *Camera Work*, attends 1913 Armory Show. Participates in the exhibition Foreign and American Pictorial Photographers at Ehrich Gallery and is a frequent visitor to Modern Gallery, opened by Stieglitz and Marius De Zayas. Meets and discusses contemporary ideas in the visual arts with Morgan Russell, Charles Sheeler, Morton Schamberg, Stanton Macdonald, and Willard Huntington Wright and French dada artists Duchamp and Picabia; is attracted also to the literary circle around *Seven Arts*. Around late 1915 or early 1916 becomes part of the Stieglitz circle, meeting Arthur Dove, John Marin, and eventually Georgia O'Keeffe.

1916–1917
During summer 1916 at Twin Lakes, Connecticut, produces first series of abstractions based on mundane objects such as architectural elements and kitchen crockery. In New York City, makes candid street portraits, first using false lens and then prism lens to avoid notice.

Is given a one-person exhibition at 291, March 1916; six works reproduced in *Camera Work*, October 1916, and eleven works in the June 1917 issue. Exhibits work with Sheeler and Schamberg at Modern Gallery, March–April 1917; is included in Society of Independent Artists' show, 1917; receives first prize for *Wall Street* at Twelfth Annual Wanamaker Exhibition, 1917.

Articles on photography by Strand published in *Camera Work* and *Seven Arts*, 1917; also writes poetry, short essays, and stories (unpublished). Helps Stieglitz dismantle 291 in 1917.

1918–1919
Receives second and fifth prizes for *Wheel Organization* and *White Fence* at Thirteenth Annual Wanamaker Exhibition; photographs in New Orleans and San Antonio while on successful mission for Stieglitz to convince O'Keeffe to leave a teaching job in Texas to live in New York City.

Is inducted into army in September 1918; attempts transfer to Signal Corps but is assigned to Medical Corps as X-ray technician. Serves until end of July 1919. Recovers from influenza during epidemic of 1919, but mother is fatally stricken.

1920
Receives first prize for group of four images at Fourteenth Annual Wanamaker Exhibition. Acquires 8 × 10 inch view camera; resumes friendship with Sheeler, who has moved to New York City; together they seek work in advertising. With movie camera owned by Sheeler, they photograph together and produce short art film based on Walt Whitman's *Mannahatta*, shown eventually as *New York the Magnificent* (presently titled *Manhatta*). Film, retitled *The Smoke of New York*, is shown at dada festival in Paris, 1923, and in London, 1926, after which it disappears until 1950.

1921–1924
Marries Rebecca (Beck) Salsbury, graduate of ECS, 1922; they reside in apartment on top floor of the Strand family home. Introduced to Stieglitz and O'Keeffe, she maintains close friendship throughout the 1920s and 1930s, posing for Stieglitz, transcribing his reminiscences, buying photographs, traveling with O'Keeffe. Both Strands work with Stieglitz to produce issue of *mss*, 1922, devoted to photography.

Inheritance from uncle in 1922 and help from Beck enable Strand to acquire an Akeley camera. Throughout remainder of the decade, he earns a living taking news and sports footage and works on shorts and feature films.

Strand makes series of machine photographs, using Akeley camera and machine tools in Akeley repair shop as subjects; continues to photograph New York City scenes; makes many portraits of Beck, emulating Stieglitz's multi-portrait project of O'Keeffe.

Engages in polemical exchanges with editors of *The Nation*, *The Freeman*, and *The Arts* about Stieglitz-circle artists; eventually limits writing to photography only. Articles include "American Water Colors at the Brooklyn Museum" in *The Arts*, 1921, "Photography and The New God" in *Broom* magazine and "John Marin" in *Art Review*, both 1922.

Lecture at Clarence White School on "Modern Photography," 1923, printed in *British Journal of Photography* as "The Art Motive in Photo-

graphy"; piece clarifies Strand's aesthetic position and defines American precisionist point of view with regard to pictorial photography.

The Strands vacation at Lake George with or near Stieglitz and O'Keeffe; become involved in couple's artistic, health, and financial problems.

1925–1926
Included in Seven Americans, arranged by Stieglitz at Anderson Galleries, New York City, 1925.

Vacation on Georgetown Island, Maine in 1925, where friends Gaston and Isobel Lachaise maintain summer home and studio. Strand makes first sustained studies of rocks and driftwood. Travels with Beck to Colorado and New Mexico in 1926; visit Estes and Mesa Verde national parks; photographs tree roots and processes film at night in makeshift darkroom in hotel cellar. Meets Mabel Dodge Luhan in Taos.

1927–1929
Pressure of film work limits time for still photography. Makes further nature studies, also portraits of Lachaise at Georgetown Island in 1927 and 1928; writes article on Lachaise's work for *The Second American Caravan*, 1928. In April 1929, Beck goes to Taos with O'Keeffe; Strand remains in New York City, visits Stieglitz at Lake George during the summer; on Beck's return, they travel to the Gaspé with recently acquired 4 × 5 inch Graflex.

Exhibits thirty-two photographs taken in Colorado and Maine at Stieglitz's Intimate Gallery, 1929; foreword for catalog written by Lachaise. Show is well-reviewed and articles on Strand's work written by Harold Clurman, Group Theatre director, and by poet Lola Ridge appear in two issues of *Creative Art*.

The Strands arrange for group of financial supporters that includes, besides Beck Strand, Paul Rosenfeld, David A. Schulte, and Alma Wertheim, to finance acquisition in 1928 by Metropolitan Museum of Art of twenty-two Stieglitz photographs; a year later they undertake to help find rooms and financing for new gallery for Stieglitz. Despite October stock-market crash, financing is found (O'Keeffe and Dorothy Norman also raise money); gallery opens as An American Place.

1930–1932
Akeley camera becomes obsolete with invention of pan head movie camera; movie business moves to West Coast; Strand's free-lance work diminishes. He returns to Taos for one month in 1930, begins to work on landscape problems; meets circle of artists and writers, among them Ward Lockwood,

Elizabeth McCausland, Ernie O'Malley, Philip Stevenson, and Ella Young; group discusses need for authentically American humanist approach to the arts.

In a letter to the *New Republic* following a review of Carl Sandburg's *Steichen The Photographer*, he argues that photography needs more exalted goals than selling products.

Strand replaces 4×5 inch camera with 5×7 inch Graflex; hopes to photograph Indian ceremonies but settles for landscapes, portraits of friends, and views of abandoned towns. Begins to think about photography as a means of revealing social history through portraits and artifacts. Returns with Beck to Taos by car in 1931; photographs for entire summer.

On the East Coast, Strand finds the cooperative spirit of the Group Theatre similar to 291; becomes member of Advisory Board (along with Stieglitz, Ralph Steiner, and others). Clurman suggests that Strand's close allegiance to Stieglitz is "unhealthy." In frequent correspondence with Elizabeth McCausland (art critic, the *Springfield Republican*), discusses new social and political outlook. Reviews Heinrich Schwarz's book on D. O. Hill for *Saturday Review of Literature*.

Included in an exhibition of American photography at the Julien Levy Gallery, 1931; exhibits, jointly with Beck Strand who shows glass paintings, for the last time at An American Place, 1932. Upset by Stieglitz's seeming lack of interest in his work, Strand returns key to An American Place and heads west to Taos.

Strand's marriage dissolves; he drives from Taos to Mexico City (with anthropologist Susan Ramsdell and son) in fall of 1932 on invitation of Carlos Chávez, Chief of the Department of Fine Arts, Mexican Secretariat of Education.

1933–1934
Appointed by Chávez to the Department of Fine Arts in April 1933; collects artwork by children for exhibition in Mexico City, May 1933, and photographs for himself in Michoacán villages accompanied by Augustin Velásquez Chávez. Exhibits fifty-two works at one-person show at Sala de Arte in Mexico City, February 1933.

Invited to produce a series of socially oriented films on Mexican life. *Redes* ("Nets," released in the United States in 1936 as *The Wave*, first commercial showing, 1937) is first and only film supervised and photographed by Strand. It is shot mainly in fishing village of Alvarado, with Henwar Rodakiewicz and Fred Zinnemann directing, working with a Mexican crew. Changes in political leadership in Secretariat of Education put an end to the project; Strand returns to New York in 1934.

1935–1936
Urged by Clurman, travels to Soviet Union in order to work with Sergey Eisenstein but is unable to convince Soviet government to issue work permit. Makes no photographs in Soviet Union; returns home via London and Ireland. Continues support of Group Theatre projects in letter to *The Nation* objecting to "defeatist" review of a play by Clifford Odets.

Is asked by Pare Lorentz in 1935 to work with Leo Hurwitz and Ralph Steiner on *The Plow That Broke the Plains*, a documentary for the Resettlement Administration of the United States government on drought conditions, released 1936. Joins Nykino, a New York film group making documentaries with a political message.

Marries Virginia Stevens, actress with the Group Theatre, and travels again to the Gaspé in 1936, this time making portraits as well as landscapes.

1937–1944
Work done in Mexico in 1932 and 1933 is included in first Museum of Modern Art (MOMA) photography exhibition, 1937. Joins the Photo League in 1938, acts as advisor and gives advanced classes. Using friend's barn in Connecticut and borrowed medical skeleton, makes overt antifascist image of skeleton crucified on swastika, 1938; image is reproduced on cover of *TAC* monthly.

In 1940, publishes (under Virginia Stevens imprimatur) portfolio of twenty hand-gravure reproductions of the Mexican images (initially intended to include twenty-five), all but one from 1933, with forward by Leo Hurwitz; sends copies to Ansel Adams and Albert Bender on West Coast.

Nykino reorganized into Frontier Films, with Strand as president. Frontier produces films on political issues; Strand photographs and directs *Native Land*, completed 1942. In 1944, goes to Hollywood for work on films for government agencies (Department of Agriculture and Navy).

After ten years of cinema work returns to still photography full time in 1943, photographing in Vermont with 5×7 inch Graflex and 8×10 inch view camera. Lectures at MOMA on "Photography and the Other Arts," 1944.

Directs production of eighty-foot-long photographic mural for campaign to reelect Franklin Delano Roosevelt, assisted by Robert Riley; exhibited at Vanderbilt Gallery, New York, 1944.

1945–1948
Nancy Newhall (acting curator of photography) arranges one-person retrospective exhibition at MOMA in 1945, generally well-received; together they plan a book on New England to be titled *Time in New England* (not

published until 1950). Travels throughout region in the fall of 1945, spending time with Marin at Cape Split; returns to New England in 1947 to try out Ektachrome film for Eastman Kodak Company.

Remains on Photo League Advisory Board. Lectures at seminar organized by Chicago Institute of Design in 1946. Becomes active in Art Division of National Council of the Arts, Sciences, and Professions in 1948–49, eventually complaining of "meetings, meetings, and more meetings." Writes articles on Stieglitz (d. 1946) for *New Masses*, 1946, and *Popular Photography*, 1947.

Marriage to Virginia Stevens ends.

1949–1951

Does intermittent commercial work in New York City for *Fortune* magazine, CBS, and Eastman Kodak; finds color reproduction disappointing.

Invited to show *Native Land* at Fourth International Film Festival in Marianske Lazne, Czechoslovakia, August 1949; film receives first prize for best script. Travels to Perugia, Italy, in September 1949, for International Congress of Film Conference; meets Cesare Zavattini. Decides to leave United States because of restrictive political climate.

Favorable reviews of *Time in New England* appear in press throughout nation; Strand displeased with reproductions in book.

Marries Hazel Kingsbury in 1951 and settles temporarily in Paris. Before finding permanent home in Orgeval (a village some thirty-five kilometers west of Paris), the Strands travel throughout France in search of a village in which to make a social portrait; eventually realizes he has produced a portrait of an entire nation. Selected images published in France in 1952 as *La France de Profil*, with text by Claude Roy. Is convinced book format can convey his social and aesthetic message, provided production is carefully supervised; oversees plate production and printing for French book at printing works in Lausanne, Switzerland, and follows similar practice with all subsequent publications.

1952–1954

Travels to Italy in 1954 to seek appropriate village in which to make social portrait; after trips to Sicily and Gaeta is taken by Zavattini to his birthplace, Luzzara, and spends eight weeks photographing. Zavattini supplies text for work published in Italy in 1955 as *Un Paese*. Portfolio of French and Italian images appears in *U.S. Camera Annual 1955*, with text by Claude Roy.

Work exhibited at Colorado Springs Fine Arts Center, 1953.

Photographs in Outer Hebrides island of South Uist (1954) for book *Tìr a'Mhurain*, with text by Basil Davidson, published in Dresden and London in 1962. (Books from German Democratic Republic not allowed into United States without stamp indicating they are from "occupied zone" of Germany.)

1955–1957

Embarks on project making portraits of French intellectuals and artists and close-ups of foliage in garden at Orgeval for publication; carries on intermittently with garden theme throughout 1960s, but book is never realized.

Included in exhibition at Limelight Gallery, New York, 1955, and in Diogenes with a Camera III at MOMA, 1956.

1959–1962

Photographs for two and one-half months in Egypt in 1959; returns second time for views of industrial sites. *Living Egypt*, with text by James Aldridge, published in Dresden and London, 1969. Takes brief photographic trips to Romania in 1960 and Morocco in 1962, with idea of possible publications.

1963–1967

Photographs in Ghana in winter of 1963/64 at invitation of President Kwame Nkrumah; is given residence and driver. (*Ghana: An African Portrait*, with text by Basil Davidson, is published posthumously by Aperture, 1976.) Works with Walter Rosenblum at Orgeval in 1964 on layout for book eventually published as *Paul Strand: A Retrospective Monograph, The Years 1915–1968*; following year meets Michael Hoffman and interests Aperture in publication. Awarded David Octavius Hill Medal by the Gesellschaft Deutscher Lichtbildner in Mannheim.

1969–1970

Acquires apartment in New York City in order to make frequent trips between France and United States more easily. Work exhibited at Kreis Museum, Freital, German Democratic Republic; Museumof Fine Arts, St. Petersburg, Florida; one-man exhibition organized by Administration Generale des Affaires Culturelles Françaises of Belgium travels throughout Belgium and The Netherlands. As guest of Swedish Photographers Association and Swedish Film Archives in October 1970, exhibits gravures of still photographs and shows films produced by Frontier Films. Plans retrospective exhibition for Philadelphia Museum and monograph of work and completes work on monograph begun in 1964. The Strands visit Spain and Canary Islands in March and April 1970.

1971–1975

Retrospective exhibition opens at Philadelphia Museum, November 1971, travels to Museum of Fine Arts in Boston; City Art Museum in St. Louis; Los Angeles County Museum; M.H. DeYoung Museum in San Francisco, 1972. Continues to Metropolitan Museum of Art in New York, 1973. Work is included in other exhibitions in Europe and the United States.

In early 1970s, Strand finds work difficult due to cataract condition finally alleviated by surgery in New York in 1973. He returns to Orgeval, works on book of garden pictures (unpublished), and prepares two portfolios, *On My Doorstep* and *The Garden*, printed with assistance from Anne Kennedy and Richard Benson. Battles spreading cancer. Seeks medical attention in Paris and New York. Benson and Kennedy help with printing of set of master prints for use in publication.

1976

Strand is too weak to attend opening in January of retrospective exhibition at the National Portrait Gallery in London; dies at Orgeval in March. His will provides gifts of selected photographs to several museums, including a large group to the Philadelphia Museum of Art; selected papers are given to Center for Creative Photography, Tucson; the Paul Strand Foundation, which later becomes the Paul Strand Archive of Aperture Foundation, is established.

Notes

Alan Trachtenberg
Introduction

1. From an unpublished manuscript, dated July 30, 1946, in the Paul Strand Archive, Center for Creative Photography, University of Arizona, Tucson.

2. Especially useful for placing Paul Strand in relation to early American modernism are Dickran Tashjian, *Skyscraper Primitives* (Middletown, Connecticut: Wesleyan University Press, 1975), and William Innes Homer, *Alfred Stieglitz and the American Avant-Garde* (Boston: New York Graphic Society, 1977). An indispensable discussion of the impact of modernist art in America is Meyer Shapiro's essay on the Armory Show of 1913, "Rebellion in Art," in *American in Crisis*, Daniel Aaron, ed. (New York: Alfred A. Knopf, 1952), 203–244; reprinted as "Introduction of Modern Art in America: The Armory Show," in Meyer Shapiro, *Modern Art: 19th & 20th Centuries* (New York: George Braziller, 1978), 135–178. A convenient source for recent discussions of modernism as such is *Modernism: Challenges and Perspectives*, Monique Chefdor, et al., eds. (Urbana, Illinois: University of Illinois Press, 1986).

3. Paul Strand, "Photography," *Seven Arts*, 2:524–25 (August 1917). Reprinted in *Classic Essays on Photography*, Alan Trachtenberg, ed., (New Haven, Connecticut: Leete's Island Books, 1980), 141–144; 142.

4. See, for example, *Writers on the Left*, Daniel Aaron, ed., (New York: Harper, Brace and Row, 1961).

5. The nexus of art and politics in Strand's case can be seen in a larger setting with the help of Raymond Williams, *The Politics of Modernism* (London: Verso, 1989).

6. Calvin Tomkins, "Profiles: Look to the Things Around You," *The New Yorker*, September 16, 1974, 44–94. Reprinted in *Paul Strand: Sixty Years of Photographs* (Millerton, New York: Aperture, 1976), 15–35; 25.

7. Ibid., 34.

8. Quoted in Ibid., 34.

9. Strand, "Photography," 142.

10. Quoted in Tomkins, 25.

11. Idem.

12. See Harold Clurman, *The Fervant Years: The Story of the Group Theatre and the Thirties* (New York: Hill and Wang, 1957).

13. Harold Clurman, "Alfred Stieglitz and the Group Idea," in Waldo Frank, et al. (eds.), *America & Alfred Stieglitz: A Collective Portrait* (New York: Doubleday, Doran and Company, 1934), 267–279, 278.

14. Quoted in Tomkins, 254.

15. Edward Abrahams, *The Lyrical Left and the Origins of Cultural Radicalism in America* (Charlottesville, Virginia: University of Virginia Press, 1986). The words by Stieglitz are quoted on page 165.

16. The definitive study of intellectual and cultural change in the early twentieth century is Henry F. May, *The End of American Innocence: The First Years of Our Own Times, 1912–1917* (New York: Alfred A. Knopf, 1959). Also important is Christopher Lasch, *The New Radicalism in America, 1889–1963: The Intellectual as Social Type* (New York: Alfred A. Knopf, 1965). For social background see Robert H. Wiebe, *The Search for Order, 1877–1920* (New York: Hill and Wang, 1967). Also relevant is Peter Conn, *The Divided Mind: Ideology and Imagination in America, 1898–1917* (New York: Cambridge University Press, 1983).

17. On New York metropolitanism in this period see Thomas Bender, *New York Intellect: A History of Intellectual Life in New York City* (New York: Alfred A. Knopf, 1987), especially 206–262. My discussion profits also from Bender, "New York, Cosmopolitan Liberalism, and American Nationalism: A Comparative Perspective" (unpublished paper), and David Hollinger, *In the American Province: Studies in the History and Historiography of Ideas* (Baltimore: Johns Hopkins University Press, 1985), Chapter Four, "Ethnic Diversity, Cosmopolitanism, and the Emergence of the American Liberal Intelligentsia," 56–73.

18. Randolph S. Bourne, "Trans-National America," in *War and the Intellectuals: Collected Essays, 1915–1919*, Carl Resek, ed. (New York: Harper Torchbooks, 1964), 107–123.

19. Bourne, "The Jew and Trans-National America," in *War and the Intellectuals*, 124–133, passim. Jews' historical experience of maintaining their cultural uniqueness while adjusting to non-Jewish national states, according to Bourne, provides "the purest pattern and the most inspiring conceptions of trans-nationalism" (128). Trans-nationalism itself, he points out, is an American Jewish idea, conceived by Jewish intellectuals like Horace Kallem who opposed the idea of cultural democracy to the ideology of the melting pot (128). Americans "need new conceptions of the state, of nationality, of citizenship, of allegiance" (126). Bourne offers as a model the Zionist reconciliation between "cultural allegiance to the Jewish centre and political allegiance to a State" (129). The early Zionist idea is that "a Jew might remain a complete Jew and at the same time be a complete citizen of any modern State where he happened to live" (130). America "needs these Zionist

conceptions," Bourne argues, which can be translated into an ideal of "co-operative Americanism," "an ideal of a freely mingling society of peoples of very different racial and cultural antecedents, with a common political allegience and common social ends but with free and distinctive cultural allegiences" (130).

20. *Classic Essays*, 143.

21. Idem.

22. Ibid., 146.

23. Idem.

24. Ibid., 148.

25. Ibid., 151.

26. Idem. For an intelligent historical discussion of the machine aesthetic in early twentieth-century American photography, and especially of Strand's own experiments in this mode, see Miles Orvell, *The Real Thing: Imitation and Authenticity in American Culture, 1880–1940* (Chapel Hill: University of North Carolina Press), 198–239.

27. Strand's apparent ambivalence toward the machine should be viewed in the context of the tension between modernism in the arts and modernity or modernization in society. See Marshall Berman, *All That Is Solid Melts into Air: The Experience of Modernity* (New York: Simon & Schuster, 1982), and *Modernism and Modernity*, Benjamin H. D. Buchloh, et al., eds. (Halifax, Nova Scotia: The Press of the Nova Scotia College of Art and Design, 1983).

28. Quoted in Tomkins, 31.

29. Quoted in Ibid., 30.

30. See Maren Strange's observations on Robert Frank's *The Americans*, its iconoclasm and its implied criticism of the very idea of photographic transparency Strand advocated, in *Symbols of Ideal Life: Social Documentary Photography in America, 1890–1950* (New York: Cambridge University Press, 1989), 147–148.

31. Paul Strand, *Time in New England*,

with text sel. and ed. Nancy Newhall (New York: Oxford University Press, 1950), vii.

32. Quoted in Homer, 251.

33. Cited in *Walker Evans at Work* (New York: Harper & Row, 1982), 24. Evans recalled the impact of the picture even many years later: "The effect was breathtaking for anyone interested in serious photography; or in pictures, for that matter." Walker Evans, "Photography," in *Quality: Its Images in the Arts,* Louis Kronenberger, ed. (New York: Atheneum, 1969), 178.

34. The anthropologist Edward Sapir used this term in a brief essay in *The Dial* 67 (1919), 233–236, which later became part of his influential essay, "Culture, Genuine and Spurious," *American Journal of Sociology,* 29 (1924), 401–29. See the critique of Strand's books in Ulrich Keller, "An Art Historical View of Paul Strand," *Image* 17, 4 (December 1974), 1–11.

Milton W. Brown
The Three Roads

1. The exhibition ran from March 13 through April 3, 1916, under the title "Photographs of New York and Other Places." Six images from the exhibition were reproduced in *Camera Work* 48 (October 1916). A different group of photographs was published in the last issue, *Camera Work* 49/50 (June 1917).

2. Paul Strand, interview in Philadelphia, 1971, in *Paul Strand, Sixty Years of Photographs* (Millerton, N.Y.: Aperture, 1976), 144.

3. These photographs have been variously titled over the years. In the original publication, *Camera Work* 49/50 (June 1917), they were all listed simply as "Photograph."

4. Paul Strand, unpublished manuscript, Paul Strand Archive, Center for Creative Photography, University of Arizona, Tucson. Edited version published as "John Marin," *Art Review* 1 (January 1922), 22–23.

5. See *Machine-Age Exposition* (New York: Little Review, 1927).

6. See William I. Homer, *Alfred Stieglitz and the American Avant-Garde* (Boston: New York Graphic Society, 1977), 246–54, and Naomi Rosenblum, "Paul Strand: The Early Years, 1910–1932" (Ph.D. diss., CUNY Graduate School, 1978), 44–62.

7. See Jonathan Green, "The Snapshot," *Aperture* 19:1 (April 1974), 47.

8. Quoted in Homer, *Stieglitz,* 251.

9. Paul Strand, letter to Van Deren Coke, March 27, 1968. Quoted in *Sixty Years,* 143.

10. Paul Strand, "Photography and the New God," *Broom* 3 (November 1922), 255–56; reprinted in *Classic Essays on Photography* Alan Trachtenberg, ed. (New Haven: Leete's Island Books, 1980), 144–51.

Naomi Rosenblum
The Early Years

Abbreviations: AS-Alfred Stieglitz ASA/YU-Alfred Stieglitz Archive, Beinecke Library, Yale University ECS-Ethical Culture School PS-Paul Strand PSC/CCP-Paul Strand Collection, Center for Creative Photography, University of Arizona, Tucson WR-Walter Rosenblum

1. Ansel Adams to Paul Strand (PS), 12 September 1933, Paul Strand Collection, Center for Creative Photography (PSC/CCP), University of Arizona, Tucson.

2. "I am planning to bring our Superintendent and several teachers . . . we are trying to introduce the camera work into our high school as a regular course." Lewis W. Hine to Alfred Stieglitz (AS), 14 December 1906, Alfred Stieglitz Archive, Beinecke Library,

Yale University (ASU/YU). According to Ethical Culture School (ECS) records, Strand attended Hine's class in 1908 and received the grade A−; he may also have participated in the Camera Club, which Hine organized outside the regular school curriculum.

3. For Hine's ideas on the value of photography in education, see L. W. Hine, "The School Camera," *The Elementary School Teacher* 6 (March 1906): 343–47; "The School in the Park," *Outlook* 83 (July 28, 1906): 712–18; "An Indian Summer," *Outlook* 84 (October 27, 1906): 502–506; "The Silhouette in Photography," *Photographic Times* 38 (November 1906): 488–90; "Photography in the School," *Photographic Times* 40 (August 1908): 227–32.

4. Paul Strand, "Letter to the Editor," *The Photographic Journal* (London) 103 (July 1963): 216.

5. PS to Mr. and Mrs. J. Strand, 11 December 1913, PSC/CCP.

6. Nancy Newhall, *Paul Strand* (New York: Museum of Modern Art, 1945), 9, and Elizabeth McCausland, "Paul Strand," *U.S. Camera* 1 (February/March 1940), 20. Strand also must have seen and not remembered the "Loan Exhibition of Secessionist Photography" shown at ECS in 1907 as part of end-term activities; see Stieglitz Scrapbook, ASA/YU.

7. Charles H. Caffin, *Photography as a Fine Art* (Hastings-on-Hudson, N.Y.: Morgan & Morgan, 1971), facsimile reprint of 1901 edition, vii, viii.

8. Strand acknowledged that his father's "faith in my work never faltered" in his dedication to *Paul Strand: A Retrospective Monograph, The Years 1915–1968*, 2 vols. (Millerton, N.Y.: Aperture, 1971). He resided at home at 314 West Eighty-third Street with his maternal grandparents, his parents, his aunt, and a cousin. He occupied an apartment on the top floor of 314

West Eighty-third Street after marriage. Jacob Strand supported Stieglitz's galleries as well, contributing to a fund for Marin, for which he received a watercolor by that artist. Both he and Paul, guided by Harold Greengard, invested in stocks and managed to weather the 1929 crash without great loss. On his death in 1950, he left a small kitchen-hardware business to Strand, which the latter sold.

9. Nathaniel Meyer, married to Josie Arnstein, sister of Strand's mother, was an attorney for the United States Rubber Company. More comfortably situated than the Strands, the childless Meyers were helpful on many occasions, among them dealings with the Camera Club of New York. On his death, Meyer's bequest enabled Strand to purchase the Akeley camera, which made his career in motion pictures possible.

10. A portrait of his mother included in the Annual Members Print Exhibition of 1910 was mentioned in *American Photography* 4 (June 1910), 371, and *Versailles*, made in Europe in 1911, received a club prize. It was the first image Strand sold. See PS to Mr. and Mrs. J. Strand, 19 April 1911, PSC/CCP.

11. F. C. Tilney, "The Exhibitions," *Photograms of the Year 1912* (London: 1912), 20.

12. *Photoisms* 2 (July 1911) and 3 (August 1911).

13. All quotations relating to this event are from papers now in the possession of Walter Rosenblum (WR), to whom Strand gave them in 1968. They consist of copies of the minutes of the Camera Club and of correspondence between Strand and the club executive committee.

14. See J. J. Firebaugh, "Coburn, Henry James's Photographer," *American Quarterly* 7 (1955): 224.

15. PS to WR, 21 May 1951, Collection WR.

16. AS to R. Child Bayley, 11 December 1913, ASA/YU.

17. Alfred Stieglitz, *Picturesque Bits of New York* [a portfolio of 12 photogravures] (New York: R. H. Russel, 1897).

18. *Camera Work* 48 (October 1916), 25–35; *Camera Work*, 49/50 (June 1917), 11–29.

19. See AS to Herbert Seligmann, 20 August 1921 and 8 October 1926, ASA/YU, regarding the relationship between sexual prowess and photographic ability.

20. The Modern Gallery, started by Stieglitz, Marius De Zayas, and Agnes Meyer, was initially conceived as a commercial arm of 291; the publication *291* appeared in 1915, put out by the group around the Modern Gallery, notably Picabia and De Zayas. *The Seven arts* was founded by James Oppenheim in 1916 and was edited by Oppenheim and Waldo Frank. Contributors, among them Randolph Bourne, Van Wyck Brooks, and Paul Rosenfeld, were united in their distaste for a repressive puritan tradition and in their hopes for a reformist but intuitive national culture.

21. For a discussion of this development, see F. Naumann, "The New York Dada Movement: Better Late Than Never," *Arts* 54, No. 6 (February 1980), 143–49 and Bram Dijkstra, *The Hieroglyphics of a New Speech: Cubism, Stieglitz and the Early Poetry of William Carlos Williams* (Princeton: Princeton University Press, 1964), 100–101. Strand's interest in dada appears to have been based on a belief in freedom for artists rather than on intellectual commitment; for example, he deplored the refusal of the Society of Independent Artists to exhibit the R. Mutt urinal submitted by Duchamp but was not interested in the object itself. See Paul Strand, "The Independents in Theory and Practice," *The Freeman* 3 (April 6, 1921), 90.

22. Strand dated all the experimental still lifes to 1915, but correspondence shows his memory to have been in error; those in the early group were produced in the summer of 1916 and the later ones in 1919; see PS to AS, 28 August 1916 and 22 November 1919, ASA/YU. These two sets of still lifes have not yet been definitively dated.

23. Strand attempted at first to use a false barrel lens attached to the side of the camera; two of the portraits were made with this device before he purchased a prism lens on advice from a Camera Club member. His next venture in this direction did not occur until some seventeen years later, when he returned to photographing in the streets, this time in Mexico.

24. Paul Strand, "What Was 291?" (unpublished typescript, October 1917), PSC/CCP.

25. The exhibition was favorably reviewed by Charles Caffin in *The New York American*, March 20, 1916, and by Royal Cortissoz in *The New York Tribune*, March 20, 1916, with the Caffin article reprinted in *Camera Craft*, May 23, 1916; *American Photography*, April 1916, printed a short review also.

26. *Wheel Organization* received second prize in the thirteenth Annual Wanamaker Exhibition. Considered both "brutal" and expressive of the power of industry, it was sold by Stieglitz to Mrs. Charles Liebman, for her husband's office. For Strand's reaction to the sale, see PS to AS, 12 May 1918, ASU/YU.

27. Paul Strand, "Photography," *The Seven arts* 2 (August 1917), 524–25.

28. See correspondence dated from July 1917 through May 1918: PS to AS, ASA/YU; O'Keeffe to PS, PSC/CCP; AS to PS, PSC/CCP.

29. Paul Strand, press release for *New York, The Magnificent* (undated typescript), PSC/CCP.

30. Paul Strand, "Alfred Stieglitz and a Machine" (New York: privately printed, 1921); reprinted in *Manuscripts* 2, No. 6/7 (March 1922) n.p. The talk to the Clarence White School was printed as "The Art Motive in Photography," in *The British Journal of Photography* (London) 70 (October 5, 1923), 613–15.

31. See Paul Strand, "Photography and the New God," *Broom* 3, No. 4 (November 1922), 257, for his disavowal of the futurists' total embrace of mechanization.

32. *The Machine Age Exposition*, New York, 1927, and *Film Und Foto*, Stuttgart, 1929, were the two major shows of machine-related art in which Strand's work was not included. Disagreement with Steichen, one of the organizers of the American portion of *Film Und Foto*, was aired in a letter to the *New Republic* 61 (January 22, 1930), 251–53. On occasion, Strand refused to participate in exhibitions or publications from which Stieglitz was excluded.

33. See W. G. Fitz, "A Few Thoughts on the Wanamaker Exhibition," *The Camera* 22 (April 1918), 205. See also Van Deren Coke, "The Cubist Photographs of Paul Strand and Morton Schamberg," *One Hundred Years of Photographic History* (Albuquerque: University of New Mexico Press, 1975), 36–40.

34. PS to AS, 3 and 4 July 1922, ASA/YU; see also Robert Katz, "Talks Between Robert Katz and Paul Strand" August 1962, typescript in PSC/CCP.

35. Paul Strand, "Georgia O'Keeffe," *Playboy* (July 1924), 16–20; a longer version in typescript is in PSC/CCP.

36. Beck was one of the donors, along with Paul Rosenfeld, Alma Wertheim, and others. See William M. Ivins, Jr., "Photographs by Alfred Stieglitz," *Metropolitan Museum of Art Bulletin* 27 (March 1969), 336–37.

37. See Rebecca Strand to PS, 8 June 1920, PSC/CCP. Strand did not allow these works to be exhibited as a group,

having concluded that the similarity to Stieglitz's concept was embarrassing. Eventually, he came to discredit all such projects as too personal and self-involved.

38. PS, interview with author, New York City, 26 March 1975. See also AS to Herbert Seligmann, 13 November 1923, ASA/YU.

39. AS to PS, 9 August 1920, PSC/CCP.

40. Strand later claimed that "he never had the same yearning as other painters and photographers to show my work all the time." PS, interview with author, New York City, 2 July 1975.

41. PS to Rebecca James, 13 December 1966, copy in PSC/CCP.

42. Waldo Frank to AS, 31 July 1923, ASA/YU.

43. Harold Clurman to PS, 21 November 1932, PSC/CCP. The Group Theatre was organized in 1929 as a year-round cooperative repertory company of actors and directors; Strand and Stieglitz were members of the advisory board during the early 1930s.

44. AS to Herbert Seligmann, 24 September 1926; see also AS to Herbert Seligmann, 18 October 1923, ASA/YU, in which he likens America to a gelded horse.

45. "I confess to an impulse to vote. . . ." PS to AS, 10 September 1928, ASA/YU. In the group with whom Strand discussed the role of the artist were Mexican composer Carlos Chávez, art critic Elizabeth McCausland, and author Philip Stevenson.

46. In a radio talk, "Art in New York," on 25 April 1945 over WNYC, Strand acknowledged he "had learned most from Stieglitz"; transcript in PSC/CCP. PS to Ansel Adams, 14 October 1933, Ansel Adams Archive, CCP; see also Paul Strand, "Correspondence on Aragon," *Art Front* 3, No. 1 (February 1937), 18.

47. Ronald Primeau, *Beyond Spoon River: The Legacy of Edgar Lee Masters*

274

(Austin: University of Texas Press, 1981), 168. "Terribleness" to describe the city first appears in a letter concerning Strand's need for a vacation; see AS to Paul Rosenfeld, 28 August 1920, ASA/YU. The sentiment is repeated in correspondence among the circle throughout the decade.

Jan-Christopher Horak
Modernist Perspectives and Romantic Impulses: *Manhatta*

1. A longer version of this essay appeared as "Modernist Perspectives and Romantic Desire: *Manhatta*," *Afterimage* 15, 14 (November 1987), 8–15. The film is made up of sixty-five shots; all of them are published in that essay. Unpublished manuscript (NHS 1), Charles Sheeler Papers, Archives of American Art (hereafter AAA).

2. Naomi Rosenblum: *Paul Strand: The Early Years, 1910–1932* (Ph.D. diss., City University of New York, 1978), 96.

3. Rosenblum, *Paul Strand*, 102.

4. Alfred Stieglitz, letter to Paul Strand, 21 September 1921. Stieglitz Archive, Center for Creative Photography (hereafter CCP), Tucson, Arizona; copy in Alfred Stieglitz Papers, Beinecke Library, Yale University.

5. Paul Strand, interview with Milton Brown and Walter Rosenblum, November 1971, transcript in Paul Strand Papers, AAA.

6. Strand interview, 8–9.

7. According to Ted Stebbins, Sheeler made two other films at this time. Schamburg appeared in the first, and Sheeler's future wife, Katherine Baird Schaffer, is the nude subject of the second film. All that remains of both films are a few stills. See Theodore E. Stebbins Jr. and Norman Keyes Jr., *Charles Sheeler, the Photographs* (Boston: Museum of Fine Arts, 1987), 15. Thanks to Ted for corrections and comments on the version of this article published in *Afterimage* 15, 4 (November 1987).

8. Paul Strand, letter to Richard Shales, 31 March 1975, Paul Strand Archive, CCP.

9. Alfred Stieglitz to Strand, 27 October 1920, Paul Strand Archive.

10. *Motion Picture News* 24, 7 (August 6 1921), 756.

11. *New York Evening Journal*, 25 July 1921, 8; *New York American*, 25 July 1921, 12; *New York Tribune*, 26 July 1921, 6. The film was also mentioned in: *Morning Telegraph*, 26 July 1921, 5; *Brooklyn Daily Eagle*, 26 July 1921, 17; *New York Herald*, 25 July 1921, 7.

12. Harriet Underhill, *New York Tribune*, 26 July 1921, 6.

13. Robert Allen Parker, "The Art of the Camera," *Arts & Decoration* 15, 6 (October 1921), 396.

14. Parker, 396.

15. Paul Strand to Stieglitz, 3 August 1921, CCP.

16. *Motion Picture World* 30 July 1921, 541.

17. Naomi Rosenblum gave a copy of the press release to the Museum of Modern Art Film Department in 1978.

18. *Camera Work* 36 (October 1911). See also Scott Hammen: "Sheeler and Strand's 'Manhatta': A Neglected Masterpiece," *Afterimage* 6, 6 (January 1979), 6–7.

19. *Vanity Fair* 15, 5 (January 1921), 72.

20. *Vanity Fair* 18, 2 (April 1922), 51.

21. *The Rouge. The Image of Industry in the Art of Charles Sheeler and Diego Rivera* (Detroit: Detroit Institute of Arts, 1978).

22. Hammen, "Neglected Masterpiece," 7.

23. Sergei Eisenstein, "A Dialectic Approach to Film Form," *in Film Form* (New York: Harcourt, Brace & Co., 1949), 45–63.

24. Alfred Steiglitz, "How I Came to Photograph Clouds," *The Amateur Photographer & Photography* 56, 1819 (1923), 255; reprinted in Nathan Lyons, ed., *Photographers on Photography* (Englewood Cliffs: Prentice-Hall, 1966), 111–12.

25. Walt Whitman, *Leaves of Grass*, Harold Blodgett and Sculley Bradley, eds. (New York: W.W. Norton & Co., 1965). All quotes are from this edition.

26. Hammen, 7.

27. Dickran Tashjian: *Skyscraper Primitives: Dada and the American Avant-Garde* (Middletown, Connecticut: Wesleyan University Press, 1975), 281.

28. Quoted in Tashjian, *Skyscraper Primitives*, 54.

29. Paul Strand, "Photography and the New God," *Broom* 3, 4 (1922), 257; reprinted in Lyons, *Photographers*, 143.

30. Strand, "Photography," in Lyons, *Photographers*, 141.

31. Strand, "Photography," in Lyons, *Photographers*, 143.

Belinda Rathbone
Portrait of a Marriage

A longer version of this essay was published in the *J. Paul Getty Museum Journal* 17 (1989), 83–98. The letters from Rebecca Salsbury to Paul Strand are at the Center for Creative Photography, University of Arizona, Tucson. The correspondence between Alfred Stieglitz, Paul Strand, and Rebecca is in the Yale Collection of American Literature, Beinecke Rare Book and Manuscript Library, Yale University. The letters from Paul Strand to Rebecca are lost.

1. Naomi Rosenblum, "Paul Strand: The Early Years, 1910–1932" (Ph.D. diss., City University of New York, 1978), 144–148.

2. Rosenblum writes that these portraits are "somewhat forced," "suggest a reticence and desire to please," and are "the least moving portraits of the 1920s, based on his inability to be objective," pages 147–8.

3. See *Georgia O'Keeffe: A Portrait by Alfred Stieglitz* (New York: The Metropolitan Museum of Art, 1978), introduction.

4. Quoted in Calvin Tomkins, "Profile," *Paul Strand: Sixty Years of Photographs* (Millerton N.Y.: Aperture, 1976), 20.

5. Paul Strand to Alfred Stieglitz, San Antonio, Texas, 18 May 1918.

6. "If I had some money I might be able to help her. . . . But I haven't—so it's all very clear that I'm not the one. Besides it's very clear that you mean more to her than anyone else—so it seems that you and she ought to have the chance of finding out what can be done—one for the other—." Strand to Stieglitz, San Antonio, Texas, 18 May 1918.

7. Paul Strand to Alfred Stieglitz, New York City, 22 October 1919.

8. Rebecca's physical health and emotional state are often mentioned obliquely in the correspondence between Stieglitz and Strand. Stieglitz's invitations to Lake George are especially telling, for example: "The rest will be beneficial for [Rebecca]. There is just quiet—and more quiet—and yet more—no excitements—and that's what she needs." Stieglitz to Strand, 1 September 1922.

9. Charles Sheeler made an experimental film of his wife, Katherine Shaffer, around 1919, from which thirteen stills have been preserved. The film must have been influenced by Stieglitz's photographs of O'Keeffe, which Sheeler saw in May 1919 and greatly admired. It is also likely that Strand saw Sheeler's film and in turn was influenced by it. See Theodore E. Stebbins, Jr., and Norman Keyes, Jr., *Charles Sheeler: The Photographs* (Boston:

Museum of Fine Arts, 1987), 16. See also "Modernist Perspectives and Romantic Impulses: *Manhatta*," Jan-Christopher Horak, in this volume.

10. Rebecca Salsbury to Paul Strand, Square Butte, Mont., June 1920.

11. Rebecca Salsbury to Paul Strand, 5 July 1920.

12. Salsbury to Strand, Square Butte, Mont., June 1920.

13. In 1947, Rebecca wrote, "I first knew Alfred Stieglitz in 1921—taken to him by Paul Strand straight from the gold and brocade parlour in my home to a tiny storage room in the old Anderson Galleries." Republished from *Stieglitz Memorial Portfolio* in *The Collection of William and Rebecca James* (Albuquerque, NM: n.p.), held in the Rebecca Strand James Papers, Beinecke Library, Yale University.

14. Rebecca Salsbury to Paul Strand, Brooklyn, N.Y. (to Nova Scotia), 23 September 1920.

15. Rebecca Salsbury to Paul Strand, 8 May 1920.

16. Paul Strand to Alfred Stieglitz, New York City, 16 November 1920.

17. Rebecca Salsbury to Paul Strand, Twin Lakes, Conn., September 1921.

18. Of her experience as Stieglitz's subject, O'Keeffe wrote the following many years later: "For those slower glass negatives I would have to be still for three or four minutes. That is hard—you blink when you shouldn't—your mouth twitches— your ear itches and some other spot itches. Your arms and hands get tired and you can't stay still. I was often spoiling a photograph because I couldn't help moving—and a great deal of fuss was made about it." In *Georgia O'Keeffe*, unpaginated.

19. Rebecca Strand to Alfred Stieglitz, New York City, 14 July 1922.

20. The "Iron Virgin" was not a hand-me-down from Stieglitz to Strand. "Many thanks for ordering the anti-

wobble." Paul Strand to Alfred Stieglitz, 11 July 1922.

21. Rebecca Strand to Alfred Stieglitz, New York City, 24 July 1922.

22. Alfred Stieglitz to Rebecca Strand, Lake George, 15 July 1922.

23. Rebecca Strand to Paul Strand, Lake George, 14 September 1922.

24. Alfred Stieglitz to Rebecca Strand, Lake George, letter undated but filed as October–November 1924.

25. Paul Strand to Alfred Stieglitz, New York City, 4 July 1922.

26. Rebecca Strand to Alfred Stieglitz, New York City, 6 November 1922.

27. At this time Strand was making a living filming sports events. The summer before, Strand had written to Stieglitz about making slow-motion films to analyze athletic form: ". . . pictures made at 130 times normal speed projected at normal speed—they are wonderful." Paul Strand to Alfred Stieglitz, 5 August 1921.

28. Alfred Stieglitz to Rebecca Strand, Lake George, 18 August 1923.

29. Paul Strand to Alfred Stieglitz, Estes Park, Colorado, 13 August 1926.

30. Rebecca Strand to Alfred Stieglitz, New York City, 25 May 1927.

31. Alfred Stieglitz to Rebecca Strand, Lake George, 19 September 1927.

32. Rebecca Strand to Alfred Stieglitz, Georgetown, Maine, 30 July 1928.

33. Rebecca Strand to Alfred Stieglitz, Taos, New Mexico, 14 May 1929.

34. Rebecca Strand to Alfred Stieglitz, New York City, 13 May 1928.

35. *Georgia O'Keeffe*, unpaginated.

36. Alfred Stieglitz, "How I Came to Photograph Clouds," *The Amateur Photographer and Photography* 56, 1819 (1923), 255.

37. Rebecca Strand to Alfred Stieglitz, Taos, New Mexico (?), 19 December 1933.

38. Alfred Stieglitz to Rebecca Strand, New York City, 22 December 1933.

Steve Yates
The Transition Years: New Mexico

Research support for this essay, which appeared in a longer form in *The Transition Years: Paul Strand in New Mexico,* Santa Fe: Museum of Fine Arts, Museum of New Mexico, 1989, was provided by a grant from the National Endowment for the Arts; the following individuals graciously offered guidance and invaluable assistance: Beaumont Newhall; Amy Rule of the Center for Creative Photography; Patricia Willis of the American Literature Collection, Beinecke Rare Book and Manuscript Library, Yale University; Phyllis Cohen of the New Mexico Museum of Fine Arts Library; Weston Naef and Gordon Baldwin of the J. Paul Getty Museum; and the University Art Museum, University of New Mexico; Anthony Montoya, Curator of the Paul Strand Archives; and the Harold Clurman Estate.

1. By the mid-twenties, the Strands were financially capable, especially from the commercial success of his filmmaking as well as Beck's work, of traveling during the summers. Beck began her stays with the painter, who was also beginning to redirect her artistic career in Taos, in 1929. See Nancy Newhall, "Strand's Story," curatorial notes typescript, February 15, 1945, 2.

2. John B. Jackson, "Looking at New Mexico," in *The Essential Landscape: The New Mexico Photographic Survey with Essays by J.B. Jackson* (Albuquerque: University of New Mexico Press, 1985), 1.

3. Other photographers, such as Laura Gilpin, Ansel Adams, and Dorothea Lange, also spent formative years producing work independently using untested and unclaimed subjects of New Mexico's cultural landscape. Edward Weston also made significant changes at mid-career after his visit in 1933 when, like Strand, he was asking

essential questions about his art, its function and purpose. The open, semi-arid landscape and adobe structures, both abandoned and inhabited, provided demands that set new artistic precepts in the work of both artists, requiring not only new ways in seeing but also a reexamination of personal working methods and camera vision. See *Modern Innovation in the Landscape: Edward Weston in New Mexico,* exhibition catalog (Santa Fe: Museum of Fine Arts, Museum of New Mexico, 1989).

4. For an account of Strand's personal recollections of the New Mexico trips in an interview in 1970, see Harold Jones, "The Work of Photographers Paul Strand and Edward Weston: With an Emphasis on their Work in New Mexico" (Ph.D. diss., University of New Mexico, 1970), 89–123. See also Van Deren Coke, *Photography in New Mexico: From the Daguerreotype to the Present* (Albuquerque: University of New Mexico Press, 1979). Georgia O'Keeffe's strong friendships with such people as Mabel Dodge Luhan are reflected in correspondence of the period. See the letters annotated by Sarah Greenough in *Georgia O'Keeffe, Art and Letters* (Boston: National Gallery of Art in association with New York Graphic Society Books, 1987), 189–215.

5. Paul Strand, letter to Alfred Stieglitz, August 22, 1931, Alfred Stieglitz Papers, American Literature Collection, Beinecke Rare Book and Manuscript Library, Yale University.

6. This unusual exhibition, including Paul's photographs and Rebecca's glass paintings (influenced by O'Keeffe), though suggested by Stieglitz, gained uncharacteristically little of his personal support. Although catalogs had been customary, there was no catalog and Strand himself installed the entire selection, predominantly recent New

Mexico work. He later heard from friends that the older photographer was creating doubts in viewers about the exhibition. All this prompted Strand's final gesture, telling Stieglitz he was through by quietly handing back the keys to the darkroom and gallery. See Newhall, "Strand's Story," 2. Strand later recalled that he went through with the exhibition with doubts for Beck's sake as well. See Naomi Rosenblum, "Paul Strand: The Early Years, 1910–1932" (Ph.D. diss., City University of New York, 1978), 232.

7. As Strand wrote to Stieglitz, " . . . the problem was a hellish one: a room 125 feet long — about 30 feet wide — ceiling 35 feet high. Kaster [*sic*] walls covered with burlap, light brown, the too long walls faced the windows. The worst possible light for reflections, even without glass — For light, there was but one thing to do, which was to block off all daylight and use overhead artificial light in the daytime. I don't think they had ever done that before — but they did it and bought higher pow-ered bulbs. Also they provided glass. . . . But the bigger problem was to fill the room with those poor little prints. But I guess I succeeded, chiefly because of what little I learned from all the many hangings at the Intimate Gallery and the Place . . . the spirit was not unlike the Place and I feel you would not be ashamed of the show." Paul Strand to Alfred Stieglitz, February 5, 1933; Stieglitz Papers.

8. Many of the performances by the experimental theater were based on national as well as international themes. One improvisation, based on the anti-war drawings of German dada artist George Grosz, was made into a short film by American photographer and filmmaker Ralph Steiner.

9. "Photographs by Paul Strand,"

Creative Camera: A Magazine of Fine and Applied Art 5 (October, 1929), 735.

10. Harold Clurman, "The Group Theatre Project," pamphlet no. 30, 22, Paul Strand Collection, Center for Creative Photography, Tucson, Arizona (hereafter PSC/CCP).

11. Harold Clurman, letter to Paul Strand, circa autumn 1934, 9, PSC/CCP.

12. This rare characterization of the earlier 291 experience, which was perti-nent to Strand's independent explora-tions of the medium in New Mexico, was included in his introduction to *Pinturas y Dibujos De Los Centros Cuturales*, exhibition catalog (Mexico City: May 24, 1933), unpaginated, PSC/CCP.

13. In this letter to Sam Kootz, Strand also explained the failure of current reproduction methods to recreate true values in important works by Stieglitz and himself; thus he did not support the completion of Kootz's publication on modern photography. Paul Strand, letter to Sam Kootz, August 28, 1931, Stieglitz Papers.

14. Strand's knowledge of Picasso, Cézanne, and other pioneering Euro-pean modernists from the advanced exhibitions of Stieglitz's 291 gallery and the Armory Show of 1913 was funda-mental in his early development. For a detailed analysis of this early develop-ment see William Innes Homer, "Stieg-litz, 291, and Paul Strand's Early Photography," *Image* 19 (June 1976), 10–19, and Rosenblum, "Paul Strand," 44–90.

15. Elizabeth McCausland, *Paul Strand*, number 1 of 50 (Springfield, Mass.: privately printed, 1933), 2–3, PSC/CCP.

16. In the 1920s, Strand purchased the revolutionary Akeley camera to produce material for film shorts and outdoor work. The camera's unprecedented design provided features that allowed

speed, reliability under the most difficult circumstances, high mobility, unique panoramic controls, and newly conceived lenses that made it possible for the first time for the camera operator to see the picture *through* the ground glass. Strand's experience with these features became important not only to his beginning commercial work, but also to the New Mexico explorations with the still camera. For an early account of the breakthroughs established by the Akeley camera, see "Picture Making: The New Akeley Camera," *N.Y.C. Motion Picture News*, May 31, 1919, unpaginated. Thanks to Austin Lamont for sharing research from his film-history course at the University of New Mexico. The use of these new photographic materials is discussed in Paul Strand, letter to Alfred Stieglitz, August 22, 1931; Stieglitz Papers.

17. Strand's remarks, published in *Minicam Photography*, May 1945, are quoted in Beaumont Newhall, "Paul Strand, Traveling Photographer," *Art in America* 50, 4 (1962), 1.

18. Kenneth Clark, *Landscape Painting* (New York: Charles Scribner's Sons, 1950), 127.

19. On his return in 1931, he discovered two basketball backboards had been built next to the rear buttress of the church. He attempted to discover in the small Spanish-American village who had placed them in there with no success. Returning to Mabel Dodge Luhan's house, he obtained the help of one of her guests, the Mexican composer Carlos Chávez. Speaking Spanish to several people, Chavez found the young boy from a house next to the church who had installed the backboards. The photographer offered the boy a dollar and they were removed. Strand not only resumed photographing but also established a friendship with Chávez that helped bring him to

Mexico as a filmmaker in 1933. See Jones, "The Work of Photographers," 94–95.

20. Paul Strand to Alfred Stieglitz, February 5, 1933, Stieglitz Papers. Paul Strand, *Photographs, exposicion de la obra del artista norteamericano*, catalog of the exhibition, February 3-15 (Mexico: Secretariat de Educacion 1933), PSC/CCP.

21. Paul Strand, letter to Ansel Adams, October 14, 1933, PSC/CCP.

22. Nancy Newhall, *Paul Strand, Photographs 1915–1945*, exhibition catalog (New York: The Museum of Modern Art, 1945), 6.

23. Harold Clurman to Paul Strand, circa autumn, 1934, 1, PSC/CCP.

24. Calvin Tomkins, "Profile: Look to the Things Around You," *The New Yorker*, September 16, 1974, 91. Thanks to Beaumont Newall for directing my attention to this statement.

Katherine C. Ware
Photographs of Mexico, 1940

1. Naomi Rosenblum, "Paul Strand: The Early Years, 1910–1932" (Ph.D. diss., City University of New York, 1978; Ann Arbor, Mich.: University Microfilms International, 1978), 163.

2. Quoted in Calvin Tomkins, "Profile," in *Paul Strand, Sixty Years of Photography* (Millerton, NY: Aperture, 1976), 155.

3. Lesley Byrd Simpson, *Many Mexicos* (Berkeley: University of California Press, 1974), 306–7.

4. See Ramón Eduardo Ruíz, *The Great Rebellion, Mexico 1905–1925* (New York: W.W. Norton & Co., 1980).

5. *The Mexican Portfolio*, with preface by David Alfaro Siqueiros (New York: produced by Aperture, Inc., for DaCapo Press, 1967).

6. Rosenblum, "Paul Strand, Early Years," 163. See also J.B. Nash, letter

to Paul Strand, May 24, 1933, and Paul Strand, letter to J.B. Nash, May 31, 1933, Paul Strand Collection, Center for Creative Photography, University of Arizona, Tucson, Arizona (hereafter PSC/CCP).

7. Translated from "La Exposition de Fotografias de Paul Strand," *Universal* (February 5 1933), in Strand scrapbook; 1929–36; PSC/CCP.

8. Quoted in Tomkins, "Profile," 155. See also the 1933 exhibition brochure, PSC/CCP.

9. The portfolio text includes a numbered sequence of titles based on the subject of the work and the city or state where the picture was taken (*Woman and Boy, Tenancingo; Cristo, Oaxaca; Plaza, State of Puebla*). These titles place Strand in four states in addition to the Distrito Federal (Mexico City) and Veracruz, where he later made a film. Velásquez Chávez mentions that he and Strand were in these four states but adds Tlaxcala. He also mentions their various modes of travel and that getting from one place to another was often slow and difficult; videotaped interview with Terence Pitts and William Johnson; August 7, 1979; PSC/CCP.

10. "Report of Paul Strand on Trip to Michoacán," June 1933, in Strand scrapbook, PSC/CCP.

11. Translation quoted in Tomkins, "Profile," 156. See also the 1933 exhibition brochure, Strand Archive.

12. Tomkins, "Profile," 156–7.

13. Ruth L.C. Simms, trans., *The Artist in New York, Letters to Jean Charlot and Unpublished Writings, 1925–1929, by José Clemente Orozco* (Austin: University of Texas Press, 1973), 93.

14. Tomkins, "Profile," 160.

15. *Photographs of Mexico*, foreword by Leo Hurwitz (New York: Virginia Stevens, 1940). Also published as *The Mexican Portfolio*, preface by David Alfaro Siqueiros (New York: produced by Aperture, Inc., for DaCapo Press, 1967).

16. Paul Strand, interview with Robert Katz, Orgeval, France, August 1962, transcript, 10, Art Department, the Oakland Museum, Oakland California.

17. Jerome Mellquist, "Paul Strand's Portfolio," *The New Republic* 103, November 4, 1940, 637–38.

18. Tomkins, "Profile," 160. To put this into perspective, the Sunday *New York Times*, September 1, 1940, carries advertisements for tickets to "Hold onto Your Hats" at the Shubert Theater ranging from $1.20 to $4.40, for men's suits at Rogers Peet Co. for thirty-two dollars, Macy's store brand shoes for women at $8.98 a pair, and weekly housing at the Hotel George Washington at Twenty-third Street and Lexington Avenue at ten to fifteen dollars for a single room. Though not astronomical, fifteen dollars was high enough in 1940 to be impractical for most middle-class families to spend on a leisure item.

19. Hispanic devotional images, or *santos*, are of two types: painted images known as *retablos*, and sculptural images known in the southwestern U.S. as *bultos*; the latter term is not commonly used in Mexico.

20. Strand, "Report on Trip to Michoacán," 7.

21. Quoted in *Paul Strand, A Retrospective Monograph* (Millerton, N.Y.: Aperture, 1971), 100.

22. Nancy Newhall, *Paul Strand, Photographs 1915–1945* (New York: Museum of Modern Art, 1945), 7.

23. Quoted in Tomkins, "Profile," 32.

24. Ibid., 19.

25. "A Picture Book for Elders," *The Saturday Review of Literature*, 21 F, December 12, 1931, in Strand scrapbook, 1929–36, PSC/CCP.

26. Harold Clurman, letter to Paul

Strand, October 4, 1940, PSC/CCP.

27. Tomkins, "Profile," 32.

Anne Tucker
Strand as Mentor

1. Paul Strand, interview with author, New York City, 24 July 1974.

2. Rudolph Burckhardt, interview with author, New York City, 3 June 1975.

3. Sam Brody remembered only the last name, Gebarti, in a letter to author, 10 June 1977. Louis Gibarti is frequently mentioned as an emissary for the W.I.R.'s founding director Willi Munzenberg in Babette Gross, *Willi Munzenberg: A Political Biography*, trans. Marian Jackson (East Lansing: Michigan State University Press, 1974).

4. "Workers Film in New York," *Experimental Cinema* 1, 3 (February 1931), 37.

5. This information is based on research in the *Daily Worker*, *New Masses*, and *Film Front* as well as interviews by the author with members of the Film and Photo League.

6. William Alexander, *Film on the Left: American Documentary Film from 1931 to 1942* (Princeton University Press, 1981) 38. Alexander's book and Russell Campbell, "Radical Cinema in the United States, 1930–1942: The Work of the Film and Photo League, Nykino, and Frontier Films" (Ph.D. diss., Northwestern University, 1978) are the most thorough sources of information on the American Film and Photo League.

7. For biographical information on these leading members see *Film on the Left*, 10–16.

8. Fred Sweet, Eugene Rosow, and Allen Francovich, "Pioneers: An Interview with Tom Brandon," *Film Quarterly* 26, 5 (Fall 1973), 15.

9. Nykino was an acronym for the New York Kino. (Kino is the Russian word for cinema and the Greek word for motion).

10. Leo Hurwitz, interview with author, New York City, 3 June 1975.

11. Film League chapters in other cities disbanded by the end of 1936. The W.I.R. had ceased to function in the United States in 1935.

12. Hurwitz interview.

13. Elizabeth McCausland, "Documentary Photography," *Photo Notes* (January 1939), 6 (reprint, Rochester: Visual Studies Workshop, 1977).

14. Newhall resigned his membership in all photographic organizations including the Photo League when he became curator of the George Eastman House in September 1948.

15. There is no indication that any members of the advisory board contributed money beyond membership dues; a few did not pay dues, but lectures and articles were gratis.

16. This information is based on research in *Photo Notes* and on copies of League ballots, brochures, and announcements in the collection of the author as well as interviews by the author with members of the Photo League.

17. Syllabus reading list, bibliography, and lecture schedule in collection of the author.

18. Paul Strand, "Engel's One Man Show," *Photo Notes* (December 1939), 2. Henceforth, this quote was used to introduce each new brochure on the League's upcoming photography classes. In all, Strand contributed nine articles to *Photo Notes*, second only to the twelve donated by McCausland.

19. Morris Engel, interview with author, New York City, 23 October 1974. Engel and his wife, Ruth Orkin, later codirected two feature films, one of which, *The Little Fugitive*, has been credited with influencing French New Wave cinema.

20. Morris Huberland, interview with author, New York City, August 1974. Jerome Mellquist, "Paul Strand's Portfolio," *New Republic* (4 November 1940), 637.

21. Strand's brutally direct photographic series on New York, which Stieglitz published in the last two issues of *Camera Work*, foretell vividly the subject matter of many Photo League projects, although photographs by League members generally included more environmental context.

22. Alden Whitman, "Paul Strand, Influential Photographer and Maker of Movies, Is Dead at 85," *New York Times*, 2 April 1976, 36.

23. Grossman felt that in Strand's 1948 class at the Photo League he "succeeded in dramatizing to a very high extent the importance of the print, the importance of organizing material in the space of a picture. These are highly important elements in photography, as in any two dimensional plastic art. But that is not the end of photography, and this was seized upon by most of Strand's students as an end in itself. This was the great vitalizing force, the strongest thing in the class. this was not enough." Transcript of tape recording of private class that Grossman taught in his home, summer 1949. Quoted courtesy of Miriam Grossman Cohen.

24. Elizabeth McCausland, "Paul Strand," *US Camera* (February–March, 1940), 23.

25. Paul Strand to Ansel Adams, October 14, 1933, quoted in *Ansel Adams: Letters and Images 1916–1984*, Mary Street Alinder and Andrea Gray Stillman, eds. (Boston: New York Graphic Society/Little Brown and Company, 1988), 62.

26. This exhibition has previously been omitted from Strand's chronology. It was not widely reviewed; the only written references to it are a Photo League mailer and a three-paragraph notice, "Paul Strand's Photos of Mexico on Display at Photo League," *Daily Worker* (13 October 1941), 7. It may have been reviewed in the October 1941 issue of *Photo Notes*, but no copies of that issue are known to have survived.

27. Strand's print prices were always at the top of the photographic market, another legacy from Stieglitz. In 1949 Strand chastised Ansel Adams for the relatively low price of his recent portfolio. "Stieglitz tried and to some extent succeeded," wrote Strand, "in giving a photograph its rightful value as an art commodity. I have adhered to that principle and will continue to do so. It seems to me that your portfolio undermines the basic concept of the value of a fine photographic print." Paul Strand, letter to Ansel Adams, 21 March 1949, quoted in *Letters and Images*, 206.

28. Paul Strand, "*An American Exodus* by Dorothea Lange and Paul S. Taylor," *Photo Notes* (March–April 1940), 2. See Dorothea Lange and Paul Schuster Taylor, *An American Exodus: A Record of Human Erosion* (New York: Reynal & Hitchcock, 1939; New Haven: Yale University Press, 1969).

29. Ibid. Many of Lange's finest photographs, such as *Migrant Mother* (1936), *Damaged Child* (1936), and *Ditched, Stalled, and Stranded* (1938) are excluded.

30. The symposium was reported briefly in both "Personals" and "Symposium," *Photo Notes* (March–April 1940), 4–5. See Margaret Bourke-White and Erskine Caldwell, *You Have Seen Their Faces* (New York: Viking, 1937; New York: Arno, 1975).

31. Despite the League's inadequacy, mostly due to lack of staff, several members were successful individually in selling their work and gaining jobs with newspapers and magazines.

32. "Personals," *Photo Notes* (March–April 1940), 4. The Feature Group's project, "Harlem Document" was never published as a whole. Aaron Siskind published his segment of it as *Harlem Document: Photography, 1932–1940: Aaron Siskind*, Ann Banks, ed. (Providence, R.I.: Matrix Publications, 1981).

33. Elizabeth McCausland, "The Chelsea Document," *Photo Notes* (May 1940), 4.

34. Weegee, *The Naked City* (New York: Essential Books, 1945; New York: Da Capo, 1975).

35. Strand's review was originally printed in *PM* newspaper and was reprinted as "We Hear from Weegee," *Photo Notes* (August 1945), 2–3.

36. Lester Talkington, "Ansel Adams at the Photo League," *Photo Notes* (March 1948), 6.

37. "The Wave," *Photo Notes* (August–September 1947), 5.

38. "90 Groups, School Names in U.S. List as being disloyal," *New York Times*, 5 December 1947, 1, 18.

39. The attorney general's list was published on December 4, 1947. On December 6 a federal grand jury indicted the writers who had become known as the "Hollywood Ten" for refusing to tell a congressional committee whether they were now or had previously been members of the Communist party. Their confrontations with the HUAC members had claimed headlines for months.

40. "Address by Paul Strand," *Photo Notes*, January 1948, 3.

41. Ibid.

42. After Hine's death in 1940, his family gave Hine's prints and negatives to the Photo League. After the League disbanded, the collection was given to the George Eastman House.

43. *Native Land* was released in 1942, produced by Frontier Films, codirected by Strand and Leo Hurwitz. The Sub-

versive Activities Control Act of 1948, known as the Mundt Bill, required organizations listed by the attorney general to submit to the attorney general's office annual reports of finances and membership lists as well as noting on all publications and correspondence that the organization had been designated as subversive. The Mundt Bill was defeated, but the above and other more punitive stipulations were passed as the McCarran–Wood Bill in September 1950.

44. "A Platform for Artists," *Photo Notes* (Fall 1948), 15.

45. "Address by Paul Strand," *Photo Notes* (January 1948), 3.

46. Regarding Adams's 1947 lecture and Strand's participation in the subsequent discussion, see Talkington, "Ansel Adams at the Photo League," 1–6, and Anne Wilkes Tucker, "The Lively Debate," *Untitled 37* (Carmel, Calif.: Friends of Photography, 1984), 17–19.

47. Paul Strand, "Paul Strand Writes to a Young Photographer," *Photo Notes* (Fall 1948), 26.

48. "Photo League School," *Photo Notes* (Spring 1949), 16. Members of the class included Barney Cole, Bill Cotton, Rosalie Gwathmey, Sy Kattleson, Rebecca Lepkoff, Arthur Leipzig, Jerry Liebling, Sol Libsohn, Sam Mahl, Bea Pancoast, Walter Rosenblum, and Sandra Weiner. That Strand enjoyed teaching the class is evident from a letter he wrote to Henwar Rodakiewicz in 1970: "Once I had a little class at the Photo League, years ago on the esthetics of photography. It was very rewarding both because your students are so eager to get whatever you have learned, but also because the job forces you to be clear—which means being clear yourself. What doesn't do that is not much value." Paul Strand to Henwar Rodakiewicz, 15 June 1970, Paul

Strand Collection, Center for Creative Photography, University of Arizona.
49. Sandra Weiner, "Symposium Report," *Photo Notes* (Spring 1949), 8.
50. Arthur Leipzig, interview with author, Sea Cliff, New Jersey, 16 April 1974.
51. Sam Mahl, transcript of taped response to written questions from author, August 1976; in author's possession.
52. Russell Porter, "Girl Aide of FBI Testifies of 7 Years as 'Communist,'" *New York Times*, 27 April 1949, 1, 11. The witness was Angela Calomiris, who had belonged to the League during World War II.

Walter Rosenblum
A Personal Memoir

1. Paul Strand, "The Art Motive in Photography," *British Journal of Photography* 70 (5 October 1923), 613–615.

William Alexander
Paul Strand as Filmmaker, 1933–1942

1. Paul Strand, interview with author, New York City, 18 February 1975.
2. Strand interview. See also Carlos Chávez, "Mexico," *Films* (Summer 1940), 20–21.
3. Ibid.
4. Fred Zinnemann, letter to author, 18 April 1975.
5. Henwar Rodakiewicz, interview with author, Seacliff, New Jersey, 15 May 1975, Gunther von Fritsch, letter to author, 17 August 1976, and Fred Zinnemann, letter to author, 4 June 1975.
6. Archibald MacLeish, quoted in Garrison Film Distributors' publicity brochure, n.d. In *Wave* file, Museum of Modern Art. Sidney Meyers, "*Redes*," *New Theatre* (November 1936), 22.
7. Strand's statement to the ministry is quoted by Meyers, "*Redes*," 22.
" . . . Reflections of their own lives . . . ," in Strand interview. " . . .Struggles and aspirations . . . ," and " . . . fellow human being . . . ," in David Platt, "'Photographer Must See, Think'— Strand," *Daily Worker*, 18 May 1937, 7.
8. Strand interview. Meyers, "*Redes*," 21.
9. Strand interview. Harold Clurman, *The Fervent Years* (New York: Hill & Wang, 1957), 150, and Calvin Tomkins, "Profiles: Look to the Things Around You," *The New Yorker*, 16 September 1974, 68, 70, 72.
10. Leo Hurwitz and Ralph Steiner, "A New Approach to Film Making," *New Theatre* (September 1935), 22–23.
11. Lack of sympathy for radicals: Pare Lorentz, "The Screen," *Vanity Fair*, December 1932, 46 and October 1933, 39. On his praise of Steiner and Strand, see Willard Van Dyke, "Letters from 'The River'," *Film Comment* (March–April 1965), 46–47. The story of this conflict is taken from several sources: Irving Lerner, "*The Plow That Broke the Plains*," *New Theatre* (July 1936), 19; Tomkins, "Profiles," 72; Leo Hurwitz, interviews with the author, New York City, 22 August 1973 and 21 November 1974; Ralph Steiner, interview with the author, Thetford Hill, Vermont, 17 August 1973; Strand interview; W. L. White, "Pare Lorentz," *Scribner's*, January 1939, 9; Van Dyke, "Letters," 45–46. On germinating ideas, see Leo Hurwitz, "One Man's Voyage: Ideas and Films in the 1930's, "*Cinema Journal* (Fall 1975), 6.
12. Pare Lorentz, "The Plow that Broke the Plains," *McCall's*, July 1936,
15. Strand's words as reported to Lorentz by Van Dyke are in Van Dyke, "Letters," 46.
13. White, "Pare Lorentz," 9.
14. Although Nykino and Frontier Films participated in the Communist party's shift to the popular front soft-

line era, that is, to a language reflecting more of the virtues and traditions of their own country, the difference in underlying vision I describe here remained firm.

15. George Sklar, letter to author, 4 July 1975, mentions this enthusiasm. Editorial, "Frontier Films," *Theatre* (March 1937), 50.

16. The brochure is in the Frontier Films file, Film Study Center of the Museum of Modern Art, New York City. Between 1937 and 1942, Frontier Films produced five major films: *Heart of Spain* (1937), about the Spanish Civil War, used as a fund-raiser for medical work on behalf of the Loyalists; *China Strikes Back* (1937), about the struggle of the Communist forces against the Japanese; *People of the Cumberland* (1938), about the Highlander Folk School in Tennessee; *Return to Life* (1937), about hospitals for wounded soldiers in Spain (much less a Frontier Films work than the others); and *Native Land*.

17. Van Dyke, "Letters," 54. Michael and Jill Klein, "*Native Land*: An Interview with Leo Hurwitz," *Cinéaste* 6, 3 (1974), 3–7.

18. Hurwitz interview with author, 21 November 1974.

19. Strand's perfectionism on *The Wave* was discussed in Rodakiewicz interview, 15 May 1975; June Gitlin, letter to author, 6 June 1975, discusses his perfectionism on *Native Land*.

20. Inez Garson, interview with author, 30 April 1975, discusses Strand as elder statesman. Ben Maddow, interview with author, Los Angeles, 1 October 1974, discusses upper house, father and sons, fierceness of decision. Hurwitz interview, 21 November 1974, discusses remote father and motor force.

21. Willard Van Dyke, interview with author, 12 May 1975, discusses the montage sequence. Willard Van Dyke, interview with author, 22 August 1973 and 12 May 1975, discusses *Native Land*, as do Hurwitz interview, 22 August 1973, and Strand interview. Vera Caspary, letter to author, 22 June 1975, and George Sklar, letter to author, 4 July 1975.

22. Hurwitz interview, 22 August 1973. Willard Van Dyke, interview with James Blue, 12 May 1975. Ralph Steiner, interview with James Blue, 12 July 1973. Steiner interview. Strand interview. Van Dyke interview discusses absence of heavy political hand.

23. Hurwitz interview, 4 November 1974.

24. Hurwitz interview, 22 August 1973. Steiner interview. MacCann reports this attitude based on his interview with Van Dyke, 19 April 1949, in Richard Dyer MacCann, *The People's Films: A Political History of U. S. Government Motion Pictures* (New York: Hastings House, 1973), 64.

25. Hurwitz interview, 22 August 1973.

26. Theodore Strauss, "Homesteading Our *Native Land*," *New York Times*, May 3, 1942, sec. 8, p. 3, puts the cost at $60,000, describes fund-raising and quotes Strand; Strand interview mentions a figure of $75,000. For discussion of decisions, see William Alexander, *Film on the Left: American Documentary Film from 1931 to 1942* (Princeton: Princeton University Press, 1981), 212–13. See also Hurwitz interview, 21 October 1974.

27. Strand interview. Further discussion of these issues is in Strand and Maddow interviews, and Hurwitz interview, 21 November 1974.

28. Strauss, "Homesteading."

29. See, for example, Ben Maddow, "Harry Alan Potamkin," *New Theatre* (February 1936), 33; Ben Maddow, "Hopes for Poetry," *New Masses* (4 August 1936); and Ben Maddow, "Film

Intensity: [Dovzenko's] *Shors*," *Films* (Spring 1940), 56; see also William Alexander, "Frontier Films, 1936–1941: The Aesthetics of Impact," *Cinema Journal* (Fall 1975), 16–28.

30. Klein, "*Native Land*," 7.

31. Epilogue quoted by David Platt in clipping from a review of the film, probably in the *Daily Worker*, in *Native Land* file at the Film Study Center, Museum of Modern Art, New York. On Browder and Foster, see Klein, "*Native Land*," 6.

32. Paul Strand, "Realism: A Personal War View," *Sight and Sound* (January 1950), 26.

John Rohrbach
Time in New England

Abbreviations: PSA/CCP-Paul Strand Archive at the Center for Creative Photography.
TINE-Nancy Newhall and Paul Strand, *Time in New England* (Oxford University Press, 1950).

1. Paul Strand, letter to Henry Allen Moe, Secretary General of the John Simon Guggenheim Memorial Foundation, 15 October 1943, copy at PSA/CCP. This was Strand's second application to this foundation. In 1940 he had applied to create one of what would be a series of retrospective portfolios of his still photographs using a format similar to that of his recently completed photogravure portfolio of Mexican photographs, and he was turned down.

2. Paul S. Taylor and Dorothea Lange, *An American Exodus: A Record of Human Erosion* (New York: Reynal and Hitchcock, 1939; New Haven: Yale University Press, 1969).

3. Newhall called to book "an autobiography of New England" in a letter to Strand, 27 October 1950, PSA/CCP.

4. Current historians often dismiss *Time in New England* as merely a lyrical poem. In doing so, they ignore the context of the book's development and publication and the balance that Strand and Newhall were trying to provide between evoking the region and making a political statement. See particularly W. J. T. Mitchell's "The Politics of Form in the Photographic Essay," *Afterimage* 16, 6 (January 1989), 9.

5. Leslie Fishbein, "*Native Land*: Document and Documentary," *Film and History* XIV, 4 (December 1984), 75. The continuing importance of this movie for Strand was symbolized by his choosing *Heart of Spain* as *the* single movie to represent his cinemagraphic work at a special conference sponsored by the Society for Photographers in Communication held in February 1973 at the Metropolitan Museum of Art in conjunction with a retrospective exhibition of Strand's photographs. *Heart of Spain* was shot by Herbert Klein and Geza Karpathi, and the film's scenario was written and the film was edited by Strand and Leo Hurwitz. See also William Alexander's "Paul Strand as Filmmaker, 1933–42," and Jan-Christopher Horak's "Modernist Perspectives and Romantic Impulses: *Manhatta*" in this volume.

6. See Michael and Jill Klein, "*Native Land*: An Interview with Leo Hurwitz," *Cinéaste* 6, 3 (1974), 2–7, for Leo Hurwitz's explication of the film.

7. In an attempt to make *Native Land* pertinent to current wartime conditions, the filmmakers even attached an afterward by the film's narrator Paul Robeson suggesting the need to shift attention from fighting for the right of union organization at home to fighting fascist repression on the international front. See William Alexander's *Film on the Left: American Documentary Film from 1931 to 1942* (Princeton: Princeton

University Press, 1981) for extended analysis of Strand's film work, including mention of this point on pp. 238–9.

8. Strand was aware of Edward Weston's 1937 and 1938 Guggenheim Fellowship and extension and felt that he was due one also. Many of the other projects he took on during the years between 1942 and 1945 were in specific support of the Roosevelt administration and the war; some are mentioned in *Paul Strand: Sixty Years of Photographs* (Millerton, N.Y.: Aperture, 1976), 161–62.

9. Duell, Sloan and Pearce had begun publishing a series called *American Folkways* in 1941. Edited by Erskine Caldwell, this series did not include illustrations, although its concept matched other series such as Alfred A. Knopf, Inc.'s *The American Scene* and *The Face of America*, edited by Arthur Rosskam for the Alliance Book Corporation. The Rosskam series relied heavily on photograph-text interactions. See also Jefferson Hunter's *Image and Word* (Cambridge, Mass.: Harvard University Press, 1988), chapter 4, for a discussion of other 1930s photo-text books.

10. Strand repeated this message the following February at a second MOMA conference held by the Committee on Art Education. In the midst of his work on *Time in New England* in 1946, Strand related these ideas to his own photography in a seminar at the Chicago Institute of Design. See *Sixty Years*, 162–3, and Paul Strand, letter to Ansel Adams, 28 March 1944, and transcript of his lecture, "Art in a Free World," 25 February 1945, PSA/CCP.

11. See Mike Weaver's essay, "Dynamic Realist," in this volume for a discussion of Strand's political affiliations during the 1930s and 1940s. See Richard Pells's *Radical Visions and American Dreams: Culture and Social Thought in the*

Depression Years (New York: Harper and Row, 1973), particularly chapters 7 and 8, for discussion of the shifting currents of American intellectual radicalism during the 1930s. Pells's *The Liberal Mind in a Conservative Age* (New York: Harper and Row, 1985) takes this story through the 1940s and 1950s. Communist party popular front policy instituted an informal coalition of liberal, socialist, and communist groups in 1936. The only prerequisite for association was acceptance of a position favoring collective action by all Western nations including the United States against Hitler.

12. Nancy Newhall and Paul Strand, *Time in New England* (New York: Oxford University Press, 1950), v. This edition has been used as the basis for this essay. The second edition, published by Aperture, Inc., in 1980, includes numerous changes of imagery plus some sequence changes, and it replaces Newhall's and Strand's forewords with an introduction by Paul Metcalf and an afterword by Beaumont Newhall.

13. See Hazel Strand, videotaped interview by James Enyeart and Harold Jones, 20 February 1978, PSA/CCP. Nancy Newhall, letter to Paul Strand, 24 January 1949, PSA/CCP.

14. Nancy Newhall, editor's foreword, *TINE* (1950), v. Indicative of the importance of Strand's earlier movie work, Strand and Newhall used cinemagraphic terms in their correspondence. On June 1, 1946, Nancy Newhall wrote Strand: "Made a rough cut of the material so far. . . . If we follow our original idea— . . . a portrait shown through the great underlying themes of social and cultural development—we need many more images with concrete associations: the sea, the country, the people." Quoted in Beaumont Newhall, "afterward," *Time*

in New England (1980), 253–54.

15. Nancy Newhall, letter to Paul Strand, 24 January 1949, PSA/CCP.

16. Charles Pearce, letter to Nancy Newhall, 24 June 1949, PSA/CCP. Pearce was the editor of *Of New England*.

17. Nancy Newhall, letter to Paul Strand, 27 October 1950, PSA/CCP.

18. Erskine Caldwell and Margaret Bourke-White, *You Have Seen Their Faces* (New York: Viking Press, 1937), unpaginated preface.

19. Archibald MacLeish, *Land of the Free* (New York: Harcourt Brace, 1938), n.p.

20. See John Rogers Puckett, *Five Photo-Textual Documentaries from the Great Depression* (Ann Arbor, Mich.: UMI Press, 1984) for an in-depth analysis of these books.

21. Paul Strand, "*An American Exodus*, by Dorothea Lange and Paul S. Taylor," *Photo Notes* (March/April 1940), 2–3.

22. See Alan Axelrod, *Colonial Revival in America* (New York: W. W. Norton, 1985) for examples of the effects of the colonial revival on material and social culture from 1876 through the 1930s. *Time in New England* was directly influenced by contemporary trends in American historical scholarship, which in the 1930s began an extensive reexamination of early American history. Particularly pertinent, as mentioned earlier, was the writing of the literary historian Van Wyck Brooks, from whose 1940 book *New England: Indian Summer*, *TINE*'s final passage was chosen. Like Brooks, Strand and Newhall celebrated colonial and early nineteenth-century American cultural achievements, suggesting that the post–Civil War era was a period of lessened achievement.

23. Newhall realized that the prose and cadences of that century's speakers and writers was confusing and difficult for twentieth-century readers to follow. Even so, evocation of these cadences was central, she believed, to the spirit she was trying to capture: "in those cadences was the sound of the sea and in their thought the germ of a nation." This problem led her carefully to edit many passages, reducing redundancies and obscurities, yet retaining the "truth" of each text. See editor's foreword, *TINE*, v–vi for this explanation.

24. Letter and preface draft from Nancy Newhall to Paul Strand, 5 October 1947, PSA/CCP.

25. Speech at the Czechoslovakia Film Festival, July 1946, quoted in *Sixty Years*, 164.

26. Calvin Tomkins, "Profile," *Sixty Years*, 31.

27. Newhall also questioned the dull gloss and the cream color of the paper stock. Even so, she was pleased that Oxford could do as well as it did and still hold the price of the book to $6. Strand agreed, suggesting that Oxford had done better than their first publisher, Duell, Sloan and Pearce, could have done. See Nancy Newhall, letter to Paul Strand, 27 October 1950, and Beaumont Newhall, letter to Strand, 20 November 1950, PSA/CCP.

28. Jacob Deschin, "Picture Books: New Volumes Are Based on Original Themes," *New York Times*, October 22, 1950, section 2, 15. See Ansel Adams, *My Camera in the Yosemite Valley* (Yosemite: Virginia Adams/Boston: Houghton, Mifflin Co., 1950).

29. Nancy Newhall, letters to Paul Strand, 31 December 1950, 6 March 1951, and 26 March 1951, PSA/CCP. Among reviews of *Time in New England* note particularly Walter Prichard Eaton in the *New York Herald Tribune Book Review*, 3 December 1950, Ruth Chapin's review in the *Christian Science Monitor*, 18 November 1950, and

Samuel T. Williamson's review in the *New York Times Book Review*, 29 December 1950.

30. P. W. H., *"Time in New England," The Photographic Journal: Official Organ of the Royal Photographic Society of Great Britain and the Photographic Alliance*, vol. 91A, sec. A (September 1951), 277.

31. Beaumont Newhall, letter to Paul Strand, 20 November 1950, PSA/CCP.

32. Lange's and Minor White's praise of *Time in New England* were related to Paul Strand in a letter from Nancy Newhall, 21 November 1950, PSA/CCP.

33. Naomi Rosenblum and Michael Hoffman have both related to me Strand's meticulous care in overseeing the printing of his European books, which included checking plates and even standing over the press during the actual printing.

34. Paul Strand, interview by Milton Brown, November 1971, transcript at Paul Strand Archive, Aperture Foundation, Millerton, New York, 70.

Estelle Jussim
Praising Humanity

1. John Dewey, "Art as Experience," in Albert Hofstadter and Richard Kuhns, eds., *Philosophies of Art and Beauty* (New York: Modern Library, 1964), 638.

2. Paul Strand, "Photography and the Other Arts," lecture; in *Paul Strand Archive*, comp. by Sharon Denton (Tucson: Center for Creative Photography, University of Arizona; Guide series number 2, 1980), 8.

3. Ibid., 9.

4. Calvin Tomkins, "Profile," in *Paul Strand: Sixty Years of Photographs* (New York: Aperture, 1976), 24.

5. Ansel Adams, letter to Paul Strand, October 31, 1932; in *Paul Strand Archive*, 7.

6. Valerie Lloyd, *Paul Strand: A Retrospective Exhibition of His Photos, 1915–1968* (London: National Portrait Gallery, 1975), n.p.

7. Paul Strand, in *Paul Strand: Sixty Years of Photographs*, 34.

8. Richard Barsam, *Nonfiction Film* (New York: Dutton, 1973), 124.

9. Paul Strand, in Tomkins, "Profile," 34.

10. Paul Strand, in *Paul Strand: A Retrospective Monograph; The Years 1915–1968* (New York: Aperture, 1971) 164.

11. Ibid., 163.

12. Ibid., 173.

13. Ibid., 172.

14. Strand, in Tomkins, "Profile," 32.

15. Ibid.

16. Milton Brown, in *Paul Strand: A Retrospective Monograph*, 370.

17. Ibid., 372.

18. Mark Haworth-Booth, in *Paul Strand* (New York: Aperture, 1987) Aperture Masters of Photography, Number 1, p. 6.

19. Ulrich Keller, "An Art Historical View of Paul Strand," *Image* 17:4 (December 1974), 11.

20. Ibid.

21. Ibid.

22. Ibid.

23. John Berger, excerpt from "Painting—or Photography," quoted in *Paul Strand: A Retrospective Monograph*, 208.

24. Joseph Losey, in *Paul Strand: Sixty Years of Photographs*, 157.

25. Paul Strand, in "Photography and Other Arts," 6.

26. Paul Strand, "The Art Motive in Photography," in *British Journal of Photography* (October 5, 1923), 612.

27. Tomkins, "Profile," 15.

Mike Weaver
Dynamic Realist

1. Paul Strand, "Photography," *Seven Arts* 2 (August 1917), 524–525.

2. Paul Strand, *Sixty Years of Photo-*

graphs (Millerton, New York: Aperture, 1976), 19, 144.

3. Harold Clurman to Alfred Stieglitz, 19 September and 15 July 1934, Alfred Stieglitz Papers, Beinecke Library, Yale University (hereafter BL).

4. Harold Clurman, "Alfred Stieglitz and the Group Idea," *America and Alfred Stieglitz*, Waldo Frank, ed., (New York: Doubleday, 1934), 278.

5. Harold Clurman to Paul Strand, 4 July 1934, Paul Strand Papers, Center for Creative Photography, University of Arizona (hereafter CCP).

6. See Clurman to Strand, 19 October 1934, CCP, where Clurman informs Strand that he has told Ralph Steiner that Strand ought to be made head of such a film group.

7. Clurman, "Group Idea," 278.

8. Clurman to Strand, 20 August 1934, CCP.

9. See Eric Bentley, ed., *Thirty Years of Treason* (London: Viking Press, 1972), 486–87.

10. Fred Zinnemann, interview with author, London, 18 December 1986.

11. Harold Clurman, *All People Are Famous* (New York: Harcourt, Brace, Jovanovich 1974), 89.

12. See *Paul Strand: A Retrospective Monograph*, 2 vols. (Millerton, New York: Aperture, 1971), I:72, 76.

13. In November 1987 and April 1990 the author received access to documents on Strand managed by the Freedom of Information–Privacy Acts Section of the Department of Justice (FBI). This FOIPA file, which provided the information on Strand's membership in the ALP, is now held by the Center for Creative Photography, University of Arizona, where it may be freely inspected. See Mike Weaver, "Paul Strand: Native Land," *The Archive* 27 (Tucson, Arizona: Center for Creative Photography, University of Arizona, 1990), 5–15.

14. Paul Strand, "A Platform for Artists," *Photo Notes* (Fall 1948), 14–15.

15. See *Paul Strand: Sixty Years*, 173.

16. Strand attended a PCA convention in Chicago in 1948. See *New Leader* (24 January 1948), 1.

17. *Daily Worker*, 30 January 1949, 3. In 1945 Strand had sponsored the black Communist leader for the New York City Council. *Daily Worker*, 10 April 1945, 4.

18. *Daily Worker*, 28 February 1949, 9.

19. *Daily Worker*, 17 June 1949, 5.

20. Typescript, July 1949, 5.

21. Paul Strand, "Realism: A Personal View," *Sight and Sound* 18:72 (January 1950), 23, 26.

22. Sandra Weiner, "Symposium Report," *Photo Notes* (Spring 1949), 8.

23. See Oliver Larkin, "The Daumier Myth," *Science and Society* (Spring 1937), 350–361, and "Courbet and His Contemporaries," *Science and Society*, (Winter 1939), 42–63. See also Milton Brown, "The Marxist Approach to Art," *Dialectics* 2 (1937), 23–31, and *The Painting of the French Revolution* (New York: Critics' Group, 1938).

24. Stanley Meltzoff, "The Revival of the Le Nains," *Art Bulletin* 24 (1942), 259–286.

25. György Lukàcs, "Propaganda or Partisanship," *Partisan Review* 1:2 (1934), 36–46, and the "Intellectual Physiognomy of Literary Characters," *International Literature* 8 (1937), 56–83.

26. "Paul Strand Writes to a Young Photographer," *Photo Notes*, Fall 1948, 27.

27. See Mike Weaver, *Robert Flaherty's The Land*, American Arts Pamphlet (Exeter, England: University of Exeter, 1979).

28. *Photo Notes*, August–September 1947, 5.

29. *Photo Notes*, March–April 1940, 2. See Dorothea Lange and Paul Schuster Taylor, *An American Exodus: A Record of*

Human Erosion (New York: Reynal & Hitchcock, 1939).

30. Typescript of lectures given at the Institute of Design, Chicago, 29–31 July, 1–2 August 1946, 80 (CCP).

31. *Photo Notes* (March–April 1940), 2.

32. Chicago lectures, 83.

33. Genevieve Taggard, "Exchange of Awe," *Masses & Mainstream* 2:4 (April 1949), 67–69.

34. Paul Strand, *Time in New England*, text sel. and ed. Nancy Newhall (New York: Oxford University Press, 1950), 155.

35. Chicago lectures, 84.

36. György Lukàcs, "Narration versus Description," *International Literature* 6 (1937), 96–112 and *Masses & Mainstream* 2:12 (December 1949), 40–61.

37. Lukàcs, "Narration," *Masses & Mainstream*, 57.

38. "Talks between Paul Strand and Leslie Katz," Orgeval, August 1962, 30, transcript at CCP.

39. Strand, *Time in New England*, 84.

40. FOIPA file (CCP).

41. These Strand landscapes should be compared with, for instance, Pissarro's *Harvest at Montfoucault, Brittany*, 1876.

42. See Roger Grenier, *Claude Roy* (Paris: P. Seghers, 1971), 19–21, 168.

Basil Davidson
Working with Strand

1. Paul Strand, *Un Paese*, text by Cesare Zavattini (Turin: Einaudi, 1955), 6.

2. Paul Strand, letter to author, 21 September 1955.

3. Strand, ibid.

4. Milton Brown, in *Paul Strand: Retrospective Monograph; The Years 1915–1968* (New York: Aperture, 1971), vol. 1, p. 370.

5. Leo Hurwitz, foreword to *The Mexican Portfolio* (1940 and 1967); re-printed in *Retrospective Monograph*, vol. 1, p. 10.

6. Paul Strand, *Living Egypt*, text by James Aldridge (Dresden: VEB Verlag der Kunst, 1969), 10–11. Cesare Zavattini, in *Un Paese*, 7.

7. Paul Strand, letter to author, 7 January 1956.

8. Paul Strand, letter to author, 14 December 1955.

9. Paul Strand, letter to author, 30 September, 1955.

10. Paul Strand, letter to author, 4 December 1955.

11. Paul Strand, letter to author, 2 May 1957.

12. Paul Strand, letter to author, 21 March 1962.

13. Paul Strand, letter to Kunst Verlag, Marrakesh, Morocco, 21 March 1962, in author's possession.

14. Basil Davidson, letter to Paul Strand, 26 March 1962.

15. Strand, letter to Kunst Verlag.

16. Mark Haworth-Booth, letter to author, 2 May 1957.

17. Paul Strand, letter to author, 2 May 1957.

18. Strand, ibid.

19. Mark Haworth-Booth, in *Paul Strand*, Aperture Masters of Photography, no. 1 (New York: Aperture, 1987), 7.

Robert Adams
Strand's Love of Country

1. All page numbers refer to Paul Strand, text sel. and ed. Nancy Newhall, 2nd ed. *Time in New England* (Millerton, N. Y.: Aperture, 1980). Although there are differences between this edition and the first edition (New York: Oxford University Press, 1950), they do not affect the images discussed.

2. Strand and Newhall's decision to reproduce the long shots smaller than the close-ups is unconventional, too. By

its magnification of people and what they make and of what people might find in nature of beauty that is scaled to them, it suggests that the sea's indifference need not induce despair.

3. Paul Hill and Thomas Cooper, *Dialogue with Photography* (New York: Farrar, Straus and Giroux, 1979), 7.

Edmundo Desnoes
Paul Strand, Dead or Alive

1. Paul Strand, *Sixty Years of Photographs*, profile by Calvin Tomkins (Millerton, N.Y.: Aperture, 1976), 164.

2. John Berger, *About Looking* (New York: Pantheon, 1980).

3. Strand, *Sixty Years*, 152.

4. Paul Strand, *On Cézanne*.

5. Jean Jacques Rousseau, *Discourse on Inequality*, trans. Maurice Cranston (New York: Penguin, 1985).

6. Paul Strand, letter to Stieglitz.

7. Paul Strand, "Photography and the New God." *Broom* 3 (November 1922): 252–58.

8. John Locke, *Two Treatises of Government*, ed. Peter Loslett (Cambridge: Cambridge Univ. Press, 1960).

Selected Bibliography

Books by Paul Strand

Time in New England. Text selected and edited by Nancy Newhall. New York: Oxford University Press, 1950; New York: Aperture, 1980.

La France de Profil. Text by Claude Roy. Lausanne: La Guilde du Livre, 1952.

Un Paese. Text by Cesare Zavattini. Turin: Giulio Einaudi, 1955.

Tir a'Mhurain. Text by Basil Davidson. Dresden: VEB Verlag der Kunst, 1962. Also published in London: MacGibbon and Kee, 1962, and in New York: Aperture, Grossman, 1968.

Living Egypt. Text by James Aldridge. Dresden: VEB Verlag der Kunst, 1969. Also published in London: MacGibbon and Kee, 1969, and in New York: Aperture, Horizon Press, 1969.

Paul Strand: A Retrospective Monograph. Text by various authors. Millerton, N.Y.: Aperture, 1971. 2 vols.

Ghana, An African Portrait. Text by Basil Davidson. Millerton, N.Y.: Aperture, 1976.

Books, Dissertations, and Exhibition Catalogs about Paul Strand

Twelfth Annual Exhibition of Photography. Philadelphia: John Wanamaker, March 1–17, 1917, unpaged (*Wall Street* reproduced).

Thirteenth Annual Exhibition of Photography. Philadelphia: John Wanamaker, March 4–16, 1918, unpaged (*Wheel Organization* and *The White Fence* reproduced).

Fourteenth Annual Exhibition of Photographs. Philadelphia: John Wanamaker, March 1920.

Alfred Stieglitz Presents Seven Americans: 159 Paintings, Photographs and Things Recent and Never Before Publicly Shown. New York: Anderson Galleries, March 1925.

Lachaise, Gaston. *Paul Strand, New Photographs.* New York: The Intimate Galleries, 1929.

American Photography Retrospective Exhibition. New York: Julien Levy, November 1931.

McCausland, Elizabeth. *Paul Strand.* Springfield, Mass.: privately printed, 1933.

Exposicion fotografica de Paul Strand. Mexico City, D.F.: Secretaria de Educacion Publica. Sala de Arte. 8p. 1933.

Newhall, Nancy. *Strand: Photographs 1915–1945.* New York: The Museum of Modern Art, 1945.

Vrba, Frantisek. *Paul Strand.* Prague: Statni nakladatelstvi krasne literary a umeni, 1961. [Text also in English.]

"Paul Strand." *The Collection of William and Rebecca James.* Albuquerque, New Mexico: University of New Mexico Art Museum, 1969.

Jones, Harold. "The Work of Photographers Edward Weston and Paul Strand. With an Emphasis on Their Work in New Mexico." Master's thesis, University of New Mexico, 1970.

Paul Strand, Sixty Years of Photographs. Profile by Calvin Tomkins. Millerton, New York: Aperture, 1976.

Rosenblum, Naomi. "Paul Strand: The Early Years, 1910–1932." Ph.D. diss., Graduate Center, CUNY, 1978; Ann Arbor, Mich.: University Microfilms International, 1978.

Paul Strand Archive. Compiled by Sharon Denton. Guide Series, no. 2. Tucson, Ariz.: Center for Creative Photography, University of Arizona, 1980.

Rosenblum, Naomi. *Paul Strand: The Stieglitz Years at 291 (1915–1917).* New York: Zabriskie Gallery, 1983.

Rohrbach, John. Essay in *Paul Strand: Time in New England.* Millerton, New York: 1983. [Unpaginated catalog for traveling exhibition of the same title.]

Fleischmann, Kaspar. *Paul Strand.* Zurich: Galerie fur Kunstphotographie Zur Stockeregg, 1987.

Paul Strand. Introductory essay by Mark Haworth-Booth. Aperture Masters of Photography, no. 1. New York: Aperture, 1987.

Johnson, Madeline C. "The Photographs of Paul Strand, 1914–1917." Master's thesis, University of Delaware, 1988.

Yates, Steve. Essay in *The Transition Years: Paul Strand in New Mexico.* Santa Fe, N.M.: Museum of Fine Arts, Museum of New Mexico, 1989.

Greenough, Sarah. *Paul Strand.* New York: Aperture/National Gallery of Art, 1990.

Articles and Reviews by Paul Strand

"Photography." *The Seven arts* 2 (August 1917): 524–525. [Reprinted in *Camera Work* 49–50 (June 1917): 3–4. Reprinted in Nathan Lyons, ed., *Photographers on Photography.* Englewood Cliffs: Prentice-Hall, 1966.]

"What was 291?" Typescript dated October 1917. Alfred Stieglitz Archives, Collection of American Literature, Beinecke Library, Yale University.

"Aesthetic Criteria." *The Freeman* 2 (12 January 1921): 426–27.

"The Subjective Method." *The Freeman* 2 (2 February 1921): 498. [Letter to the Editor.]

"Alfred Stieglitz and a Machine." New York: privately printed, 14 February 1921. [Reprinted in *Manuscripts* 2 (March 1922): 6–7. Revised for *America and Alfred Stieglitz,* Waldo Frank et al.,

eds., 281–285. New York: The Literary Guild, 1934.]

"The 'Independents' in Theory and Practice." *The Freeman* 3 (6 April 1921): 90.

"American Watercolors at The Brooklyn Museum." *The Arts* 2 (December 1921): 148–52. ["The Forum." *The Arts* 2 (February 1922): 332–33. Letter to the Editor in reply to one by Carl Sprinchorn in *The Arts* 2 (January 1922): 254–55, which was in response to Strand's article "American Watercolors at The Brooklyn Museum."]

"John Marin." *Art Review* 1 (January 1922): 22–23.

"Photography and The New God." *Broom* 3 (November 1922): 252–58. [Reprinted in *Photographers on Photography,* Nathan Lyons, ed., 138–44. Englewood Cliffs: Prentice-Hall, 1966, also in Peter C. Bunnell *A Photographic Vision: Pictorial Photography 1889–1925.* Salt Lake City: 1980.]

"News of Exhibits: Sometimes a Week Elapses Before Criticisms are Published." Letter to the Editor of *The Sun,* 31 January 1923. Also printed in the *New York Herald Tribune,* 31 January 1923, and *The World,* 11 February 1923.

"The New Art of Colour." *The Freeman* 7 (April 18, 1923): 137. [Letter to the Editor.]

"Photographers Criticized." Letter to the Editor of *The Sun,* 27 June 1923, 20.

"The Art Motive in Photography." *British Journal of Photography* 70 (5 October 1923): 613–15. [Précis of text and note of discussion in "The Art Motive in Photography: A Discussion." *Photographic Journal* 64 (March 1924): 129–32.]

"Marin Not an Escapist." *The New Republic* 55 (25 July 1928): 254–55.

"Lachaise." *Second American Caravan,* A. Kreymborg et al., eds., 650–658. New York: The Macaulay Co., 1928.

"Photographs of Lachaise Sculpture."
Creative Art 3 (August 1928): xxiii–xxviii.

"Steichen and Commercial Art." *The New Republic* 62 (19 February 1930): 21. [Letter to the Editor.]

"A Picture Book For Elders." *Saturday Review of Literature* 8 (12 December 1931): 372. [Book review.]

"El Significado de la Pintura Infantil." *Pinturas y Dibujos de los Centros Culturales*, Mexico City, D.F.: Direccion General de Accion Civica, 1933.

"Correspondence on [Louis] Aragon." *Art Front* 3 (February 1937): 18. [Comment on Aragon's "Painting and Reality," *Art Front* 3 (January 1937): 7–11.]

Essay in *Photographs of People by Morris Engel*. New York: New School for Social Research, 1939. [Reprinted in *Photo Notes*, December, 1939, 2.]

An American Exodus by Dorothea Lange and Paul S. Taylor." *Photo Notes*, March–April 1940, 2–3.

"Photography and the Other Arts." Undated typescript from a paper delivered in 1944 at the Museum of Modern Art. Department of Photography Archives, Museum of Modern Art.

"Photography to Me." *Minicam Photography* 8 (May 1945): 42–47.

"Weegee Gives Journalism a Shot for Creative Photography." *PM* (New York), 22 July 1945, 13–14.

"Alfred Stieglitz 1864–1946." *New Masses* 60 (6 August 1945): 6–7.

"Stieglitz, An Appraisal." *Popular Photography* 21 (July 1947). [Reprinted in *Photo Notes*, July 1947, 7–11.]

"Address by Paul Strand." *Photo Notes*, January 1948, 1–3.

"Paul Strand Writes a Letter to a Young Photographer." *Photo Notes*, Fall 1948, 26–28.

"A Platform for Artists." *Photo Notes*, Fall 1948, 14–15.

Photographs of Walter Rosenblum. Exhibition catalog, Brooklyn, N.Y.: Brooklyn Museum, 1950.

"Realism: A Personal View." *Sight and Sound* 18 (January 1950): 23–26. [Reprinted as "International Congress of Cinema, Perugia." *Photo Notes*, Spring 1950, 8–11, 18.]

"Italy and France." *U.S. Camera Yearbook 1955*. New York: U.S. Camera Publishing Corp., 1954, 8–17.

"How Creative is Color Photography?" *Popular Photography Color Annual*, 1957. [Strand among others.]

"Painting and Photography." *The Photographic Journal* 103 (July 1963): 216. [Letter to the Editor.]

"Manuel Alvarez Bravo." *Aperture* 13, no. 4 (1968): 2–9.

"The Snapshot." *Aperture* 19, no. 1 (1973): 46–49.

Selected Writings About Paul Strand

"The Camera Club's Annual Members' Print Exhibition." *American Photography* 4 (June 1910): 371.

Strand, Paul. *Versailles* (reproduced). *Photoisms* 2 (July 1911): unpaged.

Strand, Paul. *Two Horses* (reproduced). *Photoisms* 2 (August 1911): unpaged.

Cortissoz, Royal. "Paul Strand." *New York Tribune*, 19 March 1916, 3.

Caffin, Charles. "Paul Strand in 'Straight' Photos." *Camera Work* 48 (1916): 57–58. [Reprinted from *The New York American*, 20 March, 1916, 7.]

Stieglitz, Alfred. "Photographs by Paul Strand." *Camera Work* 48 (October 1916): 11–12.

"Photographic Art at Modern Gallery." *American Art News* 16 (31 March 1917): 3.

Stieglitz, Alfred. "Our Illustrations." *Camera Work* 49–50 (June 1917): 36.

"The 1918 Wanamaker Spring Exhibition." *American Photography* 12 (April 1918): 213.

Fitz, W.G. "A Few Thoughts on the Wanamaker Exhibition." *The Camera* 22 (April 1918): 205.

Scheffauer, Herman George. "Art: The Machine as Slave and Master." *The Freeman* 2 (12 May 1920): 208–210.

Seligmann, Herbert. "A Photographer Challenges." *The Nation* 112 (16 February 1921): 268.

Parker, Robert Allerton. "The Art of the Camera. An Experimental Movie." *Arts and Decoration,* 15 (October 1921): 369, 414.

"Manhattan — The Proud and Passionate City: Two American Artists Interpret the Spirit of New York Photographically in Terms of Line and Mass." *Vanity Fair,* April 1922, 51.

Vail, Floyd. "Members' Work at the Camera Club, New York." *The Camera* 26 (October 1922): 533–535.

Read, Helen Appleton. "Alfred Stieglitz Presents 7 Americans." *Brooklyn Daily Eagle,* 15 March 1925, 11.

Watson, Forbes. "Seven American Artists sponsored by Stieglitz." *The World,* 15 March 1925, 13.

"Cameraman's 'Mood' Big Factor in Films That Would Succeed." *Variety,* March 1925, 42.

"Seven Americans." *The Arts* 7 (April 1925): 229–230.

Fulton, Deogh. "Cabbages and Kings." *International Studio* 81 (May 1925): 144–147.

Mullin, Glenn. "Alfred Stieglitz Presents Seven Americans." *The Nation* 120 (20 May 1925): 577–578.

"Reviews — Second American Caravan." *Hound and Horn* (Fall 1928): 174–177.

Panter, Peter. "New Light." *The German Annual of Photography* 1930. Berlin: Robert und Bruno Schultz, 1929.

McBride, Henry. "The Paul Strand Photographs." *The Sun,* 23 March 1929, 34.

Clurman, Harold. "Photographs by Paul Strand." *Creative Art* 5 (October, 1929): 735–739.

Ridge, Lola. "Paul Strand." *Creative Art* 9 (October 1931): 312–316.

Sterne, Katherine Grant. "The Camera: Five Exhibitions of Photography." *New York Times,* 6 December 1931, 18, XX.

McCausland, Elizabeth. "Paul Strand's Photographs Show Medium's Possibilities." *Springfield Sunday Union and Republican,* 17 April 1932, 6E.

Bauer, Catherine. "Photography: Man Ray and Paul Strand." *Arts Weekly* 7 (May 1932): 193, 198.

Rosenfeld, Paul. "The Boy in the Darkroom." In *America and Alfred Stieglitz,* Waldo Frank et al., eds., 72, 83. New York: The Literary Guild, 1934.

Sabine, Lillian. "Paul Strand, New York City." *The Commercial Photographer* 9, (January 1934): 105–11.

Stebbins, Robert [Sidney Meyers]. "Pescados." *New Theater* 2 (June 1935): 11.

Tazelaar, Marguerite. *"The Plow That Broke the Plains —* Grand Central Palace." *New York Herald Tribune,* 26 May 1936, 13.

McCausland, Elizabeth. "Paul Strand Turns to Moving Pictures." *Springfield Sunday Union and Republican,* 6 September 1936, 5C.

Stebbins, Robert [Sidney Meyers]. *"Redes." New Theater* 3, no. 11, 1936, 20–22.

Rolfe, Edwin. "Prophecy in Stone (On a Photograph by Paul Strand)." *The New Republic* 78 (16 September 1936): 154. [Reprinted in his *First Love and Other Poems.* Los Angeles: Larry Edmonds Book Shop, 1951.]

Breckinridge, Marvin. "Gaspé — Halfway to France." *Vogue,* July 1937. [Photographs by Strand.]

"Frontier Films." *New Theater and Film* 4 (March 1937): 50.

Winsten, Archer. "*Redes (The Wave)* Opens at the Filmarte Theatre." *New York Post*, 21 April 1937, 15.

Nugent, Frank S. "At the Filmarte— *The Wave.*" *New York Times*, 21 April 1937, 18.

"An American Photographer Does Propaganda Movie for Mexico." *Life* 2 (10 May 1937): 62–65, 70.

Kelly, Etna M. "The Legendary Paul Strand." *Photography* (London) 6 (March 1938): 14.

Joseph, Robert. "Unimportance of Budget . . . *The Wave.*" *Hollywood Spectator* 13 (25 June 1938): 11.

"Power of a Fine Picture Brings Social Changes." *New York World-Telegram*, 4 March 1939, 11.

Grossman, Sid. "Documentary Film Problems Discussed at Writers' Congress." *Photo Notes*, June 1939, 4.

Smith, Job. "Photography as Art." *New Masses* 36 (9 July 1940): 31.

McCausland, Elizabeth. "Paul Strand: The Photographer and His Work." *U.S. Camera*, (February/March 1940): 20–25, 65.

McCausland, Elizabeth. "Paul Strand's Series of Photographs of Mexico." *Springfield Sunday Union and Republican*, 7 July 1940, 6E.

Mellquist, Jerome. "Paul Strand's Portfolio." *The New Republic* 103 (4 November 1940): 637–38.

Mellquist, Jerome. "Wine from These Grapes." *The Commonweal* 33, 29 (November 1940): 147–50.

McCausland, Elizabeth. "For Posterity." *Photo Technique* 3 (January 1941): 40–42.

Hurwitz, Leo. "On Paul Strand and Photography." *Photo Notes*, July/August 1941, 4–5.

Thirer, Irene. "Paul Strand and Leo Hurwitz Offer Data on *Native Land.*" *New York Post*, 9 May 1942, 13.

Crowther, Bosley. "Native Land, Impassioned and Dramatic Documentary Film on American Civil Liberties, Presented at the World." *New York Times*, 12 May 1942, 16.

"Premiere of Fine Film [*Native Land*]." *Photo Notes*, May 1942, 3.

Newhall Nancy. "Four Photographs." *Magazine of Art*, May 1943.

Brown, Milton. "Cubist–Realism: An American Style." *Marsyas* 3 (1943–1945): 139–160.

"Photographs from 1915–1945 by Paul Strand." *Cue* 14 (28 April 1945): 10.

Jewell, Edward Alden. "Strand: Three Decades." *New York Times*, 29 April 1945, 5, X.

O'Dea, Gerald. "Thirty Years with Paul Strand." *Brooklyn Citizen*, 2 May 1945, 8.

Kleinholz, Frank. "Paul Strand: Radio Interview." Published in *American Contemporary Art* 2 (May–June 1945): 10–13.

Greene, Charles. "Paul Strand." *New Masses* 55 (15 May 1945): 30–31.

Thomas, Eleanor. "Paul Strand Probes Life's Recesses with His Camera." *The Daily Worker* (New York), 11 June 1945, 11.

Goff, Loyd L. "Book Review." *The New Mexico Quarterly Review*, 15 (Summer 1945): 219–222.

"Paul Strand." *American Photography* 39 (September 1945): 60.

"Paul Strand." *American Artist* 9 (October 1945): 40.

Van Dyke, Willard. "The Interpretive Camera in Documentary Films." *Hollywood Quarterly* 1 (July 1946).

"*The Wave.*" *Photo Notes*, August–September 1947, 5.

"Exposure: Six Top-Flight Professional Photographers Discuss Their Black and White Exposure Methods." *Photo Arts* 2 (Spring 1948): 34–35, 120, 122, 123.

Adams, Ansel. "A Decade of Photographic Art." *Popular Photography* 22 (June 1948): 44, 156–159.

"Three Film Showings." *Photo Notes,* June 1948, 8.

Weiner, Sandra. "Symposium Report." *Photo Notes,* Spring 1949, 8–9.

Neugass, Fritz. "Photo League, New York." *Camera* 29 (September 1950): 262–275.

Williamson, Samuel T. *"Time in New England." New York Times Book Review,* 29 December 1950.

Eaton, Walter Prichard. *"Time in New England." New York Herald Tribune Book Review,* 30 December 1950.

Brown, Milton W. "Paul Strand and His Portrait of People." *The Daily Compass* (New York), 31 December 1950, 12.

Rosenblum, Walter. "Paul Strand." In *American Annual of Photography* (Minneapolis: American Photography Book Department, 1951): 6–18.

Deschin, Jacob. "Fine Prints by Strand." *New York Times,* 18 January 1953, 15, X.

Newhall, Beaumont and Nancy. "Letters from France and Italy: Paul Strand." *Aperture* 2, no. 2 (1953): 16–24.

Newhall, Beaumont and Nancy. "Paul Strand: A Commentary on His New York." *Modern Photography* 17 (September 1953): 46–53, 103–104.

Newhall, Beaumont. "Book Reviews. *Un Paese." Aperture* 3, no. 3 (1955): 30–32.

Soby, James Thrall. "Two Contemporary Photographers." *Saturday Review of Literature* 38 (5 November 1955): 32–33.

Deschin, Jacob. "Diogenes III at Museum." *New York Times,* 22 January 1956, 19, X.

Newhall, Beaumont and Nancy. "Paul Strand." *Masters of Photography,* New York: George Braziller, 1958, 102–117.

Harris, Susan A. "Paul Strand's Early Work: A Modern American Vision." *Arts Magazine* 59 (April 1958): 116–118.

Katz, Robert. "Talks between Paul Strand and Robert Katz." Transcript of an interview. Orgeval, France, August 1962. The Museum of Modern Art, Department of Photography Archives.

Bardi, P.M. "Paul Strand." *Diario de Sao Paulo,* 14 October 1962, 3.

Newhall, Beaumont. "Paul Strand, Traveling Photographer." *Art in America* 50 (Winter 1962): 44–47.

"Highlands and Islands." *Times Literary Supplement* (London), 28 December 1962, 1007. [Book review.]

Brown, Milton W. "Paul Strand Portfolio." *Photography Year Book 1963.* London: Photography Magazine Ltd. 1962, xiii-xv, 36–51.

Berger, John. "Painting—or Photography?" *Observer Weekend Review,* 24 February 1963, 25. [Reprinted as "Painting or Photography?" *The Photographic Journal* 103 (June 1963): 182–84. Reprinted as "Painting or Photography?" *Photography Annual, 1964.* New York: Ziff-Davis, 1963, 8–10.]

Mayer, Grace M. "Paul Strand's *Tìr a'Mhurain." Infinity* 12 (April 1963): 21–23, 27.

Chiarenza, Carl. *Tìr a'Mhurain—Outer Hebrides." Contemporary Photographer* 4 (Fall 1963): 63–65.

Rosenblum, Walter. "Starting Your Photographic Career." *Camera* 35 (82) (December 1963–January 1964): 30–31, 58–62.

Koch, Robert. "Paul Strand/*Tìr a'Mhurain: Outer Hebrides." Aperture* 11, no. 2 (1964): 80–81.

"Paul Strand." *Current Biography* 26 (July 1965): 40–42. [See also *Current Biography Yearbook* 1965, ed. Charles Moritz. New York: H. W. Wilson Company, 1965, 417–19.]

Deschin, Jacob. "Viewpoint–Paul Strand at 76." *Popular Photography* 60, (March 1967): 14, 16, 18, 58.

Deschin, Jacob. "Honor for Strand." *New York Times,* 2 April 1967, 29, D.

Deschin, Jacob. "Strand Portfolio Again Available." *New York Times,* January 28, 1968, 35, D.

"Photographs in the Metropolitan." *Metropolitan Museum of Art Bulletin,* March 1969. [Strand among others.]

Duncan, Catherine. "Life in Stillness: The Art of Paul Strand." *Meanjin Quarterly* (Melbourne) 28 (Summer 1969): 565–569.

Newhall, Beaumont and Nancy. "Paul Strand, Catalyst and Revealer." *Modern Photography* 33 (August 1969): 70–75.

"A Collection of Photography. Paul Strand." *Aperture* 14, no. 2 (Fall 1969).

"Photo-Secession." *Camera* (German edition) 12 (Dec. 1969).

Mann, Margery. "Two by Strand: When the People Draw a Curtain." *Popular Photography* 65 (December 1969): 90–91, 126.

"Living Egypt." *Album* 2 (London, 1970): 39.

"Honoring Humanity, Paul Strand." *Documentary Photography.* Life Library of Photography. New York: Time-Life Books, 1970, 132–37.

Turner, J.B.. "Viewpoint: Paul Strand." *New Zealand Studio* 6, no. 3 (1970/71): 8.

Brown, Milton W. and Walter Rosenblum. Unpublished interview with Paul Strand, 1971. Archives of American Art, Smithsonian Institution.

Kramer, Hilton. "Paul Strand at 81: Still a Vital Photographic Artist." *New York Times,* 26 November 1971, 54.

Kramer, Hilton. "A Master of the Medium." *New York Times,* 5 December 1971, 25, II.

Deschin, Jacob. "Paul Strand Retrospective." *The Photo Reporter* 1 (8) (December 15, 1971) 1, 6–7.

Weiss, Margaret. "Paul Strand, Close-Up on the Long View." *Saturday Review of Literature,* (18 December 1971): 20.

Rosenblum, Walter. "We Owe a Debt to Paul Strand as We Do to Pablo Picasso." *New York Times,* 23 January 1972, 21, II.

Frampton, Hollis. "Meditations Around Paul Strand." *Artforum* 10 (February 1972): 52–57.

Berger, John. "Arts in Society: Paul Strand. " *New Society* (London), 30 March 1972, 654–655.

Deschin, Jacob. "Paul Strand: An Eye for the Truth." *Popular Photography* 70 (April 1972): 68–73, 108–111, 176.

"Paul Strand." *Camera* (English edition) 5 (May 1972): 24–33.

McIntyre, Robert L. "The Vision of Paul Strand." *PSA Journal* 38 (8 August 1972): 18–21.

Stettner, Lou. "A Day to Remember: Paul Strand Interview." *Camera* 35, October 1972, 55–59, 72–74.

Cruger, George. "Photography: Strand's Compassionate Humanism." *The Richmond Mercury,* 14 March 1973, 16.

Rose, Barbara. "The Triumph of Photography, Or: Farewell to Status in the Arts." *New York,* 9 April 1973.

Baker, Rob. "Paul Strand: Photographer." *The World,* 10 November 1973.

Stettner, Lou. "Speaking Out: Strand Unraveled." *Camera* 35, July/August 1973, 8, 67, 70.

Blume, Mary. "A Witness for Photography," *International Herald Tribune,* 16 November 1973.

Tomkins, Calvin. "Profiles: Look to the Things Around You." *The New Yorker,* 16 September 1974, 44–94.

Keller, Ulrich. "An Art Historical View of Paul Strand." *Image* 17, No. 4 (December 1974): 1–11.

Coke, Van Deren. "The Cubist Photographs of Paul Strand and Morton Schamberg." *One Hundred Years of Photographic History: Essays in Honor of Beaumont Newhall*. Albuquerque: University of New Mexico Press, 1975, 36–39.

Homer, William Innes. "Stieglitz, 291, and Paul Strand's Early Photography." Typescript. Paul Strand Collection, Center for Creative Photography, University of Arizona, Tucson, 1975.

Haworth-Booth, Mark. "Breaking the Pictorial Barrier." *Times Literary Supplement*, 30 January 1976. [Book review.]

Jeffrey, Ian. "Paul Strand." *The Photographic Journal* (London), March/April 1976, 76–81.

Whitman, Alden. "Paul Strand, Influential Photographer, 85, Dead." *New York Times*, 2 April 1976, 36.

Homer, William Innes. "Stieglitz, 291, and Paul Strand's Early Photography." *Image* 19 (June 1976): 10–19.

Czach, Marie. "Strand's World." *History of Photography* 2, no. 1 (1978): 96. [Book review.]

Alexander, William. "Frontier Films: Trying the Impossible." *Prospects* 4, (1979): 565–69.

Hill, Paul and Thomas Cooper. "Paul Strand," in *Dialogue With Photography*. New York: Farrar, Strauss & Giroux, 1979, 1–8.

Hammen, Scott. "Sheeler and Strand's 'Manhatta': A Neglected Masterpiece." *Afterimage* 6 (January 1979): 6–7.

Coke, Van Deren. "A Talk with Paul Strand: France. Summer 1974." *History of Photography* 4, no. 2 (April 1980): 165–169.

Tucker, Anne. *Target II: 5 American Photographers: De Meyer, White, Stieglitz, Strand, Weston*. Houston: Museum of Fine Arts, 1979.

Roberts, Nancy, "Historical: Paul Strand." *Photographer's Forum*, 3, no. 1 (November–December 1980): 21–26.

Alexander, William. *Film on the Left*. Princeton, N.J.: Princeton University Press, 1981.

Oliphant, Dave and Thomas Zigal, eds., *Perspectives on Photography: Essays on the Work of Du Camp, Dancer, Robinson, Stieglitz, Strand & Smithers at the Humanities Research Center*. Austin: Humanities Research Center, University of Texas at Austin, 1982.

Rice, Shelley. "Paul Strand: A Life in Photography." *Lens on Campus* 4, no. 2 (April 1982): 22–26.

Grundberg, Andy. "Photography View: Who's More Old-Fashioned—Strand or Atget?" *New York Times*, 17 October 1982, 35, 38, II.

Fishbein, Leslie. "*Native Land*: Document and Documentary." *Film and History* 14 (1984).

Rosenblum, Naomi. "Stieglitz and Strand." *Photographica Journal*, 3, no. 3 (May–June 1986): 10–13.

Horak, Jan-Christopher. "*Manhatta*: Modernist Impulses and Romantic Desires." *Afterimage* 15 (November 1987): 9.

Cocks, J. Fraser III. "Moral Geometry: Paul Strand, 1915–1932." *Colby Library Quarterly*, 25, No. 2 (1989).

Rathbone, Belinda. "Potrait of a Marriage: Paul Strand's Photographs of Rebecca." *The J. Paul Getty Museum Journal* 17 (1989): 83–98.

Rathbone, Belinda. "Paul Strand: The Land and Its People." *The Print Collector's Newsletter* 21, 1 (March–April 1990): 1–5.

Rosenblum, Naomi. "Paul Strand." *Minolta Mirror*, 1990, 124–5.

Films

Crackerjack, 1925.

Where the Pavement Begins, 1928.

Manhatta, 1920. (Also called *New York, the Magnificent*) [Directed and photo-

graphed by Paul Strand and Charles Sheeler].

Betty Behave, 1927.

The Wave (Redes), 1935 [Produced, supervised, and photographed by Paul Strand, Augustine V. Chávez, Henwar Rodakiewicz, and Fred Zinnemann].

The Plow That Broke the Plains, 1936 [Photographed by Paul Strand, Ralph Steiner, and Leo Hurwitz].

Heart of Spain, 1937 [Edited by Paul Strand and Leo Hurwitz].

Native Land, 1942 [Directed by Paul Strand and Leo Hurwitz; photographed by Paul Strand; written by David Wolff [Ben Maddow], Leo Hurwitz, and Paul Strand]

It's Up to You, 1943 (For the Department of Agriculture).

Tomorrow We Fly, 1944 [Photographed by Paul Strand].

Personal Awards

David Octavius Hill Medal (Gesellschaft Deutscher Lichtbildner (GDL), Mannheim, West Germany, 1967.

Honorary Member, American Society of Magazine Photographers, 1973.

Fellow, Philadelphia Museum of Art, 1973.

Fellow, American Academy of Arts and Sciences.

Chevalier de l'Ordre des Arts et Lettres, 1976.

Portfolios and Limited Editions

Photographs of Mexico. Foreword by Leo Hurwitz. New York: Virginia Stevens, 1940. [Reissued as *The Mexican Portfolio*, with additional preface by David Alfaro Siqueiros. New York: produced by Aperture for DaCapo Press, 1976.]

The Garden. Introduction by Paul Strand. Millerton, N.Y.: Aperture, 1976. [A portfolio of six silver prints.]

On My Doorstep. Introduction by Paul Strand. Millerton, N.Y.: Aperture, 1976. [A portfolio of eleven silver prints.]

Paul Strand: The Formative Years 1914–1917. Introduction by Ben Lifson. New York: Aperture, 1983. [A portfolio of ten hand gravure prints.]

Portfolio III. Introduction by Mark Haworth-Booth. Millerton, N.Y.: Aperture, 1980. [A portfolio of ten silver prints.]

Portfolio IV. Introduction by Cesare Zavattini. Millerton, N.Y.: Aperture, 1980. [A portfolio of ten silver prints.]

Selected Exhibitions

New York, N.Y.: Camera Club of New York. "Annual Members' Print Exhibition." April 1910.

New York, N.Y.: Camera Club of New York. "Annual Members' Print Exhibition." April 1911.

London, England: Haywood Gallery. "London Salon." September 1912.

New York, N.Y.: Ehrich Gallery. "Group Exhibition." January 1914.

New York, N.Y.: The Print Gallery. "Pictorial Photography." 1915.

New York, N.Y.: Gallery of the Photo-Secession. [An Exhibition of Photographs of New York and Other Places by Paul Strand.] 13–28 March 1916.

New York, N.Y.: Modern Gallery. "Three Photographers." March 1917.

New York, N.Y.: Society of Independent Artists. "Group Show." 10 April–6 May, 1917.

Philadelphia, Pa.: John Wanamaker Gallery. "Twelfth Annual Exhibition of Photography." 1–17 March 1917.

Philadelphia, Pa.: John Wanamaker Gallery. "Thirteenth Annual Exhibition of Photographs." 4–16 March 1918.

Philadelphia, Pa.: John Wanamaker Gallery. "Fourteenth Annual Exhibition of Photographs." 1–13 March 1920.

New York, N.Y.: New York Camera Club. "Members' Exhibition." September 1922.

Freehold, N.J.: Municipal Building. [A Loan Exhibition of Modern Art] 8–10 June 1922.

New York, N.Y.: Anderson Galleries. "Alfred Stieglitz Presents Seven Americans." 9–28 March 1925.

New York, N.Y.: Intimate Gallery. "Forty New Photographs by Paul Strand." 19 March–7 April 1929.

New York, N.Y.: Julien Levy Gallery. "American Photography. Retrospective Exhibition." November 1931.

New York, N.Y.: An American Place. "Photographs by Paul Strand, Paintings by Rebecca Strand." April 1932.

Mexico City, Mexico: Sala de Arte de la Secretariat de Educacion. "Exposicion de la Obra del Artista Norteamericano, Paul Strand." 3–15 February 1933.

New York, N.Y.: Metropolitan Museum of Art. [title unknown] November 1940.

New York, N.Y.: Museum of Modern Art. "Sixty Photographs." 1940–1941.

New York, N.Y.: Photo League. "Mexican Portfolio" and gravures from "Camera Work." 1941.

New York, N.Y.: Museum of Modern Art. "National War Poster Competition." November 1942.

New York, N.Y.: Museum of Modern Art. "Photographs 1915–1945 by Paul Strand." 24 April–10 June 1945.

New York, N.Y.: Limelight Gallery. "Great Photographs." 1954.

New York, N.Y.: Museum of Modern Art. "Diogenes with a Camera III." 17 January–18 March 1956.

Essen, Germany: Museum Folkwang. "Hundert Jahre Photographie, 1839–1939." 1959.

Rochester, N.Y.: George Eastman House. [Photo-Secession.] November 1960–January 1961.

Rochester, N.Y.: George Eastman House. "The Art of Photography." 1961.

New York, N.Y.: Museum of Modern Art. "A Bid for Space." Spring/Summer 1962.

Philadelphia, Pa.: Photographer's Place, Harry Kulkowitz Kenmore Galleries. September–November 1962.

New York, N.Y.: Museum of Modern Art. "The Photographer and the American Landscape." 1963.

Arles, France: Museé Réattu. "Inauguration de la Collection Permanente." 1965.

Milwaukee, Wis.: University of Milwaukee Art Gallery. "New Talent." 1965.

New York, N.Y.: Gallery of Modern Art. "Night and Day." 1965.

Mannheim, West Germany: Augusta-Analge 58. "Gesellschaft Deutscher Lichtbildner (GDL). Ausstellung im Mannheimer Kunstverein e.V." 19 March–16 April 1967.

Cambridge, Mass.: Fogg Art Museum, Harvard University. "The Portrait in Photography, 1948–1966." 10 April–15 May 1967.

Worcester, Mass.: Worcester Art Museum. "Photographs by Paul Strand." 8 July–5 September 1967.

San Francisco, Calif.: San Francisco Museum of Art. "Paul Strand: 1927–1954." November 1967.

Carmel, Calif.: Friends of Photography. "Paul Strand." 14 November 31–December 1967.

New York, N.Y.: Museum of Modern Art. [Ben Schultz Memorial Collection.] February–March 1968.

New York, N.Y.: Museum of Modern Art. "The Beginnings of Modern Photography." 1968.

Verviers, Belgium: Musée Communale de Verviers. "Paul Strand." 11–28 January 1969. [Exhibition traveled to Namur, Charleroi, and Brussels.]

Freital, West Germany: Kreismuseum Freital (Haus de Heimat). "Paul Strand." 1 March–20 April 1969.

Roeselare, Belgium: Studio Callebert. "Paul Strand." May 1969.

St. Petersburg, Fla.: Museum of Fine Arts. "Paul Strand: Photographs." 22 April–18 May, 1969.

New York, N.Y.: Museum of Modern Art. "Master Photographs from the Museum of Modern Art." 1969.

Heerlen, The Netherlands: Galerie Olleke. "Paul Strand." November 1969.

Ostend, Belgium: Centre Culturel d'Ostende. "Exposition Retrospective de l'Oeuvre Photographique de Paul Strand." 31 January–23 February 1970.

New York, N.Y.: Museum of Modern Art. "Photo Eye of the 20's." 4 June–8 September 1970.

Stockholm, Sweden: Liljevalchs Art Gallery. "De Bittra Aren." 18 October–1 November 1970.

Manchester, N.H.: Currier Gallery of Art. "Paul Strand." 15 July–17 August 1971.

Philadelphia, Pa.: Philadelphia Museum of Art. "Paul Strand: Photographs 1915–1969." 24 November 1971–29 January 1972. [Exhibition traveled to St. Louis, Boston, New York, Los Angeles, and San Francisco.]

Milwaukee, Wis.: Layton School of Design. "Masters of Photography." 22 January–10 February 1972.

Rochester, N.Y.: George Eastman House. "Photo Eye of the 20's." 1971–1972. [Exhibition traveled to University of South Florida, Pasadena Art Museum, Minneapolis Institute of Art, Seattle Art Museum, Des Moines Art Center, and Art Institute of Chicago.]

New York, N.Y.: Light Gallery. "Paul Strand." 18 January–19 February 1972.

Lakeville, Conn.: Hotchkiss School. "Paul Strand." 19–27 January 1972.

Arles, France: Salle Etienne Gautier. "Paul Strand." 15–22 July 1973.

Cambridge, Mass.: Fogg Art Museum. "Contemporary American Photographs." November–December 1972.

Carmel, Calif.: Friends of Photography: "Paul Strand: Mexican Portfolio." 6 January–4 February 1973.

New York, N.Y.: Washburn Gallery. "291." 7 February–3 March 1973.

New York, N.Y.: Metropolitan Museum of Art. "Paul Strand: Photographs 1915–1968." 10 February–16 April 1973.

Dijon, France: Salle des Etats. "Confrontation 73. 12 Photographes." 17 March–1 April 1973.

New York, N.Y.: Washburn Gallery. "Exhibition 291." 1973.

New York, N.Y.: Metropolitan Museum of Art. "Landscape/Cityscape." 1973/74.

New York, N.Y.: Washburn Gallery. "Seven Americans." 6 February–2 March 1974.

Philadelphia, Pa.: Philadelphia Museum of Art. "Camera Work: The Influence of Alfred Stieglitz." March–April 1974.

Chalon-sur-Sâone, France: Maison Européenne de la Photographie. "Trois Continents." 18 June–31 July 1974.

Albuquerque, N.M.: University of New Mexico. "Photography of New Mexico." September–October 1974.

New York, N.Y.: Whitney Museum. "Photography in America." December 1974–January 1975.

Milwaukee, Wis.: Creative Photography Workshop. "Exhibition of Photogravures from Camera Work." 23 March–18 April 1975.

New York, N.Y.: Light Gallery. "Paul Strand." 1976.

London, England: National Portrait Gallery. "Paul Strand: A Retrospective Exhibition of his Photographs, 1915–1968." 1976.

Paris, France: Centre Georges Pompidou. "Paris–New York." 1977.

Edinburgh, Scotland: Scottish Photography Group. "The Hebridean Photographs." 12 August–16 September 1978. [Exhibition traveled to Aberdeen, Oxford, and Glasgow.]

Zurich, Switzerland: Kunsthaus. "Paul Strand." 1979.

Houston, Tex.: Houston Museum of Fine Arts. "Target Two: Five American Photographers." 21 September–18 November 1979.

New York, N.Y.: International Center of Photography. "Photography of the 50s." 1980. [Traveled to the Center for Creative Photography, University of Arizona, Tucson; Minneapolis Institute of Art; California State University at Long Beach; and Delaware Art Museum, Wilmington.]

Williamstown, Mass.: Sterling and Francine Clark Institute. "Cubism and American Photography." 1981.

San Francisco, Calif.: Frankael Gallery. "Vintage Photographs, 1915–1917." 1981.

New York, N.Y.: Hirschl and Adler Gallery. "Photographs 1910–1974." 1981.

Rennes, France: Franco-American Institute. "Paul Strand: 50 Prints." 1982.

New York, N.Y.: New York Public Library. "The Range of Expression 1914–1973." 16 September, 1982–15 January, 1983.

New York, N.Y.: Zabriskie Gallery. "Paul Strand (1890–1976): Mexico, Photographs of the 1930s." 20 October–12 November, 1983.

New York, N.Y.: Zabriskie Gallery, "3 Photographers/3 Sculptors: Harry Callahan, Lee Friedlander, Paul Strand, Mary Frank, Richard Stankiewicz, William Zorach." 20 November, 1982–8 January, 1983.

New York, N.Y.: Zabriskie Gallery. "Paul Strand: The Stieglitz Years at 291 (1915–1917)." 22 March–23 April 1983.

Worcester, Mass.: Worcester Art Museum. "Paul Strand: Time in New England." 1984.

Daytona Beach, Fla.: Daytona Beach Community College. "Paul Strand: 50 Photographs." 1984.

New York, N.Y.: Burden Gallery. "Paul Strand—Hazel Kingsbury: Gift of Personal Remembrance." 17 January–2 March 1985.

Addison, Me.: Cape Split Place. "Maine Photographs." 1985. [Exhibition traveled to Colby College, Waterville, Me.]

Washington, D.C.: Library of Congress. "The Spirit of Place: Photographs by Paul Strand." December 1985–April, 1986.

New Orleans, La.: New Orleans Museum of Art. "The Photogravure Print." 1987.

Malibu, Calif.: J. Paul Getty Museum. "Rare States and Unusual Subjects: Photographs by Paul Strand, André Kertész, and Man Ray." 7 July–6 September 1987.

Santa Fe, N.M.: Museum of Fine Arts, Museum of New Mexico. "The Transition Years: Paul Strand in New Mexico." 16 September–17 June 1990.

Tucson, Ariz.: Center for Creative Photography, the University of Arizona. "Paul Strand and Ansel Adams: Native Land and Natural Scene." 22 April–17 June 1990.

Contributors

Robert Adams was born in Orange, New Jersey in 1937 and earned a Ph.D. in English from the University of Southern California. Before becoming a photographer he was a college English teacher for several years. His pictures and writing have been widely honored, most recently with the Charles Pratt Memorial Award in 1987 and earlier with two fellowships from the John Simon Guggenheim Memorial Foundation. Among his many writings and monographs are those published by Aperture: *From the Missouri West* (1980), *Beauty in Photography: Essays in Defense of Traditional Values* (1981), *Our Lives & Our Children* (1983), *Summer Nights* (1985), *Los Angeles Spring* (1986), and *Perfect Times, Perfect Places* (1988).

William Alexander is Professor of English at the University of Michigan, where he teaches literature, theater, and film/video studies. He is the author of *William Dean Howells: The Realist as Humanist* (Burt Franklin, 1981) and *Film on the Left: American Documentary Film from 1931 to 1942* (Princeton University) and is currently at work on a book on community-based theater and video in the United States. He also produces collectively-created community-based plays and videos.

Russell Banks's most recent books are the novels, *Affliction* and *Continental Drift*, and a collection of short stories, *Success Stories*. His essays and articles have appeared in the *New York Times Book Review*, *The Nation*, *Conde Nast Traveler*, and other periodicals. He divides his time between his home in the Adirondack region of upstate New York and Princeton, New Jersey, where he teaches in the Creative Writing Program.

Richard M. A. Benson is a photographer and printer who has studied photographic processing techniques of the past and present. Benson has had a broad range of interests in the photographic print, whether in silver, platinum, palladium, or ink. Working in all these different mediums, sometimes re-learning forgotten crafts and sometimes making up new ones, he has come to believe that ink and the modern photo offset press possess a previously unknown potential for photographic rendition. His own pictures are published in *Lay This Laurel* (1974) and in Hart Crane's *The Bridge* (1981). His work as a craftsman is present in numerous books, among them *The Face of Lincoln* (1979), the four volume series, *The Way of Atget* (1981–85), and *Photographs from the Gilman Collection*, of which he is the co-author (1984). Since 1979, Benson has taught at Yale University in the School of Art, where he is now an adjunct professor of photography. He has been awarded two Guggenheim Fellowships (1979, 1986), is a MacArthur Fellow (1986), and has received continued support over the past fifteen years from the National Endowment for the Arts and the Eakins Press Foundation.

Milton W. Brown has taught and written extensively on American art. He received his Ph.D. in art history from the Institute of Fine Arts, New York University, and he also studied at Harvard University, the Courtauld Institute

in London, and the University of Brussels. Professor Brown taught at Brooklyn College (1946–69) and chaired the Art Department. He helped found the Ph.D. Program in Art History at the City University of New York and became its first Executive Officer (1970–79). He was Sacks Professor at the Hebrew University, Jerusalem (1972), Senior Fellow in the Prendergast Systematic Catalog Project at Williams College (1983–87), and Phi Beta Kappa Visiting Scholar (1987–88) and Samuel H. Kress Professor at the Center for Advanced Studies in the Visual Arts, National Gallery of Art (1989–90). He has also guest-curated major exhibitions in the United States and abroad. Professor Brown's publications include *American Painting from the Armory Show to the Depression, The Story of the Armory Show*, and *American Art to 1900*.

Basil Davidson has written numerous books on the culture and history of Africa, including *Modern Africa and Ghana: An African Portrait*. He also contributed the introduction to *Spectacular Vernacular: The Adobe Tradition* (Aperture, 1989).

Edmundo Desnoes is a novelist and photography critic. His best-known novel, *Memories of Underdevelopment*, was also a highly successful Cuban film. His essays on photography include "The Photographic Image of Underdevelopment," and *Para verte mejor, America Latina*, a book on reading the visual signs of Latin America, with photographs by Paolo Gasparini. Desnoes now lives and writes in New York City.

Catherine Duncan was born in Australia and worked as an actress, writer, and documentary film-maker until she came to Paris in 1947. Her friendship with Paul and Hazel Strand dates from

their arrival in France in the 1950s, and it continued during the years she worked with Paul on the texts for his books, including *The Garden Book*. Today she works as a collagist and has had exhibitions at the Victorian Arts Centre (Melbourne Australia), and for the Department of Education in France, where *The Grandmother's Book* and *Kif Kif* continue to circulate in libraries, schools, hospitals, and psychiatric centers for children. *The Grandmother's Book* was published in Australia last year.

Carolyn Forché is the author of the collection of poems *The Country Between Us* (Harper & Row, 1982). Recipient of the Lannan Foundation Fellowship in Poetry, Forché is a professor at George Mason University. She lives in Washington, D.C., where she is at work on a new volume of poetry, *The Angel of History*, and an anthology titled *Against Forgetting: Twentieth Century Poetry of Witness* (W.W. Norton & Co.).

Brewster Ghiselin has published essays, fiction, five volumes of poems, and an anthology, *The Creative Process*, which has sold more than a half-million copies since 1952. He has lectured throughout the United States on creativity in the arts, including photography. His discussion of Paul Strand's photograph *Dunes Near Abiqui* (1931), during the Esalen meetings sponsored by Aperture in 1984, was published in *Aperture* 93.

Jim Harrison is a poet, novelist, critic, outdoorsman, and nature writer. Born and raised in Michigan, where he now resides, Harrison first won acclaim for his poetry, appearing between 1965 and 1978 in volumes including *Plain Song* (1965) and *Returning to Earth*

(1977). His prose publications include *Wolf: A False Memoir* (1971), the novella *Legends of the Fall* (1979), and the thrillers *A Good Day to Die* (1978) and *Warlock* (1981).

Jan-Christopher Horak received his Ph.D. from the Westfaehlische Wilhelms University in Muenster, West Germany. He is Senior Curator of Film at the International Museum of Photography at George Eastman House, Associate Professor of Film Studies/English at the University of Rochester, and the author of numerous books and articles. He is presently completing an anthology of essays on early American avant-garde cinema.

Estelle Jussim has taught at the Graduate School of Library and Information Science at Simmons College since 1972. She is the author of *Stopping Time: The Photographs of Harold Edgerton; Landscape as Photograph* (with Elizabeth Lindquist Cock); *Frederic Remington, the Camera, and the Old West; Slave to Beauty: The Eccentric Life and Controversial Career of F. Holland Day, Photographer, Publisher, Aesthete* (winner of the New York Photographic Historical Society Prize for Distinctive Achievement in the History of Photography); and *Visual Communication and the Graphic Arts: Photographic Techniques in the Nineteenth Century.* Her collected essays have been published by Aperture in *The Eternal Moment: Essays on the Photographic Image* (1987).

Jerome Liebling is a photographer, film-maker, and teacher. He studied photography with Walter Rosenblum and was an executive officer of the Photo League. His work has been exhibited in major museums and galleries

internationally and is in numerous private and public collections, and Liebling has received two John Simon Guggenheim Fellowships as well as grants from the National Endowment for the Arts and the Massachusetts Arts and Humanities Foundation. Editor of the *Massachusetts Review* photography issue which was distributed by Light Impressions as *Photography: Current Perspectives* (1979), Liebling's most recent book, *Jerome Liebling: Photographs,* was published by Aperture in 1988.

Gloria Naylor grew up in New York City and began writing while a literature student at Brooklyn College. Her first novel, *The Women of Brewster Place,* won the American Book Award for First Fiction in 1983 and was made into a television mini-series starring Oprah Winfrey. More recent books are *Linden Hills* (1985) and *Mama Day* (1988). Ms. Naylor has been a writer-in-residence at George Washington University and has taught at both New York University and Boston University. Presently at work on a novel entitled *Bailey's Cafe,* Ms. Naylor lives in New York City.

Reynolds Price has published numerous works of fiction, poetry, plays, essays (often about photography), and translations. His most recent novel is *The Tongues of Angels,* and his third collection of poems is *The Use of Fire.* His books have been translated into sixteen languages. He is presently the James B. Duke Professor of English at Duke University.

Belinda Rathbone is an independent curator, picture editor, and writer specializing in the history of photography. She has organized exhibitions for the Ministry of Culture in Spain, The

Museum of Modern Art in New York, Magnum Photos Inc., and Polaroid Corporation. Her essays have appeared in the *J. Paul Getty Museum Journal, The Print Collectors' Newsletter*, and *Aperture*.

John Rohrbach was Director of the Paul Strand Archive from 1981 to 1986. Rohrbach is currently completing his doctorate in the Program in American Civilization at the University of Delaware; his dissertation will analyze Paul Strand's films and photography till 1950.

Naomi Rosenblum, a distinguished art historian, is the author of *World History of Photography* and has written articles on Lewis Hine, Paul Strand, and women photographers. She is currently a professor at Parsons School of Design.

Walter Rosenblum, born on Manhattan's Lower East Side in 1919, is a teacher, critic, photographer, and writer. The most-decorated United States photographer during World War II, Rosenblum covered the D-Day landings at Normandy and was the first photographer to enter Dachau. Having joined the Photo League in 1937, he eventually became its president, meeting Lewis W. Hine and Paul Strand, with whom Rosenblum maintained close personal associations. He has had individual shows at the Brooklyn Museum, the Fogg Museum, and Queens Museum, and his photographs are in numerous museum and private collections. He has been the recipient of grants from the National Endowment of the Arts, the New York State Council on the Arts, and the John Simon Guggenheim Foundation, as well as a guest fellowship from the J. Paul Getty Museum.

Charles Simic published his first volume of poetry in 1967 and many others have since followed. Most recent are *Selected Poems, 1963–1983, Unending Blues* (1986), and *The World Doesn't End* (1989), for which he received a Pulitzer Prize in 1990. Two books of essays and interviews, *The Uncertain Certainty: Interviews, Essays and Notes on Poetry* (1985) and *Wonderful Words, Silent Truth* (1990), were both published by the University of Michigan Press. Simic is Professor of English at the University of New Hampshire, where he teaches American Literature and Creative Writing.

Maren Stange is assistant professor of American Studies and coordinator of the program in communication studies at Clark University. Her book, *Symbols of Ideal Life: Social Documentary Photography in America, 1890–1950*, was recently published by Cambridge University Press, and she is now at work on a study of postwar documentary expression in several media. She has held fellowships from the American Council of Learned Societies and the Center for Advanced Study in the Visual Arts, National Gallery of Art.

Alan Trachtenberg is Neil Gray, Jr. Professor of English and Professor of American Studies at Yale University. His *Reading American Photographs: Images as History, Matthew Brady to Walker Evans* (Hill & Wang, 1989) was awarded the Charles C. Eldredge Prize in 1990. His other books include *Brooklyn Bridge: Fact and Symbol* (1965) and *The Incorporation of America: Culture and Society in the Gilded Age* (1982), and among books he has edited is *Classic Essays on Photography* (1980). He has published essays on American cultural history including literature, technology,

urbanism, and photography. Professor Trachtenberg has held fellowships from the American Council of Learned Societies, the National Endowment for the Humanities, and the Rockefeller Foundation, and he has taught as a Fulbright professor at Leningrad State University.

Anne Tucker is the Gus and Lyndall Wortham Curator at the Museum of Fine Arts, Houston, where she has worked since 1976. Her exhibitions and publications include *The Woman's Eye*, The Target Collection of American Photography series, *Unknown Territory: Photography by Ray K. Metzker, Robert Frank: New York to Nova Scotia, Czech Modernism 1900–1945*, and *Money Matters: A Critical Look at Bank Architecture*, as well as many articles and afterwords. She has researched the Photo League for half her lifetime and continues writing *Photographic Crossroads: The Photo League,* thus far with generous grants from the John Simon Guggenheim Foundation and the National Endowment for the Arts.

Katherine Chambers Ware is a historian of photography currently living in Los Angeles, California. She has worked as a curatorial assistant in the photographic departments of the Oakland Museum and the San Francisco Museum of Modern Art, and as an editor at the Smithsonian Institution Traveling Exhibition Service. She is currently a curatorial assistant in the Department of Photographs at the J. Paul Getty Museum.

Mike Weaver is Reader in American Literature at Oxford University. Editor of the international quarterly journal *History of Photography*, he is the author and editor of several books on photography.

Steve Yates is an artist and curator at the Museum of Fine Arts, Museum of New Mexico, Santa Fe, where he established the first department of photography. Museum curatorial programs that he has sponsored include little known dimensions of work by influential twentieth century artists such as Paul Strand, Edward Weston, Eliot Porter, Paul Caponigro, Betty Hahn, and Joel-Peter Witkin, and contemporary photographic work since 1950. Recent essays include "Ambiguous Space: Tradition and Non-Tradition" (The Tamarind Papers).

Index

A Propos de Nice (film), 70
Abbott, Berenice, 126, 127
Abstraction, Bowls (Strand), 23
Abstraction, Porch Shadows (Strand), 23, 40, 81
Adams, Ansel, 31, 99, 127, 129, 133–34, 174, 182, 240
 resignation from Photo League, 146
Adamson, Robert, 120, 146, 190
Adler, Felix, 32
AIZ (Arbeiter Illustrierte Zeitung), 195
Akeley Camera (Strand), 27, 45–46, 68, 182
Aldridge, James, 176, 214
Alexander Nevsky (film), 183
Alpers, Boris, 199
America and Alfred Stieglitz: A Collective Portrait (Frank, *et al.*, eds.), 7, 198
American Exodus, An (Lange and Taylor), 130, 144, 161–62, 166–67, 170, 201–02
American Labor Party (ALP), 199
American Photographs (Evans), 14
American Place, An, 48, 89, 98, 129, 194
Americans, The (Frank), 14, 15, 108
Anderson, Sherwood, 46
Apache Dancers (Strand), 98
Aperture, 176, 238
Arbeiter Fotograf, Der, 124
Arbres et Maison (Strand), *208*, 209–10
Arensberg, Walter, 59, 66
Armory Show, 18, 20, 24, 25, 36
Arts and Decoration, 60
Ashcan realism, 18, 19–20, 21, 25, 29, 37
Atget, Eugene, 126, 131, 146
Ault, George, 22

Badlands (Strand), 95
Balog, Lester, 123, 124
Balzac, Honoré de, 201
Barsam, Richard, 183

Bassols, Narciso, 111, 149
Bauhaus, 27
Beal, Gifford, 20, 21
Bell Rope, The (Strand), 204
Bellows, George, 20, 21
Benson, Richard, 238
Berger, John, 186, 252
Bergson, Henri-Louis, 19, 39
Berlin, Symphony of a City (film), 63, 65, 70
Berman, Lionel, 125, 127, 152, 157
Bessie, Alvah, 200
Bezhin Meadow (film), 199
Bird on the Edge of Space (Strand), *237*, 238
Black Mountain (Strand), 97–98
Blacklisting, 174, 200
Blind Woman (Strand), 16, 18, *19*, 41, 210
Blindman, The, 67
Blue, James, 156
Bluemner, Oscar, 25
Bombed Church (Strand), *178*, 179–80
Bourke-White, Margaret, 127, 130, 165–66, 185
Bourne, Randolph, 9, 42
Bowls (Strand), 23
Brady, Mathew, 6, 126, 131
Brandon, Tom 124–25, 126
Braque, Georges, 140
British Film Institute, 59
Brody, Sam, 123, 124, 126
Brooks, Van Wyck, 161, 172–73
Broom, 9, 10
Browder, Earl, 159
Brown, Milton W., 176, 185, 201, 214
Bruguière, Francis, 22
Bucks County House (Sheeler), 57
Burckhardt, Rudy, 123

Caffin, Charles, 24, 33
Caldwell, Erskine, 130, 165–66
Callahan, Harry, 189

Camera Club of New York, 33–35
Camera Work, 9, 28, 29, 36, 39, 62, 120, 129, 139, 145
Cameron, Julia Margaret, 257
Campbell, John Lorne, 215
Cárdenas, Lázaro, 113
Carles, Arthur B., 25
Carroll, Lewis, 257
Cartier-Bresson, Henri, 14, 249, 257
Caspary, Vera, 154, 155
Cavalcanti, Alberto, 70
Cézanne, Paul, 98, 181, 243, 246, 248, 253
Chávez, Augustine Velásquez, 112, 115, 194
Chávez, Carlos, 109, 112, 116, 148, 149, 194
Chelsea Document, The, 131
China Strikes Back (film), 155
Church Gateway, Hidalgo (Strand), 118, *119*
Church on a Hill (Strand), 246
Church Street El (Sheeler), 62
Church, Coapiaxtla (Strand), 115, 116, 118
City of Ambition (Stieglitz), 62
City Symphony (Weinberg), 65, 70
Clark, Tom C., 13, 145
Clarence White School, 44
Clurman, Harold, 7, 9, 200
 Stieglitz and, 197–98
 Strand and, 49, 88–89, 99, 120, 152, 199
Coburn, Alvin Langdon, 37, 63
Cobweb in Rain (Strand), *145*, 206
Coke, Van Deren, 30
Cole, Barney, 127
Coleman, Glenn, 20
Constantini, Paolo, 244–45
Copland, Aaron, 200
Corot, Jean-Baptiste Camille, 253
Crawford, Cheryl, 152
Creative Art, 9, 88
Cristo with Thorns (Strand), *116*, 118, 182, 187, 195
Critical realism, 200–01
Cubism, 22, 36
Cunningham, Imogen, 33

Curtis, Natalie, 68
Czechoslovakia Film Festival, 173

Daily Worker, 123, 124
Dark Mountain (Strand), 96, 97
Dasberg, Andrew, 27–28
Daumier, Honoré, 20
David Octavius Hill: Master of Photography (Schwarz), 120
Davidson, Basil, 137, 176, 218
Davis, Ben, 200
Davis, Stuart, 20
Daybooks (Weston), 5
De Chirico, Giorgio, 230
De Zayas, Marius, 36, 59
Decisive Moment, The (Strand), 108
Degas, Edgar, 20
Del Duca, Robert, 124, 126
Demuth, Charles, 22, 23, 27–28
Deschin, Jacob, 174, 175
Dewey, John, 32, 181
Dickinson, Preston, 22
Disraeli, Robert, 127
Dmytryk, Edward, 200
Documentary photography, 143–44, 165–66
Dove, Arthur, 25, 92–93, 141
Dovzhenko, 154–55
Dream of Constantine (Piero della Francesca), 214
Driggs, Elsie, 22
Duchamp, Marcel, 25, 26, 27, 28, 36, 39
Duell, Sloan and Pearce, 165
Dynamic realism, 12, 200–07, 249–50

Eastman, George, 254
Einaudi, Giulio, 213
Eisenstein, Sergey, 64, 140, 152, 182–83, 185, 199
Elisofon, Eliot, 133
Ellis, Havelock, 205
Emerson, Peter Henry, 44
Emerson, Ralph Waldo, 2
Engel, Morris, 128, 131, 144

Ethical Culture School, 6, 9, 24, 32, 33, 75
Equivalents (Stieglitz), 182
Evans, Walker, 6, 14, 16, 186, 240
Evergood, Philip, 132–33
Excavating–New York (Stieglitz), 62

Family of Man (Steichen), 251
Family, The (Strand), 98, 183, 186, *256,* 257–58
Farm Security Administration (FSA), 6, 131, 133, 167, 240, 242
 Historical Section–Photographic, 126
Federal Bureau of Investigation, 205
Ferry Boat, The (Stieglitz), 62
Fifth Avenue (Strand), 62
Film and Photo League, 123–26, 130, 152, 159
Flaherty, Robert, 151, 183, 185, 188, 201, 215
Forain, Jean-Louis, 20
Foster, William Z., 159
France de Profil, La (Strand), 13, 14, 108, 174, 175–76, 190, 205, 209, 210, 233–34
Frank, Robert, 108
Frank, Waldo, 7, 9, 10, 14, 15, 39, 46, 48
Freeman, The, 9, 68
Frontier (film), 154–55
Frontier Films, 7, 39, 126, 127, 154, 155, 156, 157, 159, 160, 163, 164, 198
Fumée de New York (film), 59
"Fuzzygraphics," 38

Gavarni, Paul, 20
Garden, The (Strand), 190, 207, 236–38
Garden of Dreams, The (Strand), 34–35
Ghana, An African Portrait (Strand and Davidson), 176, 188, 190
Ghirri, Luigi, 244–45
Gibarti, Louis, 123
Gilbert, George, 124, 125
Glackens, William, 20
Gorky, Maxim, 200

Goya, Francisco, 20
Grapes of Wrath, The (film), 166
Greco, El, 143
Grierson, John, 185
Grossman, Sidney, 127, 128, 129, 131, 135, 139, 141
Group Theatre, 49, 88, 114, 198
Guggenheim Memorial Foundation, 161, 164
Guys, Constantin, 20
Gwathmey, Robert, 133
Gwathmey, Rosalie, 127

Hals, Frans, 20
Hand of Man (Stieglitz), 62
Hartley, Marsden, 9, 25, 111, 141, 245, 246
Haworth-Booth, Mark, 219
Hawthorne, Nathaniel, 204
Haying, Haut Rhin (Strand), 206
Heart of Spain (film), 157, 163, 167
Heartfield, John, 195, 96
Hegel, George Friedrich, 250
Henri, Robert, 20, 21, 29
Heye Foundation, 111
Higgins, Eugene, 20, 21
Hill, David Octavius, 29, 120, 126, 146, 190–91
Hilltown (Strand), 225–27
Hine, Lewis W., 21, 126, 131, 146
 "progressive reform," 10
 Strand influenced by, 6, 16, 24–25, 32, 143, 181, 207
Hine (Lewis W.) Memorial Collection, 122, 133
Hirsh, Stefan, 22
Hoffman, Michael E., 176, 217, 238
Hollywood Ten, 200
Homer, William Innes, 8, 28
Hopkins, Gerard Manley, 240
Hopper, Edward, 20
Hurwitz, Leo, 173
 blacklisting, 174
 Frontier Films, 127, 156, 157, 160
 Native Land, 145, 157, 158, 159, 163, 164, 204

Hurwitz (continued)
 New York Film and Photo League,
 124, 125, 126, 132–33
 Nykino, 152
 The Plow That Broke the Plains, 153
 on Strand, 155, 214
In the New York Central Yards (Stieglitz), 62
Independent Voters Committee for
 Roosevelt, 200
International Congress of Cinema,
 Perugia, Italy, 200
International Film Festival, Marianske,
 Czechoslovakia, 200
International Literature, 201, 203

Jacobs, Lewis, 124
James, Rebecca (Salsbury) Strand.
 See Strand, Rebecca (Salsbury)
James, William 86
Jiménez, Juan Ramón, 249
John Simon Guggenheim Memorial
 Foundation, 161, 164

Kandinsky, Wassily, 2
Käsebier, Gertrude, 38
Kazan, Elia, 157, 198
Keene, Charles, 20
Keiley, Joseph, 35
Keller, Ulrich, 185–86
Kent, Rockwell, 20, 21
Kertész, André, 247
Kineto Company of America, 61
Kingsbury, Hazel. See Strand, Hazel
 (Kingsbury)
Kroll, Leon, 20, 21
Kropotkin, Peter, 198
Kunst Verlag, 217, 218

Lachaise, Gaston, 9, 47, 82, 141
Lachaise, Isabel, 82
Land of the Free (MacLeish), 166
Land, The (film), 201
Landscape, Near Saltillo (Strand), 115,
 118
Lange, Dorothea, 6, 129, 133, 146, 240

An American Exodus, 130, 144,
 161–62, 166–67, 170, 175, 201–02
Larkin, Oliver, 201
Last Candles of a Dying Sun, The
 (Strand), 238
Lathe (Strand), 27, 28
Lawrence, D.H., 3, 205
Lawson, John Howard, 156, 200
Le Nain, Louis, 186
Le Nain brothers, 201
Leaves of Grass (Whitman), 43
Leech, John, 20
Leipzig, Arthur, 135
Lerner, Irving, 124, 125, 152, 157
Levine, Jack, 132–33
Lewis W. Hine Memorial Collection,
 122, 133
Leyda, Jay, 157
Libsohn, Sol, 127, 128, 131, 135
Liebling, Jerry, 144
Little Galleries of the Photo-Secession.
 See Photo-Secession gallery
Living Egypt (Strand and Aldridge),
 176, 190, 214, 254
Locke, John, 255
Lomax, Alan, 215
London, Jack, 10
London Salon, 1912, 34
Lorentz, Pare, 153–54
Lozowick, Louis, 22, 23, 28
Luhan, Mabel Dodge, 83, 88
Lukàcs, György, 201, 207
Luks, George, 20, 21

Macdonald-Wright, Stanton, 25
Machine-Age Exposition, New York,
 1927, 27–28
MacLeish, Archibald, 150, 154, 156,
 166
Maddow, Ben, 125, 127, 152, 157
Mahl, Sam, 135
Malraux, André, 245
Man in a Derby (Strand), 41
Man of Aran (film), 185
Man Ray, 2, 22, 28
Man with a Movie Camera (film), 63, 70
Man, Tenancingo (Strand), 118

Manet, Edouard, 20
Manhatta (film), 11, 26, 55–71, 75, 148
Mannahatta (film), 58
March of Time, The (newsreel), 154
Marin, John, 9, 24, 25, 36, 47, 87, 141, 165, 245
Masses & Mainstream, 201, 202, 203
Masters, Edgar Lee, 15, 50–51, 174, 187
Matisse, Henri, 36, 140
Maurer, Alfred H., 20, 25
Mauritania (Stieglitz), 62
McCausland, Elizabeth, 92, 117, 126–27, 129, 131, 139–40
Mellquist, Jerome, 114
Meltzoff, Stanley, 201
Men of Santa Ana (Strand), 187
Mesa Verde (Strand), 90–92, 97
Metcalf, Paul, 243
Metropolitan Museum of Art, 47
Mexican Portfolio, The (Strand), 14, 114, 129
Meyer, Agnes, 36
Meyers, Sidney, 125, 150, 152, 155, 157, 160
Mr. Bennett (Strand), *100*, 101–02, 183, 187, 202, 239, 241, 243, 248
Modern American Photographers, 90
Modern Gallery, 36, 38, 50
Modernism, 2, 5–7, 19, 21–25
 international modernism, 8
 objectivity, 3, 5, 32
Moholy-Nagy, Laszlo, 2
Morgan, Barbara, 127, 146
Morris, William, 103
Mrs. John McMillan, 189
mss (periodical), 47
Murals by American Painters and Photographers (exhibition), 111
Museum of Modern Art (MOMA), 99, 111, 117, 129, 145, 164
My Camera in the Yosemite Valley (Adams), 174
Myers, Jerome, 20

Nadar, Félix, 29
Nadelman, Elie, 25

Naked City (Weegee), 131, 145
National Council of the Arts, Sciences, and Professions (NCASP), 199–200
National Portrait Gallery, London, 238
Native Land (film), 7, 13, 128, 130, 133, 145, 146, 155, 156, 157–60, 163–64, 167, 168, 173, 200, 204
Near Dompierre (Strand), 206–07
Neo-realism, 211, 213
Neruda, Pablo, 4
New Masses, 123, 124
New Mexico (Strand), *94*, 95
New Republic, The, 9
New York (Sheeler), 62
New York Camera League, 123
New York Film and Photo League, 123–26, 126, 127, 148
 See also Photo League
New York Realists, 20
New York the Magnificent (film), 58–59, 60
New York Times, 174
New York Tribune, 60
Newhall, Beaumont, 127, 146, 164, 175, 241
Newhall, Nancy
 curator of Strand exhibit, 99, 117–18
 Photo League, 133, 146
 Time in New England, 161, 162, 164–65, 167–68, 174
Nietzsche, Friedrich, 39, 197
Nykino, 125–26, 148, 152, 153, 154, 155

Octopus, The (Coburn), 63
Odets, Clifford, 200
Of New England (Strand and Newhall), 165
Offices (Sheeler), 62
O'Keeffe, Georgia, 9, 22, 25, 46, 83, 98, 141
 flower pieces, 23
 relationship with Strand, 23, 25, 43, 47, 48, 74–75, 87–88
 Stieglitz's portraits of, 5, 47, 50, 72, 73, 74, 76–77, 85
Old and New York (Stieglitz), 62

Old New York (film), 61
O'Malley, Ernie, 199
On My Doorstep (Strand), 190
Open City (film), 160
Ophuls, Marcel, 160
Order of Arts and Letters, 238
Orozco, José Clemente, 111, 113, 148
Our America, 10
Outerbridge, Paul, 22
Oxford University Press, 165, 174

Paese, Un (Strand and Zavattini), 15,
 176, 190, 211, 212, 216, 222
Parker, Robert Allen, 60–61
Partisan Review, 201
Pater, Walter, 65
Paul Strand: A Retrospective Monograph,
 218
Pay Day (film), 156
Pène du Bois, Guy, 20
Pennsylvania Academy, 20
People of the Cumberland (film), 156
Photo League, 122–135, 138–47, 166,
 196, 201, 209, 210
 farewell party for Strand, 200
Photo News, 131
Photo Notes, 127, 131, 133, 139–40,
 144, 145, 146, 166, 196, 199, 201
Photo-Secession gallery, 2, 25, 33, 36,
 89
 children's art exhibit, 113
 Strand exhibitions at, 19, 39, 42
Photo-Secession group, 2, 6–7, 8, 32,
 36, 37, 38, 42, 49, 88
Photographs of Mexico (Strand), 109–10,
 111, 112, 113, 114, 150
Photographs of New York and Other
 Places (exhibition), 39
"Photography and the New God"
 (Strand), 68, 70
Photography Journal, 174–75
Photogravure and Color Company, 107
Picabia, Francis, 25, 27, 36, 39
Picasso, Pablo, 4, 36, 140
Piero della Francesca, 191, 214, 246
Pinturas y Dibujos de los Centros Culturales
 (exhibition), 112–13

Pissaro, Camille, 207
Platt, David, 124
Plaza, The (Strand), 35
Plaza, State of Puebla (Strand), 118
Plow That Broke the Plains, The (film),
 151, 153
PM, 145
Porch Shadows (Strand), 23, 40, 81
Pound, Ezra, 66
Progressive Citizens of America (PCA),
 200
Progressive Party, 133, 200

Que Viva México (film), 183

Ramsdell, Susan, 109
Rapoport, Sid, 108
Realism, 29
 Ashcan realism, 18, 19–20, 21, 25,
 29, 37
 critical realism, 200–01
 dynamic realism, 200–07, 249–50
 neo-realism, 211, 213
 socialist realism, 140, 200–01
Redes (film), 13, 113–14, 149, 195
Rembrandt, 248
Resettlement Administration, 153
Rien Que Les Heures (film), 70
Riesenfeld, Hugo, 60
Riis, Jacob, 21, 25, 29
Riley, Robert, 196
River, The (film), 154
Rivera, Diego, 4, 110–11, 149
Robeson, Paul, 158, 159
Rochester Historical Society, 175
Rodakiewicz, Henwar, 149
Rodchenko, Alexandr Mikhailovich,
 2
Roffman, Julian, 126
Roosevelt, Franklin D., 196
Roots, Gondeville (Strand), *234*, 235
Rossellini, Roberto, 160
Rosenblum, Naomi, 28, 56, 135
Rosenblum, Walter, 127, 135, 176
Rosenfeld, Paul, 9, 39
Rousseau, Jean-Jacques, 253–54

Roy, Claude, 14, 174, 175–76, 207, 209–10, 234
Royal Photographic Society of Great Britain, 174–75
Ruttman, Walter, 63, 65, 70

Salsbury, Nate, 75
Salsbury, Rebecca. See Strand, Rebecca (Salsbury)
Sands at Seventy (Whitman), 67
Sandwich Man (Strand), 210
Saturday Evening Post, 120
Schamberg, Morton L., 22, 26–27, 36, 42
Schapiro, Meyer, 201
Schopenhauer, Arthur, 197
Schwarz, Heinrich, 120
Scientific and Cultural Conference for World Peace, 200
Scott, Walter, 201
Seligmann, Herbert, 48
Seltzer, Leo, 124
Seven Arts, 9, 10, 39, 42
Shahn, Ben, 4, 6, 132–33, 200
Shales, Richard, 58
Shapley, Harlow S., 199
Shaw, Nathaniel, 36
Sheeler, Charles, 22, 23, 26–27, 28, 36, 42
 Manhatta, 26, 43, 55, 56–59, 60, 62–63, 75, 148
Shinn, Everett, 20, 21
Shop, Le Bacarés (Strand), 228, 229–30
Siqueiros, David Alfaro, 111, 148
Siskind, Aaron, 127, 130
Skeleton/Swastika (Strand), 192–96
Sklar, George, 154, 155
Sloan, John, 20, 21
Smith, W. Eugene, 133
Smoke of New York (film), 59
Socialist realism, 140, 200–01
Spencer, Niles, 22
Spoon River Anthology (Masters), 15, 50–51, 174, 187
Stafford, William, 241
Steichen, Edward, 36, 146, 251
Steinbeck, John, 166

Steiner, Ralph, 28, 124, 125, 126, 152, 153, 156–57
Stella, Joseph, 20, 21, 22
Stevens, Virginia. See Strand, Virginia (Stevens)
Stevenson, Philip, 199
Stewart, Donald Ogden, 154
Stieglitz, Alfred, 32, 35, 37, 38–39, 42, 43, 44, 61, 68, 83, 88, 126, 145, 146, 194, 239, 248, 254
 cloud photographs, 65
 Clurman and, 198
 Clurman on, 89
 criticism of Strand, 11, 48
 on Manhatta, 56, 57, 59, 62
 marriage, 79
 Mauritania, 62
 Modern Gallery, 36
 modernism, 2, 3
 objectivity, 3, 5, 182
 Photo-Secession. See Photo-Secession gallery; Photo-Secession group
 portraits of Georgia O'Keeffe, 5, 47, 50, 72, 73, 74, 76–77, 85
 portraits of Strand, 103
 relationship with O'Keeffe, 74–75
 relationship with Strand, 9, 38–39, 43, 47–48, 87–88, 99, 109, 128–29, 139, 143
 Strand compared to, 1–5
 Strand influenced by, 2, 7, 10, 29, 181, 191, 207
 Strand's portraits of, 245
 symbolism, 182
Stijl, De, 27
Store Window (Mehle) (Strand), 92–93
Strand, Hazel (Kingsbury), 174, 188, 212, 215, 216, 217, 218, 223, 231, 232, 233, 238, 244–45
Strand, Jacob, 33
Strand, Paul
 in Army Medical Corps, 35, 41–42, 43, 75
 chronology, 260–67
 dynamic realism, 12, 200–07, 249–50
 at Ethical Culture School, 9, 24, 32, 33, 75

Strand (*continued*)
 machine canon, 26–28, 30, 44–46,
 68
 politics, 4, 6–7, 11–12, 48–49,
 199–202
 portraits of wife, 5, 42, 47, 72–86,
 198
 printmaking, 103–08
 suspension from Camera Club, 35
 See also specific headings and names
 of individual works
Strand, Rebecca (Salsbury), 48, 87–88,
 109
 marriage to William James, 86
 Paul Strand's portraits of, 5, 42, 47,
 72–86, 98
Strand, Virginia (Stevens), 192–93
Strand, Luzzara (Constantini and
 Ghirri), 244–45
Strasberg, Lee, 114, 152
Strike (film), 205
Struss, Karl, 37
Stryker, Roy, 146
Subversive Activities Control Board,
 205
Sudbury Daily Star, 214
Survey Graphic, 21
Susan Thompson (Strand), *136*, 137, 242

TAC, 192
Taggard, Genevieve, 202
Taylor, Paul Schuster, 130, 144, 170
 An American Exodus, 161–62, 166,
 175, 201–02
Temple of Love (Strand), 34
This is the Photo League (symposium),
 134
Thompson, Susan, 137
Thoreau, Henry David, 2, 172, 202
Time in New England (Strand), 14,
 15–16, 106, 108, 161–77, 187–88,
 202, 203–04, 206, 213, 216, 239,
 240–43, 247–48
Tir a'Mhurain: Outer Hebrides (Strand
 and Davidson), 176, 188–90, 213
Tisse, Edouard, 183–84
Tolstoy, Leo, 201

Tomkins, Calvin, 4
Totems in Steel (Sheeler), 62
Toulouse-Lautrec, Henri, 20
Truman, Harry S., 146
Trumbo, Dalton, 200
Twenty Centuries of Mexican Art (exhibi-
 tion), 111
291 (journal), 39
291 gallery. *See* Photo-Secession gallery
Two Schools (exhibition), 134

U.S. Camera, 117
Underhill, Harriet, 60
United States Farm Security Adminis-
 tration, etc. *See* Farm Security Ad-
 ministration, etc.
Universal, 111

Van Der Zee, James, 33
Van Dyke, Willard, 154, 155, 156–57
Vanity Fair, 62
Vasconcelos, José, 110
Vaudrin, Philip, 174
Velasquez, Diego, 20
Versailles (Strand), 34–35
Vertof, Dziga, 63, 70
View of Toledo (El Greco), 143
Vigo, Jean, 70
von Fritsch, Gunther, 149

Walkowitz, Abraham, 25
Wall Street (Strand), 26, 37–38, 57, 62,
 197, 210
Wallace, Henry A., 199
Wanamaker Exhibition of Photography,
 26, 42, 57
Water Wheel and Colossi (Strand), 246
Wave, The (film), 113, 132, 133, 149,
 155, 160, 183, 195, 199, 201
Weber, Max, 25
Weegee, 131, 145
Weinberg, Herman, 65
Weiner, Dan, 127, 144
Weiner, Sandra, 201
Weston, Edward, 33, 182, 189, 248

Strand compared to, 4–5
 objectivity, 3, 5, 182
 Photo League, 126, 127, 133, 139, 146
Wheel Organization (Strand), 26, 42
White, Clarence, 38
White, Minor, 134, 175, 189
White Fence, The (Strand), 23–24, 197
Whitman, Walt, 2, 8, 37, 71
 Edgar Lee Masters and, 50
 Leaves of Grass, 43, 58, 65–68
Williams, William Carlos, 66, 229–30
Winogrand, Gary, 243
Wire Wheel (Strand), 27
Women of Santa Ana (Strand), 52,
 53–54
Worker's International Relief (W.I.R.),
 123, 124

Workers' Art Center, 123
Workers' Bicycles (Strand), 205
Workers' Camera Leagues, 123
Workers' Film and Photo League. *See*
 Film and Photo League
World Today, The (newsreel), 154

You Have Seen Their Faces (Bourke-
 White and Caldwell), 130, 165–66
Young Boy, Gondeville (Strand), 250

Zavattini, Cesare, 15, 176, 207, 211,
 214, 216
Zhdanov, Andrey, 140
Zinneman, Fred, 149, 199

Library of Congress Catalog Number 90–081490
Hardcover ISBN: 0-89381-420-2;
Paperback ISBN: 0-89381-441-5

The staff at Aperture for *Paul Strand: Essays on His Life and Work* is Michael E. Hoffman, Executive Director; Maren Stange, Editor; Jane D. Marsching, Assistant Editor; Thomas Seelig, Susannah Levy, Editorial Work-Scholars; Stevan Baron, Production Director; Linda Tarack, Production Associate. Book Design by Wendy Byrne.

Aperture Foundation, Inc. publishes a periodical, books, and portfolios of fine photography to communicate with creative people everywhere. A complete catalog is available upon request. Address: 20 East 23 Street, New York, New York 10010.

Acknowledgments
In addition to those mentioned above, Anthony Montoya, Alan Fern, Susan Baron, and Charles Hagen have offered invaluable advice and assistance.